# COMPLETE DIGITAL PHOTOGRAPHY

## THIRD EDITION

# COMPLETE DIGITAL PHOTOGRAPHY

## THIRD EDITION

### BEN LONG

**CHARLES RIVER MEDIA, INC.**

Hingham, Massachusetts

Publisher: Jenifer Niles
Cover Design: The Printed Image
Cover Images: Ben Long

CHARLES RIVER MEDIA, INC.
10 Downer Avenue
Hingham, Massachusetts 02043
781-740-0400
781-740-8816 (FAX)
info@charlesriver.com
www.charlesriver.com

This book is printed on acid-free paper.

Ben Long. *Complete Digital Photography, Third Edition.*
ISBN: 1-58450-356-4

All brand names and product names mentioned in this book are trademarks or service marks of their respective companies. Any omission or misuse (of any kind) of service marks or trademarks should not be regarded as intent to infringe on the property of others. The publisher recognizes and respects all marks used by companies, manufacturers, and developers as a means to distinguish their products.

Library of Congress Cataloging-in-Publication Data
Long, Ben, 1967-
  Complete digital photography / Ben Long.— 3rd ed.
    p. cm.
  ISBN 1-58450-356-4 (pbk. with cd-rom : alk. paper)
  1.  Photography—Digital techniques—Handbooks, manuals, etc. 2.  Digital cameras—Handbooks, manuals, etc. 3.  Image processing—Digital techniques—Handbooks, manuals, etc.  I. Title.
  TR267.L66 2004
  775—dc22

                           2004018740
Printed in the United States of America
04 7 6 5 4 3 2 First Edition

CHARLES RIVER MEDIA titles are available for site license or bulk purchase by institutions, user groups, corporations, etc. For additional information, please contact the Special Sales Department at 781-740-0400.

Requests for replacement of a defective CD-ROM must be accompanied by the original disc, your mailing address, telephone number, date of purchase, and purchase price.  Please state the nature of the problem, and send the information to CHARLES RIVER MEDIA, INC., 10 Downer Avenue, Hingham, Massachusetts 02043. CRM's sole obligation to the purchaser is to replace the disc, based on defective materials or faulty workmanship, but not on the operation or functionality of the product.

# CONTENTS

**CHAPTER 6**     **BUILDING A WORKSTATION**                                **137**

**CHAPTER 7**     **SHOOTING**                                             **155**

**Chapter 8**     **Manual Exposure**     **211**

**Chapter 9**     **Special Shooting**     **245**

**CHAPTER 12**     **BUILDING YOUR EDITING ARSENAL**     **359**

## CHAPTER 14    SPECIAL EFFECTS

# ACKNOWLEDGMENTS

This book could not have been written (at least, not by me) without the help of a whole bunch of people.

Many people at many different companies provided help in the form of advice, answers, and evaluation hardware and software. In particular, I'd like to thank Michael Bourne at Olympus America, Joy Remuzzi at iView Multimedia, Lou Schmidt at Hoodman, Mary Resnick at Canon, and Pierre Vandevenne at DataRescue.

For their answers, help, and assistance, I'd like to thank Kalonica Mc-Questen, who edited and encouraged; Regina Saisi, Beverly Forsyth, Ron Miles, Jana Krenova, Don Byron, Dean Cook, George Colligan, and Joanna Silber, who all generously agreed to model; Dr. Ross Allen for his extreme technical answers and enjoyable emails; Rick LePage for his help, suggestions, and the pretty flower picture in Figure 11.30; Sean Wagstaff for his tips and suggestions; my mom for her modeling, and all that mom stuff; and my dad for his suggestions, comments, and all that dad stuff.

# 1

# INTRODUCTION

**In This Chapter**

- Who Is the Audience for This Book?
- What Counts as Digital Photography?
- Digital 101: A Few Basic Ideas
- The Best-Laid Plans

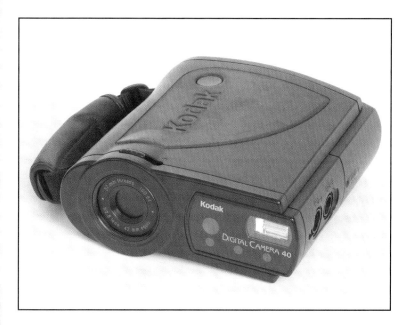

For years, if you pulled out a digital camera in the presence of a professional photographer, or even around a hobbyist photographer who had never used a digital camera, you invariably heard that digital was no competition for film. "Sure, that camera's got a good lens, but film is much higher resolution."

In the first two editions of this book, I included an entire chapter that discussed how digital output compared to film and what you could expect when making the switch to shooting digital. Those books were written at a time when one had to be a little defensive about shooting digital—when pointing out that a professional-quality print had been shot digitally would still raise eyebrows in amazement. For this third edition, I have very happily thrown that chapter in the trash because digital photography has arrived, once and for all.

"Is digital as good as film?" In years past, one would have to give a somewhat complex answer to that question: "Well, you have to consider how good your film processing is, and what kind of scanner you're using, and how skilled you are with your scanning software," and on and on. What's more, the only digital cameras that could rival film quality sold for $5,000 or higher. Now, for less than $1,000 you can buy a digital camera that easily delivers images that rival the best 35mm film scans. You can even get under-$1,000 digital cameras that use the same lenses and provide identical shooting features as professional 35mm cameras. At last, a film-quality SLR costs *less* than a good film camera and high-quality scanner. Once you factor in film and processing costs, digital quickly becomes the cheapest way to get film quality.

But eliminating the hassle and expense of scanning is only the beginning, because the digital photographer has luxuries the film photographer can only dream of: the ability to instantly view images and delete unwanted exposures, and the elimination of the environmental and financial concerns presented by film and film-processing chemicals. Artistically, the digital photographer can take advantage of unique in-camera features such as panoramic shooting, automatic image processing, exposure analysis, and the ability to shoot and shoot and shoot, trying many different settings, framings, and exposures without worrying about wasting film.

Film cameras have changed very little since their inception 150 years ago. Of course, lens, metering, and film technologies have improved tremendously over the last century and a half, but whether state-of-the-art or antique, all film cameras are basically a box that exposes a piece of film to light. By eliminating film, digital photography represents the *first* fundamental change in photographic technology since the mid-1800s. The simple fact that the camera does not record images on film makes digital photography a very different process—both technically and creatively—from traditional film photography.

In this book, we'll explore all of the technical and creative ins-and-outs of shooting digital—from choosing a camera to exposing an image to processing and printing. If you're new to photography, you'll learn the basic theory that photographers have studied for decades, as well as the latest tools and techniques made possible by the shift to digital. If you're an experienced film photographer, you'll see how you might need to change your photographic process to adapt to digital shooting. From white balancing to exposing, you'll learn how to translate the knowledge you already have into the digital realm.

I have been writing about digital photography since the very first 640 × 480-pixel consumer cameras (Figure 1.1) became available, and wrote several magazine reviews of the first megapixel cameras. (At that time, the theory was that once the 4-megapixel "barrier" was reached, we would have film quality.) Despite watching the changes and advances over the years, it's still astonishing how quickly the technology develops. In the second edition of this book I wrote: "With super-high resolutions of 8 to 10 megapixels, digital camera backs offer alternatives for photographers who already have a medium- or large-format camera body. These options are typically very expensive ($10,000 to $25,000)." As of this writing, that was a year and a half ago. You can now buy 8-megapixel cameras from Sony®, Olympus®, Canon®, and Minolta® with an average price of $800.

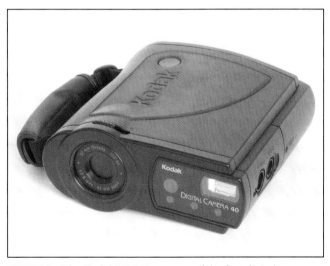

**FIGURE 1.1**    The Kodak® DC40 was one of the first digital cameras to win mass consumer appeal. It had no LCD screen, no removable storage, a "high" resolution mode of 756 × 504 pixels, and an original price in 1996 of $599. Nowadays, there are hundred-dollar cell phones that take better pictures. Nevertheless, the DC40 served an important role in getting people to recognize the practical advantages of shooting digital.

The rapid advances in technology have brought a lot of changes to the camera information in this new edition of *Complete Digital Photography*. Chapter 5, "Choosing a Digital Camera," has been thoroughly updated with current features and capabilities. It has also been reorganized to better match the organization and landscape of the current market.

However, simply updating camera information is only the beginning. Chapters 2 and 3—"How a Digital Camera Works" and "Basic Photography: A Quick Primer"—have both been rewritten and are, I believe, easier to understand.

As mentioned earlier, previous editions included a chapter that argued digital photography's merits against film. That chapter has been replaced with Chapter 4, an overview of how to evaluate a digital image. Learning to recognize what makes one image look better than another is handy for evaluating a camera when you're ready to buy, and an essential skill when using image-editing software to correct and improve an image.

As in the previous edition, the book's image-editing examples and tutorials are built around Adobe® Photoshop®. Although Photoshop is the premiere image-editing application, there are plenty of other good editors out there, and in Chapter 6, "Building a Workstation," you'll learn how to pick a package that provides the tools typically used by digital photographers. Fortunately, most image-editing programs provide the same basic tools and interfaces, so you should have no trouble adapting the lessons described here to other editing packages. All of the tutorials have been updated for the latest release of Photoshop (Photoshop CS and Photoshop Elements 2 as of this writing). Although most of the screen shots are from the Macintosh OS® X version of Photoshop, the program's interface is the same whether you use a Macintosh or Windows® computer.

In Chapter 7 you'll get started with your camera by learning the basics of shooting. In addition to learning how to configure your camera's settings for particular situations, you'll learn the basic details of framing and focusing as well as simple flash photography. Finally, you'll learn the rudiments of light metering. Like the rest of the chapter, the light metering section has been completely rewritten and is much easier to understand.

Chapter 8 builds on the basic concepts of Chapter 7 but delves into the creative possibilities provided by your camera's manual exposure features. You'll learn about motion control, depth of field, contrast, and detail, and all of the other imaging choices that are possible when you take control of your camera's manual features. As in Chapter 7, the explanations and examples in Chapter 8 have been rewritten and are now easier to understand.

Knowing the basics doesn't do you any good if you tend to shoot in unusual environments or like shooting particularly tricky subjects. Chapter 9 helps you with all of the more specialized forms of shooting that you

might engage in, from macro photography to black and white. Many new examples are provided, and the chapter has been updated to include the latest advances in gear as well as the newest features and utilities.

Once you've got a camera full of images, you're ready to start editing. Chapter 10 covers everything you need to know to prepare Photoshop's color management system, as well as detailing how to handle all of the initial cropping and resizing that you'll need to do before you can start editing. Both Photoshop CS and Photoshop Elements 2 include brand-new Image Browsers, which make finding and managing images much easier—you'll learn about these new features in this updated chapter.

A digital image editor is capable of extraordinary retouchings and special effects. But 90 percent of the chores you'll perform with your editing program are color and tone corrections. In Chapter 11, you'll learn about Photoshop's color-correction tools. By the end of the chapter, not only will you know how to perform the bulk of the corrections that you'll need to make, you'll also have a solid foundation for the more advanced correction techniques discussed later in the book. Readers of previous editions will find many new discussions and tutorials in this chapter, as well as several new technique examples.

With basic correction skills under your belt, you're ready to move on to Chapter 12, where you will expand your repertoire with a study of masking, cloning, making complex selections, and some basic layering techniques. Chapter 12 includes many new masking and selecting techniques, as well as several new examples of blending and compositing tricks.

Chapter 13 kicks up your image-editing skills several notches with discussions of many advanced masking techniques, followed by a thorough exploration of workflow. Knowing which order you should perform your editing operations in is essential to maintaining image quality. After introducing an outline of workflow, Chapter 13 details each workflow step. You'll move from initial cleanup and color and tone adjustment, to edits, resizing, and finally sharpening. Chapters 13 and 14 have seen more changes than any other chapters. Here, you'll find many new techniques, including image-based masking, better noise removal tutorials, and new sharpening strategies. Chapter 13 also includes a detailed discussion of how to use Adobe Camera Raw and how Raw files affect your overall workflow.

Chapter 14 rounds out your post-production knowledge with detailed descriptions of how to simulate shallow depth of field, stitch panoramas, convert color images to grayscale, add texture and grain, and create hand-colored images. An entirely new section on portrait touch-up is included, as well as discussions of compositing and print preparation. As with Chapter 13, this chapter includes substantial new examples, tutorials, and discussions.

Finally, with your images edited and corrected, you're ready to output. Chapter 15 covers everything you need to know to get your images *out* of your computer, whether through a printer, Web page, or e-mail. Printer technology is advancing as quickly as camera technology, and this chapter has been updated to cover the latest printing options. In addition, you'll learn the details about resolution choice and image preparation.

*ON THE CD*

In addition to the tutorials from the first edition, two video tutorials are included on the CD-ROM. In these QuickTime® movies, you can watch "over my shoulder" as I perform a number of imaging and adjustment techniques. Because many image correction processes are "interactive" rather than strictly procedural, these movies give you the opportunity to learn techniques that cannot be explained in a written, step-by-step form.

The tutorial movies are included in the Tutorials folder on the CD-ROM. You can watch them in any order, but it would be best to view them when they are called out in the text, since some of the techniques assume that you have already learned certain concepts.

## WHO IS THE AUDIENCE FOR THIS BOOK?

This book is for photographers of all skill levels. Whether you're new to photography or simply new to *digital* photography, this book will provide the explanation and answers you need to get the best images possible.

Using a film camera is a two-step process. First, you shoot your pictures—with the goal of getting as much color, contrast, and tone into your image as you can manage. Then, you develop and print the images in a way that takes maximum advantage of that information. Shooting digital photographs is no different. As with a film camera, you first shoot your subject, after carefully calculating the proper exposure. Then, you digitally process and print your image.

Although cameras might change, the physics of light remains the same (fortunately!). Consequently, digital and film photographers share all of the same concerns over apertures, shutter speeds, and metering techniques.

Overall, the book is divided into four broad sections. Chapters 1 through 4 provide the basic technical information you'll need to understand all of the topics covered later in the book. Chapters 5 and 6 help you select the camera, computer, and software that's right for you

All of your additional shooting concerns, from choosing the right exposure to using filters and flash, are covered in Chapters 7, 8, and 9. Although experienced photographers might already be comfortable with much of the information presented, they'll still want to take a close look

at these chapters for information on the particular idiosyncrasies of shooting with digital cameras.

Digitally editing and correcting your images is covered in Chapters 10 through 14, and outputting (either to print or electronically) is covered in Chapter 15.

It is difficult to separate the artistic and technical concerns involved in creating a good photo—after all, it is your technical control that allows you to achieve your artistic goals. Nevertheless, this book makes no attempt to cover certain "artistic" issues. Composition, artistic intent, photographic narrative, and many other concerns are not discussed, mainly because there are so many good books already available on this subject. See Appendix A, "Suggested Reading," for a list of valuable resources.

Because *Complete Digital Photography* is intended for users with a variety of experience levels, many terms have been defined in the Glossary rather than within the main text.

## WHAT COUNTS AS DIGITAL PHOTOGRAPHY

Many people use the term *digital photography* to cover any photographic process that involves correcting and editing a photograph digitally. By this definition, shooting with your film camera, scanning your film or prints, editing them on your computer, and then printing them on a desktop printer counts as digital photography.

In this book, digital photographs are photographs taken with a digital camera. This is an important distinction because shooting with a film camera and shooting with a digital camera involve different concerns and practices, and scanning is a science unto itself. The simple fact is that there are many things that you must do differently with a digital camera. But don't worry—this book covers them all!

## DIGITAL 101: A FEW BASIC IDEAS

In the old days, photographers made their own photographic papers, films, and *emulsions*. Whether it was to achieve a particular style or texture or to gain more control over their printing processes, photographers such as Ansel Adams, Alfred Stieglitz, and Eduard Steichen had to know a good deal about chemistry to create their prints. Similarly, to really understand how to get the most out of your digital camera, it's important to understand some of the technology behind it. Chapter 2, "How a Digital Camera Works," covers the details of how a digital camera works, but before you dive into that, you need to have a basic understanding of the *digitizing process*.

The "real" world in which we live is an *analog* world. Light and sound come to us as continuous analog waves that our senses interpret. Unfortunately, it's very difficult to invent a technology that can accurately record a continuous analog wave. For example, you can cut a continuous wave into a vinyl record, but because of the limitations of this storage process, the resulting recording is often noisy and scratchy and unable to capture a full range of sound.

Storing a series of numbers, on the other hand, is much simpler. You can carve them in stone, write them on paper, burn them to a CD-ROM, or, in the case of digital cameras, record them to small electronic memory chips. Moreover, no matter how you store them, as long as you don't make any mistakes when recording them, you'll suffer no loss of data or quality as you move those numbers from place to place. Therefore, if you can find a way to represent something in the real world as a series of numbers, then you can very easily store those numbers using your chosen recording medium.

The process of converting something into numbers (or digits) is called *digitizing*. The first step in digitizing is to divide your subject into distinct units. In the case of an image, this is a simple process of dividing your image into a grid of *picture elements* or *pixels.* How fine your grid is (that is, what *resolution* it has) varies depending on the sophistication of your equipment.

Next, each pixel in the grid is analyzed to determine its content, a process called *sampling.* Each sample is measured to determine how "full" it is; that is, a corresponding numeric value is assigned that represents that pixel's contents, a process called *quantizing.* Finally, these numeric values are stored on some type of storage medium.

Figure 1.2 is a simple image composed entirely of black and white pixels. As you can see, it's very easy to assign a 1 or a 0 to each pixel to represent the image. Because it takes only a single *bit* to represent each pixel, this image is called a *1-bit image*.

In the example shown in Figure 1.2, our individual samples can be only 0 or 1 (that is, they have a very small dynamic range) because we are storing only one bit of information per pixel. If we want to record more than simple black-and-white images, we need to be able to specify more colors—that is, we need to have more choices than just 0 or 1. By going to a higher color depth (sometimes called bit depth)—let's say 8 bits, which allows for 256 different values—we can record more information, as seen in Figure 1.3.

With 256 shades from which to choose, we can represent a finer degree of detail than we could with only two color choices. To store full-color images, we must go to an even higher bit depth and store 24 bits of information per pixel. With 24 bits, we can represent roughly 16 million

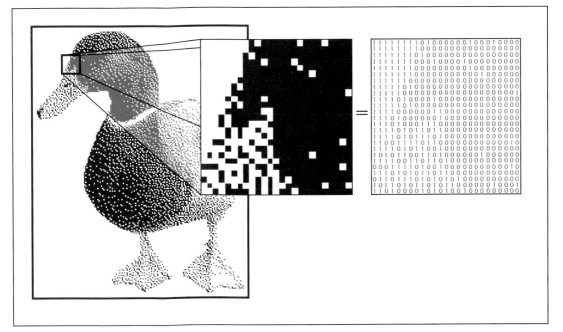

**FIGURE 1.2**    Each pixel in this 1-bit image is represented by a 1 or a 0.

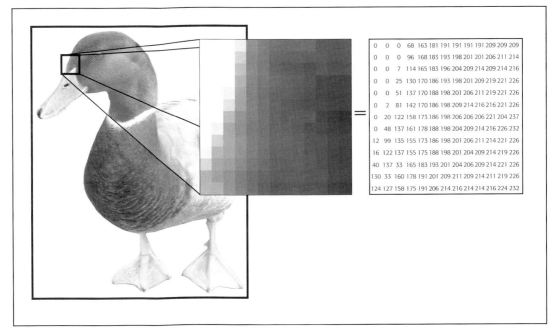

**FIGURE 1.3**    By storing bigger numbers for each pixel, we can store much more than simple black-and-white dots. With the ability to use gray pixels, the image looks much more realistic.

colors, allowing us to store photo-quality images. Note that because we're storing 8 bits per pixel as opposed to 1, our second image requires more storage space.

To sum up, two of the factors that determine the quality of a digitizing process are resolution (the size and number of your individual pixels) and dynamic range (how big a range of color choices you have for each pixel).

Many other factors affect the quality of a digitized image, from your camera's lens to its compression software. Before exploring these questions, though, let's look at how your camera manages all of this sampling, quantizing, and storage. Understanding how your camera perceives, captures, and stores color information will make certain types of editing operations easier later on.

## THE BEST-LAID PLANS

Though lots of effort has gone into ensuring accuracy in this book, mistakes do sometimes happen. An updated list of errata and corrections can be found at *www.completedigitalphotography.com/errata*. A quick check of this page will fill you in on any problems that have been found in the book since its publication. You can report any mistakes by sending an email to *oops@completedigitalphotography.com*.

# 2

# HOW A DIGITAL CAMERA WORKS

**In This Chapter**

- Something Old, Something New
- A Little Color Theory
- How a CCD Works
- Compression and Storage
- Meanwhile, Back in the Real World

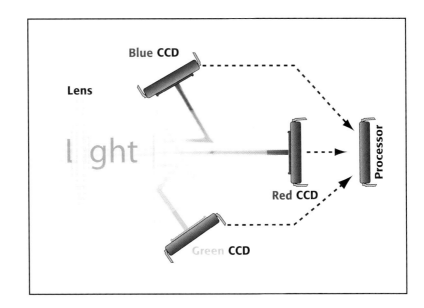

Today's "fully automatic" cameras allow anyone to immediately create portraits and snapshots of startling quality. But serious photography—whether at the hobbyist or professional level—has always required a tremendous amount of craftsmanship and technical understanding. In "wet darkroom" work, everything from paper type to chemical mixtures to the amount of agitation applied to a particular chemical has a bearing on the quality of your final print. As such, skilled film photographers have to have an in-depth understanding of the nature of their papers, chemicals, and equipment.

Digital photography is no different. To fully exploit your camera's capabilities—and to be able to effectively edit and improve your images—you must understand some of the fundamental principles and technologies behind digital imaging.

As mentioned in Chapter 1, the only real difference between a digital camera and a film camera is that a digital camera does not use film to record an image. However, this one fundamental difference affects all of the other systems on the camera, from the lens to the light meter. Consequently, knowing how your camera works will help you select the right camera and help you understand how to get better results when shooting.

## SOMETHING OLD, SOMETHING NEW

Just like a film camera, your digital camera records an image by using a lens to focus light onto a *focal plane*. The lens focuses the light through an *aperture* and a *shutter* onto a piece of film held on the focal plane. By opening or closing the aperture and by changing the amount of time that the shutter is open, the photographer can control how the focal plane is exposed. As we'll see later, exposure control allows the photographer to change the degree to which the camera "freezes" motion, how well the film records contrast and color saturation, and which parts of the image are in focus.

In a digital camera, instead of a piece of film, an *image sensor* sits on the focal plane. An image sensor is a special type of silicon chip with light-sensitive capabilities. Currently, two types of image sensors are available: the *charge-coupled device (CCD)*, and the *Complementary Metal Oxide Semiconductor (CMOS)*. CCDs are far more popular than CMOS chips, but the role of both chips is exactly the same. When you take a picture, the image sensor *samples* the light coming through the lens and converts that light into electrical signals. After the image sensor is exposed, these signals are boosted by an amplifier and sent to an analog-to-digital converter that turns the signals into

digits. These digits are then sent to an onboard computer for processing. Once the computer has calculated the final image, the new image data is stored on a memory card. (See Figure 2.1.)

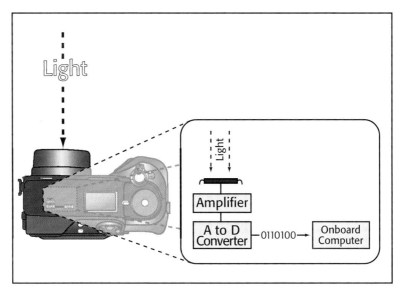

**FIGURE 2.1**    Light passes into a digital camera, just as it would in a film camera. However, instead of hitting a piece of film, it is digitized by a computer chip and passed to an onboard computer to create an image.

Though the mechanics are simple to explain, to really understand how a digital camera functions, you must know a little color theory.

## A LITTLE COLOR THEORY

In 1869, James Clerk Maxwell asked photographer Thomas Sutton (the inventor of the SLR camera) to take three black-and-white photographs of a tartan ribbon. Maxwell wanted to test a theory he had about a possible method for creating color photographs. He asked Sutton to place a different filter over the camera for each shot: first a red filter, then green, and then blue. After the film was developed, Maxwell projected all three black-and-white pictures onto a screen using three projectors fitted with the same filters that were used to shoot the photos. When the images were projected directly on top of each other, the images combined and Maxell had the world's first color photo.

Needless to say, this process was hardly convenient. Unfortunately, it took another 30 years to turn Maxwell's discovery into a commercially viable product. This happened in 1903, when the Lumière brothers used red, green, and blue dyes to color grains of starch that could be applied to glass plates to create color images. They called their process Autochrome, and it was the first successful color printing process.

In grammar school, you probably learned that you could mix primary colors together to create other colors. Painters have used this technique for centuries, of course, but what Maxwell demonstrated is that, although you can mix paints together to create darker colors, light mixes together to create lighter colors. Or, to use some jargon, paint mixes together in a *subtractive* process (as you mix, you subtract color to create black), whereas light mixes together in an *additive* process (as you mix, you add color to create white). Note that Maxwell did not discover light's additive properties—Newton had done similar experiments long before—but was the first to apply the properties to photography.

Figure 2.2 shows a simple example of how the three additive primary colors of light can be combined to create other colors.

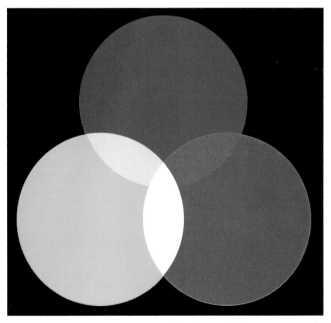

**FIGURE 2.2** Red, green, and blue—the three additive primary colors of light—can be mixed together to create other colors. As you combine them, the resulting color is lighter, eventually becoming white. Note also that where the colors overlap they create the secondary primary colors—cyan, magenta, and yellow. These are the primary colors of ink.

Your digital camera makes color images using pretty much the same process that Maxwell used in 1860: it combines three different black-and-white images to create a full-color final image.

The image shown in Figure 2.3 is called an *RGB* image because it uses red, green, and blue *channels* to create a color image. As we'll see, understanding that a full-color image is built from component channels makes it easier to identify and correct many types of problems—often by manipulating the individual color channels directly.

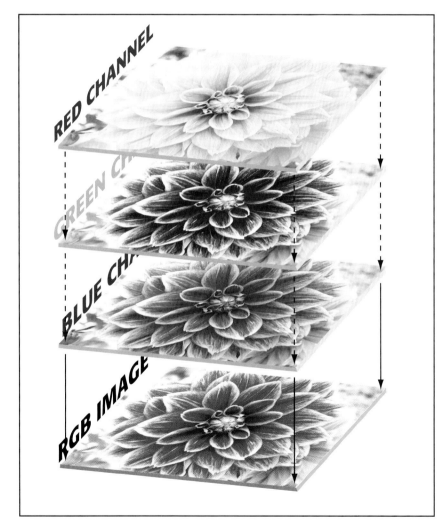

**FIGURE 2.3**    In a digital image, three separate red, green, and blue channels are combined to create a final, full-color picture.

 *YOU SAY "BLACK AND WHITE," I SAY "GRAYSCALE"*

*Although film photographers use the term black and white to denote an image that lacks color, in the digital world it's better to use the term grayscale. As we saw in Figure 1.2, your computer can create an image that is composed of only black-and-white pixels. Consequently, it's sometimes important to distinguish between an image that is made up of black-and-white pixels, and one that is made up of pixels of varying shades of gray.*

In the century and a half since Maxwell's discovery, many other ways of representing color have been discovered. For example, another model called *L\*A\*B color* (also known as Lab color) uses one channel for lightness information, another channel for greenness or redness, and a third channel for blueness or yellowness. In addition, there is the cyan, magenta, yellow, and black (*CMYK*) model that printers use.

Each of these approaches is called a *color model* or *color space*, and each model has a particular *gamut*, or range, of colors that it can display. Some gamuts are more appropriate to certain tasks, and all of these gamuts are smaller than the range of colors your eye can perceive.

We'll deal more with gamuts and color models in later chapters. For now, it's important to understand that digital photos are made up of separate red, green, and blue channels that combine to create a color image.

## HOW A CCD WORKS

George Smith and Willard Boyle were two engineers employed by Bell Labs. The story goes that one day in late October, the two men spent about an hour sketching out an idea for a new type of semiconductor that could be used for computer memory and for the creation of a solid-state, tubeless video camera. The year was 1969, and in that hour, the two men invented the CCD.

Roughly a year later, Bell Labs created a solid-state video camera using Smith and Boyle's new chip. Although their original intention was to build a simple camera that could be used in a video-telephone device, they soon built a camera that was good enough for broadcast television.

Since then, CCDs have been used in everything from cameras to fax machines. Because video cameras don't require a lot of resolution (only half a million pixels or so), the CCD worked great for creating video-quality images. For printing pictures, though, you need much higher resolution—millions and millions of pixels. Consequently, it wasn't until recently that CCDs could be manufactured with enough resolution to compete with photographic film.

## Counting Electrons

Photographic film is covered with an emulsion of light-sensitive, silver-laden crystals. When light hits the film, the silver atoms clump together. The more light there is, the bigger the clumps. In this way, a piece of film records the different amounts of light that strike each part of its surface. A piece of color film is actually a stack of of three separate layers—one sensitive to red, one to green, and one to blue.

To a degree, you have Albert Einstein to thank for your digital camera, because he was the first to explore the *photoelectric effect*. It is because of the photoelectric effect that some metals release electrons when exposed to light. (Einstein actually won the 1921 Nobel Prize in physics for his work on the photoelectric effect, not for his work on relativity or gravity, as one might expect.)

The image sensor in your digital camera is a silicon chip (similar to Figure 2.4) that is covered with a grid of small electrodes called *photosites*, one for each pixel.

**FIGURE 2.4**    The imaging area of this Kodak CCD from an Olympus E1 camera measures 18 x 13.5mm.

Before you can shoot a picture, your camera charges the surface of the CCD with electrons. Thanks to the photoelectric effect, when light strikes a particular photosite, the metal in that site releases some of its electrons. Because each photosite is bounded by nonconducting metal, the electrons remain trapped. In this way, each photosite is like a little well, storing up more and more electrons as more and more photons hit

it. After exposing the CCD to light, your camera simply has to measure the voltage at each site to determine how many electrons are there and, thus, how much light hit that particular site. (As was discussed in Chapter 1, this process is called *sampling*.) This measurement is then converted into a number by an analog-to-digital converter.

Most cameras use either a 12-bit or 14-bit analog-to-digital converter. That is, the electrical charge from each photosite is converted into a 12- or 14-bit number. In the case of a 12-bit converter, this produces a number between 0 and 4,096; with a 14-bit converter, you get a number between 0 and 16,384. Note that an analog-to-digital converter with a higher bit depth doesn't give your CCD a bigger dynamic range. The brightest and darkest colors that it can see remain the same, but the extra bit depth does mean that the camera will produce finer gradations *within* that dynamic range. As you'll see later, how many bits get used in your final image depends on the format in which you save the image.

The term "charge-coupled device" is derived from the way the camera reads the charges of the individual photosites. After exposing the CCD, the charges on the first row of photosites are transferred to a *read-out register* where they are amplified and then sent to an analog-to-digital converter. Each row of charges is electrically coupled to the next row so that, after one row has been read and deleted, all of the other rows move down to fill the now empty space. (See Figure 2.5.)

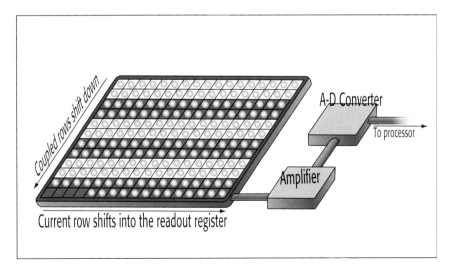

**FIGURE 2.5**    Rows of photosites on a CCD are coupled together. As the bottom row of photosites is read off of the bottom of the CCD, all of the rows above it shift down. This is the *coupled* in *charge-coupled device*.

After all of the rows of photosites have been read, the CCD is recharged with electrons and is ready to shoot another image.

Photosites are sensitive only to how much light they receive; they know nothing about color. As you've probably already guessed, to see color your camera needs to perform some type of RGB filtering similar to what James Maxwell did. There are a number of ways to perform this filtering, but the most common is through a *single array* system, sometimes referred to as a *striped array*.

## Arrays

Consider the images in Figure 2.6.

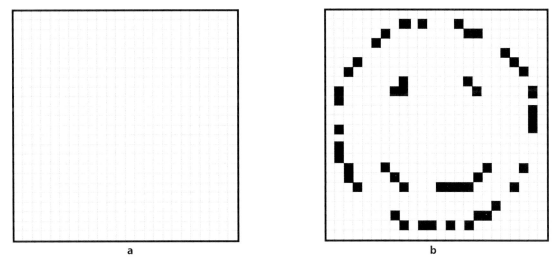

a                                         b

**FIGURE 2.6**    Although you have no idea what pixels belong in Figure 2.6a, you can probably hazard a guess as to what the missing pixels are in Figure 2.6b.

If asked to fill in any "missing" pixels in Figure 2.6a, you'd probably say "What are you talking about?" If asked to fill in any "missing" pixels in Figure 2.6b, though, you probably would have no trouble creating the image in Figure 2.7.

You would know which pixels you needed to fill in based on the other pixels that were already in the image. In other words, you would have *interpolated* the new pixels based on the existing information. You might have encountered interpolation if you've ever resized a photograph using an image-editing program such as Photoshop. To resize an image from 4" × 6" to 8" × 10", your image editor has to perform many

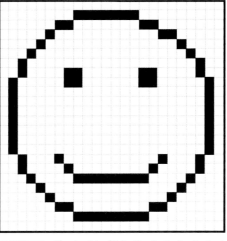

**FIGURE 2.7**   If asked to fill in the "missing" pixels in Figure 2.6b, you would probably come up with an image something like this.

calculations to determine what color all those new pixels should be. Obviously, in this example, your ability to interpolate is based on your ability to recognize a familiar icon—the happy face. An image editor knows nothing about the content of an image, of course, and must interpolate by carefully examining each of the pixels in an image to determine what the colors of any new additional pixels should be.

A typical digital camera uses a form of interpolation to create a color image. As we saw in the previous section, the image sensor in your camera is able to create a grayscale image of your subject by measuring the amount of light that strikes each part of the image sensor. To shoot color, your camera performs a variation of the same type of RGB filtering that Maxwell used in 1869. Each photosite on your camera's image sensor is covered by a filter—red, green, or blue. This combination of filters is called a *color filter array*, and most image sensors use a filter pattern like the one shown in Figure 2.8, called the *Bayer Pattern*.

With these filters, the image sensor can produce separate, incomplete red, green, and blue images. The images are incomplete because the red image, for example, is missing all of the pixels that were covered with a blue filter, whereas the blue filter is missing all of the pixels that were covered with a red filter. Both the red and blue images are missing the vast number of green-filtered pixels.

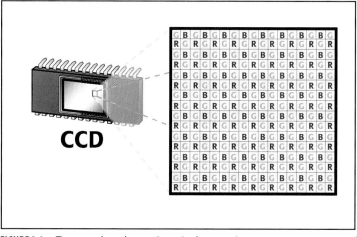

**FIGURE 2.8**    To see color, alternating pixels on an image sensor are covered with a different colored filter. The color filter array shown here is called the Bayer Pattern.

A sophisticated interpolation method is used to create a complete color image. Just as you used the partial pixel information in Figure 2.6b to calculate the missing pixels, your digital camera can calculate the color of any given pixel by analyzing all of the adjacent pixels. For example, if you look at a particular pixel and see that the pixel to the immediate left of it is a bright red pixel, the pixel to the right is a bright blue pixel, and the pixels above and below are bright green, then the pixel in question is probably white. Why? As Maxwell showed, if you mix red, green, and blue light together, you get white light. (By the way, if you're wondering why there are so many more green pixels than red or blue pixels, it's because the eye is most sensitive to green. Consequently, it's better to have as much green information as possible.)

This process of interpolating is called *demosaicing*, and different vendors employ different approaches. For example, many cameras look at only immediately adjacent pixels, but Hewlett-Packard cameras analyze a region up to 9 × 9 pixels. The Fuji® SuperCCD eschews the grid pattern of square photosites in favor of octagonal photosites arranged in a honeycomb pattern. Such a scheme requires even more demosaicing to produce rectangular image pixels, but Fuji claims this process yields a higher resolution. Differences in demosaicing algorithms are one factor that makes some cameras yield better color than others.

Some cameras use a different type of color filter array. Canon, for example, often uses cyan, yellow, green, and magenta (CYGM) filters on the photosites of their image sensors. Because it takes fewer layers of dye to create

cyan, yellow, green, and magenta filters than it does to create red, green, and blue filters, more light gets through the CYGM filter to the sensor. (Cyan, yellow, and magenta are the primary colors of ink, and therefore, don't need to be mixed to create the color filters; hence, they aren't as thick.) More light means a better signal-to-noise ratio, which produces images with better *luminance* and less noise.

As another example, Sony recently started using red, green, blue, and emerald filters. They claim these filters give a wider color gamut, yielding images with more accurate color. Dissenters argue that this approach results in bright areas of the image having a cyan color cast.

### STILL MORE INTERPOLATION

*In addition to the interpolation a camera performs to calculate color, some cameras perform an additional type of interpolation to achieve a higher resolution. For example, the Fuji FinePix S602 has a 3.1-megapixel CCD but can interpolate the image upward to produce a 6-megapixel image. We'll say more about this kind of interpolation in Chapter 5, "Choosing a Digital Camera."*

Image sensors are often very small, sometimes as small as 1/4 or 1/2 inch (6 or 12mm, respectively). By comparison, a single frame of 35mm film is 36 × 23.3mm. (See Figure 2.9.) The fact that image sensors can be so small is the main reason why digital cameras can be so tiny.

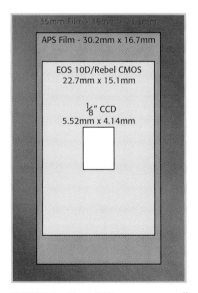

**FIGURE 2.9**   Most CCDs are very small, particularly when compared to the size of 35mm film.

By packing more and more photosites onto an image sensor, chipmakers can increase the sensor's resolution. However, there is a price to pay for this. To pack more photosites onto the surface of the chip, the individual sites have to be made much smaller. As each site gets smaller, its ability to collect light is compromised because it simply doesn't have as much physical space to catch passing photons. This limitation results in a chip with a poor *signal-to-noise ratio*; that is, the amount of good data the chip is collecting—the signal—is muddied by the amount of noise—noise from the camera's electronics, noise from other nearby electrical sources, noise from cosmic rays raining down from space—that the chip is collecting.

In your final image, this signal-to-noise confusion can manifest as grainy patterns in your image—visible noise like what you see on a staticky TV channel—or other annoying artifacts.

To improve the light-collecting ability of tiny photosites, some chipmakers position tiny microlenses over each photosite. These lenses focus the light more tightly into the photosite in an effort to improve the signal-to-noise ratio. However, these lenses can cause problems of their own in the form of artifacts in your final image.

Image sensors suffer from another problem that film lacks. If too much light hits a particular photosite, it can spill over into adjacent photosites. If the camera's software isn't smart enough to recognize that this has happened, you will see a *blooming* artifact—smearing colors or flared highlights—in your final image. Blooming is more prevalent in a physically smaller image sensor with higher-resolution because the photosites are packed more tightly together. This problem is not insurmountable, and even if your image does suffer from blooming problems from time to time, these artifacts won't necessarily be visible in your final prints.

As you might expect, interpolating the color in a camera with millions of pixels on its image sensor requires a lot of processing power. Such power (and the memory needed to support it) is one reason that digital cameras have stayed so pricey. A lot of fancy chips are necessary to make a digital camera.

*EXTRA PIXELS*

*Not all of the photosites in an image sensor are used for recording your image. Some are used to assess the black levels in your image; others are used for determining white balance. Finally, some pixels are masked away altogether. For example, if the sensor has a square array of pixels but your camera manufacturer wants to create a camera that shoots rectangular images, they will mask out some of the pixels on the edge of the sensor to get the picture shape that they want.*

### "One CCD, Hold the Interpolation"

The system described previously, which is used in most digital cameras manufactured today, is called a *single array system* because it uses a single sensor to image all three color channels. Although this scheme is the most prevalent, other ways of getting an image sensor to see color are available. The mechanisms described here are used only in high-end, often medium format, cameras intended for very high-resolution studio shoots.

In a *three-shot array* system, three separate exposures are taken, one for each color. These three shots are then combined into a full-color, RGB image.

Because they require no demosaicing, three-shot arrays are free from some of the artifacts of a single-array system. Unfortunately, taking three pictures in succession can require a few seconds, so your subject has to be stationary and your light has to be constant. Consequently, these cameras are useful only for shooting inanimate objects in a studio situation.

A *linear array* system consists of a single row of sensors that makes three separate filtered passes over the imaging area. Because there's only one row of sensors, manufacturers can pack a lot of resolution into that sensor without greatly increasing the price. Obviously, as with a three-shot array, the linear array is good only for studio work. Also like the three-shot array, no interpolation is used.

*Trilinear arrays* are a simple variant on the linear array, consisting of three linear arrays stacked on top of one another. With each array filtered separately, the camera has to make only one pass over the image area. Because this system requires only a single pass, some manufacturers have actually been able to create trilinear systems that are fast enough for shooting moving objects.

Finally, some cameras use *multiple arrays*, a collection of three separate image sensors. (See Figure 2.10.) As the light enters the camera, it is passed through a prism that splits the light into three copies. Each copy is sent to a separate sensor that is filtered for a different color. Multiple array cameras have all the flexibility of a single array system but none of the interpolation troubles. Unfortunately, because they have three times the number of sensors as a single array camera, they often cost three times the price.

Unless you're planning on spending tens of thousands of dollars, you'll be looking at single array cameras.

### Some Assembly Required

The preceding description might sound complicated. In reality, though, the process that an imaging chip employs to capture an image is even more complex.

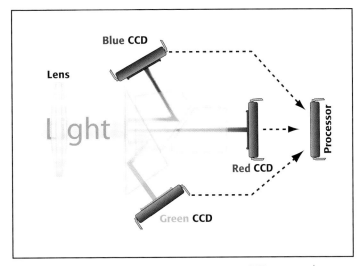

**FIGURE 2.10**    In a multiple array system, separate CCDs are used to record separate red, green, and blue channels. This system eliminates the interpolation required by single array systems.

First, the light coming through the lens is passed through several filters, including an infrared filter (some cameras use a very slight infrared filter, making them ideal for infrared photography, as we'll see in Chapter 7, "Shooting") and a low pass filter, both of which help ensure better color and fewer artifacts. After being processed and interpolated by the CCD, the image data (which is now in full color) is passed to an onboard computer that makes a number of adjustments. For example, the image is adjusted according to your camera's *white balance* and *exposure compensation* settings. (We'll discuss these in more detail later.)

In an imaging chip, when twice as much light hits a single pixel, twice as much voltage is produced. In other words, the response of the pixels to light is *linear*—increase the light and you get a linear increase in voltage. Unfortunately, brightness values are logarithmic—they increase logarithmically rather than linearly. So, to get accurate brightness values, your camera applies a mathematical curve to all of its brightness values.

Next, the camera might perform adjustments to the image's contrast and brightness. Most cameras provide user-controlled settings for how much brightness and contrast adjustment to perform. Similarly, color saturation can be increased according to user-defined settings.

Finally, many cameras perform some type of noise reduction algorithm to reduce unwanted noise in your image, and almost all cameras perform some type of *sharpening*. All of this processing takes place inside

your camera, which is one reason why it can take a while for a digital camera to store an image.

### RAW IMAGES

*Nowdays, many cameras, ranging from simple point-and-shoots to high-end digital SLRs let you download raw, unprocessed data from the camera. This is the information that comes directly off of the image sensor. If you're saving images in raw format, all of the processing that you just read about—the demosaicing, linear conversion, white balance, contrast and saturation adjustments, sharpening, and compression—are skipped. The camera simply writes out the raw, unprocessed pixel data. Through special software, you can later use your computer to specify how the raw data should be processed, with full control of white balance, sharpening, and contrast. This is a great feature for the user who demands a high degree of control and the absolute best quality. What's more, with raw files, you can elect to convert the camera's 12 or 14 bits of color to 16 bits, giving you a tremendous range of brightness values to work with. In addition, because raw images are not compressed, your images won't suffer from the compression artifacts sometimes found in JPEG images. We'll have much more to say about raw files in Chapter 13.*

## CCD VS. CMOS

Ninety to 95 percent of the digital cameras you'll look at will use CCD image sensors. The rest will use a CMOS chip of some kind. What's the difference? Because, a lot more research has been put into CCD technology, it's more prevalent. CMOS chips, though, are actually much cheaper to produce than the difficult-to-make CCDs found in most cameras. CMOS chips also consume much less power than does a typical CCD, making for longer camera battery life and fewer overheating problems. CMOS also offers the promise of integrating more functions onto one chip, thereby enabling manufacturers to reduce the number of chips in their cameras. For example, image capture and processing could both be performed on one CMOS chip, further reducing the price of a camera.

Although CMOS used to have a reputation for producing rough images with inferior color, Canon's excellent EOS series—the D30, D60, 10D, 20D, and Digital Rebel—have shown that CMOS can be a viable alternative to CCDs.

In the end, image sensor choice is irrelevant as long as the camera delivers an image quality that you like.

## COMPRESSION AND STORAGE

After your image has been processed, it's ready to be stored on whatever storage medium is provided by your camera. There are currently a number of competing storage options, and we'll discuss these in detail in Chapter 5. All of these options have one thing in common: they're finite. Consequently, to make the most of the available storage, cameras compress their images, usually using a type of compression called *JPEG*.

Created by the *Joint Photographic Experts Group*, JPEG is a powerful algorithm that can greatly reduce the size of a photo but at the cost of image quality. Consequently, JPEG is referred to as a *lossy* compression format.

When saving in JPEG mode, the camera first converts the image data from its original 12- or 14-bit format down to an 8-bit format, reducing the range of brightness levels from 4,096 or 16,384 all the way down to 256. Once the data is in 8-bit mode, the camera is ready to start compressing.

Most cameras offer two forms of JPEG compression: a low-quality option that visibly degrades an image but offers compression ratios of 10 or 20:1, and a high-quality option that performs a good amount of compression—usually around 4:1—but without severely degrading your image. Some cameras offer an even finer JPEG compression that cuts file sizes while producing images that are indistinguishable from uncompressed originals. In most cases, you'll probably find that any artifacts introduced by higher-quality JPEG compression are obscured by your printing process. For those of you who are very particular, many cameras offer a completely uncompressed mode that stores your images as large TIFF files.

JPEG compression works by exploiting the fact that human vision is more sensitive to changes in brightness than to changes in color. To JPEG-compress an image, your camera first converts the image into a color space where each pixel is expressed using a *chrominance* (color) value and a *luminance* (brightness) value.

Next, the chrominance values are analyzed in blocks of 8 × 8 pixels. The color in each 64-pixel area is averaged so that any slight (and hopefully imperceptible) change in color is removed, a process known as *quantization*. Note that because the averaging is being performed only on the chrominance channel, all of the luminance information in the image—the information your eye is most sensitive to—is preserved.

After quantization, a non-lossy compression algorithm is applied to the entire image. In the *very* simplest terms, a non-lossy compression scheme works something like this: rather than encoding AAAAAABBBBBCCC, you simply encode 6A5B3C. After quantization, the chrominance information in your image will be more uniform, so larger chunks of similar data will be available, meaning that this final compression step will be more effective.

What does all this mean to your image? Figure 2.11 shows an image that has been overcompressed. As you can see, areas of flat color or smooth gradations have turned into rectangular chunks, whereas contrast in areas of high detail has been boosted too high. Fortunately, most digital cameras offer much better compression quality than what you see here.

**FIGURE 2.11**    This image has been compressed far too much, as can be seen from the nasty JPEG artifacting.

## MEANWHILE, BACK IN THE REAL WORLD

If the information in this chapter seems unnecessary, it's probably because when you buy a film camera you don't have to worry about imaging technology—it's included in the film that you use. However, if you're serious about photography, you probably do spend some time considering the merits of different films. And, just as you need a little knowledge of film chemistry to assess the quality of a particular film stock, the topics covered in this chapter will help you better test a particular camera.

Your camera is more than just an image sensor, of course, so in Chapter 5, you'll learn about the other components and concerns that you'll need to weigh when choosing a camera.

# 3

# BASIC PHOTOGRAPHY: A QUICK PRIMER

**In This Chapter**

- Lenses
- Exposures: Apertures, Shutter Speeds, and ISO
- Mostly the Same

22mm

If you worked through the technical details of the last chapter, you saw how radically different a CCD is from a piece of film. So, why do we keep saying that there's little difference between a digital camera and a film camera? Because no matter what type of camera you use, the physics of light work the same way. Consequently, whether you're exposing a piece of film or a silicon image sensor, all of the mechanisms that a camera uses to measure and control light work the same way.

In this chapter, therefore, we're going to take a quick trip through the basics of optics, apertures, and exposures. Simply put: to understand most of what follows, you need an understanding of a few photographic principles. If you don't know an *f-stop* from a hole in the ground, you'll want to spend a little time with this chapter. Those of you with more experience will probably be able to skip ahead to Chapter 4, "Evaluating an Image."

In its most basic form, a camera is really a simple apparatus. A lens focuses the light from an image onto a focal plane where it is recorded by a piece of film or an image sensor. An aperture and shutter, placed between the lens and the focal plane, allow the photographer to control how much light reaches the focal plane and how long the focal plane will be exposed to that light.

An understanding of lenses, apertures, and shutters is not necessary to take simple snapshots using a modern, fully automatic camera. However, if you want more creative control over your image, knowing how these systems work together is essential.

## LENSES

If the name Willebrord Snell doesn't sound familiar, don't worry; most people aren't too familiar with Snell. Nevertheless, he got things started for digital cameras in 1621, when he performed the first experiments with refraction.

As Snell discovered, light travels through space in straight lines. However, when it passes through a transparent object such as water or glass, it gets slowed down and bent, a process called *refraction*. This process is why objects look strange when viewed through a glass of water, and it's what makes it possible for a lens to magnify or reduce an image. A lens is simply a piece of transparent material (usually glass or plastic) shaped to bend light in a particular way. A convex lens focuses light inward, whereas a concave lens spreads light rays apart. (See Figure 3.1.)

Unfortunately, making a perfect piece of glass or plastic for a lens is impossible. Consequently, the surface of a lens might have defects and irregularities that can produce a number of different types of problems, or *artifacts*, in your final image. Further complicating lens-building matters is

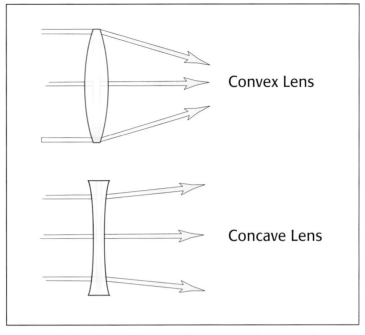

**FIGURE 3.1**    As you might remember from science class, *convex* lenses bend light inward, whereas *concave* lenses bend light outward.

the fact that not all frequencies (colors) of light bend the same amount as they pass through a lens. For example, a lens might bend red light more than yellow light, resulting in color aberrations (or *chromatic aberrations*) in your final image.

When we speak of lenses for a camera, we're not really talking about a single piece of glass, because a camera lens—whether a built-in lens or a detachable one—is actually an array of separate concave and convex lenses, called *elements*, which are engineered to work together to produce a specific magnification (see Figure 3.2). When designing a lens, engineers add elements to correct for aberrations in other elements until they eliminate as many problems as they can. Multiple elements are cemented together to form *groups*—you'll sometimes see a particular lens listed as having a certain number of elements in a certain number of groups. Although you might think that more elements and groups are inherently better because they will remove more aberrations, be aware that each new element increases the chance of reflections within the lens. These reflections will make the lens more likely to create *lens flares* in your final image. (See Chapter 5, Figure 5.19.)

In Chapter 5, you'll learn how to test and examine a lens to determine its quality and how to recognize different types of aberration.

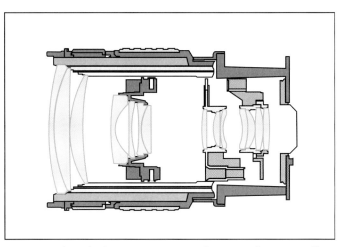

**FIGURE 3.2**    If you look at a cross section of a camera lens, you will see that it is not a single "lens" at all, but a complex series of multiple lenses.

### Focal Length

*Focal length* is a measurement of the magnifying power of a lens. Technically, focal length is the distance (usually measured in millimeters) between the lens and the focal plane, the area upon which the lens is focusing. The longer the focal length, the more magnification a lens will provide. However, as magnification increases, *field of view* decreases. (See Figure 3.3.)

If you've ever used a 35mm SLR camera, then you're probably familiar with a 50mm lens, a lens that provides a level of magnification—and corresponding field of view—that is roughly equivalent to the human eye (50–55°). A lens with a smaller focal length—28mm, for example—produces a *wide-angle* image; "long" lenses—say, 200mm—are considered *telephoto* lenses. That is, they provide a lot of magnification and a very narrow field of view. (See Figure 3.4.)

As you'll see in Chapter 5, when you're selecting a camera (or a lens, if your camera supports interchangeable lenses), the range of focal lengths provided will be of critical concern. In Chapter 7, you'll learn how focal length choice can alter the sense of space in your image.

### Zooms and Primes

*Zoom lenses*, as you might already know, are lenses whose focal length can be varied. When you "zoom in" on a subject, you are increasing the focal length of the lens, which serves to produce more magnification and a narrower field of view. A typical point-and-shoot 35mm camera will

**FIGURE 3.3**    As focal length increases, field of view decreases. Therefore, a long lens has a very narrow field of view.

22mm

50mm

480mm

**FIGURE 3.4**    These three images were shot from the same location. The only thing that changed was the focal length of the lens. As you can see, as focal length increases, so does magnification, while field of view decreases.

have a zoom lens with a range of around 35 to 110mm—that is, from wider than normal to fairly telephoto.

If you have a camera with interchangeable lenses, then you might also be looking at some *prime lenses*—lenses with fixed focal lengths. Until eight or nine years ago, it was pretty safe to say that prime lenses were always higher quality than zoom lenses. Today, advances in design and manufacturing techniques have so improved the quality of zoom lenses that they are often indistinguishable from prime lenses.

However, if you're shopping around at the high end of the lens market, you will see a difference in quality between zooms and primes. In general, quality prime lenses offer better sharpness, and zoom lenses offer greater flexibility.

## EXPOSURE: APERTURES, SHUTTER SPEEDS, AND ISO

As you saw in the last chapter, an image sensor—like a piece of film—is sensitive to light. Although not as sophisticated as the human eye, your camera's image sensor needs to be exposed to only a tiny bit of light to create an image. The proper amount of light is calculated by your camera's light meter (though, as you'll see later, you'll often want to deviate from your light meter's suggestion).

As with a film camera, if you subject an image sensor to too much light, your image will be overexposed, meaning it will be too light and washed out. If you overexpose an image enough, it will turn completely white. Conversely, if you don't expose the image to enough light, your image will be underexposed—dark and muddy. Underexpose it enough, and you'll have an image that is completely black.

Your camera provides two mechanical mechanisms for controlling the amount of light that strikes the image sensor: the shutter and the aperture.

The shutter is actually like a little door that opens and closes very quickly to control how much light passes through to the image sensor. Shutter speed is a measure of how long the shutter stays open, as measured in seconds. You'll usually use shutter speeds of 1/60th of a second or faster. (Once you get below 1/30th of a second, it becomes difficult to hold the camera steady enough to get a sharp image, unless you're using a tripod.) By varying the shutter speed, you can intentionally blur or freeze moving objects. Obviously, a slower shutter speed allows more light to pass through to the image sensor.

In addition to a shutter, your camera also has an aperture. The aperture is an expandable opening that provides another mechanism for controlling the amount of light that strikes the focal plane. By choosing a larger or

smaller aperture, you can control which parts of an image are in focus. For example, you could choose to have the entire image in sharp focus, or you can elect to blur out the background behind your subject, as shown in Figure 7.5 in Chapter 7.

The aperture in your camera is usually an *iris* composed of thin, sliding, interlocking metal plates. As you close the iris down to a smaller aperture, it stops more light from passing through to the CCD. The size of the aperture is measured in *stops* or *f-stops*. The higher the f-stop rating, the more light your aperture is stopping. For example, a lens set on f8 has a smaller aperture than a lens set on f4. (See Figure 3.5.) In other words, f8 stops more light than f4.

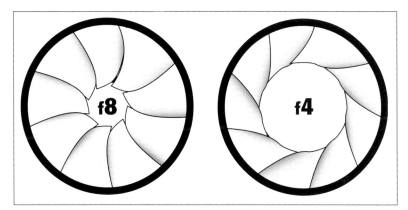

**FIGURE 3.5**    The iris on the left is stopping more light than the iris on the right; consequently, it has a higher f-stop value.

Aperture and shutter speed are interrelated, and you'll often change one to afford you more flexibility with the other. For example, if you're shooting a moving object and want to use a fast shutter speed to ensure that the object is frozen in the frame, you might need to use a wider aperture. Why? Because the fast shutter speed will greatly reduce the amount of light striking the focal plane, necessitating the wider aperture to allow more light to pass through to the focal plane to compensate.

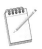

*F-STOP DEFINED*

*In case you're wondering where those f-numbers come from, f-stop values are simply the ratio of the focal length of the lens to the diameter of the opening in the aperture.*

### Reciprocity

Modern digital and film cameras offer a vast selection of aperture and shutter speed settings. For the sake of example, let's assume for a minute that you're using a more "conventional," all-manual film camera. Traditionally, each aperture setting on a lens stopped twice as much light as the previous setting. Therefore, a lens typically had a range of f-stop settings that went something like f2, f2.8, f4, f5.6, f8, f11, and f16. (The presence of fractional numbers has to do with the fact that apertures are circular, and halving the area of a circle involves some fractional numbers.)

Like apertures, shutter speeds typically double with each setting. Therefore, a list of possible shutter speeds on a camera will often progress as follows: 1/500th, 1/250th, 1/125th, 1/60th, 1/30th, 1/15th, 1/8th, 1/4th, 1/2, 1, 2, 4, 8, and so on. (All times are in seconds.)

Because aperture size and shutter speed always increase by 2, it's easy to calculate different, equivalent exposures. For example, let's say you are shooting a picture of a very fast-moving race car, and your light meter has told you that the "correct" exposure for the image is f16 at 1/60th of a second (that is, your light meter says you should set your aperture to f16 and your shutter speed to 1/60th). However, because your subject is moving so fast, you have decided that you want to use a higher shutter speed to guarantee that your subject won't be blurry.

If you increase your shutter speed to the next setting—1/125$^{th}$—the shutter will be open for only half as long and the amount of light hitting the focal plane will be cut in half. If your light meter was correct, then your new setting will result in an image that is underexposed. To correct this, you simply open your aperture from f16 to f11. (See Figure 3.6.) Your aperture is now twice as wide, which lets in twice as much light, and compensates for the fact that the shutter is open only half as long. Note that *the total amount of light that's striking the focal plane is the same as in your original exposure setting.* This relationship between apertures and shutter speeds is called *reciprocity* because of the reciprocal relationship between the two values.

Reciprocity is a powerful function because it means that many different shutter speed/aperture combinations all yield the same exposure. For example, Figure 3.7 shows four different images of the same subject. Each image was shot using a different reciprocal shutter speed/aperture combination. Because they're reciprocal, the *exposure* for each image—the total amount of light hitting the image sensor—turns out to be the same. Because these are all the same exposure, no one image is too bright or two dark. However, there are differences.

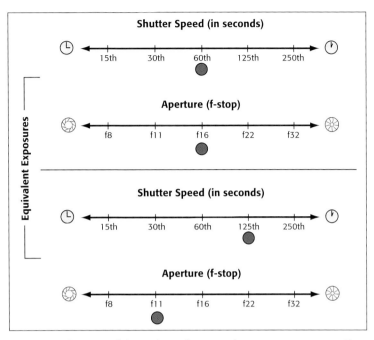

**FIGURE 3.6**    Because of the reciprocal nature of exposure parameters, if you change one parameter in one direction, you can move the other parameter in the opposite direction and still yield the same overall exposure.

The first image (A) is a straight snapshot with everything in the image—both foreground and background—in focus. In the second image (B), a wider aperture was used (and, therefore, a corresponding, reciprocally faster shutter speed) to cause the background to be rendered out of focus, bringing the viewer's attention to the foreground. In the third image (C), an exposure was chosen that blurred the motion in the subject's hand. Finally, in the fourth image (D), an exposure was chosen that would more accurately capture the darker, more saturated tones in the image. Later, you'll see which exposure controls on your camera produce these different effects.

Digital cameras and many new film cameras expand on this traditional approach by allowing aperture settings that progress in increments of one-half or one-third of a stop. Moreover, with the electronic, computer-controlled shutters on modern cameras, you can have odd shutter speeds; for example, 1/252nd. We'll cover the uses and implications of these new settings in Chapter 7.

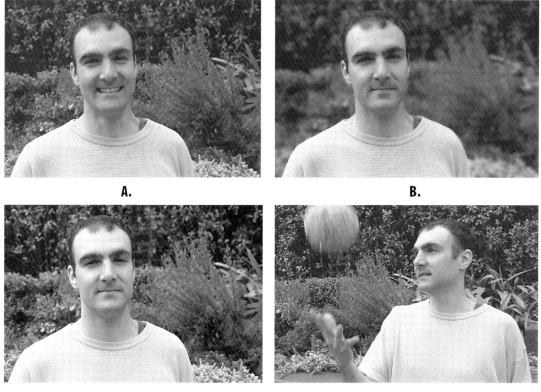

**FIGURE 3.7** We used four different reciprocal exposures for these images, to produce four different results. Moving clockwise from upper-left: in the first image, we shot as the camera's automatic metering suggested and got a well-exposed image with deep depth of field. In the second image, we shot with a wider aperture to reduce depth of field. In the third image, we shot with a slower shutter speed to introduce blur, while in the fourth image, we underexposed to darken the black tones.

## Lens Speed

Another way to understand a lens is to think of it as a device for gathering light onto the camera's focal plane. Depending on its quality, one lens might take longer to gather the same amount of light as another lens. Simply put, it's going to take more time for the same amount of light to shine through a lens made of murky glass than it will to shine through very clear glass.

The speed of a lens is measured in terms of its widest aperture. Therefore, a lens that can be opened to f1.8 is a faster lens than one that can be opened only to f4. Faster lenses enable you to shoot in less light and provide a greater range of apertures and, therefore, more creative freedom. A faster lens is also more difficult to build and, as a result, more expensive.

Zoom lenses usually have different speeds at different focal lengths. That is, at full telephoto, your lens might have a maximum aperture of f5.6, but at full wide, it might have a faster aperture of f4. Engineering a lens in this way allows lens designers to reduce the size of the front element of the lens, making for a physically lighter, smaller lens.

If your camera supports removable lenses, you'll probably find that prime lenses are available in much faster speeds than zoom lenses.

### ISO, Or "Try to Be More Sensitive"

Different types of films have different sensitivities to light as measured by their *ISO* rating. (ASA is another measure of film speed, but most photographers now use the more common ISO system.) The higher the ISO rating, the more sensitive the film is to light. Because it is more sensitive, a film with a higher ISO rating doesn't need as long of an exposure to make an image. Consequently, films with high ISO ratings are often referred to as "faster" films. Because faster films need less light to make an image, they facilitate shooting in low-light situations and offer the ability to shoot in bright daylight with faster shutter speeds and smaller apertures.

The downside to a faster film is that it produces images with far more grain. Although grain can be stylish and attractive, it can also be problematic if you want to enlarge your image or blow up just a part of it.

The sensitivity of an image sensor is also measured and rated using the ISO system. As with film, an image sensor with a higher ISO rating produces images with more noise. Because the ISO rating on your digital camera can be changed on a shot-by-shot basis (unlike film, where ISO is fixed for the whole roll), ISO is a third factor that you can control when choosing an exposure. This is a tremendous advantage that digital cameras have over their film counterparts.

*CONFUSED BY "SPEED"*

*The word speed comes up a lot when speaking of photography because it can be used to describe three different things: the quickness with which the shutter opens and closes, the maximum aperture of a lens, and the sensitivity of a piece of film or image sensor. As you become more comfortable with these concepts, you should have no trouble determining which meaning is being used at any given time.*

### Summing Up

The relationship between shutter speed, aperture, and ISO setting can be confusing to new photographers. Hopefully, the chart in Figure 3.8 will clarify some of the information presented here.

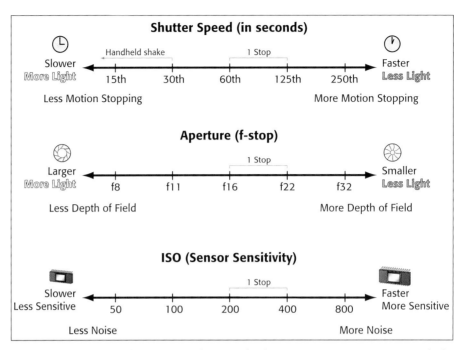

**FIGURE 3.8**    Shutter speed, aperture, and ISO are the three exposure parameters over which you have control. Each one provides a different way of controlling the amount of light that strikes the focal plane. Each adjustment, in turn, affects your image in different ways.

Remember, if you move any one of these parameters in one direction, you must move one of the others in the opposite direction to maintain equivalent exposure, because all three parameters are reciprocally related. Of course, you can choose to move one parameter or another without moving any others to create an intentional over- or underexposure. In Chapters 7 and 8, you'll learn more about why you would choose to do this.

In Chapters 7 and 8, we'll be spending a lot more time with exposure settings and will cover in more detail what you might use these settings for and how you might change them on your camera.

## MOSTLY THE SAME

For the most part, all of the terms and topics we have discussed here apply directly to digital cameras. However, because of differences between film and digital image sensors, and because of features made possible by new digital technology, some of the systems and functions we discussed in this chapter work a little differently in the digital world.

# EVALUATING AN IMAGE

**In This Chapter**

- A Word about the Images in This Book
- How Things Look On-Screen Doesn't Always Matter
- The Top Eight Imaging Problems You're Likely to Encounter
- Why Bad Can Be Good

"If it ain't broke, don't fix it" is often a valuable maxim to follow when trying to decide how to improve an image. However, when reviewing images that you've shot, there will be numerous times where you'll think: "Well it *is* broke, but I don't know *how* to fix it." The first step in solving a problem is, of course, to identify and understand the problem. Oftentimes, an image may look strange, but you won't know exactly what is wrong with it.

In this chapter, we're going to look at the types of problems that are particular to digital photography, both the symptoms and the causes. In addition to providing you with a vocabulary for discussing these issues, studying these problems will help you train your eye to be more discerning, making it easier to select a camera, avoid problems when shooting, and correct your images later.

## A Word about the Images in This Book

Although a lot of hard work went into ensuring that the images in this book are accurately printed, some of the image-quality issues discussed herein are very subtle and might not be easy to spot in the figures shown. The printing process and paper used in this book are not as good as what one would normally choose for a high-quality photographic reproduction, so some of the problems discussed here may not appear exactly as they would in a print produced from a high-quality photo printer.

*ON THE CD*

For closer, more accurate examination, many of the images in this book are included on the companion CD-ROM in the Images folder, and are organized by chapter.

## How Things Look On-Screen Doesn't Always Matter

When evaluating an image on-screen, it's easy to get obsessed with problems that are visible at the individual pixel level. Once you zoom in with an image-editing program and start digging around, you can almost always find flaws, artifacts, and trouble spots. (This is also true with high-end scans from film.)

Consider, though, that if you're looking at the full-resolution output of a 4" × 6" image from a 6-megapixel camera, a single pixel is less than 1/512 of an inch! When printed on even the best photo printer, that individual—possibly troublesome—pixel is not going to be visible.

This isn't to say that a high-resolution camera inherently hides bad image data. A *group* of troublesome pixels can definitely show up in a print. The point is that if your images are ultimately destined for printing,

then when evaluating an image, you should be evaluating that image as printed on your printer of choice. If your images are going to be viewed at full resolution on a computer screen, then individual pixels do matter. But if not, don't get obsessed over minute artifacts that may not be visible on your target output device. (See Figure 4.1.)

**FIGURE 4.1**   When viewed up close, this image exhibits some slight color artifacts. When viewed at the target print size, though, the artifacts are completely invisible. Consequently, we don't really need to expend any effort in trying to eliminate them.

Evaluating prints using a printer lets you see not only which artifacts are visible but also how the colors on your screen will translate into print. We'll have much more to say about printing accurate color in Chapter 15, and the tips in that chapter should help you get better printed results.

## THE TOP EIGHT IMAGING PROBLEMS YOU'RE LIKELY TO ENCOUNTER

With all this talk about identifying image problems, you may be thinking, "Do I really want a digital camera?" Fortunately, things aren't nearly as

bad as the last few pages may have made it seem. The fact is, even a less expensive digital camera will produce much better images than a typical point-and-shoot 35mm camera. (If you're curious about why, or if you don't believe this claim, check out the PDF file "Digital vs. Film" located in the Tutorials > Chapter 4 directory of the Complete Digital Photography CD-ROM.)

The current generation of quality digital cameras may differ in the way they choose to reproduce color, and some may have better or worse lenses than others, but in general there are only a few image-wrecking problems that you're likely to encounter. We're going to look at the top eight in this section.

### Noise

One of the easiest problems to identify in any digital image is *noise*. Noise is analogous to *grain* in a film image, and many cameras produce noise that looks very much like film grain. Noise is not necessarily a bad thing; it can add texture and atmosphere to an image, and photographers cultivate grain or noise in their images to produce more evocative results. Unfortunately, you would ideally like to *choose* if you want noise in an image. If your camera has a serious noise problem, therefore, you may become frustrated that *all* of your images have "texture and atmosphere."

Also, not all cameras produce noise that looks like film grain. Some produce noise that looks more like static on a TV set, whereas others produce blotchy patterns with lots of red and blue dots scattered about the image.

Figure 4.2 was shot with a Sony DSC-T1 using the camera's default automatic settings. No exposure adjustments were made and no edits were performed.

**FIGURE 4.2**    Like many digital camera images, this scene has some trouble with noise, particularly in the shadow areas.

If you look closely at any of the shadowy areas, you'll see that they are fairly noisy. In fact, even some of the middle-tone areas have a marked amount of noise in them. Although noise can sometimes appear as a grainlike texture, in this image, the noise shows up as light-colored speckles—mostly magenta or green—spread throughout the shadow areas.

Noise typically occurs in darker parts of an image, although even some of the lighter shades on the pink building are suffering from a little too much noise. Note that this particular image is free of noise in the sky—a problem that plagues some digital cameras.

Different cameras produce different amounts of noise, and some digital cameras produce "prettier" noise than others. In some cases, the noise has less color in it and almost looks like nothing more than film grain.

On the positive side, depending on the quality of your printing process, this noise might not be a problem. If you're using a somewhat coarse, noisy printing process—such as what you might get when printing on watercolor paper—then the printer might produce enough artifacts of its own that the noise in your image will be obscured. This is a bit of a gamble, though, and it's better to try to get a camera that produces less noise, especially because you might one day upgrade to a higher-quality printer.

Although you can reduce noise with some simple editing tricks, it's difficult or impossible to get rid of it all. Moreover, because certain editing operations can actually make noise more pronounced, it's a good idea to stay aware of any noise in your image.

## Color Troubles

There are many different types of color problems that can occur in any image, whether digital or film, but digital cameras have a few problems all their own. Learning to spot them will give you a better idea of where and how to start making corrections.

### Downright Incorrect Color

Color reproduction is a subjective characteristic, and although some cameras might be more accurate in terms of color reproduction, they might not produce an image that you find as attractive as another model does. Some cameras consistently shoot warmer, some shoot cooler, some shoot more or less saturated. None of these characteristics are "wrong" in any absolute sense, but they might be wrong for your particular taste. Of course, there are also cameras that are so bad that they produce colors just about everyone would consider bad.

With a film camera, your color concerns are a factor of the type of film that you use, and you can always change your film choice at any time. With a digital camera, you have to consider image quality when you choose a camera, and you can't change it later! Fortunately, many of today's digital cameras are capable of excellent color reproduction.

### Color Casts

Some cameras have a tendency to produce images with particular color casts—overall color tones that make the image appear as if it were shot through a colored filter of some kind. Sometimes a camera will have a tendency to cast only the colors in a particular range. For example, shadows might appear too blue or yellow but the midtones and highlights are fine.

Although color casts aren't attractive, they're usually not too hard to remove, because they typically present themselves in just one range of colors in an image. You'll learn more about removing color casts in Chapter 13, "Essential Imaging Tactics."

### Bad White Balance

As you'll see, before you shoot with a digital camera, you need to calibrate it to your current light source, a process called *white balancing*. If improperly white balanced, the camera will not be able to accurately reproduce colors.

Images with bad white balance are similar to images with color casts, except that white balance color damage usually affects more areas of the image. Figure 7.6 shows the same scene shot with a variety of white balance settings. Notice the shift from red to blue throughout the image as the white balance changes.

### Chromatic Aberration

All cameras—including film cameras—are subject to a type of color artifact called *chromatic aberration*. Affectionately known among digital photographers as "purple fringing," chromatic aberration is a term whose definition has expanded somewhat, because not everyone agrees on what causes this particular artifact.

Traditionally, chromatic aberration was a term used to describe the strange color artifacts that occur when a lens focuses some wavelengths of light slightly more or less than others. If some wavelengths are not being focused onto the same focal plane as other wavelengths, color halos can form. This is often the cause of the purple or reddish fringing that can occur with a digital camera.

Others believe that purple fringing has a different cause. If an individual photosite in your camera's sensor "fills up" with too many electrons, it can overflow into adjacent photosites to create a "sensor bloom." This theory is backed up by the fact that purple fringing didn't become a problem until image sensors hit the 2- to 3-megapixel level. At this resolution, photosites are smaller and are packed more closely together, so they're more susceptible to spilling into each other. Many image sensor manufacturers try to eliminate this problem by placing a tiny lens over each photosite to more accurately focus light directly into that photosite.

In most cases, the true cause of purple fringing is probably a combination of these two explanations. (See Figure 4.3.)

**FIGURE 4.3**    The purple fringing shown in this crop is an example of chromatic aberration, a color artifact that often appears in high-contrast areas, when shooting with a wide-angle lens.

You might assume that if this problem is bad with a 3-megapixel camera, it must be *terrible* with a 5- or 6-megapixel camera. Remember, though, that it's not the number of pixels that causes the problem, it's how closely they're packed together. Higher-resolution cameras sometimes have physically larger image sensors, which can make them less susceptible to sensor blooming.

The good news is that chromatic aberrations usually occur only in areas of tremendous contrast—highly backlit scenes, for example. (You

can see this in Figure 4.3. Notice that the purple fringe conspicuously begins and ends along the white part of the player's shirt.) Also, shooting at extreme wide angles increases the chance of chromatic aberrations, simply because wide-angle lenses are more prone to distortion.

All cameras and lenses are subject to chromatic aberration. The example shown in Figure 4.2 was shot with a Canon EOS 10D using a 14mm lens. Even with this level of gear, chromatic aberrations still occurred. However, some cameras (such as the Canon S1 used to shoot Figure 4.3) are especially prone to chromatic aberration and produce artifacts much worse than those shown here.

## Detail and Sharpness

After bad or weird color, lack of sharpness or detail in an image is one of the most easily recognized problems faced by any type of camera. The amount of detail visible in an image is the result of several factors:

- How much resolution your camera has. A camera with more resolution can resolve finer details.
- How good your lens is. A better lens can focus more sharply and produce better image detail.
- How good the sharpening algorithms in your camera are. As we'll see later, all digital cameras employ sharpening algorithms that help improve detail and apparent sharpness. Some cameras are better at this than others, and some can even go too far, producing images that are *over*sharpened. Detail is closely related to sharpness in an image. The sharper the image, the easier it is to resolve fine detail. We'll spend a lot of time discussing sharpening later in the book.

Unfortunately, assessing detail can sometimes be tricky because you may not know that there is detail missing. In other words, you might look at an image and think that it looks fine because you're simply not aware of what's not there.

Figure 4.4 shows two images shot with the same camera, a Canon EOS 10D, but using two different lenses at the same focal length. As you can see, though there's nothing terribly wrong with the image on the left; the image on the right simply shows more detail. (Note, too, that difference in lens quality can affect color reproduction.)

Learning to assess image detail is largely a matter of experience and practice. As you spend more time shooting with different cameras and lenses, and as you spend more time intelligently looking at images, you'll gradually learn how much detail it is possible to expect in an image. This will make it easier to recognize low-detail images.

**FIGURE 4.4**    These two images were shot with the same camera, a Canon EOS 10D, using the same exposure but with different lenses, each set to roughly the same focal length. As you can see, even though both images are acceptable, there is a difference in overall sharpness and color.

The amount of detail is related to the sharpness of the image. Sharpness is a function of the quality of your lens, as well as the quality of the sharpening algorithm used both in your camera and in your editing workflow. All digital cameras employ sharpening algorithms, but some are better than others. Believe it or not, too much sharpness is not always a good thing.

Figure 4.5 shows three frames, one with no additional sharpening, one with a reasonable level of additional sharpening, and one with too much sharpening.

**FIGURE 4.5**    The left image here is plainly a little soft, whereas the middle image has a nice, sharp clarity. You may think that more sharpness is inherently better, but the right image shows that if you sharpen an image too far, you end up with an image that is strangely overcontrasty.

How can you tell if an image is appropriately sharp? Lack of sharpness is something that becomes easier to spot with experience. A softer image is similar to a low-detail image in that you don't always know how much sharper it can look until you sharpen it. Over time, though, you'll begin to recognize certain high-contrast transitions in an image as needing some sharpening.

Oversharpening is easier to spot. First of all, the image will have a slightly "harsh" look. As we'll see later, sharpening algorithms work by adding white and black halos around areas of high contrast in an image. Figure 4.6 shows what an oversharpened area looks like up close.

Those extra-dark areas scattered around all of the lines in the image are what creates the "harsh" look in the image. In a sense, those halos are extra image data that your eye has to consider. They essentially add a completely different type of "noise" to the image, making it more jarring.

Unfortunately, there's little to be done about oversharpening, which means it's always best to err on the side of not sharpening enough, because you can always add more later.

Digital cameras are also susceptible to *aliasing* artifacts that film cameras are immune to. Sometimes referred to as *jaggies*, these stair-step patterns (Figure 4.7) are simply a function of trying to represent a diagonal line using a horizontal and vertical grid of square pixels.

**FIGURE 4.6**   To make this image look sharper, the computer has greatly increased the contrast along any line where there appears to be an edge. So, white areas are too white, black areas are too black, and the image has a very harsh feel. (In addition, this image suffers from some color noise troubles and some JPEG artifacts, which you'll learn about later.)

**FIGURE 4.7**   Aliasing—the stair-stepping pattern visible around this woman's glasses—can be a common problem with lower-resolution cameras. However, even high-end digital cameras can suffer from slight aliasing under certain conditions.

Aliasing artifacts usually appear only in areas of high contrast. As an example, telephone wires against a blue sky are often susceptible to aliasing artifacts. Aliasing problems can sometimes be avoided by lowering your camera's sharpening setting, but it is difficult, if not impossible, to eliminate them later using image-editing software.

## Exposure Problems

As with a film camera, if you choose a bad exposure on a digital camera, you'll get a bad image. Although modern automatic light-metering systems are sophisticated and often do a good job, they can still make mistakes, particularly if they aren't used properly. The meters in most cameras have tendencies, and experience will usually help you predict how your camera's meter might respond to a particular lighting situation.

Figure 4.8 shows three different exposures of the same image. The left image shows an underexposed image, which lacks details in its shadow areas. Exposure and detail is a matter of taste, of course, and one could easily argue that it doesn't matter that there are no shadow details. However, if you were hoping for a different level of contrast in the image—one that might reveal some detail in those dark areas—you'd be out of luck with this picture.

**FIGURE 4.8**    In addition to overall brightness, color tone and detail are affected by changes in exposure, as you can see in this example where we go from underexposed, through the camera's recommended exposure, and finally to an overexposed image.

The middle image was shot with the camera's recommended metering. It provides a good balance of shadow and highlight detail, evidence that the camera does a good job of metering in bright daylight. The right image was overexposed, yielding an image that has the most detail in its shadow areas but no detail in its highlights. Again, you might prefer the darker or lighter image. The point is to recognize how a camera's metering and exposure choice can affect detail and overall results.

## Lens Distortion

On a typical zoom lens, you'll most likely find a little distortion at the extreme ends of the lens. When you zoom all the way in (to full telephoto), you might notice *pincushion distortion*, which causes straight lines to bend inward. More common is *barrel distortion*, which you'll encounter only at extreme wide angles. As you might expect, barrel distortion causes vertical and horizontal lines to bend outward. (See Figure 4.9.)

**FIGURE 4.9**    Wide-angle lenses often suffer from a little bit of barrel distortion. Though it's slight in this image, you can see it along the top of the garage door.

Very wide-angle lenses are always going to have some distortion, and in many cases these types of distortions are going to be concealed by the subject matter of your image. It's only when you have very strong horizontal and vertical lines—a horizon or the top or sides of buildings, for example—that these problems will become apparent.

## "Reason?! We Don't Need No Stinking Reason!": Why Bad Can Be Good

Sometimes an image just looks bad, and there's no real reason why. Sure, you can look for color casts, aberrations, and contrast troubles, but often there are simply indefinable combinations of all of these things that cause an image to just look "wrong." Similarly, an image might be full of technical mistakes but still be a good image. Before you spend too much time obsessing over technical details, step back from the image and examine it as a whole. You might find that your technical concerns are irrelevant.

Nevertheless, it is important to know a camera's technical shortcomings so that you can work around them or, sometimes, exploit them, as in Figure 4.10, a low-resolution, grainy, technically bad image that is still nice to look at.

**FIGURE 4.10** Technically, this image has many mistakes—uneven exposure, weird perspective and distortion, visible seams from the process of stitching it together from individual images, and of course, the extreme noise. Nevertheless, despite its technical flaws, it's a good image. It is important to remember that image quality cannot be quantified down to a checklist of flaws.

# 5

# CHOOSING A DIGITAL CAMERA

**In This Chapter**

- Budget
- Basic Anatomy
- Resolution
- Basic Controls
- Features
- What's in the Box?
- Special Features
- What Should I Buy?

I f you don't yet have a digital camera, or if you want to upgrade to a new camera, then this chapter should help you understand the questions and concerns that you need to address when considering a particular model. There are no specific recommendations or reviews in this chapter. Rather, the goal is to help you understand how a camera works, and what the various features are that you might find, so that you can learn to evaluate cameras on your own.

Before you head out to the store, though, you need to accept one painful fact: the camera you buy will be replaced very soon by a newer model. Waiting for the next generation isn't going to help, because there's going to be another generation right after that one, and another one after that, and so on. However, this sad fact doesn't have to be as depressing as it might seem.

The good news is that the digital camera market has matured to a level where the level of advancement from one generation to another is not as marked as it used to be. Back when the new generation meant a change from 1 megapixel to 2 megapixels, waiting around made sense. But these days, when the change is from 4 to 5 megapixels, or no change in resolution but the addition of features, then the evolutionary advancement between generations isn't so critical. In fact, these days, new models are sometimes *inferior* to the previous generation.

As with any computer gear, if you don't need a camera right away, then wait, because you might get more for your money later. But if you're ready to buy, start your research now. A lot of great cameras are out there, so there's no reason to put off picking one of them!

In this chapter, we take a fairly straightforward approach to choosing a camera:

- First, determine how much you're willing to spend. Your goal is to get the best camera that you can for your budget. *Best* is defined as the balance of features that serves your particular needs.
- Next, determine what resolution you need for the type of output you're creating.
- Among the cameras with the right price and resolution, select the ones that have the shooting features and controls that you want.
- Of those cameras, make your final choice based on which model delivers the best image quality.

## BUDGET

For most people, the first limiting factor in a digital camera purchasing decision is going to be price. Before you make any other choices or evaluations, you should decide how much you're willing to spend. Digital cameras run the gamut from cheapo $100 point-and-shoots, to professional-level SLRs costing

thousands of dollars, so it's important to zero in on a price range that you can afford. Bear in mind that you may have to buy some extra accessories in addition to the camera—storage cards, rechargeable batteries, printer, camera case—so don't forget to factor these expenses into your budget.

Once you've selected a price range, your goal is to find the best camera that can be had for that price. *Best* is a subjective term, of course—if portability is your main concern, a high-resolution professional camera with a super telephoto lens is not going to be the best option. After you've selected a price point, you're ready to begin evaluating the camera's features.

## BASIC ANATOMY

Just as all film cameras have certain things in common—shutter button, film advance, aperture controls—digital cameras all share some basic external anatomy. Although there are variations in implementation, the anatomical characteristics shown in Figure 5.1 are typical of most of the digital cameras you'll see, no matter what their cost or body design.

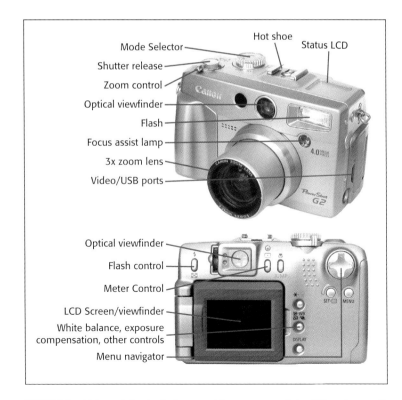

**FIGURE 5.1**    Although body designs and feature sets might differ, almost all digital cameras share some variation of the feature set shown here.

In the rest of this chapter, we will discuss all of the issues and features that you need to consider when shopping for a digital camera, in addition to providing tips and guidelines for evaluating each feature. To begin, we'll look at the very guts of the camera and weigh the merits of different image sensors.

## RESOLUTION

As you've probably already discovered, there are *many* digital cameras out there. The quickest way to winnow the field of possibilities is to focus on cameras with a particular resolution. Why not just buy the most resolution that you can afford? Because *resolution is not the final arbiter of image quality!* If you learn nothing else from this chapter, take that maxim to heart. Obviously, more pixels mean more resolution, which means more detail, which should mean a better picture. However, it doesn't always work this way because the *quality* of the pixels being captured is every bit as important as the *number* of pixels being captured. As such, resolution alone is not a measure of a camera's quality. Consequently, it's important not to get caught up in the "resolution wars" that many vendors wage with each other.

So how do you choose? By considering how you'll most likely be outputting your images. If you need to regularly create 13" × 19" prints, you definitely need a higher-resolution camera. But if you spend the bulk of your time printing out 4" × 6" prints or posting to the Web, you'll be able to get away with less resolution. The fact is, there's a *lot* you can do with just 3 or 4 megapixels. And don't worry—if you commit to a 4-megapixel camera, it doesn't mean that you absolutely can't output a larger print. As you'll see later, it is possible to scale up an image, albeit with a loss of some quality.

*YOU SAY YOU WANT A RESOLUTION*

*If you're confused about the concept of resolution, check out Digital 101: A Few Basic Ideas in Chapter 1.*

Resolution can be a tricky number because many vendors make their resolution claims based on the total number of pixels on the camera's image sensor, when, in fact, the camera doesn't use all of those pixels. (See

Figure 5.2.) For example, the Olympus C-8080 uses a CCD sensor with a resolution of 8.3 megapixels, but the camera's maximum image size is only 3264 × 2448, or 7,990,272 pixels. So where'd the other 300,000 pixels go? Some are masked away to deliver the 4:3 image proportions that Olympus wanted, whereas others are needed by the camera for internal functions such as determining black levels and for demosaicing the pixels along the edge of the frame. (Remember, the camera determines the color of each pixel by examining the pixels around it. So, there need to be some extra pixels beyond the effective edge of the frame.) Olympus only claims a resolution of 8 megapixels for the C-8080, but other vendors are not always so honest. Therefore, if you're a resolution stickler, be sure to check the number of pixels being used, or the *effective pixel count*.

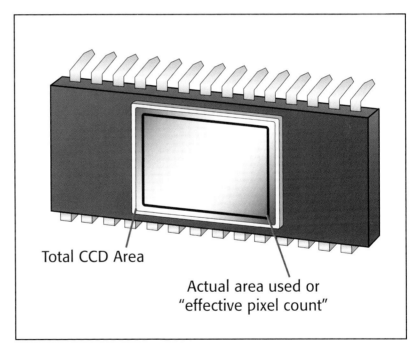

**FIGURE 5.2**   The actual number of pixels that a CCD uses is often smaller than the total number of pixels it provides.

## FOVEON®—FULL COLOR WITHOUT INTERPOLATING

In Chapter 2, you learned that digital cameras perceive color by analyzing a group of pixels to determine the color of every single pixel in your image. This complex mechanism is necessary because the individual pixels in most sensors can read only light and dark, not color. Foveon, Inc., has developed an image sensor that uses a completely different approach. Their unique X3® image sensor has separate red, green, and blue sensors at each photosite, meaning that each pixel in the sensor can read full color, *with no demosaicing necessary.*

In theory this setup eliminates any number of color artifacts and problems that derive from the color interpolation required by every other type of image sensor.

So why should you even consider a camera equipped with anything else? Because the simple fact is, if you compare a Foveon-equipped camera with a competing CCD- or CMOS-equipped camera, you'll probably find that Foveon hasn't yet caught up to the other technologies. CCD and CMOS have decades of research and engineering behind them. Foveon is a new technology with issues of its own. It's certainly possible that in the future, this technology will win out, but in the meantime, image quality and feature set—not potential coolness of the underlying technology—are still the benchmarks for camera value.

However, there are some good Foveon-equipped cameras out there that are certainly worth your consideration.

### Choosing a Resolution

As mentioned previously, the quickest way to narrow your digital camera search is to zero in on a resolution that's suitable to the type of output that you're going to produce. Simply put, to make a quality print of a particular size using a typical photo ink-jet printer, you need a certain number of pixels. We'll talk about resolution in much more detail in Chapters 10 and 15. For now, you can use Figure 15.2 on page 517 as a guideline.

Note that these numbers are not hard and fast. If you pick a 3.3 megapixel camera, that doesn't mean it's impossible for you to print an image larger than 5" × 7"; it just means that you will start to see a softening and lack of sharpness as you enlarge past 5" × 7". Whether this lack of sharpness will matter depends on how picky you are and the types of shots you're taking.

Unfortunately, you can't always frame your image exactly as you want it in your final print. If you can't get close enough to your subject and don't have a long enough telephoto lens on your camera, you may have to shoot your image with the idea of cropping it later. So, even if

you never expect to print anything larger than, say, 5" × 7", you might still want to bump up one resolution class, so that your images will have enough pixels to allow you to crop but still print at 5" × 7".

## BLOWING UP YOUR IMAGES

With modern imaging software, you don't have to settle for the resolution provided by your camera. Through interpolation (also called *resampling*), you can use your image-editing software to enlarge your pictures. Therefore, when we say that a typical 3-megapixel camera can print a 4" x 6" picture, we mean that it can do so without any postprocessing. You can, of course, print much larger than this by up-sampling your images.

However, you can enlarge a picture only so far before you begin to see interpolation artifacts. (See Figure 5.3.) Obviously, the more resolution you start with, the better the results.

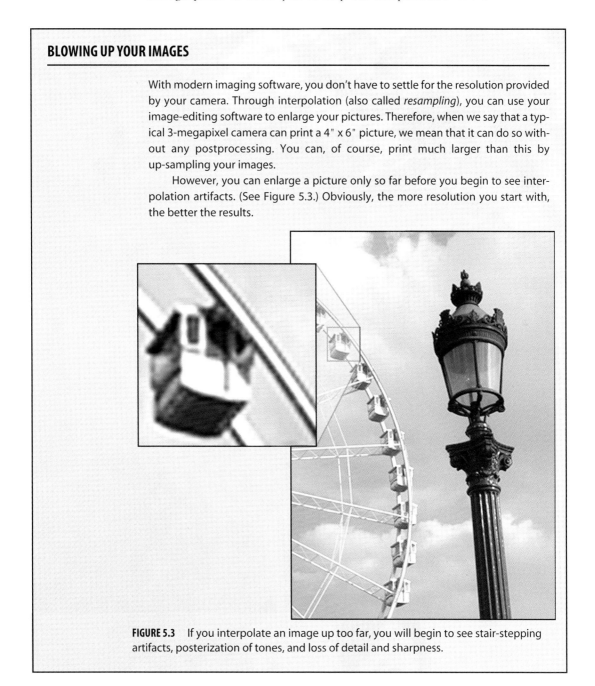

**FIGURE 5.3**    If you interpolate an image up too far, you will begin to see stair-stepping artifacts, posterization of tones, and loss of detail and sharpness.

### How Much Bigger Is That Extra Megapixel?

If you're considering spending the extra money for a camera with higher resolution, it's worth doing a little math. A 50 percent increase in the number of pixels in a camera adds only 22.5 percent more print area. This is the difference between an 8" × 10" print and a 10" × 12" print. Therefore, the extra resolution won't give you substantially bigger prints. However, if your camera and optics are good enough, higher resolution can give you better detail. (You can see the difference in relative image sizes in Figure 15.2, in Chapter 15.) Figure 5.4 shows the differences in pixel dimensions for specific resolutions.

| |
|---|
| 2.1 megapixels - 1600 x 1200 |
| 3.14 megapixels - 2048 x 1536 |
| 3.8 megapixels - 2272 x 1704 |
| 4.92 megapixels - 2560 x 1920 |
| 5.0 megapixels - 2592 x 1944 |
| 6.3 megapixels - 3072 x 2048 |
| 8.3 megapixels - 3264 x 2448 |
| 11 megapixels - 4,064 x 2,704 |
| 13.7 megapixels - 4500 x 3000 |

**FIGURE 5.4**    Before you decide that you need a particular resolution, it's important to understand that the difference between one resolution and another is not always as large as it might seem. Depending on how big you want to print, you might find that you don't need to spend the extra money on extra pixels.

*BUY SOME MEDIA BEFORE SHOPPING*

*Because a camera's LCD screen is too small to accurately judge a camera's perfor-mance, consider buying your own media card. You can then take the card to your local camera store, use it in a few different cameras, and then examine the results at home. When you finally buy a camera, you can always reuse the card.*

---

## DOES SENSOR SIZE MATTER?

Image sensors, whether CCD or CMOS, can be very small—as small as 1/4". Should you be concerned about the physical size of the sensor if it packs the resolution you want? In many cases, yes, because it is ideally better to have a physically larger sensor. Building a lens that can focus onto a very small area can be difficult, so lens quality becomes *more* important when the image sensor is very small.

As explained in Chapter 2, "How a Digital Camera Works," the surface of an image sensor is divided into a grid of pixels. On a larger sensor, each pixel is physically larger than those of a smaller sensor. Larger pixels are capable of collecting more light, which means they are usually more color-accurate than smaller pixels. In addition, on a smaller sensor, where the pixels are packed more closely together, there is a greater chance of electron spillage and blooming (see Chapter 4), which can appear as weird color artifacts in your images. Finally, larger pixels result in a better signal-to-noise ratio, resulting in images with less noise.

These are just some of the reasons why raw pixel count is not necessarily a measure of a camera's imaging quality.

At the time of this writing, digital SLR cameras are topping out at 14 megapixels. Some theorize that there is no need for resolution to go any higher than this because the physical size of the individual pixels is beyond the resolving power of the best lenses now available. In other words, we have reached the point where lens technology, not image sensor technology, is now the limiting factor on high-end cameras.

If this is true, future improvements in image sensor technology will not involve more pixels, but will be made by crafting sensors with the same resolutions that we have today but with larger pixels.

Unfortunately, image sensors are difficult to make, so it's more cost effective for a manufacturer to create physically smaller chips.

Sensor size is not a parameter you need to consider when evaluating a camera. If sensor size is a problem, you'll find out when you begin seeing artifacts in the camera's images.

## BASIC CONTROLS

Once you've narrowed your search to a particular resolution class, you're ready to start considering the features, controls, and designs of specific cameras. This stage of your decision centers around the specifics of what you need for the type of shooting you like to do, as well as your personal preference for camera feel and—let's face it—what's cool.

## Exposure Control

After resolution, the next demarcation in the digital camera market is the degree of basic exposure control provided by the camera. In other words, are you looking for a simple, fully automatic snapshot camera? Or do you expect a more advanced camera with extra control? Or perhaps you don't know from extra control and would like a snapshot camera with some extra manual controls that will let you grow into a more serious level of photography.

In the old days of film cameras (circa 20 years ago), you had to pay a lot of extra money to get a camera that offered completely automatic operation. Now, every digital camera offers complete automation, and you have to pay a lot of money for a camera that offers any manual controls.

Typically, cameras that offer more control also offer higher-quality lenses and, therefore, better image quality. Vendors figure that users who are serious enough about photography to understand manual overrides are serious enough to want higher-quality components in their camera.

So what do we mean by manual control? If you read Chapter 3, you got an introduction to the concept of shutter speed, aperture, ISO, and exposure control. A camera with more sophisticated controls will provide you with several options for taking control of exposure decisions. Presented next are the shooting options you can expect to find on a camera. How many of these options are necessary depends on your photographic needs.

### Program Mode

All digital cameras provide a fully automatic *Program Mode,* which makes the camera function as a point-and-shoot camera. Exposure, white balance, ISO, and focus are all calculated automatically. Depending on the quality of the camera's automation mechanisms, this might be the only mode you need for 80 percent of your shooting.

However, automatic routines don't always make choices that yield the *best* result. They often make choices that yield an *average* result. In a tricky lighting situation, average results are nothing to sneeze at. However, there might be times when the camera's estimations are simply wrong for the situation. It is these times when you'll want some additional shooting control.

### Preset Exposure Modes

In addition to a fully automatic Program Mode, almost all digital cameras these days offer a selection of preset exposure modes. These modes don't

do any type of magic processing; they simply favor—or lock the camera into—particular apertures and shutter speeds that are appropriate to certain situations. Most cameras with preset exposures include variations on the following modes:

**Landscape:**   Cancels the flash, locks focus on infinity, and typically uses as small an aperture as possible for maximum depth of field.

**Portrait:**   Favors wider apertures to produce a softer background.

**Pan-focus:**   Provides settings intended for really fast shooting. Focal length is locked on full wide; focus is kept at infinity. This mode essentially turns your camera into a speedy, fixed-focus camera.

**Fast shutter:**   Forces a large aperture to facilitate a fast shutter speed; sometimes called "Sports."

**Night:**   Uses slow shutter speeds for dimly lit scenes, and typically fires the flash to provide some foreground illumination. Many cameras let you choose whether to fire the flash at the beginning or end of the exposure. Sometimes called "Slow sync." (See Figure 7.30.)

**Sand and Snow:**   Intentionally overexposes the scene so that snow is rendered white instead of gray. This mode will make more sense when you learn about light meters in Chapter 7. Sometimes called "Beach."

Though these modes provide no facility for fine-tuning, they do let you bias the camera's decision-making process in a direction that might be more appropriate for your current shooting situation.

### Priority Modes

Priority modes are where the real power lies for the serious photographer. With these modes, your camera gives up some of its autopilot mechanisms and lets you call the shots. For maximum creative control, you'll want to have at least one of the following shooting modes in addition to the camera's automatic mode:

**Aperture priority:**   *Aperture priority mode* lets you select the aperture you want to use, leaving the selection of an appropriate shutter speed up to the camera. When you are looking at a camera's aperture priority mode, pay particular attention to the range of f-stops available. You want an aperture priority control that will let you pick any of the camera's possible apertures.

**Shutter priority:**   *Shutter priority mode* is the opposite of aperture priority mode. Pick a shutter speed, and the camera will automatically select the right aperture.

**Manual:**   In true *manual mode*, you can set both the aperture and shutter speed, giving you full control over the camera's exposure.

When evaluating the manual modes on a camera, be sure that the controls for both aperture and shutter speed are easy to use and convenient. You don't want to miss a shot because you couldn't figure out how to change the camera's aperture, or because it took too long to set the shutter speed. In addition, make sure the camera displays some type of meter reading while you're changing your settings; otherwise, it will be impossible to know if you're over- or underexposing.

If you know that you're never going to adjust an aperture or shutter speed setting, then you simply don't need priority or manual modes. This decision will immediately eliminate some more cameras from your buying decision. Similarly, if you know that you want to be able to override automatic exposure settings, you can also eliminate some cameras from your field of view.

Now you're ready to start looking at some of the other exposure features that the camera offers. These are controls that you need to think about, no matter what level of photographer you are and what types of pictures you most often take.

### Automatic Reciprocity

As you learned in Chapter 3, many combinations of shutter speeds and apertures yield an equivalent exposure. Many cameras provide a simple control that lets you automatically cycle through all reciprocal exposures after the camera has metered. With an automatic reciprocity control, you can meter your scene and then simply flip through all equivalent exposures until you find one that better suits your photographic intent. If you want a fast-moving object to appear blurry, for example, you can cycle through to an exposure combination that uses a slower shutter speed. Similarly, if you want an image with a shallow depth of field, you can cycle through to an exposure that uses a wider aperture. Automatic reciprocity allows you to have a fine degree of exposure control without having to resort to a priority or manual mode.

### Exposure Compensation

Exposure compensation controls let you force the camera to over- or underexpose by a certain number of stops (or fractions of stops) without having to worry about actual apertures and shutter speeds. With exposure compensation controls you can, for example, tell the camera to underexpose by half a stop, and it will find a way to do so that still yields a good exposure. These controls are powerful and will often be the only exposure controls you'll need to use, even if you're a serious photographer. We'll discuss them in great detail in Chapters 7 and 8.

Together, automatic reciprocity and exposure compensation controls provide all of the manual control you'll need for most situations. When you are evaluating a camera, take a quick look to see how these controls are implemented. You'll be using them a lot, so make sure they're easy to use and that you can find them by feel without having to take your eyes off of the viewfinder. You'll also want to ensure that both controls provide good feedback, allowing you to easily see settings as you change them. Finally, be certain that the exposure compensation control provides at least two stops of adjustment in both directions. Most controls let you adjust in 1/3-stop or 1/2-stop increments.

### White Balance

*White balance* is not actually part of the exposure process. However, because it's a parameter that you'll want to consider while shooting, we're going to discuss it alongside the exposure controls. The sooner you get into the habit of remembering to think about white balance, the better off you'll be.

White balancing is the process of calibrating your camera so that it can correctly interpret colors under the type of light in which you're shooting. We'll discuss white balance in great detail in Chapter 7. When you are assessing a camera, though, you'll want to consider the following things:

- In addition to an automatic white balance control, find out if the camera offers separate settings for daylight, fluorescent, and tungsten. Some systems provide white balance presets that are measured in degrees Kelvin (5500°K, for example). This is fine as long as you know which *color temperatures* relate to which kinds of light. (See Figure 7.7.)
- For maximum flexibility you'll want a manual white balance control that lets you set white balance for your particular situation by focusing the white balance system onto a white object. Make sure these controls are easy to get to, because you'll be using them often.
- Does the camera use a through-the-lens (TTL) white balance system or an external white-balance sensor? Ideally, you want a TTL white balance system for better accuracy.
- Many cameras offer "white balance fine tuning," a slider that lets you tweak the color parameters of the camera's preset white balance modes. This fine-tuning lets you compensate for weaknesses in the camera's built-in settings, as well as for unusual lighting situations.

Finally, you'll want to take a look at the quality of the camera's white balance. Take some sample pictures using the appropriate white balance settings and check for odd color casts. Chapter 7 will give you a better idea of what to expect when white balance goes wrong.

## Metering

Whether you're shooting on full automatic or calculating your exposures by hand, if you don't have a decent light meter you'll end up with the wrong exposure. The modern light meter is an incredibly sophisticated device, and many camera vendors have not scrimped on adding high-caliber, state-of-the-art metering systems to their digital cameras.

Arguing which company's metering software is better is a discussion that is far too technical for this book. Fortunately, metering systems from companies such as Nikon®, Olympus, and Canon come with years of refinements and are all generally excellent. However, you'll probably find that metering systems from different companies have different characteristics and tendencies. Some might consistently meter shadows well, whereas others might excel at midtones or highlights. The good news is that a meter's tendencies will usually be consistent, meaning that over time you will come to learn how your meter will handle specific situations.

Most higher-quality cameras include a selection of different metering modes. (See Figure 5.5.) These modes typically break down into variations of the following categories:

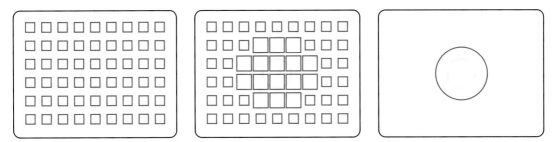

**FIGURE 5.5**   Most cameras offer some combination of three metering types. From left to right, *matrix*, which averages meterings from across the frame; *center-weight*, which meters across the frame but gives more emphasis to the middle cells; and *spot metering*, which meters a single area in the center of the image.

**Matrix (sometimes called multisegment):**   A *matrix (multisegment) metering* system divides the imaging area into a grid, or matrix, and meters the light coming from each cell. These readings are then analyzed and averaged to calculate the ideal exposure for the shot.

**Center-weight metering:**   A variation of matrix metering, *center-weight metering* also divides the image area into a grid but lends more "weight" to the readings from the middle of the image.

**Spot metering:**   A *spot meter* reads only a single area in your image, usually the center. A spot meter lets you deal with complex lighting situations or tricky backlighting.

As with white-balance sensors, you want a camera that uses TTL light metering rather than a meter that's external to the lens. With an external meter, your camera will not be able to accurately account for any filters or lens attachments that you might be using.

Most cameras include some mix of the three systems described previously. To test them, try shooting in complex lighting situations (dark foreground with a bright background and vice versa; darkly shadowed areas; and areas with lots of bright highlights) and see how the camera chooses to meter. Does it preserve shadows? Does it blow out highlights? Most important, does it do these things consistently? Before testing a metering system, it's a good idea to read the metering and exposure sections in Chapter 7.

### ISO Control

One of the great advantages of a film camera over a digital camera is that you can change your recording medium (the film). Although ripping out your digital camera's image sensor and replacing it with a more sensitive chip is hardly practical, many cameras do offer an option to change the sensitivity, or "speed," of the sensor using the same ISO measure that film photographers use.

Most digital cameras have a standard ISO rating somewhere between 80 and 100. In other words, these cameras have a light sensitivity that is roughly equivalent to film rated at 100 ISO. Many digital cameras allow you to increase their ISO rating, typically offering a choice of 100, 200, or 400. Some cameras, such as the Canon G6, offer a slower ISO 50 speed, whereas higher-end cameras can go as high as 3200. These faster, more sensitive modes allow you to shoot in lower light without using a flash (which is ideal for situations where a flash is inappropriate) and allow you to use faster shutter speeds and smaller apertures in bright daylight. However, just as faster film produces grainier images, higher ISO settings in a digital camera produce images with a lot more noise. (See Figure 5.6.)

The ideal camera is one that provides an automatic ISO mechanism (that is, it automatically selects a faster ISO when there is not enough light) as well as manual selection of ISO. Be sure to look at images shot with different ISOs to get a sense of how noisy the camera becomes at higher speeds.

Unlike film cameras, digital cameras let you change ISO from shot to shot, meaning it serves as a third exposure parameter (after shutter speed

**FIGURE 5.6**    The ability to change your camera's ISO setting provides a tremendous amount of shooting flexibility, making it possible to shoot in low-light situations without a flash, and opening up more exposure options when shooting in bright daylight. In this example, we wanted deeper depth of field, which required a very small aperture. At ISO 100, the camera's light meter indicated underexposure. By cranking the ISO up to 1600, we gained enough latitude to shoot with a very small f-stop setting. However, there is a price to pay for this flexibility: as you increase your camera's ISO setting, your images will get noisier.

and aperture). As such, you ideally want an ISO control that is easy to access and that provides a clear indication of what the current ISO is. You don't want to shoot indoors at ISO 400 and then forget to change back to a slower speed when shooting outdoors, because you'll be introducing extra grain into your images.

### Live Histogram

You're going to learn a lot more about histograms—a type of graph of your exposure—in later chapters. Histograms are an essential tool for performing analysis and correction of images. Fortunately, many cameras now provide live histogram displays that can be used while shooting. (See Figure 5.7.)

Though not a feature for the typical snapshot photographer, if you have more serious photographic goals, a live histogram can be a valuable feature.

**FIGURE 5.7**    A live histogram display (shown here directly beneath the focusing target) is an excellent exposure tool that makes it much easier to determine the correct exposure. A live histogram is particularly useful for cameras that lack optical viewfinders, because LCD viewfinders don't always provide a full view of an image's dynamic range.

### Exposure Locks and Panoramas

Panoramic shooting is a great way to capture broad vistas without having to spring for a fancy wide-angle lens or adapter. Although you might have experimented with shooting panoramas with your film camera, your digital camera is a much better tool for creating collaged (panoramic) images, thanks to powerful stitching software that you can use to process your images.

We'll discuss panoramic shooting in more detail in Chapter 9. When you buy a camera, it's worth trying to get one that has a *panoramic* or *exposure lock* mode. Exposure lock simply means that after you take the first image, the camera locks its exposure and shoots the rest of your panoramic series using those same settings to ensure even exposure across the entire image.

Some cameras offer a special *stitch assist* mode that provides visual cues to ease panoramic shooting. These modes often work with special software that can automatically stitch an image as it's transferred to your computer. Although such automation is nice, it's not required for high-quality panoramic shooting.

Exposure lock can also be handy in normal shooting situations when you want to meter off of one part of an image and then reframe your

shot. You can do this on most cameras by pressing the shutter button, but you lock focus as well as exposure. A dedicated exposure lock lets you independently control exposure and focus.

### Selectable Color Space

As discussed in Chapter 2, there are many different ways of modeling and representing color. Each of these models has a particular gamut of colors that it can display. The available gamut is referred to as a *color space*. You'll learn more about color spaces later. For now, all you need to know is that some color spaces are better than others and that many cameras offer a choice. Ideally, you want a camera that provides an assortment of color spaces, including Adobe RGB. Most cameras will shoot in the sRGB color space.

## Camera Design

By this stage, you should have decided what resolution you want and what basic features you need to have for the type of shooting you do. Digital cameras provide many more features than just the shooting modes described in the previous section. You can further reduce the field of candidates by making some basic decisions about the physical design of the camera you want. These considerations range from the physical size of the camera, to the type of viewfinder, to whether you need interchangeable lenses. This is also the stage where you'll consider the feel and control layout of the camera. Like any tool, a camera will be of dubious value if it is poorly designed and difficult to use.

With 150 years of photographic practice behind them, photographers are used to thinking and working in a particular way. However, with the elimination of film—and all of the film-handling mechanics that a film camera requires—it's possible to make a digital camera that provides a size, body design, and features that film photographers of ten years ago would never have dreamed of. Consequently, camera makers find themselves trying to balance the old against the new. Sometimes the balance works, and sometimes it doesn't.

When you are considering a camera's design, you will evaluate size, comfort, and features. However, camera selection also involves trying to find a camera that facilitates your style of shooting. For example, if you're a film photographer, you might be used to SLR viewfinders and so will want a digital SLR. If you're used to the ground glass of a medium-format viewfinder, though, you might be biased toward a camera with a good LCD viewfinder. Perhaps you're a sports or nature photographer who needs to be able to shoot at a moment's notice. If so, you'll want to choose a camera that doesn't require a lengthy *boot time* and offers a good burst

mode and a long lens. Or, maybe you take lots of candid "people" shots, which will be facilitated by a camera with a moveable LCD viewfinder for more discreet shooting.

Finally, the design of your camera's body influences how easily and quickly you can get to the camera's controls and settings. Therefore, you want a camera with a design that makes sense to you and allows you to "feel" your way around without having to take your eye off of your subject.

### Size

Probably your first concern when considering the physical specs of a camera is how big it is. Are you looking for a tiny camera that will fit in a shirt pocket? Or are you willing to carry something bigger? Though tiny and portable is great, there's a price to pay with a smaller camera, because smaller units typically lack the features and controls of larger models. Also, because smaller cameras have smaller lenses, they can sometimes suffer from image-quality problems. On the other hand, a camera doesn't do you any good if you don't have it with you, so small cameras definitely gain points for the fact that you're simply more likely to carry them. (See Figure 5.8.)

**FIGURE 5.8**   These days you can get a very good digital camera in just about any size. Tiny pocket-size cameras such as the Canon Digital Elph® and the Sony DSC-T1 pack high-resolution sensors and very good lenses that produce excellent images, but lack some more sophisticated controls.

Larger cameras typically sport better viewfinders, often better lenses, have more controls, and are usually a little easier to shoot with. The larger size makes for an easier grip, whereas the heavier weight can make it easier to shoot steady, sharp images.

As digital camera technology progresses, vendors are integrating more and more functions into custom chip sets that can be easily dropped into any camera. For example, the Canon DIGIC® image-processing chip first appeared in some of their higher-end cameras as a single-chip solution for all of the cameras' image-processing needs. This chip soon migrated down to the lower end of Canon's lineup, bringing high-end features to less expensive cameras.

Many other vendors have followed suit, meaning you can now get a low-priced ($300–$400) mid-sized camera that offers the same program and manual modes as a higher-end camera. Models such as the Canon A85 offer full manual and priority modes as well as adjustable ISOs, more sophisticated light meters, and a flip-out LCD screen—features that used to be available only at the higher end—for less than $500. What separates these models from their higher-end brethren? Though high-end and low-end cameras now share more and more features and body designs, higher-end cameras still sport better, more expensive lenses and often have additional high-end controls, as we'll see later. (See Figure 5.9.)

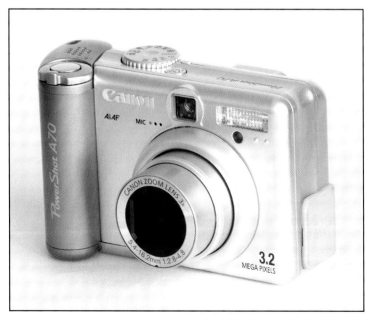

**FIGURE 5.9** Camera makers are migrating more and more high-end features into low-priced cameras, meaning you can now get mid-sized cameras with full manual controls, such as the Canon A70 shown here.

Your size decision will often be determined by other features that you need. For example, if you need a long telephoto lens, you'll be going with a larger camera. Or perhaps you want a particular kind of viewfinder. Having given size some consideration, it's now time to think more about the camera's design.

### Body Design

Because film cameras have to have a mechanism for rolling film from one spool, across the focal plane, and onto another spool, they all have a basic design that is roughly the same. Digital cameras don't have this limitation. Because image sensors are so small, they can be tucked away into just about any part of a camera's body. This means that digital cameras can have radically different shapes and designs from traditional film cameras.

Consider, for example, the Sony DSC-F828. (See Figure 5.10.) The latest in a series of similarly designed Sony cameras, the F828 is predominantly a large lens with a swiveling LCD screen attached to the right side. This lens tilts up and down, affording you a wide range of viewing angles, thus allowing you to use the camera while holding it over your head, at waist level, or up to your eye.

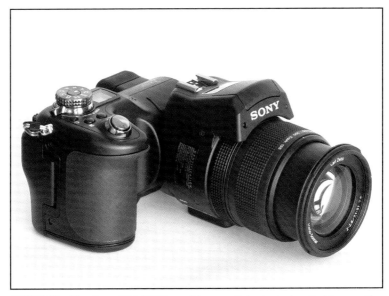

**FIGURE 5.10**   The Sony DSC-F828 provides a split-body design that houses the LCD and camera controls in a swiveling chassis held separate from the lens and image sensor.

These days, most cameras employ a typical boxy design reminiscent of point-and-shoot film cameras. (See Figure 5.11.) However, even within this traditional design, vendors often add some extra variations such as tilt-out LCD screens that provide the same shooting flexibility as the Sony F828.

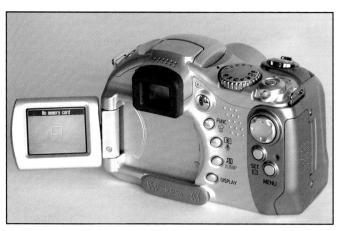

**FIGURE 5.11**    Many point-and-shoot cameras offer traditional, boxy camera designs but with unique improvements such as tilt-and-swivel LCD screens that provide incredible shooting flexibility.

As you learned earlier, a digital camera takes pictures using the same basic mechanisms as a film camera. Light is focused by a lens onto an image sensor, which captures an image and stores it on a memory card. Obviously, as with a film camera, you need some way of "aiming" the camera so that you can see what the camera is seeing, to compose your shot. This is, of course, the role of the camera's viewfinder. There are three basic viewfinder designs, and they are different enough that they form three different classes of cameras.

### Rangefinder Cameras

In a rangefinder camera, the image sensor is positioned directly behind the lens. An additional, smaller lens positioned above the main lens provides you with a view of your scene. In other words, the camera looks through one lens while you look through another. (See Figure 5.12.)

Because they are optically less sophisticated, rangefinder systems are much easier to build than other viewfinder systems. What's more, because they lack the moving mirror of an SLR, they are less prone to the mirror vibrations that can sometimes cause blurriness in a long exposure.

**FIGURE 5.12**    In a rangefinder camera, the light passing through the camera's lens falls onto the focal plane. The viewfinder uses a completely different light path, meaning that what you're seeing in your viewfinder is not exactly what's landing on the image sensor.

On the downside, because you're not looking through the same lens that the image sensor is looking through, you're not necessarily seeing the exact image that will be recorded. If you're using lens filters or extensions—such as a telephoto or wide-angle extension—you won't be able to see the effects of these lens add-ons through your viewfinder.

Also, because the viewfinder is positioned above or to the side of the imaging lens (or sometimes, a little of each) you might have trouble with *parallax* when shooting objects that are very close. Just as something very close to your face appears in a slightly different position when you close one or the other eye, objects very close to your camera will appear in a different position in your viewfinder than they will in your final image.

The viewfinder lens is referred to as the *optical viewfinder,* but most rangefinder cameras also let you use the camera's LCD screen as a

viewfinder. With the LCD viewfinder, you'll have much more flexibility in the way you shoot because you can position the camera wherever you want. And, because the image on the LCD is coming directly off of the camera's image sensor, you get to see a close approximation of your final image. It's not an exact image because your camera might do some processing (color correction, sharpening, noise reduction, and so forth) of the image data before saving. If you're using any lens filters or lens attachments, though, you'll be able to see their effects on the LCD.

The downside to LCD viewfinders is that images in them can be difficult, if not impossible, to see in direct sunlight. Also troublesome is that LCD screens can be battery-hungry. For this reason, an optical viewfinder can be handy.

Unfortunately, most vendors don't put much effort into their optical viewfinders, so you won't have a lot of options when you shop around. When testing an optical viewfinder, check for simple issues such as clarity and distortion. Does the viewfinder provide an image that is clear and easy to see? Most cameras also include one or two status lights within their optical viewfinders—one to tell you that the camera has focused, and another to tell you that the flash is ready. Make sure that these lights are easy to see within the viewfinder and that they are visible in bright daylight.

You'll also want to be sure that the viewfinder provides some type of focusing target such as *crosshairs*, and if you'll be doing a lot of macro photography, then you'll probably want some parallax guides. (See Figure 5.13.)

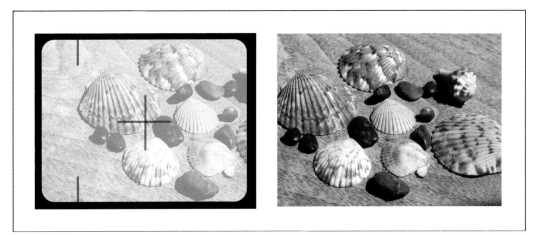

**FIGURE 5.13**   When you shoot at close range, what you see through the viewfinder of a rangefinder camera is not what your camera will actually shoot. Parallax guides give you an indication of where the real edges of the image are. The image on the left shows the view through the viewfinder, whereas the image on the right shows the resulting picture. Notice that the parallax lines allow you to correctly frame the left side of the image, even though you can't see the right side (because you're too close to the subject). If a camera's viewfinder is above the lens rather than next to it, the camera will exhibit parallax shift vertically rather than horizontally.

The most important thing to know about optical viewfinders is that they don't provide good coverage. That is, they don't show you the same field of view that the camera's lens is seeing. On average, an optical viewfinder will display about 85 percent of the final image, although some can go as low as 65 or 70 percent. (See Figure 5.14.) By comparison, LCD viewfinders and the viewfinders in high-quality SLRs deliver about 95 percent coverage.

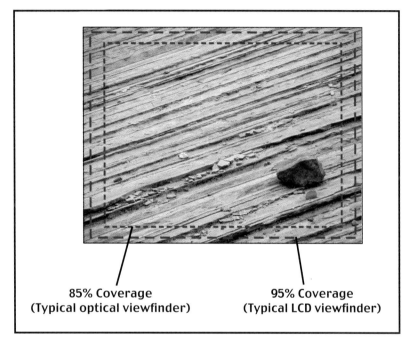

85% Coverage
(Typical optical viewfinder)

95% Coverage
(Typical LCD viewfinder)

**FIGURE 5.14**    The LCD viewfinders on most digital cameras offer an almost complete view of the image that will be captured. The optical viewfinders on most point-and-shoot and prosumer cameras offer much lower coverage.

Because you're seeing a smaller-than-actual-size image, you don't have to worry about accidentally cropping something out of your frame, but you will have to crop your image later to get the same framing that you saw when you looked through the viewfinder. Because you have limited resolution in your camera, optical viewfinders can be frustrating in that they don't allow you to make the best use of all of the pixels at your disposal.

If you wear glasses, look for a *diopter* adjustment next to the optical viewfinder. (See Figure 5.15.) This is a small wheel that allows you to adjust the optical viewfinder to keep it in focus.

**FIGURE 5.15** A diopter wheel lets you adjust your optical viewfinder to compensate for your own vision.

These days, the majority of the cameras that you see will be rangefinder cameras that have both an optical viewfinder and an LCD viewfinder. This combination provides tremendous flexibility, and you'll probably find that you spend the bulk of your time using the LCD viewfinder, with the optical as an important fallback for difficult lighting situations.

What's more, many vendors model their digital rangefinder cameras off of the same rangefinder designs they use for the point-and-shoot 35mm and APS film cameras. As such, you might feel comfortable and familiar with a rangefinder camera; familiarity makes for quick learning. These types of cameras can also be made very small, making it simple to carry them anywhere. Because these designs span the spectrum from low-end to high-end, you don't have to compromise image quality to get an easy-to-use, possibly familiar digital camera.

### LCD-Only Cameras

Some cameras eschew the optical viewfinder/LCD combo in favor of an LCD-only approach. Available in a range of resolutions and packing vast arrays of features, these cameras often offer the most radical departures in camera design. For example, the Sony T1 shown in Figure 5.29 is so small partly because it lacks an optical viewfinder. Other cameras jettison the optical viewfinder to afford more unusual designs, such as the Sony F828 shown in Figure 5.10.

On the downside, because LCD screens use more battery power, if most of your photography takes you into the wilderness, foreign countries, or other situations where battery charging is difficult or impossible, an LCD-only camera might not be practical. Moreover, without an optical viewfinder, you might find shooting in bright daylight to be difficult or impossible with these cameras, because direct sunlight can wash out the LCD screen, making it too hard to see images. Similarly, shooting in very dark situations can be difficult, because the camera's image sensor may not be able to resolve enough detail to make a clear image. (This doesn't mean the camera still can't take a legible image by using a long exposure. It just means you'll have a difficult time framing that image.) Finally, many photographers simply never get used to the process of holding a camera at odd angles or a few inches from the eye.

When considering an LCD-only camera, you'll need to weigh all of the same factors that you would with any other type of camera, but you'll probably want to put a little extra emphasis on assessing the quality of the camera's LCD screen (see "Evaluating an LCD screen" on page 85). After all, because this is your only way of framing a shot, you'll want to be certain that it provides a good view.

### Single Lens Reflex (SLR) Cameras

In an SLR, the image sensor is also positioned directly behind the lens. However, unlike other cameras, a mirror is positioned between the lens and the image sensor. (The shutter sits between the mirror and the sensor.) This mirror reflects the light coming through the lens up into another mirror, which bounces the light out through the eyepiece. When you press the shutter button, the mirror flips up, so that the light coming through the lens passes onto the image sensor. (See Figure 5.16.)

The movement of the mirror is what causes your viewfinder to black out when you press the shutter release. (With the mirror pulled up, your viewfinder is no longer being fed the light that's coming through the lens.) Because they look directly through the lens, SLR viewfinders present a much higher-quality view than a rangefinder, which looks through sepa-

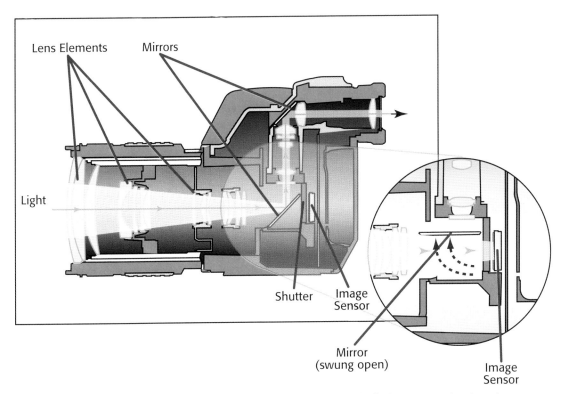

**Lens Elements**   **Mirrors**

**Light**

**Shutter**   **Image Sensor**

**Mirror (swung open)**   **Image Sensor**

**FIGURE 5.16**   In an SLR camera, light passing through the lens is bounced off of a mirror and up into the viewfinder. This *through-the-lens* (TTL) light path ensures that you are seeing the same thing the camera sees. When you press the shutter-release button, the mirror is flipped up so that the light can pass onto the image sensor.

rate, low-quality optics. The result is a viewfinder that is usually brighter and clearer than the optical viewfinders on a typical rangefinder camera.

In addition, because you are looking through the same lens that the image sensor looks through, you can see the effects of any filters or lens extensions you may have installed on your lens, and you don't have to worry about parallax. You also typically get better coverage from an SLR viewfinder than you do from the optical viewfinder found on a rangefinder camera. Finally, SLR viewfinders usually include status displays that show exposure information and other camera settings. Because you can see your image and all of your settings in the same viewfinder, you're free to concentrate on your image.

However, there can be a downside. One of the great advantages of digital cameras is the ability to use the LCD on the back of the camera as a viewfinder. This is achieved by pulling the current "live" image off of

the image sensor and passing it to the screen. In an SLR, though, there *is* no light hitting the image sensor until you press the shutter release. So, on many SLRs, you can't use the LCD as a viewfinder. Some SLRs work around this by using a beam splitter instead of a mirror, which allows some light to go up into the normal viewfinder while the rest passes to the image sensor to provide an image for the LCD.

The most recognizable SLR camera is the traditional 35mm film camera with removable lenses. Though previously the realm of high-end (read "wealthy") professional photographers, the digital versions built around traditional 35mm film bodies can now be had for less than $1,000. (See Figure 5.17.)

**FIGURE 5.17**   The Canon Digital Rebel, an under-$1000 digital camera with the body and features of a 35mm film camera.

These cameras have a number of advantages, including:

**High-quality image sensors:**   Digital SLRs use larger image sensors than smaller rangefinder cameras. As already explained, larger sensors have a number of advantages over smaller sensors of the same resolution. Also, many of these sensors are more sophisticated than

what you find in a typical point-and-shoot digital camera. For example, the Canon EOS series of digital SLRs is renowned for its extraordinary lack of noise.

**Interchangeable lenses:**  The ability to change lenses means you're not limited to any particular range of focal lengths. What's more, you have the freedom to select lenses of exceptional quality—assuming you have the cash to pay for them. We'll have more to say about SLR lenses on page 95.

**Superior viewfinders:**  Digital SLRs typically have much better viewfinders than smaller rangefinder cameras. In addition to being larger and offering more coverage (usually around 95 percent), they also offer extensive feedback as to the camera's current settings, meaning you don't have to take your eye away from the viewfinder to know what the camera is up to.

**Faster performance:**  Digital SLRs tend to offer faster frame rates (the ability to shoot multiple frames very quickly) than smaller digital cameras. They also tend to have faster processing power overall, meaning saving and playing back images is faster, as is menu navigation. With their faster performance, these cameras are always ready to shoot, greatly reducing your chances of missing a shot.

**Professional features:**  Finally, because they are aimed at a higher-end market, these cameras typically offer a few higher-end features, such as servo autofocus (the ability for the camera to automatically track and focus a moving object); extra durability in the form of rugged bodies and weatherproof controls; and higher ISO ratings.

As we'll see later, because SLRs use physically larger lenses, they provide a degree of artistic freedom that is not possible with smaller cameras.

For many professionals, the features and quality provided by an SLR is essential. For sports and nature photography, the ability to use longer lenses with faster burst rates is essential. What's more, if you're used to holding a camera up to your face, blocking out the rest of the world, and framing your shot, then learning to use an LCD viewfinder can be a big adjustment. You might also find that there's a comfortable, familiar feel to a digital SLR. Because digital SLRs have a mirror—and, usually, a mechanical rather than electronic shutter—they deliver all of the same visual and audible feedback that a film camera does. In other words, when you press the button, you hear a discernible click, and your viewfinder goes dark for a moment. For an experienced film photographer, this can be much more comfortable and familiar than the simple electronic beeps that most rangefinder cameras use to indicate that they have fired.

---

## ELECTRONIC TTL VIEWFINDERS: THE "OTHER" SLR

There are many cameras that have an SLR appearance but that don't actually have a true single lens reflex design. Though these cameras have a viewfinder positioned just like a real SLR, the viewfinder is not optical. Rather, it is an electronic viewfinder—a little LCD screen—just like you'd find on a camcorder. Electronic TTL viewfinders show the exact same image as the LCD screen on the back of the camera. Although this is a terrific advantage over the typical optical viewfinder found on a rangefinder camera, it is far inferior to a true SLR viewfinder.

Electronic TTL viewfinders lack the clarity and resolution of a true SLR viewfinder, which makes manually focusing extremely difficult, and can be distracting when framing. They're often difficult to see in bright light, and many of them freeze their displays while the camera is autofocusing, which makes it very difficult to track moving action. In addition, the lack of clarity and freezing image can be a distraction in your picture-taking process.

Also, because they're limited by the performance of the camera's imaging chip, electronic viewfinders inherently have a lower dynamic range than an optical viewfinder. Though this means that the viewfinder will show a truer representation of the range that the camera can capture, it also means that you're not seeing the full range of colors that are actually there, which might hamper your process of deciding which colors you want to capture.

To their credit, they offer extensive feedback of the camera's current settings and, unlike an LCD screen, can be seen in bright sunlight. You'll want to evaluate these viewfinders just as you would any other LCD screen. If you're set on a camera with an electronic viewfinder, try to find one that also offers a live histogram feature. Because you'll be looking at an inferior image, you'll need all of the technical feedback you can get.

---

### Evaluating an LCD Screen

One of the great advantages of a digital camera, of course, is the built-in LCD screen that can be used to review your images as soon as you've taken them. Most cameras also let you use their LCDs as a viewfinder, displaying a real-time, continuously updated image of what the camera is pointed at.

However, a bad LCD screen can actually be an impediment to good results, especially if your camera only provides an LCD viewfinder. When you evaluate a camera, be sure to consider the following issues regarding the LCD screen:

**How big is the LCD?**    When it comes to LCD viewfinders, bigger is better. Most LCDs range between $1\frac{1}{2}$ and 2 inches (measured diagonally).

**How bright is the LCD, and how visible is it in bright sunlight?**
Brighter is better because it will make the screen easier to read in direct sunlight. *Transreflective LCD screens* use a combination of backlighting and reflected ambient light to create an image that is very clear in bright sunlight. If you plan on doing a lot of outdoor photography, this feature is a valuable one.

**How good is the refresh rate?**  The frequency with which the camera updates its LCD viewfinder is referred to as the *refresh rate*. A camera with a low refresh rate will deliver a stuttery image in the viewfinder. A low refresh rate can also cause smeared color artifacts and lower resolution.

**How does the LCD viewfinder perform in low light?**  If you plan on doing a lot of night shooting, you'll probably need a camera with both an LCD and an optical viewfinder, because there's a good chance that images in your LCD screen will appear black in low-light situations. Some cameras, though, offer special modes that artificially brighten the image in low light. If you spend most of your time photographing in the dark, this might be a worthwhile feature to seek out.

**How good is the coverage on the LCD?**  Most LCD viewfinders show an image that is 95 percent to 98 percent of the image that will actually be shot. Any less than this should be considered a liability.

**Does the LCD have an antireflective coating?**  This feature can make a big difference when you are shooting in bright sunlight, because it will greatly cut down on glare on the LCD.

**Does the LCD offer a brightness control?**  Many cameras feature LCD screens with adjustable brightness. Although a brighter screen uses more power, it can be easier to see in direct sunlight.

You'll also want to consider the physical design of the LCD. Most cameras simply have their LCD screens mounted on the back of the camera body, but some models place the LCD on a swiveling panel that can be flipped out, away from the camera. This means the LCD can be quickly and easily rotated to just about any viewing angle, and then safely stored against the camera's body. (See Figure 5.11.) A swiveling viewfinder makes it possible to shoot self-portraits, over-the-head shots, and low angles without having to twist, crouch, or crawl on your stomach. For these reasons, swiveling LCDs are ideal for *macro photography*.

*VIEWFINDER HOODS*

*Although the quality of LCD viewfinders has greatly improved, it can still be difficult to see them in bright sunlight. Special hoods that fit over the LCD screen, such as the Hoodman (Figure 5.18) offer a simple, portable solution for reducing glare in direct sunlight. For more information, check out* www.completedigitalphotography.com/hoodman/.

**FIGURE 5.18**    Hoodman, USA produces numerous LCD hood accessories that make your camera's LCD screen much easier to see in bright daylight. In addition to shielding the screen, many Hoodmans also include built-in magnifiers that produce a larger image.

### What We Know So Far

Keeping in mind the questions we've outlined so far, you should have narrowed your decision based on the following criteria and decisions:

- You've made a budget and determined your price point
- You should have selected a resolution
- You've made some decisions about the basic control and exposure options that you want
- You've identified the size of camera you're looking for
- Based on your understanding of the advantages and disadvantages of different viewfinder systems and how they relate to your photographic style, you should have further refined your search.

In other words, you should have narrowed your selections to cameras with a particular resolution, of a particular size, and built around a particular viewfinder system—most likely either rangefinder or SLR.

Now you're ready to start evaluating the individual features of each camera you'll consider. No matter what resolution, size, or style of camera, the next section will give you an idea of what features you might want to look for and how to evaluate them when you find them. There are a lot of features available, but if you've already resolved the previous criteria, you've done most of the difficult work of selecting a camera.

## "HOW ABOUT USING MY DIGITAL VIDEO CAMERA?"

Your digital video (DV) camera probably has a "still" or "picture" mode of some kind. These modes usually record a still image over several seconds of videotape or, alternatively, record it to a removable flash card. For the user who needs both stills and video, this might seem like an ideal solution, because you have to carry only one device.

Video cameras, however, typically shoot still images that are far inferior to even an inexpensive digital still camera. First of all, even though many video cameras are now offering still modes of one or two megapixels, this is far less than even an inexpensive digital still camera. And, because these devices are primarily concerned about recording video, and because video is very low resolution compared to a digital still image, the typical video camera does not have to have a particularly great lens. Even though it might have a high-resolution sensor, it may not have a lens that can really take advantage of it. Second, the images are usually interlaced, meaning they are composed of two alternating, interwoven images (unless your camera has a progressive scan mode). In addition, if the image is being stored on tape, the image will be compressed using DV compression. Third, a video camera is designed and optimized to produce images for the NTSC or PAL color gamut, color spaces that are more limited than what a digital still camera can produce. They also tend to oversharpen images to compensate for the low resolution of broadcast television. Fourth, DV cameras use rectangular pixels so you might have to correct all of your images to compensate for the change to the square pixels of your computer monitor. Finally, if your camera stores images on tape, you'll face a workflow hassle when you're ready to pull out your images. All in all, it's best to use a video camera for video. Buy a still camera for your still images, unless you're going for a somewhat degraded, video look.

However, many still cameras are now offering excellent video modes that are capable of recording full-screen, 30-frames-per-second video with sound. Obviously, you can't shoot for hours, but for grabbing the occasional video clip without sacrificing still-image quality, a still camera that shoots video is definitely a better option than a video camera that shoots still images.

## FEATURES

It used to be that when you bought a camera, you got a device that took pictures. Well, not anymore! Now when you buy a camera, you get a device that takes pictures of many different sizes, with many different color options and effects, using many different automated tools, and that might even shoot full-resolution video with sound. Sure, you might not need *all* of these features, but for quality work, you will need a lot of them. Consequently, it's important to spend some time considering the quality and

performance of the various hardware and software systems on-board any camera you're considering.

In this section, we're going to work through all of the major options found on today's cameras. In the process, you'll get a better idea of whether each feature is valuable to you and learn some criteria by which you can evaluate these options.

## Lenses

Your camera's lens is where the whole imaging process starts. (Actually, your light source is where the whole imaging process starts, but let's forget about that for the moment.) If you have an inferior lens that can't do a good job of focusing light onto the camera's focal plane, then the quality of the camera's image sensor and internal processing software won't really matter.

Because their image sensors are so small—much smaller than a piece of 35mm film—digital camera lenses must be of very high quality. Effectively focusing light onto such a small area is not easy. However, the physics of designing a lens for a very small focal plane allows for a lens to be much shorter, and of much smaller diameter, than a lens for a 35mm camera. This is great news for lens designers, because it's much easier to correct aberrations in shorter lenses with small diameters. Consequently, digital cameras—even inexpensive ones—tend to have very good lenses. Often, the lens on a point-and-shoot digital camera is far superior to the lens on a point-and-shoot film camera, meaning that you'll usually get *better* results from a low-end digital camera than from a low-end film camera.

As with other features, you should do a little lens testing before you commit to buying a particular camera. The easiest way to test a lens is to shoot some images with it and look for aberrations and image quality troubles. There are a number of different types of lens aberrations ranging from *astigmatism* to *comas,* but in a modern, high-quality lens, you need to worry about only a few types of aberrations. When you look for aberrations or image-quality issues, be sure to test the lens throughout its zoom range. When evaluating a lens, consider the following:

- First, check for general **focus and sharpness.** How well does the lens render fine detail? Are the corners of the image as sharp as the middle? Be sure to check throughout the camera's zoom range. Often, as you zoom to a wider (shorter) focal length, the camera will have more trouble maintaining sharpness from corner to corner. Also, try shooting with a number of different apertures. Most cameras have an aperture

"sweet spot" that yields the best focus. Also, any good lens will fare well at smaller apertures, because the smaller aperture yields deeper depth of field. (You'll learn more about this in Chapter 7.) Shooting with the aperture wide open (that is, with the lowest-numbered f-stop) is often what separates the good lenses from the inferior.

- Does the lens have trouble with **chromatic aberrations?** (See Chapter 4 for more on what this problem looks like.) Shooting trees or telephone wires against a bright sky is often a good way to force chromatic aberrations. This problem usually occurs only at wider—sometimes fully wide—angles. Even the best lens can suffer from chromatic aberration, so don't immediately discount a camera if you see some purple or red fringing around an object. Rather, try to assess how severe the problem is, how extreme your shooting situation is (in other words, will you realistically be shooting in such a situation very often), and whether or not the problem is actually bad enough to show up in print.

- *Vignetting* is a darkening of the image around the edges and corners that usually occurs at the extremes of the camera's zoom range. Look for changes in brightness across the image and throughout the zoom range.

- **Barrel and pincushion distortion** (Figure 4.9) are spatial distortions of your image that work similar to a funhouse mirror. *Barrel distortion* causes a straight vertical line to be bowed outward toward the edges of the frame; *pincushion distortion* causes a straight vertical line to be bowed inward toward the middle of the frame. These distortions are more prevalent at the wide angles of your zoom lens and will definitely occur if you attach a telephoto, wide-angle, or *fisheye* attachment to your lens.

- The **contrast** produced by a lens might vary when you are using smaller apertures. Try shooting some high-contrast areas using the widest and narrowest apertures of the lens.

- Wider-angle lenses are more prone to **lens flares.** (See Figure 5.19.) Zoom the lens to its widest angle and shoot some tests into bright light sources (but never point a camera directly at the sun!) to test for flares.

- Lens quality can also affect **color reproduction.** If you find that a camera tends to shoot images that are a little "warm" or "cold," the trouble might be in the lens.

It is impossible to eliminate all aberrations in a lens. Your goal in testing a lens is to determine what kind of troubles it has, how bad those troubles are, if you think they will affect the type of shooting that you tend to do, and if you can work around them. For example, all aberrations except for distortions can be reduced by stopping down the lens, and many kinds of distortion can be eliminated using special software.

**FIGURE 5.19**    This lens flare is an example of one of the types of flares that can occur as light bounces around inside the lens. Better lenses are less prone to flaring.

When you are looking at cameras, you'll often see specifications that describe a lens as being *aspherical*. This simply means that the lens is not a perfectly round hemisphere and has some nonspherical elements in it that are designed to eliminate certain aberrations. You might also see that a lens has some type of *coating* on it that usually serves to reduce reflections and flares.

In addition to the quality issues described previously, you'll want to consider the following lens features when evaluating a camera:

**Does the lens have threads?**    A *threaded lens* allows you to add filters, which can be essential for achieving certain effects. Some cameras require a special adapter for attaching threaded components. If you're considering such a camera, be sure to add in the cost of the extra

adapter and try to determine how easy it is to attach and remove the adapter. In addition, find out if you have to remove your attachments before you can remove the adapter, because these actions will make the camera a bit more difficult to use.

**Does the lens extend and retract?** For the sake of miniaturization, some vendors make lenses that extend and retract when the camera is powered on. Although such lenses allow for a smaller camera, they also make for longer boot and shutdown times. Some require you to remove any filters or lens attachments before you shut down.

**Does the camera have an electronic or manual zoom control?** On a longer lens, a manual zoom mechanism—usually a rotatable ring on the camera's lens—is better than an electronic mechanism because it allows for a finer degree of control, faster zooming, and less use of battery power. On smaller cameras, manual zoom controls are simply not possible.

**Is the camera's zoom control proportional?** A *proportional zoom control* varies zoom speed depending on how far you push the zoom button. In other words, if you push the zoom control just a little way "in," the lens zooms in slowly. If you press it a long way "in," the lens zooms in quickly. Proportional zoom controls make it easier to make fine adjustments and to quickly get the lens zoomed to the area you're targeting.

### Zoom Ranges and Focal Lengths

If you have much experience shooting 35mm film, you probably have a good understanding of the field of view and magnification provided by lenses with particular focal lengths. For example, you're probably used to the idea of a 28mm lens being wide-angle and a 200mm lens being telephoto.

As we've already discussed, an image sensor is much smaller than a piece of 35mm film, and the distance between the lens and the focal plane in a digital camera is usually much shorter than in a film camera. Consequently, a particular focal length on the lens of a digital camera won't yield the same field of view as the focal length on a 35mm camera. (See Figure 5.20.) In other words, although a 50mm lens on a film camera provides roughly the same field of view as the human eye, a 50mm lens on a typical digital camera will yield a substantially narrower field of view—the equivalent of an extreme telephoto lens on a 35mm camera.

(This concept will be familiar to you if you've ever done any photography using film formats that are larger than 35mm. Lenses for medium-format and large-format cameras yield very different fields of view than 35mm lenses of the same length.)

**FIGURE 5.20**    Unfortunately, focal lengths on most digital cameras don't always produce the same field of view and magnification that you might be accustomed to if you regularly shoot with a 35mm camera. Both of these pictures were shot with the same 300mm lens. When placed on a 35mm film camera, the lens yields the field of view and magnification shown in the upper image. Place the same lens on a Canon EOS 20D, though, and you get a much narrower field of view, as shown in the lower image (on the 20D, the field of view becomes equivalent to a 480mm lens on a 35mm film camera). Understanding the effective focal length ranges of a camera's lens is a crucial part of your digital camera buying decision.

For example, a typical zoom lens for a 35mm camera has focal lengths in the range of 28mm to 135mm, but on a digital camera lens, you'll find focal lengths that are *much* shorter—7mm to 25mm, for example. Whereas seven millimeters on a film camera would be *extremely* wide angle, on a typical digital camera, this tiny focal range yields a field of view equivalent to

about 35mm on a 35mm film camera—just slightly wider-angle than the field of view of your eye.

Fortunately, most digital camera vendors are diligent about publishing *35mm equivalencies* when they list focal lengths for their cameras. Because different digital camera designs may have radically different-sized lenses and image sensors, 35mm equivalency provides a valuable reference point for comparison. Most important, 35mm equivalency lets photographers continue to think in terms of the focal lengths to which they are accustomed. For example, the Canon Powershot S1 IS—which has a very long zoom lens—has an actual focal length range of 5.8–58mm. Its *35mm equivalent range*, though, is 38–380mm. Sometimes, vendors will publish a *focal length multiplier*, which makes it easy to figure out equivalent focal lengths. For example, the Powershot S1 has a focal length multiplier of roughly 6.5.

For the 35mm photographer who's used to wide-angle lenses of 24 or 28mm (or even wider), 38mm hardly seems wide-angle. Unfortunately, making a high-quality wide-angle lens of the typically small diameter found on a digital camera is very difficult. Consequently, if you're expecting to find a camera with extremely short focal lengths, don't hold your breath. However, if wide angle is essential for your work or aesthetic, you can opt for a camera that accepts additional lens attachments. Several manufacturers and third-party vendors offer wide-angle and fisheye attachments that clip or screw onto the front of some camera lenses. Although not as high quality as a dedicated lens, these attachments do provide a workable solution.

Telephoto lenses are much easier to come by and, as you can see from the S1 example, it's possible to buy a digital camera with a powerful telephoto lens that is well suited to sports or nature photography.

Unfortunately, digital camera makers have adopted a convention started by the camcorder industry wherein zoom lenses are measured using a multiplication factor, rather than a focal range. For example, you'll see lenses labeled as having "3x" zooms. The problem with this convention is that it doesn't tell you anything about where that 3x range begins and ends. A little research will usually yield the focal length range in both actual length and 35mm equivalencies.

Finally, some lower-end cameras have a fixed focal length, fixed focus lens. Such lenses usually have a wide field of view and a very small aperture, ensuring that everything in the image will be in focus. The advantage to such cameras is that they're easy to use—you don't really even need to look through the viewfinder—and they are usually inexpensive. The downside is that they offer very limited creative control.

Finally, it's very important to understand that because the built-in lenses on most digital cameras are so short, they are limited in their abil-

ity to control *depth of field*—that is, it is difficult to opt to have only part of the image in focus. Why wouldn't you want to always have the whole image in focus? The most frequent example is portrait photography, where the photographer chooses to blur out the background to bring more emphasis to the subject. (You'll learn more about depth of field in Chapter 7.) If this level of control is critical to your work, you might be better served by a camera that supports interchangeable lenses.

### Interchangeable Lenses

If you have opted for a digital SLR that supports interchangeable lenses, your lens evaluations are going to be more complicated simply because you have so many more choices. You'll have the option to use lenses that can go much wider or much more telephoto than what you'll find on cameras with built-in lenses. You'll have options for many different zoom ranges, as well as *prime* lenses—non-zoom lenses of a fixed focal length. And, of course, you'll be able to choose amongst a selection of lenses with drastically varied quality.

When evaluating a lens for a digital SLR camera, you'll want to consider all of the same issues discussed in the previous section. In addition, however, you'll need to weigh the following factors particular to interchangeable lenses:

**Focal length:**   Whether you're looking at a zoom or prime lens, your first concern is to get a lens that provides the focal length that you want. If your camera has an image sensor that's smaller than a piece of 35mm film (and currently, almost all digital SLRs have smaller image sensors), remember that the effective focal length of any lens will be longer. For example, the Canon EOS 20D has a focal length multiplier of 1.6x, meaning any lens you stick on the camera will have an effective focal length that is 1.6 times greater than it would be if mounted on a 35mm camera. This means that to get a wide-angle field of view, you must buy a lens with an extremely short focal length. These lenses are often expensive and very large.

**Lens speed:**   As mentioned in Chapter 3, the speed of a lens is determined by its widest opening. An f1.4 lens can collect light much more quickly than an f4 lens. Vendors often sell faster and slower versions of any particular lens, with faster lenses being more expensive. So, you might be able to choose between an f1.4 and f1.8 50mm lens, for example. A faster lens affords you more shooting flexibility, but if you don't think you need the wider apertures, you might be able to get a lens of equivalent image quality for less money.

**Image stabilized:**   Many lenses include image stabilization hardware, which is a must-have for extremely telephoto lenses, and if you can afford it, is worth having on just about any lens.

**Size of the lens:**   Obviously, you'll want to consider the size and weight of a lens, simply to assess whether you really want to lug it around with you. But with a very large-diameter lens—such as an extreme wide-angle lens—you'll want to also check to see if the lens casts a shadow when used with the camera's on-board flash. (See Figure 5.21.)

**FIGURE 5.21**   Some wide-angle lenses, or wide-angle attachments, are large enough that they can cast a shadow into your scene when you use the camera's on-board flash. Therefore, if you want to shoot wide-angle with a flash, you'll need to find a smaller lens or get an external flash that can be positioned away from the lens.

A digital SLR can be very generous to a lens. For example, some wide-angle lenses are susceptible to lens flares and vignetting around the edges and corners. However, because a digital camera is using only the middle portion of the lens (the lens was engineered to focus onto the larger frame size of a 35mm camera), these troubles are often cropped away.

At the same time, a cheaper lens that fares sufficiently on a 35mm film camera might not perform as well on a digital camera, simply because a digital camera requires a lens that can focus well to a smaller area.

## OF EOS-S LENSES AND LEICAS

As you saw in Figure 5.16, the very rear element of a lens does not extend all the way to the focal plane of a camera. You've got to have room for the shutter and, in the case of an SLR camera, the mirror that bounces light up into the viewfinder. However, if you can position a lens closer to the focal plane, you can make a lens smaller (which often equates to higher quality, since there's less glass in the lens). Because of this, Canon created a new lens mount for their digital SLRs, called the EOS-S system. EOS-S cameras incorporate a smaller mirror, which means that there's more space inside the camera. Thanks to this extra space, EOS-S lenses can have a rear element that extends further into the camera and thus, closer to the image sensor. (All of this is possible because digital image sensors are smaller than 35mm film, so the lens doesn't have to cover as big an area.) At the time of this writing, Canon has released two EOS-S compatible cameras—the Digital Rebel, and the EOS 20D—and four S-series lenses. Fortunately, the EOS-S system can also mount Canon's full line of EF and L-series lenses.

Traditional Leica® rangefinder cameras were also engineered to place the lens as close to the focal plane as possible, which is one of the reasons that Leica lenses are so exceptional. Leica's Digilux 2 digital camera is a digital version of the traditional Leica rangefinder design and is fully compatible with Leica's excellent lenses.

## LENS ATTACHMENTS

Many digital cameras that have built-in lenses include support for lens attachments. These additional lens elements screw onto lens threads or attach to other special mounting devices on the lens. For a camera that doesn't have interchangeable lenses, such attachments provide a way for you to add extra wide-angle or telephoto power to your camera.

For example, Olympus touts their E20 as a camera designed from the ground up to work with its built-in lens. They claim that having an image sensor and lens engineered to work together yields better image quality than using a lens that was originally engineered for 35mm film. They provide a number of lens attachments that greatly extend the functionality of the built-in lens.

When buying any lens attachment, evaluate it carefully, checking for all of the aberrations and potential problems discussed earlier. Many third-party attachments use inferior optics that deliver lousy image quality.

In addition, pay attention to the following:

- Does the attachment block the optical viewfinder? Some attachments are large enough that they will obscure part of the optical viewfinder, making it difficult to frame your shot.

- Does the attachment cast a shadow when used with the camera's on-board flash? (Figure 5.21)
- Does the attachment require a special adapter or step-up ring? If so, you'll need to be sure to buy one of these.

Finally, you'll also want to see how easy it is to attach and remove the device, including any adapters or step-up rings it might require.

A camera that supports lens attachments can be a less-expensive, and smaller, alternative to a full-blown SLR with interchangeable lenses.

## Digital Zoom

Loosely related to lenses are the *digital zooms* provided by most cameras. Evaluating a digital zoom feature is a simple two-step process:

**Step 1:** Turn off the digital zoom feature.

**Step 2:** Don't ever turn it on again.

That's it! You're done and can now go on to consider other features.

The fact is that most digital zoom features do a terrible job of acting like a zoom lens. Obviously, the camera cannot digitally increase its focal length, so these features work by cropping the image, and then scaling that cropped area up to the full size of the frame. The problem with most digital zooms is that they use bad interpolation algorithms when they scale up, so they tend to produce jagged, blocky images. Consequently, rather than using a digital zoom, it's much better to shoot the image with your camera's maximum optical zoom, and then crop and enlarge it yourself using Photoshop. This process will provide a better form of interpolation.

There are three occasions when a digital zoom can prove useful:

- If you don't have any image-editing software that is capable of cropping and upsampling.
- If you don't want to magnify the JPEG artifacts in your image. Because the camera enlarges your image *before* compressing, digital zooms don't worsen any JPEG artifacts. Enlarging the image in an image editor will.
- If you're shooting at one of the camera's lower resolutions, a digital zoom may help. Most of the time, when you shoot at a lower resolution, the camera simply shoots at full resolution and then downsamples. Because there's more resolution to start with, using a digital zoom on a lower-resolution image often produces fine results.

If you must use a digital zoom feature, you ideally want to have one that offers good interpolation and provides a continuous range of zooming rather than fixed zoom ratios.

## Focus

No matter how much you spend on a camera, you're going to get a camera with an autofocus feature. Believe it or not, using the autofocus mechanism properly is one of the biggest problems that new users face when they first start shooting. Fortunately, all of these mechanisms work the same way.

Using the camera's viewfinder, you place the focusing target (usually the middle of the viewfinder) on the object in your scene that you want to have in focus. (See Figure 5.22.) When you press the shutter release button halfway, the camera measures the distance to that object and *locks the focus*; pressing the button the rest of the way will take the picture. (If your camera has a fixed-focus lens, you can skip this section.)

**FIGURE 5.22**    Many cameras have multiple focus spots. When you press the shutter button halfway, the camera determines which focus spot is on your subject, automatically focuses the lens to that point, and locks the focus. Here, the camera has selectd the upper focus spot.

We'll discuss all of the concerns and practices of using an autofocus system in Chapter 7, "Shooting." When you choose a camera, though, look for the following items:

**Passive versus active autofocus:**    Autofocus systems that use a *passive* TTL system determine focus by looking through the lens. *Active autofocus* mechanisms employ a separate sensor outside the lens to measure distance; focus is then set accordingly. *Passive autofocus* systems are usually more accurate and have the advantage of working with lens extensions and attachments.

**Focus-assist lamp:**    The downside to most passive TTL autofocus mechanisms is that they don't work well (or at all) in low-contrast situations. A *focus-assist lamp* (sometimes called an *autofocus-assist lamp*) (Figure 5.23) is a white or red light that the camera automatically shines into your scene when there isn't enough contrast to lock focus. Look for a focus-assist lamp that can be deactivated for more discreet shooting.

**FIGURE 5.23**    A focus-assist light shines a white or red light into low-contrast scenes to help the camera's autofocus mechanism.

**Number of autofocus points:**    Though less expensive cameras will always use the middle of the viewfinder as the autofocus "target," fancier cameras will usually provide several autofocus points that can be used for determining focus. The camera tries to assess what elements in the scene need to be in focus (that is, what's in the foreground and what's in the background) and selects an autofocus point accordingly. These systems often provide much more accurate focus, but they can make mistakes, so look for a camera that has the option to select an autofocus point manually or to default to a center point for focusing. Because autofocus mechanisms are typically more sensitive to horizontal features, having more image points can make up for this lack of sensitivity to vertical elements and improve the cam-

era's ability to focus. Also, if your camera has a servo-tracking feature (the ability to automatically track and focus a moving object), having more autofocus points will result in better tracking.

**Number of autofocus steps:**    With more autofocus steps, there are more locations that a lens can set itself to in order to get focused. However, as we'll see in Chapter 7, this doesn't necessarily mean that the camera will do a better job of focusing.

### Continuous Autofocus

Some cameras offer a *continuous autofocus*, which constantly refocuses as you move the camera. The advantage to this mechanism is that when you're finally ready to shoot, the camera might already be in focus. If you're considering a camera with a continuous autofocus feature, make sure it's possible to disable the feature because you might need to occasionally turn it off to save your battery.

### Manual Focus

Manual focus can be a boon for times when your camera's autofocus mechanism can't lock focus, or when you want to force the camera to focus on something in particular. Unfortunately (unless you're using an SLR), most digital cameras don't have an old-fashioned, lens-mounted manual focus ring. Instead, many cameras use a special menu option that requires you to dial in the distance to your subject or use buttons on your camera to manually focus the lens. Although these controls are adequate, the lack of high-quality viewfinders on most cameras can make manual focusing difficult or impossible.

At the very least, try to get a camera that has a manual infinity focus lock. This will allow you to lock the focus on infinity, which can be a real battery and timesaver when you know you'll be shooting objects that are far away.

## Shutters and Apertures

Your camera's shutter and iris controls allow you to change exposure to control the brightness or darkness of your image, as well as the depth of field and motion-stopping power. Whereas film cameras have mechanical irises and shutters—actual metal, cloth, or plastic mechanisms that open and close—digital cameras often use different methods, such as electronic shutters, for exposing the image sensor. Rather than having a mechanism that opens and closes in front of the sensor, a camera with an

electronic shutter simply turns its image sensor on and off for the appropriate length of time. One shutter mechanism is not necessarily better than another, as long as the camera offers the shutter-speed control that you need to take the kind of shots you want.

All digital cameras offer an *automatic exposure* feature, which will automatically calculate the appropriate shutter speed and aperture at the time you take a picture. Some cameras, though, also offer manual controls for shutter speed and aperture. When you are assessing a camera's manual overrides, make sure that the camera offers a good range of shutter speeds—ideally ranging from a few seconds to at least 1/500th of a second. It's also nice to have a *bulb mode,* which makes the camera leave its shutter open for as long as you hold down the shutter release button.

As in a film camera, the aperture in a digital camera is controlled by an iris, an interlocking set of metal blades whose opening can expand or contract to make a bigger or smaller aperture. Many digital cameras, however, have only two apertures, usually f2.8 and f5.6 or f8 and f11. These cameras make up for their lack of aperture options by varying shutter speed. Although this configuration doesn't limit the conditions under which you can shoot, it does possibly hobble your creative possibilities. Ideally, you want a camera with more aperture options.

Some cameras use their iris as a shutter, simply snapping it open and closed to make an exposure. The downside to this scheme is that at higher shutter speeds, the camera might require you to use smaller apertures because a wider aperture would take too long to close and would prevent the camera from achieving the desired shutter speed. Again, if you want maximum creative flexibility, this type of mechanism might be too limiting.

Also, some cameras limit their minimum aperture to f8 in an effort to avoid certain diffraction artifacts caused by the camera's lens. The automatic meters in these cameras, therefore, tend to favor wide-open apertures. These factors can limit your creative flexibility, so you might want to do a little investigation when evaluating a camera.

## Image Control

In a film camera, once you select a type of film, you're stuck with the characteristics of that film until you shoot the entire roll. Different digital cameras can have particular imaging characteristics, but most cameras also include a number of controls that let you fine-tune how you want the camera to process and store images.

### Image Resolution and Compression Controls

Almost all digital cameras offer a choice of resolutions. In addition to the camera's maximum resolution, most cameras offer lower-resolution options that allow you to fit more images onto the camera's storage card. Even though you might have spent the extra money for a 4- or 5-megapixel camera, you might not always need to shoot at full resolution. For example, if you need to shoot images for the Web (and you're *sure* you'll never want to print them), your storage will go a lot farther if you shoot at *VGA* or *XGA* resolution (that is, 640 × 480 pixels or 800 × 600 pixels, respectively) than if you shoot at the camera's full resolution.

For maximum flexibility, you want to be sure that you choose a camera that provides a range of switchable resolutions. Most cameras offer at least full-resolution, an intermediate resolution, and two Web-quality low resolutions (usually VGA and XGA).

*PUT YOUR MONEY WHERE YOUR STORAGE GOES*

*Nowadays, digital camera storage is so cheap that there's really no reason not to always shoot at the highest resolution your camera provides. In other words, instead of trying to conserve space on your storage card, just buy some additional cards. By shooting at full resolution, you'll have the option to enlarge parts of your images, and if you decide later that you want to print your images, you'll have the resolution you need to get a good print.*

*ABANDON HOPE, YE WHO INTERPOLATE HERE*

*Some cameras offer special interpolation modes that produce higher resolutions than the pixel count that their image sensors actually provide. These cameras achieve their results by shooting an image and then performing an upsample, or interpolation, to produce an image of higher resolution. Unfortunately, these modes sometimes produce images with nasty interpolation artifacts. If you want a bigger image than what your camera can provide, it's much better to shoot the cleanest, highest-quality image that your camera can manage, and then sample it up later in an image editor. You'll have more control and will get better results, and your camera's storage will go farther.*

### Image Compression

Compression can save a tremendous amount of storage space, but it can also adversely affect image quality. Ideally, your camera will offer a range of compression settings, from a high-quality JPEG compression to a really squeezed, low-quality JPEG compression that yields very small files. JPEG

compressors that deliver 3:1 or 4:1 compression ratios are considered high quality. Lower-quality JPEG compression typically provides ratios of 10:1 or 20:1.

Compression settings are not something you'll change often. In fact, you'll probably change them only if you start to run out of storage. Nevertheless, it's worth double-checking a camera's interface to its compression settings. Ideally, you want something that offers the flexibility to mix and match different image sizes and compression settings. At the very least, you want two or three compression settings for each resolution setting on the camera.

On many digital cameras, the best-quality JPEG settings are so good that they're indistinguishable from uncompressed images. Nevertheless, certain shooting conditions leave your images especially susceptible to JPEG artifacts. Areas of complex contrast, such as foliage and leaves, as well as areas of broad, flat color, such as skies, are often prone to bad artifacting. Having an uncompressed option can be a lifesaver if you find yourself shooting under these circumstances.

### Raw Files and Uncompressed Files

If image quality is your highest concern and storage is of little consequence, you'll want to get a camera that can also store an uncompressed image, usually a raw, or TIFF file. Although these files are typically huge—9 or more megabytes on a 3-megapixel camera—they won't suffer from any compression artifacts.

For the ultimate in image quality and editing power, you'll want a camera that provides an option to store *raw data*. Remember that your camera works by taking data from the pixels on the image sensor (which is usually 12 or 14 bits of data per pixel) and interpolating it up to 16 bits per pixel before processing, compressing, and storing it on your camera's storage card. In raw mode, the camera stores the *original* information that came directly off the sensor. Raw data has several advantages over normal processed data. First, JPEG files are usually downsampled to 8 bits of color data per pixel before being compressed. Therefore, if your camera normally shoots 12 or 14 bits per pixel, the camera will be throwing out some color information during the JPEG conversion. With raw files, you have the option of converting the image into a 16-bit format that can be used with many editing programs. Consequently, you can get much better color and much more editing flexibility by using raw instead of JPEG format.

Because raw data has not been interpolated (you do the interpolation later, using your computer), it's usually significantly smaller than a full, uncompressed TIFF file. For example, a raw 2048 × 1536 pixel image

usually comes out to around 3.9 MB, whereas a 2048 × 1536 TIFF image typically weighs in around 9.4 MB. Some cameras use a *lossless* compressor on raw data to further reduce file size. Also, because your computer has much more processing power than your camera, it can use more sophisticated interpolation algorithms to process your image. And, because the raw data hasn't been compressed, it won't suffer from JPEG artifacts.

Finally, raw images are stored *before* the camera performs any internal processing such as color balancing, contrast adjustment, white balance, sharpening, or noise reduction. This frees you to control these processes *after* you've taken the shot, using software provided with the camera.

The raw processing software that ships with most cameras is very weak, but there are good third-party solutions. Fortunately, Photoshop CS now includes an excellent built-in raw facility that makes raw-image workflow as easy as working with JPEGs. (See Figure 5.24.) Note, though, that if you're using more complex raw-processing software, raw-image workflow can be complicated and time-consuming. Because of this, some cameras now offer the ability to save a raw file and a JPEG file simultaneously. So, when you shoot a picture, a raw file, as well as a normal JPEG file that has been processed according to your camera's current settings, is stored on your card. If you need to quickly review or use an image, you can simply use the JPEG file. For more serious editing work, you can turn to the raw file when you're ready.

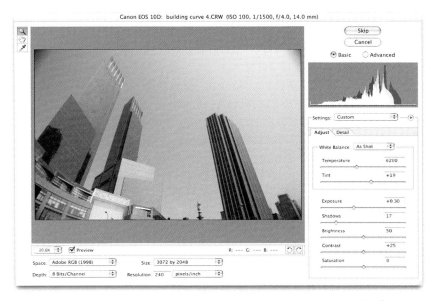

**FIGURE 5.24**    If your camera provides a raw data mode, you can use special software to change parameters such as white balance, sharpening, and contrast after you've shot your image.

Because raw files are so large, some cameras simply can't muster the processing power to do anything else while they're writing a raw file to a storage card. After shooting a raw image, these cameras will lock up and not be capable of shooting another image until the raw file is stored. Obviously, this is hardly conducive to rapid shooting. So, if you plan on shooting lots of raw files, be sure to try a few shots in raw mode to see how quickly the camera can handle repetitive raw shooting.

We'll discuss raw files in more detail in Chapter 13.

### Macro Mode

Most digital cameras include a special macro mode for shooting extremely close objects. (See Figure 9.1.) Digital cameras fare much better than most 35mm cameras when it comes to macro photography. Because they have tiny lenses with a deep depth of field, digital macro photographers have a focus advantage over cameras with larger lenses. Some digital cameras can focus on an object as close as 5 inches, or 2 cm, away! In addition, movable LCD screens can make the physical process of macro photography much simpler.

Most macro modes should be used with the lens set to its widest angle (shortest focal length). Unfortunately, most lenses have difficulty focusing evenly across the entire image when set to their widest angle. So, when evaluating a camera's macro feature, zoom the lens to its widest setting and carefully check the focus in the corners and edges of the image.

### Sharpness, Saturation, and Contrast Controls

Many digital cameras now include adjustable levels of sharpness, saturation, and contrast. Technically, these settings have nothing to do with exposure. Rather, they control the post-processing that your camera performs before storing the image. The idea of "too much" sharpening might seem strange at first, but as you saw in Chapter 4, it is possible to oversharpen an image. Similarly, the default settings on some cameras yield images that can be oversaturated. Adjusting these parameters lets you tailor your camera to your personal tastes and to the needs of particular shooting situations. (See Figure 5.25.)

### Aspect Ratio

The ratio of an image's length to its width is called the *aspect ratio*. Most digital cameras use the same 4:3 aspect ratio that your computer screen

<div align="center">Contrast -1          Saturation -1</div>

<div align="center">Color Tone -1          Normal          Color Tone +1</div>

<div align="center">Contrast +1          Saturation +1</div>

**FIGURE 5.25** If your camera supports different contrast, saturation, and/or color settings, you can dramatically change the camera's color qualities. All photos shown here were shot using full-automatic mode. The only difference was the change in settings noted beneath each image.

and television use, but some higher-end cameras use the 3:2 aspect ratio of 35mm film. (See Figure 5.26.)

Some cameras, offer a choice of either aspect ratio. (See Figure 5.27.) However, it's important to note that when you shoot in 3:2 mode, you're simply shooting a cropped version of the camera's native 4:3 ratio. Therefore, when you shoot 3:2, you're shooting lower-resolution images. It's often better to simply shoot 4:3 and crop the image later. If you prefer a particular aspect ratio, you'll want to make sure to pick a camera that can shoot with those dimensions.

**FIGURE 5.26** Most digital cameras use the same 4:3 aspect ratio as your computer monitor. Some cameras offer the 3:2 aspect ratio of 35mm film.

## Flash

No matter what level of camera you are considering, most units will have a built-in flash. Obviously, bigger cameras will have a larger, more powerful flash unit, but even small cameras can offer good flash hardware.

**FIGURE 5.27**    Some cameras offer a choice of aspect ratios. Usually, the wider choice is nothing more than a cropped version of the normal 4:3 aspect ratio. It is better to shoot full-screen and do the cropping later.

Flash photography is one of the most difficult things for any camera to handle, and digital cameras are no exception. Consequently, it's important to carefully evaluate a camera's flash system before you buy.

There are a few simple issues to clarify up front:

**What is the range of the flash?**    Because of their small size, most built-in flashes have a range of only around 10 to 15 feet. Although this is fine for most snapshot situations, for more serious work you'll need additional lighting. If you're looking at a particular small camera, pay close attention to flash coverage. Because smaller cameras have such small flash units, it's sometimes difficult for them to cover even a mid-sized room with their built-in flash.

**Does the flash produce a color cast?**    Do some simple flash tests to ensure that flash pictures are not plagued by weird color casts. Unfortunately, some cameras have trouble calculating a proper white balance when shooting with a flash.

**Does the flash have a hot shoe or external flash sync connection?**    For maximum flash flexibility and control, you want a *hot shoe* for connecting an external flash. (See Figure 5.28.) These standard connections are usually designed to work with specific flash units made by the manufacturer. Make sure that the camera offers TTL metering with the hot shoe. If the camera doesn't have an actual hot shoe (or is too small to have one), look for a connection for an *external flash sync*, which will allow you to connect an external flash (again, usually a specific model) to the camera using a small cable. You'll probably need to buy some type of bracket to hold the flash.

**FIGURE 5.28**    For serious flash work, you'll want a camera with a hot shoe or external flash sync connector.

**Where is the internal flash positioned?**   Ideally, you want a flash that is as far from the lens as possible. If the flash is too close to the lens, the camera will be more susceptible to the red-eye effect. We'll discuss this in more detail in Chapter 13, "Essential Imaging Tactics."

**What flash modes does the camera offer?**   Look for a camera that offers a completely automatic mode, where the camera decides when to use the flash; a *force flash* or *fill flash* mode, which allows you to force the flash to fire to provide a slight fill light; and a *red-eye reduction* mode, which reduces the chance of red eye in your image by first firing a short flash to close down the irises in the eyes of your subject. Many cameras also offer a *slow sync* mode that lets you combine flash photography with long shutter speeds to capture more background detail when shooting in low light. Be sure that the camera lets you specify whether the flash fires at the beginning or end of the exposure. And, of course, you want the ability to turn off the flash altogether.

**Does the camera offer control over flash intensity?**   Many cameras let you control how strong the flash will be by specifying more or less power, usually measured in f-stops, or fractions of a stop. Given the difficulty that many cameras have with flash metering, this manual override can be essential to getting good flash photos.

In addition to the physical specifications of the camera's flash, you'll also want to assess how well the camera meters and white balances when you use the flash. The best test of a flash's performance is to shoot pictures of people's faces indoors under a slight mix of lighting. The human eye is well tuned to flesh tones, so pictures of faces make a good test of how well a flash system is reproducing color.

Look at the overall exposure of your image. A poor flash system will overexpose the highlights, resulting in bright white smears instead of smoothly gradated highlights. Skin tones will often go pale or wash out when they are shot with a less-capable flash system. A flash that is too bright will also cast harsh shadows across and behind your subject.

Look at the overall color tone of the image. Is there a color cast of some kind? If you're in a room with strong lights (usually incandescent, or tungsten, lights), your camera might choose to favor those lights when it white balances, resulting in an image with slightly blue highlights. If your image ends up with a slight yellow cast to its highlights, the camera probably favored the on-board flash when it was white balancing.

If your camera has a special manual white balance setting for use with a flash, be sure to switch to that setting and try a few shots. You might get better results.

## Body Design and Construction

You'll want to spend some time considering the body design and construction of your potential purchase. Poor design can make a camera's controls difficult to use, which can often cause you to miss shots. Wimpier construction can shorten the life of your camera.

Modern cameras can be made of any number of materials, from metal to carbon fiber to aluminum to plastic. (See Figure 5.29.) Obviously, sturdier materials are more durable (and usually feel better in terms of finish and heft), but even a predominantly plastic body can hold up well in rough conditions.

**FIGURE 5.29** Although small, this Sony DSC-T1 is a very sturdy, all-metal camera.

When you are assessing a camera, try to get a feel for the quality of its build. If you lightly squeeze it, does it creak or does it feel solid? A creaky camera might just get creakier—and possibly more fragile—as its screws and joints loosen. If the camera has a split body or flip-out LCD screen, try to get an idea of the durability of the swiveling mechanism. Will it hold up to normal use, or might it wear out?

Digital cameras can often have strange designs, so make sure that your camera sports a finish and moldings that make it comfortable to hold onto and difficult to drop. Finger moldings and rubberized components can make an otherwise odd shape comfortable to hold. If you're a nature photographer who spends a lot of time shooting in cold weather, you may want to consider how easy the camera is to operate with gloves, and whether or not it has water-resistant seals and seams. Smaller cameras can be particularly difficult to hold onto and use comfortably, so spend some time determining how comfortable the camera is to use with one or both hands, and make certain it includes a wrist strap.

Doors and port covers can be especially fragile components. Check the battery compartment door and media card door for durability and easy access. (See Figure 5.30.) You'll be using these mechanisms *a lot*, so make sure they can stand up to repeated use. In addition, make sure that you can get to them in a hurry if you need to, even when the camera is mounted on a tripod. Rubber or plastic port covers (such as what might go over a battery charging port or a USB port) are often the flimsiest part of a camera. Try to get a feeling for the weaknesses of these covers. Although you won't be able to improve them, they might at least last a bit longer if you are aware of how easily they can be broken off.

**FIGURE 5.30**    Pay attention to the doors and covers that a camera uses for its media, batteries, and ports. You'll be opening and closing these a lot, so make sure they're sturdy and durable.

Heft is often a concern for more serious photographers. A heavier camera, although a bit of a pain to lug around, is usually easier to shoot with, because extra weight makes for a more stable shot. If you're used to a film camera with a good deal of weight, you might want to look for the same thing in a digital camera.

Finally, try to get an idea as to how much of the camera's body and internal chassis are made of metal. As we'll see in Chapter 9, "Special Shooting," heat can greatly degrade image quality, and components such as LCD screens and large-capacity memory cards can produce a lot of heat. Metal substructures and chassis can serve to dissipate heat that might otherwise affect image quality.

### Status LCDs

Not to be confused with your camera's full-color viewfinder/playback LCD is the small status LCD that might be present on the top of the camera. Most modern digital cameras have such a screen for displaying current camera settings and the number of shots remaining.

Some cameras skip these displays and assume that you'll simply get this information from the viewfinder LCD. However, if you're in bright sunlight or if your batteries are running low, you might not want to activate your main LCD just to find out if your flash is turned on. Most important, having a permanent display of camera status makes for faster, more convenient shooting.

Figure 5.31 shows a typical, full-featured status LCD.

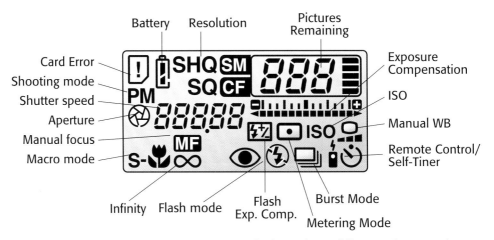

**FIGURE 5.31**   You'll want your camera's LCD status display to show a full range of status and setting information. When you're shooting on the go, you don't want to have to dig into the camera's menu system to check on a particular setting.

## Tripod Mount

This might seem like a superfluous item to bring up for discussion (rather like considering what bag you'll choose for carrying your camera), but a poor tripod mount can really ruin your entire day. Any experienced photographer will tell you that there is a difference between a good tripod mount and a bad one. The following features make for a good tripod mount:

**Metal construction:**  A tripod mount is a simple screw socket recessed into the bottom of the camera. (Some tripod mounts also include additional stabilizing holes.) If the screw socket is made of plastic, it can be very easy to strip out the screw threads by forcing the tripod in at the wrong angle. Even if you're always very careful, fragile plastic threads can wear out with repeated use. Look for a metal screw mount.

**Positioned along the lens axis:**  Ideally, you want a tripod mount that is positioned so that the camera will pan (rotate) around the axis of its focal plane. (See Figure 5.32.) Such a tripod is required for shooting panoramas.

**FIGURE 5.32**   Ideally, you want a tripod mount that lies on the same axis as the lens.

**Positioned so you can remove the batteries and media:**    Once you put a camera on a tripod for a shoot, you don't want to have to dismount it to change batteries or storage media. Make sure the battery and media doors are unblocked when the camera is tripod-mounted.

### Image Buffering

As you'll recall from Chapter 2, after a digital camera exposes its CCD, the image data is passed to a special on-board computer for processing. After it is interpolated for color, white balanced, sharpened, and de-noised (among other things), the data is compressed and then stored on the camera's storage device. All this processing can take a lot of time, which means that your camera can be too busy to take any more pictures.

Fortunately, most cameras now include special memory buffers (and sometimes separate processors) to handle the processing of an image, which frees up the camera to shoot again immediately. Ideally, you want an *image buffer* that can hold at least five or six full-resolution shots. Odds are that you won't be shooting more than that in quick succession, but if you are, you'll need to use a special "continuous" shooting mode.

### Continuous Shooting

Many cameras offer special modes for shooting a rapid series—or *burst*—of images. With speeds varying from a single frame to 5 to 6 frames per second, these features are ideal for shooting sports or fast-moving objects. But burst shooting is handy for more than just sports or nature photography. Shooting bursts of people is the best way to capture a particular moment or the best expression. By shooting a burst, you can grab a series of frames, and then pick the best one out of the bunch.

Referred to as *burst, continuous*, or *drive mode*, continuous shooting modes usually work just like an autowinder on a film camera. Just press the shutter button, hold it down, and the camera will shoot as quickly as it can. (See Figure 5.33.)

Note that some cameras can achieve their full burst speed only when they are shooting at a lower resolution. If you want full print quality from your burst images, make sure that your camera's continuous mode supports the full resolution of your camera. Note, too, that some cameras can shoot up to only a certain number of shots before they have to stop and flush the series of images out to storage. Be sure to investigate the maximum number of burst shots that can be taken at once.

**FIGURE 5.33**    If your camera has a drive mode, you can shoot a sequence of shots in rapid succession. Not all cameras support burst shooting at full resolution.

 *CONTINUOUS FLASH SHOTS*

*Most cameras can't use a flash when shooting in continuous mode, because there isn't enough time for the flash to recharge. However, some cameras can manage roughly one frame per second when shooting with the built-in flash. If you have a job that needs continuous flash shots, keep an eye out for this feature.*

## Movie Mode

Many digital cameras offer the ability to shoot movies, in either AVI, QuickTime, or MPEG format. Until recently, these movies were limited to

320 × 240 resolution and a maximum of 24 to 40 seconds. In addition, they were usually extremely compressed. Most cameras still limit their movie modes to these smaller sizes and durations, but more and more are offering quality that approaches that of a digital video camera.

Most movie modes work the same way: you simply press the shutter button and the camera begins recording; press it again and recording stops.

Because movies—even 320 × 240 movies—quickly generate a lot of data, most cameras can't shoot, compress, and store a movie on the fly. Therefore, most digital cameras record video by storing the video frames in the camera's internal memory buffer (the one that buffers full-resolution images to increase shooting speed). When the buffer is full, the movie is dumped to the camera's storage card. Consequently, the length of individual movies is determined by the size of the camera's internal buffer, not the size of the camera's storage media. However, as cameras get faster, more and more models are offering movie lengths limited only by the amount of storage on your card.

Note that it can take a while to flush the buffer out to the card—sometimes 30 or 40 seconds—so you can't just keep hitting the button after each movie to immediately start another one.

When you are assessing a camera's movie mode, you'll want to look at maximum frame size, maximum recording time, and quality of the compression. In addition, you'll want to find out if the camera can record sound, and whether the camera has a speaker for movie playback.

Finally, if you're looking at a camera that offers a full-resolution, high-quality movie mode, note that it might require a special high-speed memory card to record this higher-quality video.

### Black and White

Many digital cameras offer special black-and-white modes for shooting grayscale images. Because you can use your image-editing program to convert a color image to grayscale, and because a black-and-white image takes the same amount of storage space as a color image does, you might wonder why you would want to shoot in black and white? After all, isn't it better to shoot in color and have the *option* of black and white images later?

The advantage of a dedicated black-and-white mode is that the camera skips the color interpolation process that it would normally go through. In other words, instead of having to make up a bunch of data (as we saw in Chapter 2), a black-and-white image can use the full, un-interpolated resolution of your camera's CCD, which means your final images will be free from any demosaicing artifacts.

Some cameras such as the Canon EOS 20D go even farther with their black-and-white modes, offering built-in processing that mimics the

types of lens filters that film photographers have traditionally used to improve contrast in black-and-white photos.

### Self-Timers and Remote Controls

At some point, you've probably owned a film camera that had a self-timer on it. You know: you set the timer and then run as fast as you can to try to get in the shot and look natural in the five seconds or so that you have before the camera fires. Most digital cameras have the same type of feature.

Some cameras also offer a wireless remote control that provides zoom and shutter controls. (See Figure 5.34.) These remotes not only facilitate self-portraits but also serve as a shutter release for long-exposure images. If remote operation is important to you, consider the following:

- Make sure the range of the remote is long enough for your typical remote-shooting jobs.
- Ideally, you'll want to have an infrared sensor on both the front and back of your camera.
- If you will be using your camera to run slide shows (through its video out port), you'll want remote playback control and shooting control.
- Some remotes offer a time-lapse feature (sometimes referred to as an *intervalometer*), which will automatically take a shot at a given interval.
- Some remotes also offer a long-exposure timer that allows you to take longer exposures than you can manage with the camera alone. (In other words, these remotes provide a *bulb* mode to cameras that might not otherwise have them.)

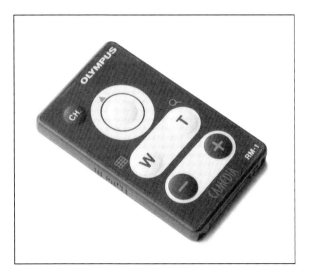

**FIGURE 5.34**   A wireless remote control lets you shoot hands-free, just as you would with a cable release on a film camera.

### Camera Timings—or, Is Your Camera Speedy Enough to Get the Shots You Want?

Great image quality doesn't do you any good if your camera is too slow to get the shots you need. Because a digital camera must do so much calculating and processing to create an image, it's easy for it to get bogged down in ways that film cameras can't. You'll *definitely* want to consider the speed and performance of a camera before you buy one. In addition to the speed of the menu system, be sure to consider and measure the following:

**Boot time:**   How long does it take the camera to boot up? Ideally, you'll want a camera that doesn't need more than three or four seconds of preparation from the time you switch it on—any more than this, and you might miss a shot. Check to see if the camera offers a low-power sleep mode, and test how long it takes the camera to wake up. Leaving your camera in sleep mode will help ensure that it's always ready to shoot, although sleep mode can drain your batteries. One of the downsides to cameras with an extending lens is that they take a while to boot up because they have to take the time to extend the lens. In addition, you might not feel comfortable walking around with the camera in sleep mode, because the lens will still be extended. However, if you shut down the camera to retract the lens, you'll be forced to wait through a boot cycle when you're ready to shoot again.

**Prefocus time:**   When you press your camera's shutter release halfway down, the camera will perform all of its autofocusing as well as its metering and white balancing. (We'll discuss this *prefocusing* step more in Chapter 7.) When you test a camera, try to get a sense of how quickly it can perform these prefocusing steps.

**Shutter lag:**   Some digital cameras have a noticeable lag between the time you press the shutter release and the time the camera actually takes a picture, even if you've already prefocused. If the *shutter lag* is long enough, you might miss that moment you were trying to capture. This is probably the most important performance characteristic to assess before you buy.

**Recycling:**   Be sure to check how long it takes the camera to *recycle* itself after you take a shot. Ideally, you'll want to be able to shoot again immediately. Most modern cameras can recycle right away by storing the previous image in a memory buffer. When the buffer is full, you'll have to wait for it to flush out to the storage card. Be sure to test the camera's performance both before and after the buffer has filled.

## Playback Options

You'll be spending a lot of time reviewing images using your camera's playback options, especially when you're in the field. Consequently, it's worth taking a little time to explore a camera's playback features. Are they easy to use? How quickly can you switch from record to playback mode?

In addition to general usability, look for the following features:

**A *thumbnail* view that lets you view multiple images on-screen at once:** This feature can greatly speed navigation of a large media card. (See Figure 5.35.)

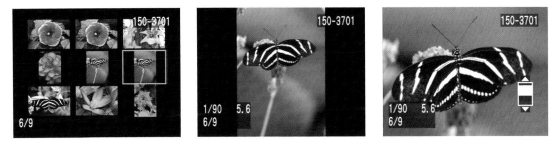

**FIGURE 5.35**  A thumbnail view lets you quickly see the contents of your media card. Some cameras also allow you to zoom in to an image and pan around it, making it easier to check focus and depth of field.

**Zoom features that let you zoom in on an image and pan around:** A good zoom feature can be a great way of ensuring that a shot was in focus. Most cameras include a number of preset zoom levels (2x, 4x, and so on) as well as the ability to zoom out to view multiple thumbnails. For panning about an image, a smooth pan is much better than a camera that restricts you to looking at specific "quadrants" of an image.

**The ability to zoom raw images:** If you expect that you'll regularly be shooting in raw mode, you might want to have a camera with the ability to zoom into raw images when in playback mode. Not all cameras allow this.

**Easy deletion and locking of features are a must:** In other words, you need a simple, quick interface for deleting single or multiple images. When you have to free up space on a card, you don't want to miss a shot because your camera's interface is too complex.

Some cameras also offer features that automatically rotate the image so that it's upright, whether you shot it vertically or horizontally. This

feature is of questionable advantage when using the camera's playback mode—after all, it's not too hard to simply tilt your camera. Most cameras store this rotation information with the picture. If your image editor or cataloging program can read it, it will automatically rotate your image.

Other cameras feature printing commands that let you print to special printers designed to work with your camera. Such features can turn your digital camera into a instant camera, but for serious work, you'll want more image-editing and printing control.

Finally, as you'll see in Chapter 8, *histograms* (computer-generated graphs of the distribution of tones in an image) can be a great exposure calculation aid. Many cameras can display a histogram of an image that you've already shot. (See Figure 5.36.)

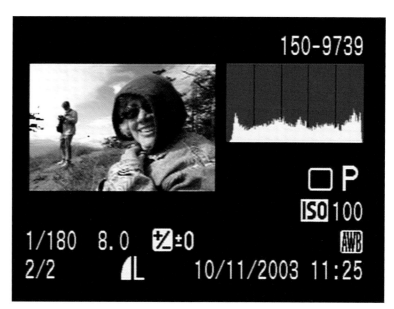

**FIGURE 5.36**    As you'll learn in Chapter 8, having a camera that can display a histogram is an invaluable aid for using your camera's manual exposure features.

This feature is valuable if you plan to use any manual exposure features.

## Storage and Input/Output

A digital camera isn't much good if you can't get your pictures out of it. Fortunately, most cameras come equipped with a number of interfaces for moving your pictures to another device.

### Transferring and Viewing Images

Today, almost all cameras come equipped with a USB connector of some kind, along with a cable to connect the camera's USB port to the standard USB port on your computer. USB is a good interface that makes for reasonably quick transfer of images. Some cameras also provide remote camera control through the USB port. If you need a computer-operated camera (either for time-lapse or other automated operations), be sure that your camera's software supports remote operation.

Note that smaller cameras often achieve their small size by leaving off the USB port. Instead, they provide a special dock in which you can place the camera. You then connect the dock to your computer. There's no penalty for this, performance-wise, but it is an extra piece of gear that you'll have to carry if you want image-transfer capability on the road.

FireWire® is a better alternative to USB, simply because it's a much faster interface. However, you'll find FireWire ports only on higher-end cameras, and even there it's somewhat rare. If you're concerned about transfer time, don't worry. There are plenty of ways to move images to your computer speedily.

### Transfer Software

Your camera will come bundled with software for transferring images to and from your camera. Some units come with a simple *TWAIN driver* that can be used from within your editing package, whereas others offer standalone applications that allow for *media cataloging*, simple editing, and printing. Many computer operating systems (such as Apple's OS X, and Windows XP) offer automatic image transfer through a system called Picture Transport Protocol. With these systems, any time you plug a camera into your computer, the OS automatically transfers all of the images in the camera to your hard drive.

Because transferring via cable can take a while (and drain your camera batteries in the process), and because you'll usually want more editing power than what is provided by most bundled software, you don't need to worry too much about the capabilities of a camera's software.

Nevertheless, the following elements make for a stand-out camera application:

- Drag-and-drop transfer of images to and from the camera
- Automatic panoramic stitching (This is not usually included in the main application itself, but in some bundled software.)

Of course, if your camera supports a raw data format, you'll want software that allows you to manipulate the raw data (unless you're using

Photoshop CS or Photoshop Elements 2, which have this functionality built in).

### Video Input/Output

Most cameras provide a special video output port that lets you connect your camera to a television to view your images. Although televisions don't provide nearly enough *dynamic range* to view your images in all their glory, they do seem to be everywhere, providing a convenient way to review images when you are traveling. A video connection can also provide a convenient way to present a slide show of images, and most cameras offer some type of automatic slide-show feature that allows you to step through all of the images on your camera.

Because not all countries use the same video standard, make sure you get a camera that supports the appropriate standard. Most cameras come in either NTSC or PAL versions.

## Storage

Film is a clever invention because it can both capture and store an image. An image sensor, on the other hand, can only capture an image. Consequently, once your camera is done *sampling* and processing an image, it needs a place to put it.

Today, most cameras use some form of *flash memory* card. These are small waferlike cards that house a type of RAM that doesn't require a constant stream of power (that is, it is *nonvolatile*). Therefore, after your camera has recorded an image, you can shut off the power without worrying about what has been stored on the memory card.

Flash memory cards (or just "flash cards") are a great solution to the digital camera storage problem. They're small, they can hold huge amounts of data (up to 4 GB in some cases), and they can be easily swapped with other cards, just like a roll of film.

With higher-capacity cards costing less and less, it can be tempting to invest in a single card with loads of space. Bear in mind, though, that a large card is something of an "all of your eggs in one basket" situation. If that card crashes, you lose everything. As such, you might consider investing, for example, in two 128-MB cards rather than a single 512-MB card.

### How Much Do You Need?

How much storage you need depends largely on your shooting conditions, how many pictures you typically take, how big your camera's

images are, and what level of compression you're using. Obviously, if you're shooting in a computer-equipped studio, storage is less of a concern because you can dump your pictures to disk as you shoot. Similarly, if you're in the field with your laptop, you'll be able to clear your camera's storage as it fills. However, if you're planning a three-month trip through the Amazon (or even a three-hour trip to the zoo, and you tend to be shutter-happy), storage might be a bit of a concern.

If you're like most people, when you shoot film you probably take 36 exposures and get back three or four shots that you like—maybe. Digital cameras are no different. For every 40 or so images that you shoot, you'll maybe want to keep a third of them. However, with a digital camera, you don't have to wait until you've shot all 40 before you decide which ones you want to keep. Rather, you can delete the bad pictures as soon as you've taken them. Consequently, digital camera storage goes a little further than an equivalent number of film exposures because you'll be more selective along the way.

Unfortunately, experience is the only way to find out what your storage needs are. It's safe to assume that on a typical 2- or 3-megapixel camera, a 32-MB card will get you two dozen high-quality images. Start with this estimate and try to get an idea for what this translates into in terms of "keeper" images. Then, make sure you have an appropriate amount of storage before embarking on an important shoot.

Currently, there are several major competing flash memory standards. When evaluating a camera, you'll want to take note of which type of card the camera uses. For the most part, there's little practical difference between these formats, but some are more popular than others, and that usually translates into cheaper prices.

### CompactFlash

Developed by SanDisk®, *CompactFlash*™ cards are durable and currently come in capacities up to 2 GB. (See Figure 5.37.) CompactFlash cards are currently the most popular storage card format, which is good for the end user because it means cheaper media prices. In addition, CompactFlash cards come in higher capacities than any other format.

Although CompactFlash cards are durable, they are thin enough that you don't have to apply much pressure to snap one in two. Nevertheless, normal use (including the occasional drop) seems to have no effect on the cards. In addition, many vendors offer lifetime guarantees.

Some vendors tout their cards as being faster than other vendors' cards and, in tests, this can be proven to be true. However, in everyday use, you might not be able to feel a difference between one type of card

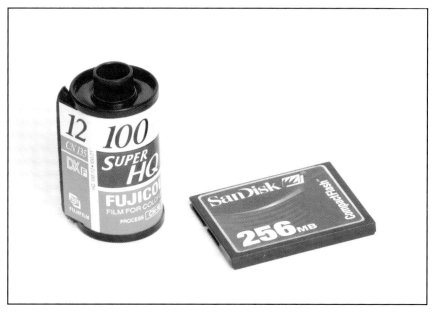

**FIGURE 5.37** Because they're used in more cameras than other formats, CompactFlash cards currently provide the highest capacities and best price per megabyte of any flash media.

and another. They all seem much faster than using film and much slower than the instantaneous times that we'd all love to see from our computers.

CompactFlash cards come in two sizes:

- Type I CompactFlash cards are the standard-size cards used in most cameras.
- Type II CompactFlash cards are twice as thick as Type I cards, meaning they can hold twice as much memory. The IBM® *MicroDrives*™ are tiny hard drives shoved into Type II CompactFlash cases. With capacities up to 4 GB, these are seemingly the ideal storage solution. However, there are some MicroDrive caveats: because they use a physical mechanism—a tiny hard drive—they are, in theory, more prone to data loss than a solid-state memory card. MicroDrives also tend to produce a lot of heat. Consequently, in addition to having a Type II CompactFlash slot, a camera needs to be designed to manage the extra heat produced by a MicroDrive. MicroDrives also use more battery power than flash memory cards do, so your battery might drain faster. They're also much slower than a flash memory card. This will probably be most noticeable when waking up your camera from sleep. With a MicroDrive, your camera will take much more time to prepare for a shot than with a memory card.

Most CompactFlash vendors label their cards with some type of speed claim—16x, 24x, and so forth. Unfortunately, vendors have never agreed on what, exactly, 1x is, so it's difficult to say to what these speed claims really equate. Also note that read and write times are often more dependent on the camera than on the storage card, so a particular card might be speedier or slower in one device than it will be in another.

### SIZE DOES MATTER

*Although vendors usually measure their flash cards in terms of megabytes, many vendors define a megabyte as being 1,000,000 bytes. Your computer, on the other hand, defines a megabyte as being 1,048,576 bytes. Therefore, when you stick a flash card in your computer, it might display a slightly smaller capacity than what you were expecting.*

### Memory Stick

A proprietary format developed by Sony for use in their digital cameras, camcorders, and MP3 players, the *Memory Stick*™ is a small, rectangular flash card with shielded contacts on one end. No better or worse than any of the other formats, the main drawback to Memory Sticks is that the technology is completely controlled by Sony. (Just think "Beta videotape" and you'll understand why this is a problem.) Consequently, without third-party development, Memory Stick capacities usually lag behind other technologies in terms of maximum storage capacity and price.

Many smaller cameras use the new Memory Stick Duo™ format, a half-size version of the memory stick that can work with normal memory stick devices through the use of a special adapter. (See Figure 5.38.)

In addition, Sony sells another variant of both Memory Sticks, the Memory Stick Pro format. Higher-priced, these cards offer faster throughput that enables storage of high-quality MPEG-compressed video.

### SmartMedia

Even thinner than a CompactFlash card, *SmartMedia*™ *cards* are barely thicker than a piece of paper. Between their size and their exposed plane of electrical contacts, SmartMedia cards feel very fragile. However, in regular use, they don't seem to be any less durable than a CompactFlash card.

The main downside to SmartMedia technology is that the controller circuitry is not included in the card; it must be built into the camera. Consequently, if a company comes up with some breakthrough that allows for twice as much storage on a SmartMedia card, you won't be able to use

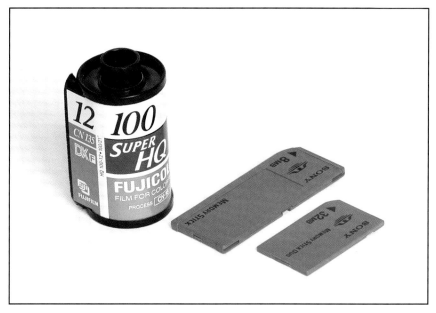

**FIGURE 5.38**   Though priced competitively with other formats, Memory Sticks are still somewhat limited in size. Sony makes two formats of Memory Stick, regular (the larger card) and Memory Stick Duo. Both are available in more expensive Pro versions, which provide faster transfer rates.

those new cards in your older camera. Many vendors provide upgrades to their SmartMedia-based cameras, but these upgrades require sending your camera back to the factory to have it altered, a time-consuming process that most people are hesitant to do.

SmartMedia currently has a much lower maximum capacity than CompactFlash (at the time of this writing, SmartMedia has a maximum of 128 MB), although their prices are competitive.

SmartMedia cards (Figure 5.39) come in two variations: 3.3v and 5v cards. The variants are not interchangeable, and you can tell which is which by looking at the corners of your card. It is possible to incorrectly insert a card, but this doesn't seem to damage the card or camera.

### XD Picture Cards

Rapidly gaining on CompactFlash in terms of popularity, *XD Picture Cards*™ are physically smaller than CompactFlash and currently offer capacities up to 512 MB. (See Figure 5.39.) At the time of this writing, XD cards are much more expensive than CompactFlash cards (or even Memory Sticks) for an equivalent amount of storage. As more vendors adopt the format, expect prices to fall a little.

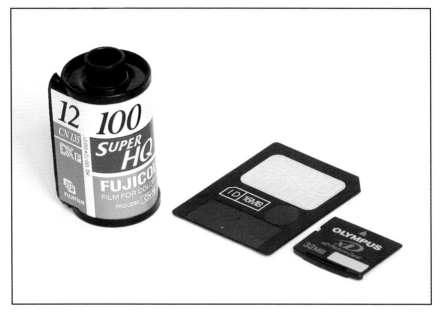

**FIGURE 5.39**    Although SmartMedia's popularity (the larger card shown here) is on the wane, XD Picture Card is rapidly gaining favor, particularly for use in very small cameras.

### MMC and SD Cards

MMC (MultiMediaCard) and SD (SecureDigital cards) are not widely used yet in digital cameras, though you'll find them a lot in cell phone–based cameras and in MP3 players and PDAs. Consequently, capacities and prices are rapidly improving, which could cause more vendors to adopt these formats.

### Does Any of This Matter?

Although there are people who will make arguments for one format over another, there's really not much difference. They are all equally reliable, equally speedy, and (mostly) equivalently priced. CompactFlash is the most popular of the three and, consequently, might have the greatest longevity. Nevertheless, you won't want to base your buying decision on media format.

### Media Tips

There are a few things you should know about removable media. Obviously, these cards are fragile, so treat them with care. Also consider the following issues:

- The number of images a card can hold depends on the resolution and compression settings with which you're currently shooting. These vary greatly from camera to camera, so you'll need to consult the camera's manual to find these statistics.
- The bigger the card's capacity, the more power it takes to keep it running. Consequently, in theory, smaller cards use less battery. Although it's difficult to tell if this has any bearing in the real world, switching to a smaller-capacity card when your batteries run low might garner you a few extra shots.
- Larger-capacity cards generate more heat. If you're using a tiny camera, which tends to get hot simply because of its design, it might be worth sticking to smaller-capacity cards. As you'll see later, excess heat can make your images noisier.
- If something goes wrong with a larger-capacity card, you'll lose more images than you would if you had been using a smaller-capacity card. Therefore, it might be worth buying a number of smaller cards instead of one big one.
- X-rays don't seem to matter, so feel free to take your camera with you to the airport, dentist, or thoracic surgeon.

## MEDIA DRIVES

The best way to transfer images to your computer is through a drive that supports the same media that your camera uses. These devices work just like any other drive on your computer: insert your media card into the drive, and it will show up on your desktop. You can then copy files to and from the card. Priced anywhere from $25 to $70, these drives are the fastest and easiest way to transfer images to your computer, and they don't require you to drain your camera batteries. (See Figure 6.7.) Media drives are available for all popular media formats and come with either USB or FireWire connections. FireWire drives are usually faster, though final speed is usually dependent upon the speed of your memory card.

If you have a laptop computer with a PC card slot, you might consider getting a PC card adapter for your camera's media. These are special PC cards into which you insert your camera's media. Put the card into your laptop's PC slot, and the storage media will appear on your desktop like any other drive. (See Figure 6.2.)

## WHAT'S IN THE BOX?

When you buy a camera, you'll want to consider everything you're getting for your money, so take some time to assess what else is bundled with your camera. (See Figure 5.40.)

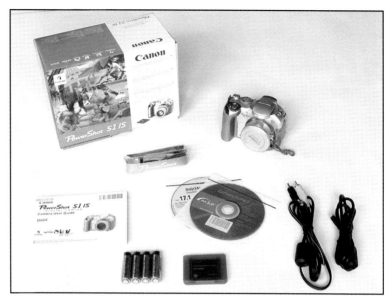

**FIGURE 5.40**   Ideally, you want a camera package that includes these components.

Don't expect to get a huge media card with your camera. Most vendors ship 8-MB cards with their 1- and 2-megapixel cameras, and 16-MB or 32-MB cards with their 3- to 6-megapixel cameras. If these seem small, that's because they are. Unfortunately, because of the economies of scale, adding a bigger card would usually raise the price of the camera by more than it would cost you to buy a bigger card on your own. Therefore, you should plan to buy some additional media along with your camera.

## Batteries

What with the image sensor, the LCD screen, the media drive, the flash, and the motorized zoom lens, the typical digital camera demands a *lot* of power. Your camera will use one of two different battery systems: a proprietary (custom) battery or batteries of standard size (usually AA).

**Proprietary batteries:**   More and more vendors are using special proprietary (custom) battery packs in their cameras. The advantage to these is that they usually provide extremely long life and include special controllers that can provide accurate charge estimates (Sony InfoLithium™ batteries are particularly accurate in their estimation of remaining charge), as well as special power-saving operations. What's more, these batteries tend to be smaller and lighter than an

equivalent amount of AA or AAA batteries. On the downside, custom batteries require custom chargers, so if your battery dies in the field, you can't just run down to the corner store and buy another. Of course, you can protect yourself against this eventuality by buying an extra battery for your camera. Note that there are now many third-party battery options available for most popular digital cameras. These batteries usually offer equivalent performance and longevity at a *substantially* lower price. Even if you're wary of the quality of these batteries, they're usually so cheap that it's worth buying one just to try it out.

**Standard-size rechargeable batteries:**  Offering the same battery technology as a proprietary battery, standard-size rechargeable batteries offer much longer life than normal, nonrechargeable alkaline batteries, as well as the advantage of universality. As better battery technology comes along (as long as it comes along in the same size), you can drop these batteries into your camera. Standard-size rechargeables are much cheaper than proprietary designs, are readily available, and in a pinch can always be replaced by alkaline batteries. (See Figure 5.41.)

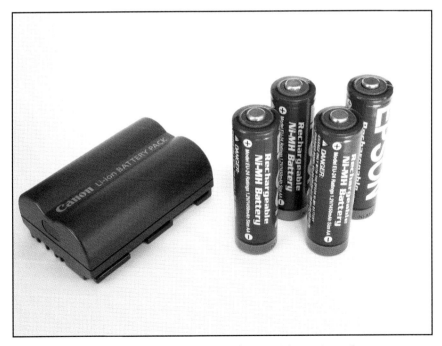

**FIGURE 5.41**    Rechargeable batteries come in either special proprietary formats or standard AA sizes.

In addition to sizes, there are a number of different battery technologies available.

**Alkaline batteries:** Alkaline batteries are really not good for much when it comes to a digital camera. In some cases, you'll be hard-pressed to get half a dozen shots out of a set of alkalines before they are too weak to be used. Digital cameras have very specific power requirements, and as soon as a set of alkalines drops below those levels, the camera will register them as dead. You can usually continue to use them for a while in a lower-power device such as a radio or tape player. In general, use alkalines only when you absolutely have to. The cost, waste, and environmental impact just isn't worth it.

**NiCAD (Nickel Cadmium) batteries:**   *NiCAD batteries* were, until recently, the most popular rechargeable technology. NiCADs don't deliver a lot of power, though, and they need to be drained completely before you recharge them or they will develop a "memory" that will prevent them from being completely recharged.

**NiMH (Nickel-Metal-Hydride) batteries:**   *NiMH batteries* are relatively inexpensive (usually $25 to $30 for a set of four, plus another $15 or $25 for a charger), powerful, quick to recharge, and lack a memory. In addition, NiMH batteries are more environmentally friendly than either NiCADs or alkalines. NiMH batteries are the ideal choice for the digital camera owner. In fact, buy a few sets—one for your camera, an extra set to go in your pocket, and a set to go in your recharger.

**L-Ion (Lithium Ion) batteries:**   *L-Ion batteries* are also a good choice, although not as prevalent, and they are sometimes more expensive. You can often find chargers that will charge both NiMH and L-Ion batteries.

**Lithium batteries:**   Lithium batteries are not rechargeable but offer a lot of power for a long time. Roughly the shape of two AA-size batteries stuck together, you'll need to be sure your camera can use Lithium batteries. Although strong and long lasting, they're still disposable and are usually rather pricey.

When you shop for a recharger, you might want to consider the strength of the charger. Some chargers can recharge faster than others—in some cases, as fast as 15 or 20 minutes. In general, any recharger will probably serve you just fine. If you plan to travel to other countries, look for a recharger that can work with a range of input voltages. We'll discuss battery use, management, and performance in more detail in Chapter 7.

*SOLAR RECHARGER*

*If you want to take your digital camera camping, hiking, or boating, you might consider buying a solar-powered battery charge. A solar recharger is able to recharge a set of four AA-size batteries in 12 hours of direct sunlight exposure and can solve most of your power requirements when you're literally "in the field."*

## SPECIAL FEATURES

On top of the many features we just discussed, many vendors pack their cameras with special, unique features that can be a boon or a burden to the digital photographer. With their on-board computers and automatic functions, digital cameras can perform many tricks that film cameras can't. Listed next are some unique features that you might encounter in your camera shopping. Some of these features are great; others are rather silly.

**Time-lapse:** Unfortunately, only a few cameras offer a time-lapse feature that lets you program the camera to automatically shoot a picture at a predefined interval. A good time-lapse feature will let you specify an interval ranging from a few seconds to a few days. For documenting slow processes, creating animations, or producing high-quality time-lapse video, a time-lapse feature is essential. Some cameras provide time-lapse features (sometimes called an *intervalometer*) through an external remote control.

**Remote computer control:** Some cameras include software that lets you control your camera from your computer via the same serial or USB link that the camera uses to download images. If you need to take pictures in harsh, industrial conditions, or want to leave your camera unattended, this feature might be the answer.

**Auto-bracketing:** As we'll see in Chapter 8, *bracketing* is the process of shooting the same image with slightly different exposure settings to help ensure that you get a good shot. Many cameras now feature an *auto-bracketing* feature that will automatically shoot four or five images with slightly different exposures each time you press the shutter release.

**White-balance bracketing:** Similar to exposure bracketing, white-balance bracketing automatically shoots a series of frames with slightly altered white balance in each shot. For tricky lighting situations where you're unsure of what proper white balance should be, this feature can help you get the right color. However, it's not a deal-breaking feature that you absolutely have to have.

**Focus bracketing:**    This feature does the same thing as exposure or white-balance bracketing, but alters the focus slightly in each shot. To be honest, this is kind of a silly feature. It's probably most useful if you do a lot of macro photography, a situation where proper focus can often be difficult.

**Voice annotation:**    Although the ability to record and store small voice annotations (comments) with each image is not a tremendously useful feature, some applications—real estate photography, for example—can benefit from it. Remember that it will use up storage on your media card, so you'll want to buy more storage or shoot at a lower-quality level (or both).

**Best-shot selection:**    Some of Nikon's digital cameras include a unique "best-shot selector" that automatically shoots a series of images when you press the shutter button, analyzes them to determine which one is best, saves that one, and throws out the rest. This feature is best used in tricky macro situations where it can be difficult to hold the camera steady enough to get a clear shot. (Best-shot selection seems to work by simply selecting the largest file as the best. Because the sharpest image will compress the least, the file with the largest size is most likely the sharpest.)

**In-camera effects:**    Many cameras offer special effects features that can automatically *solarize*, tint, or turn your images into negatives. These are, of course, all tasks that can be performed on your computer with a great deal more control. It's almost always better to skip these features and shoot the cleanest, best-looking image you can.

**Neutral Density Filter:**    A neutral density (ND) filter is normally a physical filter that you attach to a camera's lens. It cuts the intensity of the light entering the lens without altering the light's color. ND filters can be useful for bright situations where you'd like to have a little more aperture or shutter-speed latitude. Some cameras now include an internal ND filter that can be activated automatically or manually. Though somewhat rare, it can be a handy feature.

**Noise reduction:**    Some cameras include special noise reduction modes that kick in automatically during longer exposures. Such schemes can often greatly improve the quality of low-light shots.

**Pixel mapping:**    It is possible for a pixel on your camera's image sensor to die or "get stuck." Some cameras now feature *pixel mapping* features that will cause the camera to analyze its image sensor and map out any dead pixels. The camera will then interpolate the missing pixels when it produces the final image.

**User sets:**    User sets allow you to define different combinations of features that can be quickly accessed by simply changing feature sets.

For example, you might define a particular configuration for indoor flash photography and another for outdoor manual exposures.

**Automatic image rotation:**    Some cameras are able to detect whether you're holding the camera in *portrait* or *landscape* orientation (that is, vertically or horizontally) and can mark the image as being rotated or not. When you play back the image on the camera, it will be automatically rotated. Having the image rotated on the camera is actually not that useful, because it's easy enough to rotate the camera. However, if you use an image editor that can read image rotation information, the image will be automatically rotated when you open it.

**Custom tone curves:**    In Chapter 2, you learned that before your camera saves an image, it applies a mathematical curve to the data in your image to correct for the fact that your camera records data in a linear fashion. Some higher-end cameras let you manually create custom tone curves that can be downloaded to the camera, giving you precise control over the camera's contrast and color response. Presently, this is a feature that's found only on very high-end professional digital SLRs.

## WHAT SHOULD I BUY?

As you've seen, choosing a digital camera involves balancing and compromising on a number of different features and technical considerations. If you've followed the procedure outlined throughout this chapter, you should have made the following decisions, in this order:

- What resolution do you need?
- How much exposure control do you need? Fully automatic? Or a mix of automatic and manual controls?
- What type of camera are you looking for? Tiny pocketable camera? Mid-sized point-and-shoot? Pro-level SLR?
- What features do you need?

Each of these steps should further reduce the field of possibilities, making your buying options simpler as you make each decision. These are some of the baseline features and capabilities that you should look for:

- Resolution that's appropriate for your intended output medium. Although it's simple to follow the "more is better" approach when choosing a resolution, this isn't always the case. If you're not sure about the resolution needs of your intended output medium, see Chapter 15, "Output."

# 6  BUILDING A WORKSTATION

**In This Chapter**

- Choosing an Operating System
- Building Your System
- Software
- Accessories

Ask any experienced film photographer and he or she will tell you that shooting the picture is only half the work of taking a photograph. The other half occurs in the darkroom where you exercise precise control over developing and printing techniques to achieve the results you imagined when you were shooting. Digital photography is no different—but, of course, there's no darkroom involved. Whereas film photographers rely on rooms full of enlargers, plumbing, and photographic chemicals, the digital photographer needs a decent computer, a lot of storage, some image-processing software, and a printer.

In this chapter, we'll explore the issues and questions you need to resolve when you construct a workstation for processing your digital images. Although we discuss computer hardware and image-editing software in this chapter, printers and other output devices will be covered separately in Chapter 15, "Output."

Your first step in assembling a workstation is one you might have already taken: select an operating system.

## CHOOSING AN OPERATING SYSTEM

If you're interested in digital photography, you probably already own a computer and so have already chosen an operating system (OS). If you haven't, or if you're thinking of upgrading, or if you simply don't like your operating system, then it's time to make a choice. Because the OS you choose will affect all your other buying decisions, it's the first issue to consider.

As far as digital photography is concerned, OS choice is really a matter of preference. Whether you choose a Macintosh or Windows computer, you'll get pretty much the same capability and spend about the same amount of money. The main differences between them are in their interfaces, but a discussion of the strengths and weakness of each system is far beyond the scope of this book. Rather, this chapter will simply cover the issues that are relevant to digital photographers.

### Macintosh

The Macintosh is where mainstream digital image editing began. Photoshop and its first competitors were originally written for the Mac OS between 1988 and 1990, providing Apple® and its developers with 15 years to tweak and refine their image-processing capabilities. As a result, the Mac OS has a slight advantage over Windows in some areas. Apple's

*color-matching software*, ColorSync®, is several years ahead of its Windows competition and is supported by a huge range of vendors, from software developers to scanner and printer manufacturers. However, it takes a little work to use color-matching software. If you don't really think you'll bother with the necessary practices (see Chapter 10, "Preparing Your Images for Editing"), ColorSync doesn't really matter.

On the hardware side, Apple's thorough integration of FireWire and USB into all of their latest hardware makes for systems—both desktops and laptops—that are well prepared for connecting to digital cameras. OS X can automatically recognize and download images from just about any camera you plug into it. What's more, every Mac comes preinstalled with iPhoto™, a free, very capable image-cataloging and printing application with an exceptional interface. In addition, all Macs include built-in video hardware that allows for *video LUT animation*—a feature that greatly eases many image-editing tasks. (See the section "Monitors" later in this chapter.)

### Windows

The main advantage of Windows over the Mac OS is that it is ubiquitous. Consequently, you probably won't ever have trouble finding a service bureau that can handle your Windows-based files. Similarly, repair shops and new equipment are often easier to find and less expensive because the Windows realm is more competitive.

The main disadvantage to a Windows-based computer is that it is more difficult to maintain. With more complicated hardware and software setups, you might spend a lot more time fidgeting with your computer than working with your images. However, like OS X, Windows XP includes automatic image-downloading features that will take care of moving your pictures onto your computer whenever you plug in a camera or insert a media card.

For the type of work covered in this book, your only real concern is the capability to run a capable image-editing program, so either a Mac or a Windows computer should work just fine for your digital darkroom forays.

## BUILDING YOUR SYSTEM

Once you've chosen an OS, you're ready to select a computer. Your hardware concerns are mostly the same no matter which OS you use. When you select a computer, you'll want to pay particular attention to the following items:

- RAM
- Processor speed
- Storage
- Monitors
- Input/output options

Of course, you'll probably be using your computer for more than just processing images, so if you have other concerns (perhaps you'll also be using it for editing video, making music, and checking e-mail), you'll need to factor in the particular requirements of those tasks as well.

## RAM

Although a fast processor is essential for good image-editing performance, of greater concern is the amount of random access memory (RAM) in your computer. High-resolution digital photos can be very memory hungry, and if you start performing complex effects, your memory needs will go even higher. As such, the amount of RAM installed in your computer will have a huge effect on image-editing performance.

For editing images in Photoshop, Adobe recommends a RAM size equal to two to three times the size of your typical image. Although your image might be only 4 MB, your RAM requirements can actually be much higher once you start using some of the more memory-hungry features in Photoshop, such as layers, complex filters, or the History palette. For maximum performance, you'll want a RAM level closer to 20 times the size of your image. In addition, remember that your OS and other applications will also need some memory, so don't base your RAM needs on Photoshop alone.

In the end, if you're on a budget, you might want to consider paying for a slightly slower, less-expensive processor and putting the money you save into more RAM. (See Figure 6.1.)

Fortunately, RAM is cheap, so you should be able to easily outfit your computer with 512 MB of RAM, or higher. Of course, you can always add more RAM later, if you find out that your current memory capacity is too low.

## Processor Speed

These days, even the slowest processors are fast enough for most image-editing work. If you're in a high-pressure production environment where you need to crank out images in a hurry, it's worth investing a little more for a faster CPU. For most tasks, however, you can get by with a fairly average (by today's standards) processor.

**FIGURE 6.1**    If Photoshop's Efficiency meter drops below 100 percent, you know that it can no longer keep all of its image data in RAM. Less than 100 percent efficiency means it is spooling information to disk, which leads to slower performance. Keeping an eye on the Efficiency gauge is a good way to determine if your system could use more RAM.

The good news is that even machines in the 500 to 700 MHz class (whether PowerPC or Pentium) are fine for image editing. With the bottom end of the computer market clocking in at around 1.5 GHz, pretty much any new computer that you buy is going to be more than powerful enough for your image-editing needs.

### Storage

The bad news is that digital images can take up a lot of space. The good news is that hard disk storage is really cheap. Simply put, the more storage you have, the better. Bear in mind that you'll need space for your OS, your image-editing applications, and any other software you plan on using, and that's all *before* you've shot any pictures. A 40- to 80-GB drive will keep you editing for a long time.

You'll also want some type of storage for backing up and for transporting images to service bureaus. Recordable CDs offer the best price per megabyte, and almost every computer has a CD-ROM drive. Additional external hard drives are also a good option. External FireWire and USB drives are small, hot-swappable (meaning they can be plugged and unplugged without restarting the computer), and score over recordable CDs because they are rewritable.

### CDR OR CDRW

*Some recordable CD drives can also create rewritable discs using special, more expensive rewritable media. CDRWs are great for storing copies of work in progress. Backing up in-progress works to a reusable CDRW while you're working and then to a normal CD when you're finished is a great way to prevent the confusion of having multiple versions of a work-in-progress.*

## Monitors

You're going to be spending a lot of time staring at your computer screen so it's important to choose wisely when you select a monitor. In addition to the usual questions of brightness, sharpness, and contrast, as a digital photographer you should be particularly choosy about color reproduction. How picky you should be depends largely on the final destination of your photos.

If you're shooting for the Web, color fidelity is less of a concern because there is no *color calibration* system for the Web. That is, even though you might have the color set perfectly on your screen, there's no telling what the image will look like on someone else's monitor. Therefore, simply choose a monitor that looks good to you and is comfortable to use.

If print is your final destination, get ready to spend some additional money. For serious print work (that is, commercial press–ready print work), you're going to want a high-quality monitor that can be hardware calibrated. (We'll discuss hardware calibration more in Chapter 10.) Typically, a print-quality monitor is going to start at $399 and go up from there.

Of course, you'll need a video card to feed a signal to your monitor. If your computer doesn't already have a video card, you'll want to consider the following when you shop:

**What resolutions does it support?**   For most image-editing work, you want to be sure you're using a video card that supports 1024 × 768 pixels. Because of the palette-heavy interfaces of most image-editing programs, a screen with a resolution less than 1024 × 786 can feel uncomfortably cramped. Higher resolution is fine, but it takes a

good monitor to display a very high-resolution image with no visible distortion.

**What color depth does it support?**    Or, how much *video RAM (VRAM)* does it have? The number of colors that a video card can simultaneously display is known as its *color depth*. Color depth is also referred to as *bit depth* because more bits per pixel means more simultaneous colors. The amount of video RAM installed on the card determines both the color depth and resolution that the card can display. Make sure that your card can support millions of colors (or *24-bit color*) at your desired resolution.

**Does it provide any acceleration?**    Some video cards include special co-processors for accelerating both two-dimensional (2D) and three-dimensional (3D) performance. 2D acceleration means that scrolling and screen redrawing will be much faster; 3D acceleration will greatly improve your computer's performance when you're working in a 3D modeling and animation package.

**Can it perform video LUT animation?**    A look-up table, or LUT, is the full index of colors that a monitor can display. By changing the contents of the LUT, it's possible to immediately change the contents of the screen. Animating the LUT is a quick and easy way for a program to show changes on-screen. If your video card supports video LUT animation, many color-correction and editing tasks in Photoshop will be much easier because the program will be able to manipulate the LUT to display color corrections in real-time.

When you shop for a monitor, you'll want to try to assess the monitor's image quality. First, look for overall color quality and sharpness. Check the edges of the screen for any convergence troubles (slight red, green, or blue fringing around pixels) and for distortion problems—slight bulging or pinching of the image. In addition, you'll need to consider the following issues:

**Size:**    The physical area of your screen is largely a subjective choice. Do you prefer squinting at a smaller image on a 15" monitor, or bathing in the radiation of a 22" monitor? Whatever size fits your ocular preference and desktop space is the size that's right for you.

**Frequency:**    The refresh rate—the frequency with which a monitor's screen is redrawn—is measured in hertz (Hz). The higher the number, the more frequently the screen refreshes. The more frequent the refresh, the less flicker a screen will have. Ideally, you want a screen that supports multiple frequencies and different resolutions. Higher frequency is better.

**Curvature:**    The front of a monitor usually has a slight curve to it. If you're willing to pay more money, you can get a monitor with less curve, or even one that's totally flat. Less curve means less distortion at the edges of your image.

### LCD Monitors

If desk space is a concern, or if you're not thrilled about the potential health effects of sitting in front of a cathode ray tube (CRT), an LCD monitor might be a good choice for you. Just a few years ago, there was no point in even considering an LCD for serious photography work, because the image quality simply wasn't good enough. LCD technology has greatly improved, however, and an LCD monitor is now a viable option for the serious digital photographer and image editor.

However, be warned that LCD monitors often don't offer *contrast ratios* that are as good as what you'll find on a CRT. Lighter shades, for example, will often appear completely white on an LCD, making it difficult to judge the true color balance of an image. As with any monitor, over time you'll probably come to understand how the image you see on your LCD screen will actually look when it is printed. In the meantime, expect to do a lot of printing and adjusting and reprinting to get the colors and contrast ratios that you're looking for.

When you use an LCD screen, be aware that the brightness and contrast of most screens change depending on your viewing angle. If you're using a big enough screen, you can be tricked into thinking that the edge of the screen is darker than it really is. When you consider an LCD, try moving from side to side and up and down in front of the screen to see how the brightness and contrast varies over the surface of the image. (Yes, people will look at you funny, but given the price of the typical LCD monitor, it will be worth the humiliation.)

---

**WHAT ABOUT A LAPTOP?**

The ideal computer choice for a digital photographer is a good, high-powered laptop. Because it is portable, a laptop computer allows you to edit, retouch, and print your images anywhere, and makes for a great mass storage device for those extended digital photography expeditions.

For the most part, choosing a laptop computer involves all of the same processor, RAM, and storage considerations as choosing a desktop.

In addition to the performance concerns discussed previously, you'll want to look for the following features:

- **A very good screen.** Follow the same guidelines listed in the previous section for assessing the quality of a laptop's screen. As with a desktop computer, you'll want a resolution of at least 1024 x 768.
- **A video out port.** The ideal laptop setup is to use your laptop LCD screen in the field, and a high-quality monitor when you're back home. At the very least, a video out port will allow you to take your computer to a service bureau and connect to a monitor there for final proofing. Using a two-monitor system (the laptop's LCD screen and an additional external monitor) can also make your virtual workspace more comfortable. You can, for example, keep all of your image editor's tool palettes on your laptop's LCD screen and your image on your CRT.
- **USB, FireWire, or serial ports.** Be sure to get a computer that provides the type of port that your camera uses. Currently, most cameras connect through a USB port, some higher-end cameras use FireWire, but most older cameras use a normal serial connection.
- **A PC card slot.** A PC card slot provides a simple, quick way to transfer images to your computer. Using an adapter such as the one shown in Figure 6.2, you can simply insert the media from your camera directly into your laptop. The media will show up on your desktop just as a floppy disk or CD would. You can then drag and drop files from the card to your computer's hard drive. PC card adapters are currently available for all removable formats.

Finally, you'll want to consider size and weight when you shop for a laptop. Remember that you're already going to be carrying a bag of camera gear, so you don't want to weigh yourself down even more with a computer that's too heavy.

**FIGURE 6.2**   With a PC card adapter, you can insert your camera's media directly into your laptop.

## SOFTWARE

When it comes to editing, correcting, manipulating, and adjusting your digital images, you'll probably spend most of your time in a single image-editing application. However, there might be times when you also move your images into special programs designed for panoramic stitching, animation, video production, or compression.

### Image-Editing Applications

In case you haven't noticed already, this book was written by a Photoshop devotee. Yes, there are other good image-editing applications out there, and yes, some of them have features that Photoshop needs. In the end, though, the combination of features, interface, third-party and user support, and Photoshop's excellent color fidelity and printer support make it difficult to recommend anything else.

Beginning users might find Photoshop ($599) complicated because it is a feature-rich, powerful program. However, with just a little bit of explanation, even novice users can quickly learn the Photoshop basics. In this book, all examples and tutorials are Photoshop-based, and Mac and Windows demo versions are included on the companion CD-ROM.

*ON THE CD*

Photoshop Elements is a less expensive ($99), stripped-down version of Photoshop that offers all of the functionality that most users will ever need. Photoshop Elements uses an interface similar to Photoshop CS's interface, so you get all of the advantages of Photoshop's excellent interface design, as well as most of the higher-end package's most important features and performance characteristics. What you *don't* get are some important tools that you may or may not need. For example, Elements lacks the capability to work with CMYK images—the type of images you need to create if you're going to output to a professional offset press. You cannot use Elements to edit and view individual color channels. As you'll see later, this can be important, because channel editing is a necessary feature for creating certain types of effects. Elements does not have a Curves control, but if you shoot raw images, your raw conversion software might offer Curves controls of its own. Finally, Elements does not include some of Photoshop CS's more advanced editing tools such as the Healing Brush and Patch tools, high-end masking tools, and automation capabilities.

In general, Elements is probably enough power for most of your image-processing needs. Whether it's right for you should become more apparent as you learn more about the techniques and theories presented in Chapters 10 through 15. Some of the tricks shown in later chapters are

not possible in Elements, but it's still a great way to get into Photoshop. If you need more power later, you can always upgrade to the full version, which shares most of the Elements interface. (See Figure 6.3.)

**FIGURE 6.3**    Photoshop Elements offers a good deal of Photoshop's power but at a far more affordable price.

Adobe provides a time-limited fully functional evaluation copy of Photoshop Elements, that's free to download. For more info, see *www.completedigitalphotography.com/pselements*.

If, for some reason, you decide to use something other than Photoshop, you'll want to look for the features described in the next sections.

### Levels and Curves Controls

There's no better, easier way to adjust contrast, color, and saturation than with Levels and Curves controls. Although your program's interface might vary somewhat, make sure that its Levels and Curves features include the controls and adjustments that are highlighted in Figures 6.4a and 6.4b.

### An Eyedropper Tool with an Information Readout

For more refined image analysis, it's essential to have an Eyedropper tool and some type of information window or palette. With these tools, you

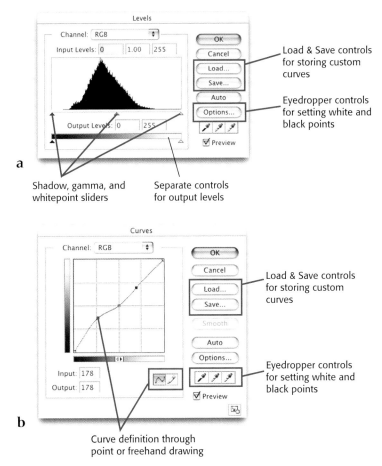

**FIGURE 6.4**    If you're not going to use Photoshop for your image-editing tasks, be sure that the program you choose offers Levels and Curves dialog boxes similar to the ones shown here. You will learn more about these controls later in this book.

can find out exactly what the color values are in a particular part of an image. Such information can be handy when you make tone and color adjustments.

### Good Paintbrush and Clone Tools

For retouching, you must have a good set of paintbrushes. Make sure your program supports pressure-sensitive tablets for more natural-looking brushstrokes. A *Clone* (sometimes called Rubber Stamp) tool is absolutely essential for everything from erasing artifacts to touching up images.

Although nowadays this shouldn't be too much of a concern, make sure that your program's paintbrushes are antialiased (that is, they have soft edges).

### Access to Individual Color Channels

You'll perform a lot of corrections and adjustments by working on specific color channels. (See Figure 6.5.) Make sure your image editor lets you view and edit specific color channels directly.

**FIGURE 6.5**    The image editor you choose should have support for editing and viewing individual color channels.

### Support for Multiple Color Spaces

Although your camera and desktop printer both operate in RGB color space, you might need other color spaces for specific tasks. Commercial printers usually require documents to be in CMYK color, whereas some corrections and adjustments are easier to perform in L*A*B color. If you do a lot of black-and-white work, you'll probably want the capability to make *duotones, tritones*, and *quadtones*.

### Support for Photoshop Plug-Ins

You can expand and extend Photoshop's features through the use of special *plug-ins*, small bits of code that can be added to Photoshop. Photoshop plug-ins allow you to do everything from blurring an image to adding 3D objects. Many digital cameras interface with your computer through a Photoshop *Acquire Plug-in,* a special piece of software that lets Photoshop communicate with your camera through a serial, USB, or FireWire cable. If your camera requires the use of such a plug-in, you'll definitely need an image editor that supports Photoshop's plug-in format.

### Unsharp Mask, Blur, and Noise Filters

You'll use these three basic filters for many everyday editing chores, so make sure your application provides some equivalent.

### File Format Support

TIFF, JPEG, GIF, BMP, and ideally Photoshop (PSD) are the bare minimum file formats that your application should support. Obviously, if your job requires specific file formats, you'll want to be sure your application supports those as well.

The tutorials and examples included in this book use all of the features discussed here. Even if your program of choice provides different approaches to these features, you should be able to follow along with the tutorials and examples.

## Panoramic Software

In Chapter 9, "Special Shooting," we'll discuss panoramic shooting, the process of shooting a series of image "tiles" that can be *stitched* together to create a seamless panorama. If your camera didn't ship with stitching software, you'll need to buy some.

## Wavelet Compression

Using *wavelet compression* technologies, products such as the Altamira® Genuine Fractals™ PrintPro™ can losslessly compress your image and enlarge it to huge dimensions with little or no artifacting. If you want to blow up your images to larger sizes, Genuine Fractals, a set of Photoshop Import and Export plug-ins, is an excellent solution.

How big can you enlarge images? In November of 2000, Nikon took a photograph from a Coolpix® 990 and used Genuine Fractals to blow it up to 65' × 43' (that's right, *feet!*). The resulting six-story image was printed on vinyl and hung on the side of a building in New York City's Times Square.

## Image-Cataloging Software

One of the great things about a digital camera is that you can shoot and shoot and shoot. Unfortunately, one result of all this shooting is that you'll end up with a drive filled with zillions of files, each with a vague name like P000394.jpg. An image cataloging program not only provides a way of keeping your images organized, sortable, and searchable, it can also provide a quick and easy way of viewing a disk full of images at the end of the day. Think of it as a giant digital light table.  Although a number of cataloging applications are out there, iView® MediaPro is one of the best, offering good speed, powerful features, and decent networking. (See Figure 6.6.) You'll find demo versions of both the Mac and Windows versions on the companion CD-ROM.

*ON THE CD*

Photoshop CS and Photoshop Elements 2 include a very capable image browser that provides a lot of the functionality of a standalone image cataloger. However, even if you are using Photoshop CS, it's still worth checking out a few image-cataloging demos. The Photoshop image browser can show you only the contents of a folder; it cannot create catalogs that you can store and view later.

When considering an image cataloger, be sure to look for the following features:

**Speed:**    You want a cataloger that can quickly build a catalog of thumbnails from a folder full of images. The goal of cataloging is to speed up your workflow, and a slow cataloger is only going to be frustrating.

**File renaming:**    You want a program that allows you to rename a file from within your cataloger. This is much easier than having to switch back to your operating system's File Manager.

**Keyword sorting and finding:**    A good find facility is essential, and you want one that can search by file name, date, or any other crucial parameter. You also want a package that allows you to assign keywords to your images so that you can create and search on your own categories.

**Customization:**    Ideally, you want a program with a choice of thumbnail sizes so that you can build catalogs that allow you to see the level of image detail, or number of images at once, that you want to see.

**FIGURE 6.6**     An image-cataloging program such as iView is a must-have for managing the huge number of images that you can quickly produce with a digital camera.

**Raw file support:**   If you shoot raw files (see page 110 in Chapter 5), be sure to select a cataloging program that can read raw files and build thumbnails. Both iView and the Photoshop CS Image Browser can read the raw files produced by most cameras currently available.

**Image editor launching:**   After you've browsed through a catalog of thumbnails and found the image that you want to edit, you don't want to have to go back out to your File Manager and manually find the image to open it up in your image editor. You want to be able to tell your image cataloger to open it for you in your editor of choice. (Obviously, this isn't a concern with the Photoshop built-in browser.)

iView MediaPro includes all of the features mentioned in the previous list and many, many more. In addition, the Photoshop Image Browser provides most of the same functionality, though it lacks the ability to save a catalog file that can be read by other people—a handy facility for passing thumbnails to clients for approval. On the other hand, it's built into Photoshop so you don't have to spend extra for it. Apple's free iPhoto application is a good choice for Mac users, but there are some workflow considerations to be aware of. We'll have more to say about those issues in Chapter 10.

### File Recovery Software

Alas, there might come a time when you accidentally erase an image, or an entire card of images, without realizing that you haven't backed them up to your computer. Fortunately, a number of excellent programs can often recover your images intact, as long as you haven't already recorded new images onto the card.

Although you might already own file recovery software such as Norton Utilities®, it's important to note that such programs usually can't recognize removable media such as CompactFlash cards or Memory Sticks. Fortunately, a number of vendors have written software specifically designed for recovering data from these types of media.

*ON THE CD*

PhotoRescue™ is one such program. Available for Mac and Windows, a demo version is included on the companion CD-ROM. Although the program is well designed and very effective, you will, hopefully, never need to use it.

## ACCESSORIES

There are a few accessory items that can make your life with your digital camera easier, the most convenient one being a media drive that supports the type of media used by your camera. (See Figure 6.7.) These drives typically connect through your computer's USB or FireWire port. Insert your camera's media into the drive's slot, just as you would insert a floppy into a floppy drive, and it will appear on your desktop as another volume, allowing you to drag and drop images onto your computer's hard drive. These drives are usually faster than transferring files from your camera via a cable and don't require you to use your camera's battery power.

**FIGURE 6.7**   A CompactFlash or SmartMedia drive provides a simple, quick way to get your images into your computer. In addition to saving time, you'll save camera-battery power.

If your camera uses a USB cable to connect to your computer, and if you already have a number of USB devices installed, you might need to get a USB or FireWire hub. Offering multiple ports, hubs make it possible to connect several devices simultaneously.

# SHOOTING

**In This Chapter**

- Initial Camera Settings
- Shooting Settings
- Framing and Focusing
- Metering
- Simple Flash Photography
- Power and Storage Management
- And That's Just the Beginning!

According to Ansel Adams, when famed photographer Margaret Bourke-White was shooting, she would simply set her camera on 1/100th of a second and then shoot the same image over and over using every aperture that her camera could manage. This, combined with her gift for composition, ensured that at least one of her images would come out the way she envisioned.

If you're like most people, you probably find yourself shooting whole rolls of film hoping that one or two of the images will be "keepers." Unfortunately, no camera technology can guarantee that you'll always shoot great images, but there are a number of things that you can do to improve your chances of getting images that you like, and digital cameras offer a number of creative advantages that make it easier to take good shots.

Though digital cameras make Bourke-White's approach far more cost-effective, a much better practice is to spend some time learning how to intelligently use the tools and features found on your camera to ensure that you can get a good shot with only one or two exposures.

Although there is plenty of room for artistry in the photographic process, when it finally comes down to pressing that shutter button, you have to make a *lot* of simple mechanical decisions, ranging from lens choice to exposure options. As mentioned earlier, this book is going to leave the discussion of photographic artistry to the photographic artists. Composition, perception, and other more "artistic" topics are well covered in any number of books, and a list of recommendations is included in Appendix A, "Suggested Reading."

Once you have a vision of how you want a particular image to look, you need to know how to use the controls and settings on your camera to achieve that vision. In this chapter, you'll learn about the framing controls and automatic exposure options that your camera provides. In the next chapter, we'll delve more deeply into the complex processes of light metering and selecting an exposure.

## INITIAL CAMERA SETTINGS

Before you start to shoot a picture, you'll need to configure your camera based on your current shooting conditions, and on the type of output you want. Some of these settings will rarely change, whereas others might change with every shot.

### Semi-Permanent Settings

You must think about a number of settings every time you take a shot—exposure settings and white-balance settings, for example. There are

other settings, such as image size and compression, that you'll rarely change. In fact, you'll probably configure some features on your camera when you first take it out of the box and then never change them again. Nevertheless, it's important to remember the impact that these settings have on your final image, and at least give them a quick consideration when you first enter a shooting situation.

### Image Size and Compression

Your camera probably allows you to select from a number of different size and compression settings. Nowadays, with storage so cheap, there's almost no reason not to shoot at full resolution all the time, even if you're shooting for the Web. Sure, full-resolution images have to be resized before being posted to the Web, but the extra resolution gives you the option of later repurposing your images for print. As such, when you first get your camera, you'll most likely set resolution and compression to their highest-quality settings, and then leave them there.

However, there are some times when you might want to change these settings. If you're on a long shoot and you begin to run out of storage, for example. Or, if you're shooting for a particular workflow—such as for the Web or for a small print size—and you don't want to spend a lot of time resizing your images later.

Image size is simply the dimensions, in pixels, of the image the camera will create. A 3-megapixel camera, for example, typically offers a maximum resolution of roughly 2048 × 1536 pixels, along with options for shooting in XGA resolution (1024 × 768 pixels) and VGA resolution (640 × 480 pixels). Some cameras offer additional resolutions, such as the Coolpix 995's 2048 × 1360 pixels, which crops the camera's vertical resolution to provide the same 3:2 aspect ratio as 35mm film.

Which size is the "correct" size depends on how you will be outputting your images. If your images are destined for the Web, you might be able to get away with 640 × 480 resolution. The correct image size for print depends on the type of printer to which you'll be outputting, as well as the final print size of your image. We'll discuss these issues in detail in Chapter 10, "Preparing Your Images for Editing," and Chapter 15, "Output."

As mentioned earlier, shooting at the highest resolution provides the greatest output flexibility. But even if you know you're shooting only for the Web, you still might want to select a higher resolution, because doing so will make it possible to enlarge sections of an image, allowing you to blow up a single element in a picture, or to crop and enlarge an image to create a new framing.

When it comes to compression, it's best to always shoot with the lowest level (highest quality), particularly if you're shooting images that

don't fare well under JPEG compression. (See Chapter 2, "How a Digital Camera Works.") JPEG artifacts are difficult, if not impossible, to remove later, so it's best to avoid them altogether.

Obviously, choosing the largest image size with the lowest compression setting means you won't be able to fit as many images onto your storage medium. If you run short on storage when you're in the field, you might want to switch to different image size and compression settings:

- If your destination is the Web, you can afford to lower the camera's resolution (and hope that you never want to print any of your images).
- If your final destination is print, you should keep your resolution the same but increase your compression (and hope that the artifacting isn't too bad).

*MONEY CAN BUY PHOTOGRAPHIC HAPPINESS*

*Storage is one of those few problems that you can easily solve by spending additional money. If you want to ensure that you can always shoot at the highest quality that your camera allows, then you should invest in more storage.*

Some cameras do not allow you to adjust image size and compression separately. Instead, they'll offer a menu of predefined combinations. In Figure 7.1, the camera shows options for full resolution with high quality (low compression), full resolution with low quality (high compression), and then the same options for medium and small resolution, and finally raw format. Though not as flexible as a camera that allows you to create any combination of resolutions and compression ratios, it still probably provides most of the control you need.

**FIGURE 7.1**   A typical image-size menu. You can select between three different sizes, each with a choice of two compression (quality) settings, or raw format.

### File Format

Though JPEG is the format of choice for all digital cameras, many models also offer some additional uncompressed formats. Uncompressed files take up substantially more space than JPEGs, but they are free from the blocky artifacts that JPEG images sometimes possess. You'll probably spend most of your time shooting in JPEG mode, but there might be times when you want to switch to an uncompressed format. Your camera probably supports either or both of the following formats:

**TIFF:**   TIFF files are a standard, uncompressed file format that just about every graphics program can read. The easiest way to determine the size difference between shooting in TIFF and shooting in JPEG is to stick an empty card into your camera and note how many pictures are available in JPEG format. Now switch to TIFF format and note the remaining pictures. It will probably be much lower. TIFF files are useful for those times when you want to greatly enlarge an area or part of an area and simply can't afford to see any JPEG artifacts.

**Raw:**   If your camera supports it, raw is the preferred choice for uncompressed shooting. In addition to their lack of JPEG artifacts, raw files offer tremendous editing flexibility. Whereas JPEG files are processed by the camera according to your current settings (white balance, sharpness, saturation, and so forth), raw files allow you to perform these operations yourself later, using special software. Raw files are ideal for when you want maximum image quality and the most editing control. Select raw files when you are in a difficult white balance situation, when you are particularly concerned about color, or when you absolutely don't want any JPEG artifacts. Some photographers shoot exclusively in raw, but before you make this decision, you'll want to fully explore the workflow ramifications. You'll learn more about this in Chapter 13. (See Figure 7.2.)

You'll probably rarely change image size and compression, unless you start to run out of storage. You might change file format more often, though beginning digital photographers might want to stick with JPEG before complicating matters with raw options.

With these configurations in place, you're ready to consider the settings that you'll change more often, sometimes even with every shot.

Pictures remaining

**FIGURE 7.2**    Raw images yield better image quality and substantially improved editing flexibility over JPEG images. The upper image shows remaining pictures in JPEG mode. In the lower image we switched to Raw mode. As you can see, when you're shooting raw, your storage won't go nearly as far as when you shoot JPEG.

## SHOOTING SETTINGS

Though you probably won't change your image size, compression settings, and file format often, there are plenty of other settings that you'll need to think about with every shot, or at least when you begin shooting in a particular environment.

### Choosing a Mode

Your digital camera probably has a number of shooting modes that dictate what exposure decisions will be made by the camera and what decisions will be left up to you. Your first task when you approach a shot, therefore, is to choose the appropriate shooting mode. (See Figure 7.3.) Often, shooting on full automatic will be all you need to do. (And don't worry, shooting on automatic doesn't mean you're a wimpy photographer.) In other cases, you might have a lighting situation that's just tricky enough, or a compositional vision that's just unusual enough that you

need to put the camera into a mode that will provide you with the appropriate manual overrides. Every photographic situation is unique, of course, but there are some general guidelines you can follow to determine when you should use each shooting mode. As you learn more about digital photography, and your camera in general, you'll get a better idea of which mode to choose. You might even find yourself shooting the same scene several times with different modes as you try different exposures and approaches to capturing your scene.

**FIGURE 7.3**    Some cameras have physical dials that let you select different shooting modes; others require a trip into the camera's menu system to change modes.

### Full Automatic

Most automatic modes take care of everything. They select a white balance, ISO, shutter speed, and aperture, and choose whether to use the flash. Automatic modes usually also let you select a metering mode, if your camera offers a choice. For the most part, the automatic mode on your camera will do a good job in just about any situation. If you're in a hurry to catch a fleeting action, this might be your best bet. Or, if you're simply tired of thinking about your camera all the time and just want to take a picture, go with automatic mode. (See Figure 7.4.)

**FIGURE 7.4** Often, fully automatic mode is all you need. The automatic modes of modern cameras are very sophisticated and can handle images with a wide range of light to dark.

### Program Mode

Program mode offers most of the automatic functionality of a fully automatic mode—auto white balancing, light metering, exposure choice—but allows you to override some options. On most cameras, Program mode will let you make your own selection of ISO, white balance, and exposure compensation. Some will even let you cycle through reciprocal exposures to choose a shutter speed/aperture combination that's more appropriate to your desired image. For most shooting tasks, the simple manual overrides provided by Program mode are all you'll ever need.

### Shutter Priority and Aperture Priority Modes

Automatic modes can yield excellent results, but they also make certain assumptions about how you want your image to look. For example, in automatic mode, your images will be evenly exposed, and the camera will try to defer to faster shutter speeds to stop motion. There will be times, however, when these assumptions will be wrong. Perhaps you want to use a slow shutter speed to make a fast-moving object look blurry, for example. Or maybe you want to try to render some parts of your image out of focus to bring attention to other parts.

*Shutter priority mode* lets you select the shutter speed you'd like to use. The camera then selects an appropriate aperture based on the camera's

light meter reading. Shutter priority is ideal for times when you have to freeze motion, such as capturing action at a sporting event, because it lets you force the camera to shoot with a particular (fast) shutter speed. Similarly, there might be other times when you want to ensure that a speeding object looks blurry in your final image. By forcing the camera to use a slow shutter, you'll get a more dynamic image.

*Aperture priority mode* works the same way, but it allows you to select an aperture and leaves the choice of shutter speed up to the camera. Aperture priority modes give you control over the *depth of field* in your image, allowing you to control how much of the image is in focus. (See Figure 7.5.)

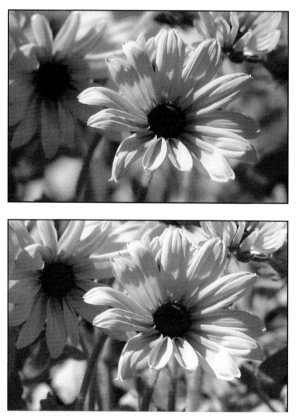

**FIGURE 7.5**   By changing the camera's aperture, we can control the depth of field in an image. Note the difference in background in these two images. The lower image has a much deeper depth of field, resulting in a more focused background, whereas the upper image has a shallow depth of field, resulting in a blurry, softly focused background. These images were shot with reciprocal exposures—only the aperture changed.

Most shutter and aperture priority modes also yield control of ISO and white balance. In Chapter 8, "Manual Exposure," you'll learn much more about how to use these modes.

### Manual Mode

As you would expect, full manual mode gives you control of everything. Although this might seem like the ultimate "power user" mode, you might find that you often need control of only one exposure parameter or the other, and so you will use a priority mode. However, manual mode is a must for maximum creative freedom and for handling difficult lighting situations.

### Special Shooting Modes

Some cameras offer special shooting modes for specific situations. In these modes, certain features are preset. For example, Landscape modes typically fix the focus on infinity and select the smallest possible aperture to ensure maximum focus and depth of field. Sometimes, these special modes are the only way to gain access to certain features such as slow-sync flash (which we'll discuss later). Before you use any of these modes, however, check the camera's documentation and be sure that you understand the settings that might be affected.

As you learn more about the decisions you'll make when you shoot, choosing a mode will become more obvious. Because this book won't cover how to use the controls of specific cameras, it's important for you to spend some time learning how the various modes on your camera work.

## White Balance

Different types of light shine at different temperatures, or colors. Direct sunlight, for example, has a color temperature of 5500°K (light is always measured in degrees Kelvin), whereas fluorescent lights have a color temperature of 4500°K. One of the amazing characteristics of your eyes is that as you move among all of these different types of light, you still perceive colors the same way. Blue looks blue whether you're in sunlight or a lamp-lit room. Your eyes can even understand mixed lighting conditions—sunlight shining through a window into a fluorescent-lit room, for example.

Film and digital cameras are not so sophisticated. To accurately record color, film has to be specially formulated for the type of light in which you are shooting. There is "daylight" film, which chemistry tuned

for recording color in daylight, or "tungsten" film, which is capable of accurately recording color under tungsten lighting. Use either film in the wrong kind of light, and your colors will be off—using daylight film indoors will produce images that are very gold or reddish; using tungsten film outdoors will produce images with a bluish cast.

Image sensors have the same trouble. Fortunately, though, an image sensor is not tuned to a specific type of light the way film is. An image sensor simply captures light and passes it to the camera's onboard computer for processing. It's up to that computer to interpret the color correctly for the particular type of light in which you are shooting. For it to correctly perform this interpretation, the camera's computer needs to determine, or be told, the color temperature of the light that is striking your subject. Fortunately, there's a very easy way to perform this calibration.

As you learned in grade school, white light is composed of every other color. Therefore, if a camera can accurately reproduce white, then it can accurately represent any other color. *White balancing* is the process of determining what, in your scene, is white. Once your camera knows what is supposed to be white, it can determine the color temperature of the light in your scene and accurately reproduce any other color. Figure 7.6 shows the same scene shot several times, each with a different white balance setting.

### Setting White Balance

Every time you take your camera into a new lighting situation, you need to consider how to best white balance it for that light. Proper white balance is essential to getting accurate color, and the only equivalent it has in the film world is the choice you make when you buy a particular type of film. Consequently, whether you're new to photography or you're an experienced film photographer, *you must learn to start thinking about white balance!*

All cameras have an automatic white-balance feature and, depending on the quality of your camera, this might be all you need to use to get accurate white balance. The simplest automatic white-balance mechanisms look for the brightest point in your shot, assume that that point is white, and then use that point as a reference to balance accordingly. More sophisticated automatic white balancers perform a complex analysis of many different areas in your image. Both mechanisms are surprisingly effective, and on a good camera you can probably get away with automatic white balance for 85 percent of your shots. However, sometimes you have to manually white balance even the best camera.

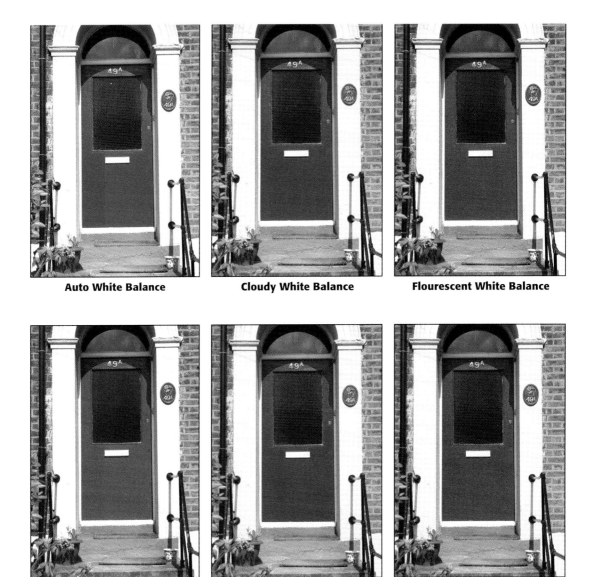

**Auto White Balance**    **Cloudy White Balance**    **Flourescent White Balance**

**Incandescent White Balance**    **Shadow White Balance**    **Sunlight White Balance**

**FIGURE 7.6** Although film photographers need to select a film that is balanced for the type of light in which they'll be shooting, digital photographers need to make certain that their cameras are properly white-balanced for the current light. Use the wrong white-balance setting, and your images will have strange color casts that can be difficult to remove.

Let's say, for example, that you're shooting a marching band on a dreary, foggy day, and the brightest thing in the scene is the gold sheen of a tuba. Your camera could very well assume that the bright gold tuba is

white and throw off the color balance of your entire image. As another example, let's say you're shooting the Irish golf team at a well-watered golf course on St. Patrick's Day. Because everything in the scene is green, the camera could easily get confused about how to identify white. Auto white balance works best outdoors in bright sunlight. Even a few clouds can confuse an auto-white-balance mechanism, though, and shift the colors in your image toward blue.

Fortunately, most cameras offer preset configurations for different lighting conditions—Daylight, Tungsten, Fluorescent, and possibly a Cloudy or Overcast setting. (Tungsten is sometimes called "Incandescent" or "Indoors.") Because there are two different temperatures of fluorescent lights—"cool white" and "warm white"—some cameras offer separate settings for each fluorescent color.

Other cameras will actually specify manual white balance settings in degrees Kelvin. Be sure you understand which setting corresponds to which type of light. (See Figure 7.7.)

| White Balance in K° | | |
|---|---|---|
| **3000°K** | – | **White Tungsten** |
| **3700°K** | – | **Yellow Tungsten** |
| **4000°K** | – | **Flourescent** |
| **4500°K** | – | **Flourescent** |
| **5500°K** | – | **Sunlight** |
| **6500°K** | – | **Cloudy** |
| **7500°K** | – | **Shade** |

**FIGURE 7.7**    Some cameras use manual white-balance controls that are measured in degrees Kelvin. If your camera simply presents a list of temperatures, here are the types of lights to which those temperatures correspond.

These white-balance presets are usually more accurate than automatic white balance in the situations for which they're designed. However, you can't always be sure that your lighting situation is exactly the color temperature that your camera's preset is expecting. For these situations, some cameras offer white balance fine-tuning that allows you to alter a preset white balance to be warmer or cooler.

Mixed lighting, such as a tungsten-lit room that has large sun-facing windows, or an exterior location on a partly-cloudy day, presents the

trickiest white-balance situation. For the absolute best results under any lighting situation—and especially under mixed lighting—you'll want to use your camera's manual white balance. To use a manual white-balance control, hold a white object—such as a piece of paper—in front of the camera, and then press the camera's manual-white-balance button. The camera will calculate a white balance based on the light in your scene.

### MEASURE THE RIGHT LIGHT WITH THE RIGHT WHITE

*When you manually white balance, be sure to hold your white card in the light that is hitting your subject. This is particularly critical in a studio situation where your camera might be sitting in very different light from your subject.*

When you first get your camera, it's worth taking some test pictures to learn more about its white-balance peculiarities. You might, for example, learn that your camera's automatic white balance does a much better job outside than it does indoors. You'll probably also get a feel for the accuracy of your camera's white-balance presets.

You should also dig through your camera's manual to determine if your camera has a *TTL* white balance system or a white balance sensor that sits outside the camera's lens. External sensors can sometimes pick up color casts from objects that are outside the picture. A bright red car sitting just outside the frame of your image might be all it takes to throw off the camera's white balance. Some experimentation will help you understand how sensitive your camera's external white balance sensor is.

### Bad White Balance

You might be tempted to assume that you don't have to worry about correct white balance because you can always use your image editor to correct white-balance troubles. This is sometimes true, but it can take a lot of work to correct a bad white balance. (See Figure 7.8.) The color shifts that occur from incorrect white balance don't affect all of the colors in an image equally. For example, the highlights in an image might be shifted more than the shadows. Consequently, you won't be able to do a simple "remove a certain amount of blue from the image" type of correction. Moreover, as you'll see later, by the time you're done correcting the white balance, you might have used up enough of your image's dynamic range that it will be difficult to perform further corrections and adjustments without introducing artifacts. In the end, it's best to shoot with the most accurate white balance that your camera can manage.

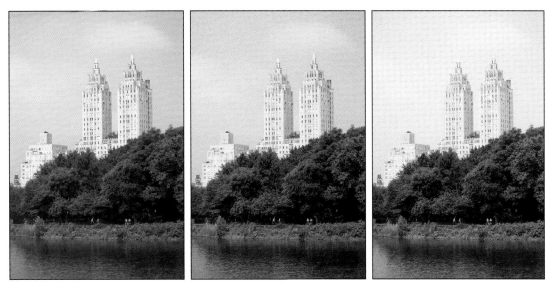

**FIGURE 7.8**   The left image was accidentally shot with Tungsten white balance (instead of auto, or daylight). The middle image shows our attempts to correct the color. Though the image is improved, completely removing the bad color casts is extremely difficult and results in an image with bad posterizing artifacts (which are difficult to see at this size). The right image was shot with a correct white balance. As you can see, white balance choice is not to be taken lightly, because correcting it later is extremely difficult.

*WHITE BALANCE AND RAW MODE*

*If your camera offers a Raw mode, you can choose to set the white balance of your image later. Although raw images take up more space and can be a bit of a hassle to work with, if you aren't sure of a correct white balance setting for a particular lighting situation, and if you don't have a white object that you can use for a manual white balance, shoot in raw mode and adjust the white balance of the image later.*

*BE CAREFUL WITH THOSE FILTERS*

*Fitting your lens with a filter or lens attachment can alter your camera's preset white balances because they can shift the color of the light passing through your lens. You'll usually want to use manual white balance when attaching anything to your lens.*

## Metering

You're going to be reading a lot about metering, both later in this chapter and in Chapter 8. For now, simply be aware that your camera provides different metering choices. It probably defaults to some form of matrix metering, which will be the best option for most shooting situations. If

you change your meter to another setting, be sure to remember to change it back when you change shooting situations.

### Sharpness, Saturation, or Contrast

Many cameras offer different levels of sharpness, color saturation, contrast, or all three. Only you can decide which settings suit your taste, so you'll need to try a lot of test shots with these different settings. Be aware, however, that as you increase sharpness, you will also increase contrast. Your goal when you configure these settings is to allow the camera to capture the most dynamic range and detail possible. If you set contrast or sharpness too high, you might lose color information that you need later. (You'll learn more about these issues in Chapter 11, "Correcting Tone and Color.") Consequently, it's worth doing a little experimentation with the idea of erring on the side of soft. After all, you can always sharpen your images later, using your image editor, but you can't repair an image that's been oversharpened by your camera. Once you've found settings you like, you probably won't change them too often, if ever.

For example, consider the images in Figure 7.9.

**FIGURE 7.9**    Some cameras allow you to change the amount of in-camera sharpening performed. The image on the left was shot with the softest setting on our Canon EOS 10D; the image on the right was shot with a higher setting.

### ISOs

As you saw in Chapter 3, "Basic Photography: A Quick Primer," a digital camera's sensitivity to light is measured using the same ISO scale used by film cameras. As ISO rating increases, the camera becomes more light sensitive, and a more light-sensitive camera offers different creative possibilities. In addition to allowing you to shoot using less light, a higher ISO rating allows you to use smaller apertures and higher shutter speeds when shooting bright daylight.

Although the most common ISO speeds are 100, 200, and 400, higher-end models can go as high as 3200 ISO. Some cameras, such as the Canon G5, offer a super slow ISO 50.

There is a price to pay for this increased sensitivity, though. As explained in Chapter 3, as you increase ISO, your images will get noisier. So, you'll want to keep your ISO setting as low as possible. (See Figure 7.10.)

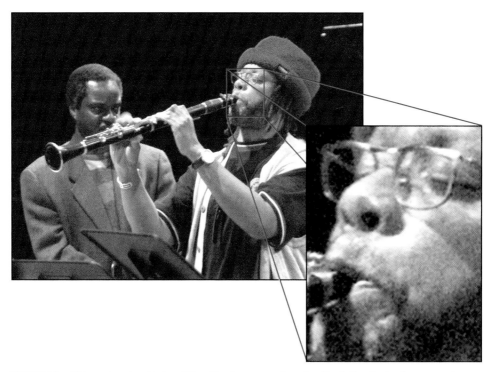

**FIGURE 7.10**   Although using higher ISOs affords greater shooting flexibility, it also increases the amount of noise in your image.

Some cameras handle this extra noise better than others, producing fine-grained, monochromatic noise that almost looks like the increased grain that you'd find in high-speed film. Higher-end cameras often don't show a noticeable increase in noise until around ISO 800. Other cameras, though, produce increased noise that is quite ugly. (See Figure 7.11.)

In Chapter 13, "Essential Imaging Tactics," we'll look at some methods for trying to remove noise from your images.

Cameras with very low ISOs produce images with very little noise. However, shooting at ISO 50 is only practical in bright sunlight or with a tripod.

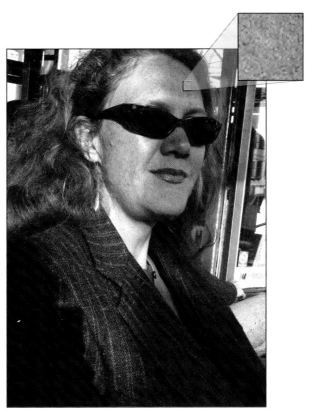

**FIGURE 7.11** All noise is bad, but some noise is worse than others. When shooting at high ISO, the Canon G2 produces very speckly noise with bright color artifacts, as seen in this image.

*KEEP AN EYE ON YOUR ISO*

*Most cameras remember your last ISO setting, even after you've turned off the camera. Therefore, if you spent a long night shooting at ISO 400, don't forget to check your ISO setting the next day, before you go out shooting in bright daylight. Although your camera will be able to shoot in daylight at ISO 400, your images might be overexposed; they will certainly be noisier than at a slower speed, and your shutter speeds will be very high.*

## FRAMING AND FOCUSING

After you configure your camera settings as described in the previous section, you're ready to start framing and focusing your shot. As we said at the

beginning of this chapter, composition and other areas of photographic artistry are beyond the scope of this book. However, there are a number of technical concerns that will immediately improve the composition of your images, no matter what your artistic or journalistic intent might be.

## Focal Length

The great thing about a zoom lens is that it provides great flexibility when you frame a shot. Without changing your position, you can quickly zoom in to a subject to get a tighter view and a different framing. However, it's important to recognize that as you zoom, a lot of things change in your image besides the field of view and magnification. A zoom lens is more than just a convenience. The ability to select a focal length lets you greatly alter the sense of space in your composition.

It's easy to think of your zoom lens as a big magnifying glass and, to a degree, it is. As you zoom in, your subject appears larger and larger. This is why digital camera manufacturers label their lenses with a magnification factor—2x, 3x, and so forth. However, a few other things happen to your image when you zoom.

As you go to a longer focal length (zoom in), your field of view gets narrower. The human eye has a field of view of about 50° to 55°. This is considered a "normal" field of view, and any lens that produces a 50° to 55° viewing angle is said to be a *normal lens*.

More important, though, is to pay attention to the way a lens magnifies different parts of your image and how it compresses depth overall as you zoom in and out. Consider the images in Figure 7.12.

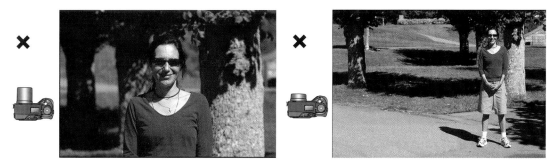

**FIGURE 7.12**    In these two images, neither the photographer nor the subject moved. In the first image, a slightly longer (telephoto) focal length was used, whereas in the second image, a very wide (shorter) focal length was used. Notice how much farther away the background trees appear in the second image. Though you might be tempted to simply use your zoom lens to frame your shot a particular way, it's important to consider how different focal lengths affect the appearance of your background.

Both of these images were shot from the same location. The only thing that changed between shots was the focal length of the lens. In addition to the framing and the size of the subject, notice how the background appears much farther away in the wide-angle image. In general, the wide-angle image has a much greater sense of depth. Now look at the two images in Figure 7.13.

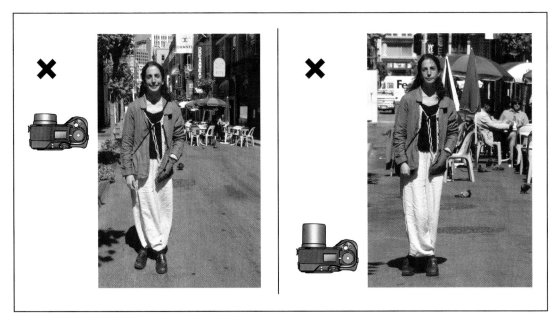

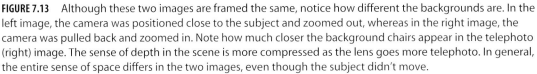

**FIGURE 7.13**    Although these two images are framed the same, notice how different the backgrounds are. In the left image, the camera was positioned close to the subject and zoomed out, whereas in the right image, the camera was pulled back and zoomed in. Note how much closer the background chairs appear in the telephoto (right) image. The sense of depth in the scene is more compressed as the lens goes more telephoto. In general, the entire sense of space differs in the two images, even though the subject didn't move.

In these two images, the subject remained in the same place, but the photographer moved farther away and used a different focal length to keep the images framed identically. Notice how much closer the tables and chairs look in the second image. As the photographer moved back and zoomed in, the depth in the image became compressed, resulting in the background elements appearing closer.

As you can see, both field of view and the sense of depth in an image are functions of the position of your camera and the focal length that you choose to use. When you shoot with a wide-angle lens, objects that are closer to the lens get magnified more than objects that are farther away; a

telephoto lens magnifies near and far images equally. Because all objects, no matter how far away they are, are magnified equally, a telephoto lens compresses the depth in your scene.

At some point, you've probably looked at a photograph of yourself and thought, "That doesn't really look like me." One reason for the poor result might be that the photographer used a wide-angle lens. Shooting a portrait with a wide-angle lens can be problematic because some parts of your subject's face are closer to the lens than others. Consequently, those parts will be magnified more than the parts that are farther away. Check out the pictures in Figure 7.14. The image on the left was shot with a slightly telephoto lens and really does look like the actual person. The image on the right is not such a good likeness. The nose is too big, and the ears have been rendered too small. In addition, the distance between the nose and ears—the depth of the picture—is too long. (Of course, although the picture on the right is less literally correct, it might be a better expression of the person's true character.)

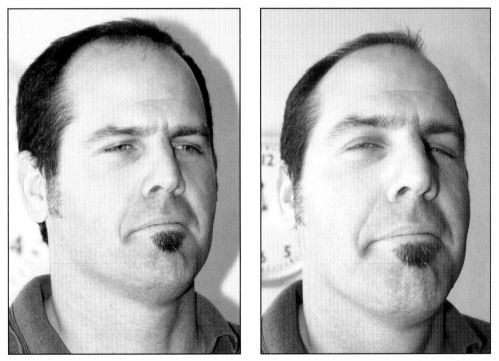

**FIGURE 7.14**    A change in focal length can make a huge difference in the appearance of your subject. The image on the left was shot with a long (telephoto) focal length. Next, we zoomed out and moved closer to our subject to produce the oddly distorted image on the right. (As in the previous example, note how the telephoto lens has compressed the depth in the scene. The clock over the man's shoulder appears much closer in the left image.)

Typically, portrait photographers use a slightly telephoto lens. Some even use special "portrait" lenses that have some spherical aberration designed into the lens. These aberrations tend to soften the detail in the image to improve skin tones.

Your choice of focal length—and the corresponding position of your camera—will have a lot to do with the sense of space and depth in your image. As you saw in Figure 7.13, the difference in results when you shoot at close proximity with a wide-angle lens and when you shoot from far away with a telephoto lens can be quite dramatic. Therefore, just because you can zoom in to the framing that you want for a particular shot doesn't mean that it's the right choice for the shot. Your subject might be better served by you repositioning the camera and choosing a different focal length.

### Geometric Distortion

Most zoom lenses exhibit some form of barrel or pincushion distortion when zoomed to either of their extremes. These distortions will show up as curves and warps around the edges and corners of your image. (You can see an example in Figure 4.9.)

When you find yourself at the limits of your zoom range, check the edges of your image to see if there's any distortion. If there is, and you can live with it, then by all means take the shot. If it bothers you, you might need to reposition your camera and select a new focal length. If the distortion isn't too bad, you might be able to remove it with your image-editing software, as we'll see in Chapter 10. Barrel distortion is especially prevalent when shooting macro photographs, because you tend to be zoomed out all the way and positioned very close to your subject. It's not necessarily a problem, but it's good to keep an eye out for it while you're shooting. If you get an unacceptable level of distortion, you may want to zoom in some and go for a shot that isn't as close to your subject.

*ONE WAY TO AVOID EMBARRASSMENT*

*If you're using a rangefinder camera with an optical viewfinder, note that, because you aren't looking through the camera's imaging lens, it is actually possible to shoot with the lens cap on. Some cameras are smart enough to warn you, but others will let you blithely go along shooting black frames. Be sure to double-check! If your subject is pointing and laughing at you, there's a good chance that it's because your lens cap is on, or you're having a bad hair day.*

*CUTTING DOWN ON LENS FLARES*

*Figure 5.19 shows the type of flaring that can occur with some lenses. Typically, lenses with wider diameters are more prone to flaring. There are several ways to eliminate flares, the easiest being to simply hold your hand above the lens (or put a sunshade on your lens) to block the flare-causing light. Circular polarizers will also help reduce flare, although at the expense of f-stops.*

## Prefocusing/Focusing

Your digital camera invariably has an automatic focus, but you still need to give some thought to focusing. Your camera's autofocus mechanism has to make some decisions about what it thinks it should focus on. If it makes the wrong choice, your picture will be out of focus. Unfortunately, your LCD screen is too small to provide an accurate gauge of focus, so you may not know your picture is out of focus until you get back to your computer. Consequently, it's a good idea to understand the workings of your camera's autofocus system so that you can use it effectively.

No matter what type of system your camera uses for determining focus, the process of focusing is the same: you frame your shot and press down the shutter down halfway. The camera will calculate and lock focus (as well as calculate exposure and auto white balance) and then beep or show a light to indicate that it's ready. Pressing the button the rest of the way will take the picture using the focus, exposure, and white balance settings that the camera has calculated. This process, called *prefocusing*, is identical to the way autofocus mechanisms work in film cameras.

Although this system is simple to use, photographers who are new to autofocus cameras can be quickly frustrated by what seems to be an extreme lag between the time they push the button and the time the camera actually takes the picture. This *shutter lag* usually occurs because the photographer is simply pressing the button down all the way to take the picture, rather than pressing down the button halfway and giving the camera a chance to prefocus. By pressing down the button all the way, you're asking the camera to focus, calculate exposure, and figure out white balance all in the instant that you want to take the picture. *Neglecting to prefocus is the biggest mistake that beginning autofocus photographers make, and it's one that can lead to a great deal of frustrating, missed photos. Get in the habit of prefocusing!*

Prefocusing might sound like an inconvenience, but it's really no more trouble than what you'd have to do with a manually focused camera, except that instead of focusing manually, the camera is focusing for you.

*SHUTTER LAG EVEN WITH PREFOCUSING*

*As you saw in Chapter 5, some cameras have a bit of a shutter lag, even if you've already pressed down the shutter release halfway to go through the prefocusing step. Unfortunately, there's really nothing you can do to work around this problem except to learn how long the lag is so that you can try to anticipate when you need to press the shutter to capture the action you want. Another option is to switch to your camera's Burst mode and shoot a series of images with the hope that one of them will capture the moment you were looking for. If your subject is far away, consider using your camera's landscape mode, which locks focus on infinity, eliminating the need for focusing when the shutter is pressed halfway.*

Your camera might also have a continuous autofocus mechanism, which automatically focuses every time you move or zoom the camera. With continuous autofocus, your camera stands a much better chance of being ready to shoot at any time. However, it can also drain your battery and sometimes be distracting, because you will constantly hear the lens working. If your camera has a speedy autofocus, you might find little advantage to a continuous mechanism.

Some cameras also feature a *focus tracking*, or *servo tracking*, feature that can automatically track a moving object and keep it in focus for as long as you hold down the shutter button halfway. For sports and nature photography, this feature can help to ensure that you're always ready to get the shot.

Most digital cameras employ one of two different autofocus mechanisms, each with its own strengths and weaknesses.

### Active Autofocus

Although less popular than it used to be, some lower-end cameras still provide *active autofocus* mechanisms because they're typically the cheapest system to implement. An active autofocus mechanism works by using an infrared beam to measure the distance to your subject; your camera then sets the focus accordingly. It's called an "active" system because the camera is actively emitting a signal in an effort to measure distance. The easiest way to tell if your camera uses an active system is to look at the technical specifications included in your camera's manual.

Although active autofocus mechanisms work fairly well, they have a number of limitations.

- You must have a clear line of sight between you and your subject. Bars in a zoo, fence posts, or other obstructions can keep the camera from accurately measuring distance.

- Because the infrared beam is not originating from the lens, the camera might not correctly calculate focus if you're using any type of lens attachment, such as a wide-angle or telephoto adapter. Consequently, most cameras with active autofocus mechanisms don't provide for such attachments.
- If you're standing close to another strong infrared source—such as a hot campfire or a birthday cake covered with candles—the heat from that source can confuse the camera's autofocus mechanism.
- On the positive side, active autofocus systems work just fine in the dark.

### Passive Autofocus

Today, most cameras use a *passive autofocus* system, sometimes called a *contrast detection* system. You should be able to find out what type of system your camera uses by simply looking at the specifications table in your camera's manual. For example, the Olympus C2100 specifies its autofocus system as a *"TTL* contrast detection autofocus."

Contrast-detecting autofocus systems work by focusing the lens until the image has as much contrast as possible. The idea is that a low-contrast image is a blurry image. Therefore, by increasing contrast, the camera increases sharpness. The top image in Figure 7.15 shows an out-of-focus image. Look at the individual pixels up close and you'll see that there is very little change from one pixel to the next. That is, the pixels have little contrast between them. In the bottom image in Figure 7.15, a sharp image, you can see that individual pixels have a more dramatic change in contrast from pixel to pixel.

When you press the shutter release halfway, a passive autofocus camera takes an initial reading of the contrast in your shot. It then focuses the lens closer and checks the contrast again. If contrast has increased, the camera continues focusing inward until the contrast decreases. With a decrease in focus, the camera knows it has gone too far and can step back to the correct focus. Obviously, many variables can affect this process, such as the camera's ability to detect contrast, the precision with which it can move its lens, and the speed at which it can go through the entire procedure. Theoretically, a camera with more autofocus steps can achieve a more precise focus position and, therefore, achieve better focus. However, digital cameras typically have *very* deep depths of field, so tiny changes in focus usually aren't that important. Moreover, most of the steps in an autofocus system are centered around very close (macro) ranges, where they tend to be needed, and where depth of field offers less compensation, so a camera that provides more autofocus steps will not yield significantly better performance in everyday use.

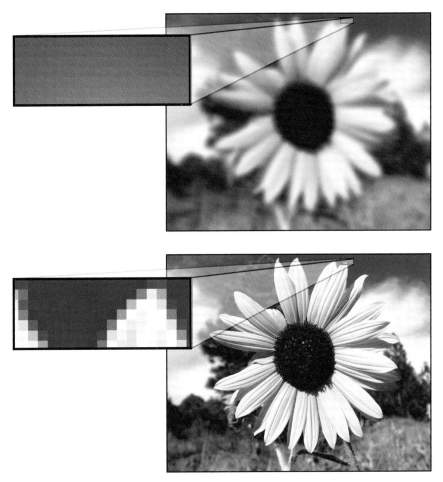

**FIGURE 7.15** If you look closely at the pixels in the top, blurry image, you'll see that there is very little change in tone from one to the next. That is, there is little contrast between them. In the bottom image, there is a big contrast change from pixel to pixel. This is why searching for high contrast is a good way to detect focus.

Contrast detection is largely a function of the available light in your scene. If the area in which you're pointing your camera is too dark, or is uniformly colored, your camera won't be able to detect any contrast and will be unable to determine focus. Today, most cameras include an automatic *focus-assist lamp* (also known as an *autofocus-assist lamp*) that shines a light onto your scene if the camera can detect focus. By lighting up the scene, your camera's autofocus mechanism can "see" better. Some cameras use a normal white-light focus-assist lamp, whereas others use a less intrusive red lamp.

A passive autofocus mechanism has many advantages, including the following:

- Because they look through the camera's lens, passive autofocus systems work with any filters or lens attachments that you might be using.
- They're simply analyzing what the camera is seeing, so they can work through windows, water, or other transparent materials.
- They have no distance limitation, although your camera's autofocus-assist lamp will have some type of limiting distance.
- Unlike non-TTL active systems, you can be sure that a passive system is focusing on something that's actually in the camera's field of view.

On the downside, passive systems do require light in your scene and a subject that has enough detail to produce contrast. However, these limitations are minor, and, as you'll see later, you can usually work around them using one of several techniques.

---

### ADVANCED AUTOFOCUS MECHANISMS

If you have a higher-end digital SLR, such as the Nikon D1, your camera probably uses a more advanced form of autofocus called *phase difference*, or *phase detection*. Phase detection autofocus is a passive TTL metering system that uses a complex arrangement of prisms and two tiny CCD arrays that are placed next to the focal plane. Both CCDs see the same part of the image, but one CCD looks through the left edge of the lens and the other looks through the right edge.

When the lens is focused too close, the image in the left edge of the CCD will be slightly to the left of the right-edge CCD. When the lens is focused too far, the opposite occurs. By analyzing the two images and determining the difference in shift between them, the camera can calculate which way to move the lens and how far it needs to go.

As with other autofocus systems, the quality of a phase difference system depends on its ability to quickly and accurately control the lens motor, as well as its ability to detect what area needs to be in focus.

Phase difference systems are incredibly accurate and generally speedy. In addition, many of these systems are capable of focusing in near darkness. On the downside, some phase difference autofocus mechanisms become less reliable at apertures below f5.6, because as the aperture gets smaller, the CCDs lose their line of sight out of the lens and the mechanism can become confused. In general, though, these systems, whether single- or multispot, are by far the most accurate, quickest autofocus mechanisms available.

### Focus Spots

Obviously, you want your autofocusing system to focus on the subject of your image, not on something else in the scene. Therefore, your camera has a *focusing zone* or *spot* that determines which part of the image will be analyzed for focus. Most cameras simply use a small area in the middle of the frame as the focus target. Sometimes this area is marked with crosshairs or a box.

However, if your subject isn't in the middle of the frame, then there's a good chance that your camera is going to focus on the background of your image, leaving the foreground soft or outright blurry. You can get around this problem by taking advantage of the fact that when you press down your camera's shutter button halfway, the camera calculates focus and then locks it until you either let go of the button or take the picture.

Therefore, if you want to focus on something on the right side of the frame, you can simply point the camera's focusing target (usually the middle of the frame) at that object, press your shutter button halfway to lock focus, hold it, *and then reframe your shot* to your desired framing. When you press the button the rest of the way, the camera will take the picture using the focus that it initially calculated. Figure 7.16 shows an example of this method.

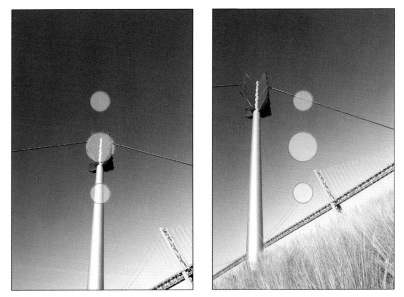

**FIGURE 7.16**    To keep the camera from focusing on the sky, the camera's focusing target was pointed at the arrow shaft, and the shutter release was pressed down halfway to lock focus. The image was reframed, and the shutter button was pressed the rest of the way.

Be aware, though, that there are some potential pitfalls to this technique.

In addition to calculating focus, when you press down your shutter button halfway, your camera also calculates exposure and white balance (if you're using automatic white balance). If the lighting in your frame is substantially different after you reframe from what it was when you locked focus, your camera's exposure could be off. (As you'll see in the next chapter, you can sometimes use this exposure change to your advantage.)

As we explained earlier, automatic white balance mechanisms can be confused when presented with a preponderance of similar colors. When you perform your initial focus, make sure there are no fields of color that might confuse your camera's white balance. For example, if your subject is standing against a bright red wall when you lock focus, and then you reframe so that only a bit of that wall is showing, your white balance could be inaccurate.

Camera manufacturers have come up with two solutions for these problems. The first is a separate *exposure lock* button that allows you to lock your camera's exposure and focus independently. (See Figure 7.17.) Different exposure lock features work in different ways, but most allow you to do something like this: frame your shot, measure and lock the exposure, move your camera and lock focus on your subject, and then return to your final framing with everything ready to go. As we'll see later, exposure lock is also necessary for taking good panoramic shots.

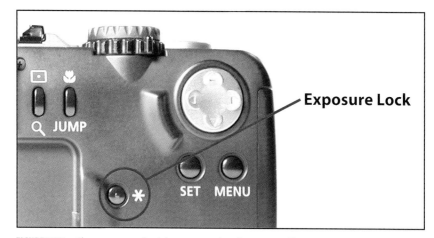

**FIGURE 7.17**    The exposure lock button on the Canon G1 allows you to lock focus and exposure independent of each other.

Other cameras include multiple focus zones—usually three, sometimes as many as seven. A camera with multiple focus spots analyzes several different points in your image to determine where your subject might be. Once it has decided, it analyzes the focus spot or spots closest to that subject to calculate focus. (See Figure 7.18.) This process allows you to frame your image as you like without having to worry about your subject being in the middle of the frame. However, it's important to pay attention to where the camera is focusing, because it will often pick the wrong subject. Consequently, some cameras let you manually select a focus point to ensure that your autofocus mechanism analyzes the right area. Most cameras with multispot autofocus mechanisms also allow you to put the camera into a single, *center-spot focusing* mode (sometimes called *spot focus*), which forces the camera to behave like a normal single-spot autofocus camera.

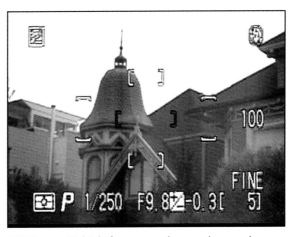

**FIGURE 7.18**   Multiple focus zones let you choose where the camera's autofocus mechanism will look when it determines focus.

If your camera uses a TTL contrast-detection focusing system, the center focusing spot (no matter how many focus zones the camera has) is usually a *dual-axis zone*. That is, it examines contrast along both a horizontal and vertical axis. If the camera has multiple focus spots, there's a good chance that the other zones are *single-axis zones*, which measure only contrast (and, therefore, focus) along a horizontal axis. For locking focus on horizontal subjects, such as horizons, a single-axis zone can be problematic. For these situations, you might want to force the camera to use its center, dual-axis zone.

If there's any one rule to using an autofocus camera—whether a single-spot or multispot focusing system—it's simply to pay attention. Don't just assume that the camera will be able to calculate everything accurately. If your camera has a single-spot focusing system that sometimes requires you to lock focus and reframe, be sure to look for any potential metering and white balance troubles before you shoot. If your camera has a multi-spot focusing system, be certain that it has chosen the correct subject and focusing zone.

### What to Do If Your Autofocus Won't Lock Focus

If you're using a contrast-detecting autofocus system, there will be times when it won't be able to lock focus. Shooting in low light is especially problematic, because there might not be enough contrast in your scene for the camera to detect focus. Hopefully, the camera has an automatic focus-assist lamp that will activate to light the scene. If the focus-assist lamp lights up and the camera still can't focus, try moving the camera slightly. You might illuminate something that has enough contrast for the camera to be able to focus, but be careful that the camera doesn't focus on something at the wrong distance.

Autofocus mechanisms can even get confused in bright daylight if your camera is pointed at something with low contrast. In Figure 7.19, you can see that the middle of the frame is filled with an object that is a solid color (the lamp). In this case, the lamp had so little contrast that the camera's contrast-detecting autofocus system was unable to focus. By tilting the camera up so that the focusing target sits on top of a part of the lamp with more contrast, the autofocus mechanism can find and lock focus. After locking focus, we tilted the camera back down to our desired framing, as shown in the image on the right. Always be certain to choose an image with more contrast that's at the same distance as the area you want to focus on.

### Manual Focus

Your camera's autofocus system is probably all the focusing control you'll ever need. However, if you run into a situation where your camera can't autofocus and you can't work around it, or if you have a particularly "creative" shot that you want to compose, you might need to resort to your camera's manual focus. (This is assuming that you're using a prosumer-type camera that lacks interchangeable lenses with focus rings. If you're using an SLR, you'll probably be regularly switching between automatic and manual focus.)

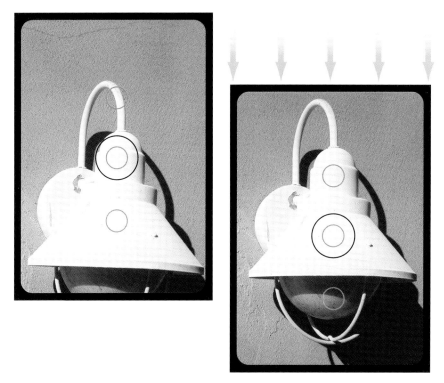

**FIGURE 7.19**  Because this white lamp is a solid color, there's little contrast for a camera's contrast-detecting autofocus mechanism to detect. To get the camera to lock focus, you must frame the shot at a point where there is some contrast, lock focus, and then reframe. (Be sure you lock on a point that's the same distance away as your subject.)

Unfortunately, manual focus features on non-SLR digital cameras leave a *lot* to be desired. Between poorly designed controls and viewfinders that lack focusing aids, getting an accurate manual focus out of your camera can be difficult. A few years ago, most digital cameras simply offered you a choice of distances. Consequently, in addition to trying to estimate the distance to your subject, you had to hope that the camera provided a preset focus distance that was close to what you needed.

Some digital cameras still work this way, but most manual-focus mechanisms are now more robust, letting you smoothly move throughout the focus range of your camera. However, determining when you've achieved focus is still difficult, because neither your camera's LCD screen nor optical viewfinder will be good enough to let you see focus.

Fortunately, because digital cameras typically use very small apertures, and because small apertures create such deep depth of field, you

often don't have to worry about your focus being dead on. You can further improve your chances of getting good focus by using your camera's manual controls to set as small an aperture as possible when you're using manual focus.

Even if your camera doesn't have a full manual-focus control, it probably has a preset control for locking focus at infinity. This can be a handy feature for landscape photography or for other times when your subject is far away. Lock your camera's focus at infinity and it will perform faster—it won't be trying to autofocus—and your batteries might last a little longer—the camera won't be moving the lens.

## METERING

When you press your camera's shutter button, you expose the camera's image sensor to light. By adjusting the camera's shutter speed and aperture size, you can control how much light will reach the sensor, but how do you know how much is enough? By using your camera's light meter.

At the simplest level, a light meter helps ensure that your pictures are not too bright or too dark, so that you can actually see the subjects in your image. But as your photographic expertise grows, your light meter will help you more accurately capture a picture that is true to your "artistic vision." With a little thought and planning, your light meter—and the associated exposure controls—becomes the most powerful creative tool on your camera. In this section, you'll learn the basics of metering and look at what exposure options you have when you shoot with your camera in automatic mode. Manual controls and advanced exposure topics will be covered in Chapter 8.

### What Your Light Meter Tells You

To really know how to get the most from your camera's built-in light meter, it's almost as important to understand what it *cannot* do as it is to understand what it *can* do. The light meter on a typical point-and-shoot, prosumer, or even most higher-end cameras cannot tell you anything about the colors in your scene, how much contrast there is, or how to preserve all of the detail that's present. In other words, your light meter doesn't tell you (or your camera) the *best* exposure for the scene you are shooting. Rather, your light meter simply tells you an *adequate* exposure for the scene you are shooting—one that will not grossly over- or underexpose your image. In many cases, you will take your meter's adequate reading as a starting point and build from there into the best exposure.

The photographic process is complicated by the fact that your eyes can see a much greater range of light to dark—as well as far more color—than can your digital or film camera. Your eyes' greater sensitivity to light is one of the reasons that it's difficult to capture a photo that looks like the actual scene—your camera simply can't record all the light that you're seeing.

As you learned earlier, each time you change your aperture or your shutter speed setting by one full stop, you are doubling or halving the amount of light that hits the focal plane. Open your aperture by a stop, and the amount of light doubles. Close it one stop, and the amount of light is halved. In other words, a "stop" is a measure of light. The human eye can perceive a range of 16 stops of light, whereas a digital camera can typically capture only four or five stops of light. Therefore, when shooting a picture, you have to decide which four or five stops you want to capture. These days, a good light meter will almost always pick a range of stops that yields a good image, when shooting in a bright, evenly lit situation. At other times, things can be more complicated.

For example, consider Figure 7.20. In real life, the bottom of the canyon and the blue of the sky were visible to the eye. However, because the camera (a Canon G3) could capture only about five stops of light, it was not possible to shoot a single exposure that would properly expose both the depths of the canyon and the bright sky above. So, though we can see detail in the canyon in the first image, we see no detail in the sky. In the second image, we have the exact opposite problem. When metering, you'll sometimes have to choose which areas of detail you want to preserve.

As you've probably already guessed, your light meter is the tool that you use to determine appropriate exposure settings for whatever range of light you ultimately choose to capture.

Your light meter does only one thing: it measures the *luminance* of the light reflected by your subject. Whether it measures the luminance of the entire scene or just a part of it depends on the type of meter you are using.

Figure 7.21 shows a grid with an equal number of black and white squares. If you were to measure this grid with a light meter, you would find that it is reflecting 18 percent of the light that is striking it. (Yes, it might seem like it should be reflecting 50 percent of the light, but it's not.) The luminance of most scenes averages out to be the same as this grid—that is, most scenes in the real world reflect 18 percent of the light that strikes them. Because this is a measure only of luminance (not color), you can also think of this 18 percent reflectance as a shade of gray. Therefore, this particular gray shade is known to photographers as *18 percent gray* or *middle gray*.

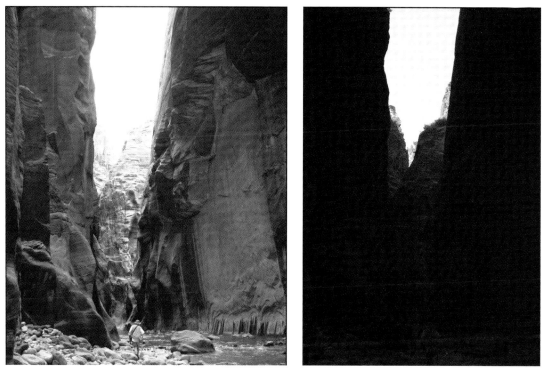

**FIGURE 7.20**    Because of the huge range of light to dark in this canyon, it was not possible to take a single exposure that captured both the bottom of the canyon and the sky above. In Chapter 14, you'll see one way to solve this particular exposure problem.

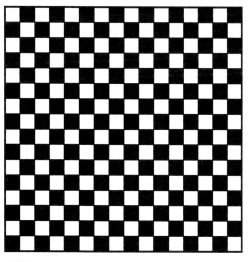

**FIGURE 7.21**    Although each of these squares is black or white, the entire field of squares meters as 18 percent, or middle gray.

The most important thing to know about your camera's light meter is that *it always assumes that it is pointed at something that is 18 percent gray.* In other words, your light meter calculates an exposure recommendation that will accurately reproduce middle gray under your current lighting. Because a typical scene reflects 18 percent of the light that hits it, this assumption is usually fairly accurate. Obviously, if the lighting in your scene suddenly changes, the readings will no longer be accurate (even if the scene is still reflecting 18 percent of that light), and you'll have to re-meter.

However, because your scene might not be exactly 18 percent gray, to get the best results from your light meter, you'll want to meter off of something that is middle gray, such as an 18 percent gray card. Readily available at any photo supply store, you can simply place this card in your scene and use it as the subject for your metering.

Unfortunately, though 18 percent gray is often a good assumption, it's not always correct. For example, the left image in Figure 7.22 was shot using the camera's default metering. The image is neither too bright nor too dark—in other words, the meter did a good job of picking a range of stops that yields a good image. However, the black statue appears a little grayer than it did in real life. This is because the camera is *assuming* that the statue is gray, and so is calculating an exposure that will correctly render the statue as *gray*.

**FIGURE 7.22**    Though the left image looks good, the camera's default metering did not render the statue in its true black tone. By underexposing, we were able to produce a truer representation in the right image.

In the right image, we underexposed the image to render the statue in its true, blacker tone. Note that by underexposing we also got a better rendering of the brightly lit columns in the background. Because they're not overexposed anymore, you can see more detail on them. In other words, we took the camera's initial metering as a starting point, then modified it to capture a range of tones that is more accurate.

Note that this adjustment does not mean that there's something wrong with our light meter. The light meter was actually doing what it's supposed to do.

Just as we underexposed to restore the blacks in the image, if you're shooting something white—or if you're in a white environment, such as snow—you'll need to overexpose to correctly render white objects as white, rather than as middle gray.

Colors have a luminance—or tone—just as black-and-white images do and, therefore, need the same type of compensation for accurate re-production. For example, look at Figure 7.23. The left image was shot with the camera's recommended metering, whereas the right image was underexposed by a third of stop because the red color of the scooter was a bit darker than 18 percent gray. Simply put, by overexposing your im-ages, your colors will become lighter; underexposing will make your col-ors darker. Such adjustments allow you to either restore the right color to the objects in your scene or intentionally boost or decrease the saturation of objects within your scene.

As stated earlier, your camera's light meter generates exposure set-tings that create an adequate picture. In general, your camera's meter will yield images with good color and proper exposure throughout the shadows and highlights. However, because of your light meter's assump-tions, your picture might come out lacking details in some highlights or shadows. Or, it might look a little flat, because darker or lighter tones will all be rendered as middle tones. With some simple exposure adjustments you can turn these images from adequate to exceptional, yielding images with improved color accuracy, contrast, and saturation (or tonal accuracy and contrast, if you're shooting black and white).

## The Right Meter for the Job

Your camera probably offers a choice of different metering modes. These are usually selected from a button on the camera's body, or from a menu within the camera's menu system. (Note that if you're in a fully auto-matic shooting mode, you probably cannot change the metering mode.) To shoot a well-exposed image, you need to choose a metering mode that's right for your scene.

**FIGURE 7.23** Through careful choice of exposure when shooting, you can capture images with better color saturation.

### Matrix Metering

A *matrix meter* (sometimes called a *multisegment meter*) divides your image into a grid and takes a separate meter reading for each cell in the grid. These cells are then analyzed to determine an exposure setting.

Matrix metering is the best choice for most situations and is certainly the best option when you're simply trying to get a quick shot using your camera's automatic features. However, as you saw earlier, there will be times when you'll need to make some adjustments to your matrix meter reading. You might need to over- or underexpose to restore proper tone to your images, or you might need to bias the camera in a particular direction if you're shooting a scene that has more than four or five stops of tonal values. Your main concern when you use a matrix meter is to understand how it will preserve shadow and high-

light areas. Try to find some locations that have both bright highlights and dark shadows, and spend some time experimenting with your camera's capability to preserve shadow information. Then, try to determine how far you can overexpose before you blow out bright areas, such as skies. This information will inform the exposure-adjustment decisions you'll be making later.

### Center-Weighted Metering

A variation of matrix metering, *center-weighted metering* also divides your image into a grid of cells, but when analyzing the readings, a center-weighted metering system gives preference to the cells in the middle of the image. Typically, the middle 80 percent of the cells are considered more important than the outlying regions. Center-weighted metering is designed for those times when your subject is in the middle of your frame, and your background contains bright lights, dark shadows, or other extreme lighting situations that might throw off the metering in the center of your image.

### Spot Metering

A *spot meter* measures only a small area of your image, usually the center. The metering from this area is the only information used to calculate an exposure. The most common use for a spot meter is for dealing with extremely backlit situations—a person standing in front of a window, for example—that would normally cause your camera to underexpose your foreground. Spot meters can also be handy with dark backgrounds, such as the one shown in Figure 7.24. In the top image, the background is deeply shadowed and has lost detail. By activating the camera's spot meter and metering off of the shadowy background, the camera produces an image with much better shadow detail. Unfortunately, some foreground detail and color saturation was washed out in the process.

For serious exposure calculation, a spot meter is essential. However, if the camera of your choice doesn't have a spot meter, you can always use an external spot meter, as long as your camera provides manual-exposure controls.

### Automatic Exposure

If you're shooting using your camera's automatic mode, it will automatically meter and select an exposure whenever you press down the shutter release halfway. As you saw earlier, the camera's meter makes a number

**FIGURE 7.24** Switching from the matrix meter to the spot meter made it possible to reveal more detail in the shadowy background area, albeit at the cost of overexposed highlights.

of assumptions about the contents of your scene, the main one being that your scene has an average reflectance of 18 percent. This is great for most scenes, but if you point your camera into a bright white, highly reflective

field of snow, your meter will be dead wrong, because rather than telling you the correct exposure for bright snow, it will tell you the correct exposure for middle gray. Your white snow will then come out gray.

When you shoot a scene that's brighter or darker than middle gray, you need to correct for your meter's assumption by over- or underexposing your shot. In the old days, if you were using a manual film camera, you would over- or underexpose by adjusting your camera's aperture and shutter speed controls. If you're using your digital camera in its automatic mode, or if your digital camera doesn't have manual shutter speed and aperture controls, you'll have to use other tricks to force a change in exposure.

Fortunately, almost all digital cameras these days offer exposure compensation features—simple controls that let you easily over- or underexpose by up to two stops, usually in 1/2- or 1/3-stop increments. If you think your scene needs to be overexposed by a stop, simply press the + exposure button twice (assuming your exposure compensation increments in half stops). Exposure compensation controls are the quickest and easiest way (and on some cameras, the only way) to make exposure adjustments.

When you shoot in automatic mode, most cameras will opt for a high shutter speed to help ensure a sharp image—slower speeds can result in a blurry image if you're not holding the camera steady. Similarly, when you use exposure compensation, most cameras try to achieve the requested change in exposure by changing shutter speed. When this isn't possible, either because the camera's shutter can't go any faster or because slowing the shutter speed would risk blurring the image, the camera will make changes to aperture. Sometimes, the camera will make slight changes to both shutter speed and aperture. Fortunately, these changes are usually minor enough that you won't see any change in the camera's ability to freeze motion or in the image's depth of field.

### CONTROLLING EXPOSURE WITH YOUR LIGHT METER

*Using a built-in light meter, you can force an over- or underexposure by pointing the camera at something darker or lighter. Meter off of a darker subject, and your camera will overexpose. Meter off of a lighter subject, and you'll get an underexposure. (See Figure 7.25.) However, because your camera will probably lock focus at the same time as exposure, you'll need to be certain that you are metering off something that is at the same distance as the image you would like to have in focus, or use your camera's exposure lock feature (if it has one).*

Exposure compensation controls are powerful tools, and you will continue to use them even after you've learned some of the more advanced techniques that will be covered in the next chapter. Get comfortable with

**FIGURE 7.25**   The upper-left image was exposed using the camera's default metering, which obviously biased itself toward the bright window, leaving the rest of the room in darkness. By tilting the camera down, we were able to force the camera to more accurately meter for the dark tones in the image, resulting in the lower-left picture. Finally, we cut the properly-exposed window from the dark frame, and composited it with the well-exposed image to produce the final composite shown in the lower-right. You'll learn more about compositing multiple exposures in Chapter 8.

your camera's exposure compensation controls, learn how to use them quickly, and begin learning how to recognize how much compensation is necessary for different situations. Because there are no hard-and-fast rules for over- or underexposing, you have to go out and practice!

## SIMPLE FLASH PHOTOGRAPHY

Using your camera's built-in flash is pretty simple: just turn it on and let the camera worry about when and how much to fire it. Using your camera's built-in flash *well* is a bit more difficult. Unfortunately, the small

flash units provided by most cameras are low powered, and because of their positioning on the camera, they don't often produce very flattering light. However, your camera's built-in flash does have its uses, and with a little know-how you can get it to yield good results.

When you shoot a picture using your flash, many things happen in a short amount of time. First, the camera opens its shutter and begins exposing the image sensor according to the settings defined by you or your camera's light meter. Then, the camera turns on the lamp in its flash unit. With the lamp on, the camera begins measuring the flash illumination that is bouncing off of the subject and returning to the camera. In this way, the camera can meter the light of the flash while it's flashing. When it has decided that the flash has cast enough illumination, it shuts off the flash, finishes the exposure, and closes the shutter.

## Flash Modes

Most digital cameras provide several different flash modes. If you're shooting in a fully automatic mode, your camera will try to determine, on the fly, whether the flash is needed. If it deems the flash necessary, it will fire it for the appropriate amount of time. In addition to this mode, your camera probably provides the following:

**Fill:**   This mode uses the flash to fill in shadows. It is typically used for backlit situations or other instances where you're shooting in bright light but your subject is in shadow. Usually, the camera uses a lower power flash setting so as not to overexpose the shadows in your image.

**Force flash:**   Force flash mode simply forces your camera's flash to fire, whether or not the camera's light meter thinks a flash is necessary. Not all cameras have both fill and force flash. If your camera lacks a fill mode, you can use the force flash mode, although the resulting image might be somewhat overexposed, because the camera will fire the flash at full intensity.

**Red-eye reduction:**   The "red-eye" effect (see Figure 7.26) occurs when the light from your flash bounces off the retinas of your subject's eyes as they look into the lens. If the flash on your camera is placed close to the lens, there's a much better chance of getting red-eye, because it's easier for the light to bounce straight back into the lens. Red-eye reduction modes work by firing a flash, or the camera's autofocus-assist lamp, to close the subject's pupils. When you use these modes, be sure to inform your subject that there will be two flashes. Otherwise, they might move or close their eyes after the first firing.

**FIGURE 7.26**    Red-eye is prevalent in small cameras because of the position of the flash. Fortunately, correcting the problem is fairly simple using tools found in most image editors.

Whether you're shooting with or without a red-eye reduction flash, moving slightly to one side before you shoot can prevent your subjects from looking directly into the camera's lens. You can also try turning on all the lights in the room in an attempt to narrow everyone's pupils.

*OL' BLUE, ER, RED EYES...*

*Generally, people with lighter-colored eyes are more susceptible to red-eye in photographs than people with darker-colored eyes. Probably the worst red-eye situation is shooting a blue-eyed person in a dark room. When you shoot lighter-eyed people, it's a good idea to take the time to review your images on your camera's LCD. If your camera has a zoom feature in its playback mode, zoom in and check out the eyes. You might find you need to reshoot.*

**Cancel:**    This feature simply deactivates the flash. This isn't exactly a mode, but it is important for times when you're shooting in an area where a flash is not appropriate or when you want to handle low light in a different way.

Spend some time using the different flash modes on your camera to learn their characteristics. In particular, determine if the flash consistently over- or underexposes, and if it tends to produce odd color casts. If so, you might want to adjust its settings as described in this section.

After the flash has fired, any leftover charge is saved for the next firing. Consequently, your flash's recycle time can vary depending on how much it had to fire. In other words, you'll get faster recycle times when you use your flash in brighter light, because the flash won't have to fire for as long and, hence, won't have to recharge as much.

One problem with onboard flashes is that they're really not positioned to provide flattering light. Our eyes are used to a strong overhead light source, so flashing a bright light directly in front of a subject usually produces a somewhat weird lighting perspective. In addition, a poor flash exposure can result in harsh lighting with overblown highlights and hard-edged black shadows if the flash fired too much, or an underexposed image if the flash fired too little. (See Figure 7.27.)

**FIGURE 7.27**    At times, you might find that your camera's onboard flash creates harshly lit scenes with blown-out highlights. Flash exposure compensation lets you dial down the power of the flash for better exposure.

Fortunately, many cameras offer flash power adjustment controls—sometimes called *flash exposure compensation*—that let you increase or decrease the power of the flash by one or two stops in either direction. After a test shot, you might find that your camera's flash is too strong. Dialing down the power by a stop or so might be enough to produce a much better exposure.

Remember that your camera's flash has a limited range, usually no more than 10 or 15 feet. Consequently, as your focal length increases, your flash's effectiveness decreases. That is, if you zoom in on an object 20 feet away, don't expect your flash to do a great job of illuminating it. Increasing the flash power by a couple of stops might improve your flash performance at these distances.

## Flash White Balance

Your flash is usually not the only source of light in a room. In most cases, you'll be shooting flash photos in a room that also contains incandescent or fluorescent lights and maybe even sunlight. All of these light sources can serve to create a complex, mixed lighting situation that requires a special white balance.

Some cameras have a separate white balance setting for flash that can often correct color-cast problems, but on most cameras, automatic white balance will yield the best results. In fact, on most cameras, using anything *but* automatic will yield bad results.

To get an idea of your how your camera white balances when you use the flash, take some test flash pictures indoors under normal incandescent (tungsten) lighting using the camera's automatic white balance. If the images come out with a slightly blue cast or if the highlights are blue, the camera's white balance chose to favor the room's tungsten lighting. If the images come out a little yellow or have yellow highlights, the camera white-balanced in favor of the flash.

There's little you can do about these color casts. Sometimes dialing down the flash's power will reduce the effect, or you can try to filter your flash. If you find blue highlights in your flash pictures, buy some yellow filter material at your camera store and tape a piece of it over your flash. This will balance your flash for tungsten, making it better match the indoor lighting (which your camera is white-balancing for anyway).

### Fill Flash

One of the most important things to learn about your flash is that *it is not just for shooting in low light!* Your camera's fill flash mode is a great tool for shooting better pictures in bright sunlight.

As you already learned, your camera captures a much smaller range of light than what your eye can see. Consequently, when shooting outside, you'll often find that the sky is much brighter than your subject. Most matrix metering systems will favor the sky when metering, causing your subject to be rendered too dark. If your camera has a spot meter, you can work around this problem by spot-metering off of your foreground subject, which will cause the background to overexpose and wash out completely.

A better solution is to activate your camera's fill flash. This will throw enough light on your foreground that the camera will properly expose both the foreground and background. (See Figure 7.28.)

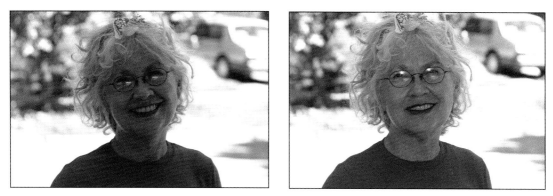

**FIGURE 7.28**    Don't think your camera's flash is just for shooting in dark, low-light situations. Even in bright sunlight, you might sometimes need to use flash to compensate for a bright background or for shadow-producing hats, trees, or buildings.

This is the same practice that you'll use in a brightly lit room to counter any backlighting caused by bright windows. Fill flash is also great for subjects who are wearing hats or are shaded by overhanging trees or other foreground objects. Usually, the bright outdoor light will be so strong that your flash will provide a rather soft fill light, with none of the harsh shadows you might see indoors or in lower light.

### Slow-sync Flash

This may sound strange, but one of the troubles with using your flash in a dark environment is that the resulting picture doesn't look dark. That is, of course, the point of a flash, but if you're trying to capture the atmosphere of a dark environs or of a nighttime scene, your flash is not going to render an authentic image.

When you shoot with your flash, your camera calculates an exposure that's appropriate for the subject that's being illuminated *by the flash*. In Figure 7.29, our subject is brightly lit by our flash, but the background details are completely dark because the camera did not have enough time to expose them properly, and the flash was not powerful enough to illuminate them.

**FIGURE 7.29**  This exterior night shot was illuminated only by our flash. Though it did a good job of exposing our subject, nothing in the background is visible, because the camera chose a shutter speed that was appropriate only to capture the flash-illuminated woman.

Most digital cameras provide a special slow-sync mode, which combines a long exposure with a flash to produce a more evenly exposed image. (See Figure 7.30.)

In slow-sync mode, the flash illuminates your subject, and the longer exposure time creates a well-exposed background. The resulting image looks more realistic and is more evocative of a darker milieu. In general, your camera will not select a tremendously long exposure, so the flash will be enough to freeze your subject so that it doesn't appear motion-blurred in the final image. However, for best results, you should tell your subject not to move until you say so. If they move as soon as the flash fires, there's a good chance that they'll be blurry in the final image. (See Figure 7.31.)

**FIGURE 7.30**    This image was shot a few seconds after Figure 7.29, using the camera's slow-sync mode. The flash was fired to illuminate the subject and freeze her motion, but the shutter was left open for several seconds to capture the background, resulting in an image that reveals far more detail. If we had used only a slow shutter speed, our subject would most likely have been blurry.

**FIGURE 7.31**    When shooting in slow-sync flash mode, your flash can do a good job of freezing motion, but because you'll be using such a long shutter speed, you'll still need to tell your subjects to stay still, and you'll ideally want to use a tripod. In this image, both the camera and subjects moved during the exposure, resulting in a weird double-exposure effect.

## POWER AND STORAGE MANAGEMENT

Film cameras do have one marked advantage over digital cameras: they don't *have* to have batteries. With an all-manual film camera, all you need is film (as long as you don't want a light meter), making it simple to go on long photographic excursions without carrying batteries, battery chargers, and laptop computers.

Digital cameras are not so efficient. For a few days of shooting, you probably won't have to worry too much about batteries and storage when you use your digital camera, unless you're very shutter happy or have a tiny storage card. For long trips, though, you'll want to make some effort to conserve and maximize both batteries and storage.

### Feel the Power

The easiest way to allay your power fears is simply to buy lots of batteries. If your camera uses a custom, proprietary battery, buy an extra. If your camera didn't ship with an external charger (that is, you have to recharge batteries in the camera), you might want to spring for a charger as well.

If your camera uses AA-size batteries, pick up two sets of NiMH rechargeables and a charger. NiMH batteries don't usually reach their full level of performance until they've been charged a couple of times, so make sure to give them good strong charges the first few times you recharge them. Unlike NiCAD batteries, you don't have to drain NiMH batteries before you charge them because they have no "memory effect," so after the second recharging, feel free to "top them off" before you go shooting. Be aware, though, that NiMH batteries will lose their charge over time, whether they're in or out of your camera. A month on the shelf is often enough for them to drain completely, so if you haven't used your batteries in a while, be sure to give them a good charge. In addition, once they're fully charged, take them out of the charger. Leaving the batteries in the charger, constantly recharging, can shorten their life.

Obviously, when you travel abroad, you'll need to buy the appropriate adapters and converters to power your charger, as well as any other equipment you might choose to bring along.

Even with a spare set of batteries, it's a good idea to get in the habit of shooting with an eye toward battery conservation. The two systems on your camera that use the most power are the LCD screen and the flash. If your camera has only an LCD viewfinder (or if you prefer using the LCD viewfinder), you might want to conserve power by limiting the amount of time you spend reviewing images on the LCD screen.

Your camera probably has a sleep mode that causes it to switch to a low-power setting if you don't use it for a while. Try to get a feel for how long it takes the camera to wake up. You might need to wait an extra two to five seconds if your camera has gone into its sleep mode. Most cameras doze off if you don't use them for 30 seconds. This is fine for everyday, snapshot shooting, but it can be a real bother if you're shooting portraits or other studio work that requires a long setup. For these occasions, you might want to change the sleep time to its maximum (15 to 30 minutes). If you know you're going to be away from the camera for a bit, turn off the LCD screen to conserve power.

Over time, you'll get a better idea of how many pictures you can expect to get from a set of batteries. However, there will still be times when your batteries will wane before you're done shooting. For these instances, you might want to employ some of the following battery-saving measures:

- Switch off your camera's LCD and use the optical viewfinder. If your camera doesn't have an optical viewfinder, turn off the LCD whenever you're not framing a shot. In addition, if your camera's LCD provides a backlight that can be turned off, turn it off.

- Some cameras include a "review" setting that lets you specify how long an image will be displayed on the LCD after you shoot. Turn off this review, or at least set it to its smallest value.

- Try to avoid flash pictures. If you have to shoot in low light, switch to a higher ISO, or try long exposures from a tripod.

- Switch to a smaller storage card. Higher-capacity cards consume more power, so a smaller card can sometimes let you coax one or two more pictures out of your batteries. If you use an IBM MicroDrive, try switching to a flash memory card, because they use less power.

- Turning your camera off and on often uses more power than simply letting it sleep. (Turning it off and on usually causes the camera to zoom the lens a lot.) Unless you know it will be a while until your next shot, simply let your camera sleep.

- If your camera offers manual focus and zoom features, switch to these.

- If your camera doesn't offer a usable manual focus, but you know that your pictures will all be shot at the same distance (infinity, for example), lock the camera's focus on infinity. Keeping the camera from autofocusing will save a tiny bit of power.

- If you need to transfer pictures to a computer in the field, don't use your camera's cable connection. Use a media drive or PC card adapter instead.

Finally, be aware that cold temperatures will noticeably shorten battery life. If you're shooting outside in below-freezing temperatures, your batteries will probably die quickly. You can often squeeze a little more power out of them by taking them out of the camera and warming them up inside your pocket. This might sound hard to believe, but it's true. A few minutes inside your coat can often get you an additional dozen pictures. Don't put the whole camera in your pocket—this will most likely fog up your lens. (See the cold weather tips in Chapter 9, "Special Shooting.") Lithium batteries (not to be confused with L-Ion rechargeables) often stand up much better to cold weather than do NiMH or alkaline batteries.

## Media Baron

Earlier in this chapter, you read about some image size/compression strategies for saving media. Although these practices can make your storage go farther, the ideal solution is simply to buy more media cards. The price of media cards continues to drop, but if you tend to shoot *lots* of images, or if you're planning an extended trip, consider some of these storage alternatives.

### Laptop Computers

For longer trips, take a laptop computer. In addition to giving you a place to store images, you'll have a complete darkroom with you. With a laptop and your favorite image-editing application, you can assess right away whether your day's shooting was successful and determine if you need to reshoot something. Be sure to bring all necessary power, media adapters (or drives), and cables.

### Portable Battery-Powered Hard Drives

If you don't feel like lugging around your laptop computer, consider a standalone battery-powered hard drive device such as the SmartDisk® FlashTrax® or the Delkin® PicturePAD®. (See Figure 7.32.) Measuring roughly the same size as a paperback book, these battery-powered devices contain a hard drive, a media slot, and an LCD screen. Simply insert the media from your camera into the slot, and you can back up your images to the internal drive. You can then put the card back into your camera, erase it, and start shooting again. With either device, you can use the built-in LCD screen and simple controls to view and delete images, or build slide shows that can be displayed on a TV via a standard video out port. Because they're built around standard laptop computer hard drives, these types of

**FIGURE 7.32**   The Delkin PicturePAD provides up to 60 GB of portable battery-powered storage providing a small, high-capacity location to offload your images, letting you free your storage cards for more shooting.

devices deliver a much cheaper price-per-megabyte than any type of flash card. Though bigger and heavier than a handful of flash cards, they offer a tremendous amount of storage in less space than a full-blown laptop. (See *www.completedigitalphotography.com/harddrivestorage* for more details.)

 *IF YOU'RE CARRYING AN IPOD® ANYWAY...*

*If you're already traveling with an Apple iPod that has a dock connector (as opposed to the original iPod, which had a 6-pin FireWire port), you might want to consider a Belkin® Media Reader (Figure 7.33), a device about the size of the iPod that attaches to the iPod's dock. Belkin makes two media readers, each powered by 4 AAA batteries. The Media Reader for iPod attaches to your iPod's dock connector and includes a media slot that can accept the media cards from your camera. Insert a card and it's automatically copied to your iPod. Similarly, connect the Belkin Digital Camera Link to your iPod's dock connector and string a USB cable between the Camera Link and your camera, and your pictures will automatically download to your iPod. In either case, you can retrieve them later by attaching your iPod to your computer. Be warned, though, the Belkin Media Reader is a slow device. Slow enough that you might use an entire iPod battery charge by transferring one or two*

*512-MB cards. The Camera Link is much faster, but will use up some of your camera charge in the process of transferring. However, if you're already carrying an iPod (and you've got extra space available), these devices provide a simple, cost-effective place to offload images. See www.completedigitalphotography.com/belkin for more info.*

**FIGURE 7.33**   If you have an iPod, you can use one of Belkin's media-reading devices to transfer images from your digital camera to your iPod for on-the-road offloading.

### Blank CDs, Cables, and PC Adapters

Finally, you can simply carry around some blank CD-ROMs and all of your camera's connectivity options. Then, you need only to find a service bureau, an Internet café, or a friend with a computer to burn your camera's images to your blanks. Obviously, your service bureau or friend will need a CD burner and the appropriate port. If they're running an older operating system that doesn't automatically download images, you'll need to bring the transfer software provided with your camera.

### HEDGE YOUR BETS BY OFFLOADING

*Even if you have a very large storage card—one that can hold all of the pictures you might conceivably need to shoot—it's still a good idea to offload some images from time to time. Media cards can crash, so backing up to another form of media is a good way to ensure that you won't lose all of your images in the event of a storage crash. If you have the space, consider making more than one backup.*

## And That's Just the Beginning!

The automatic modes on many digital cameras can do an extraordinary job of metering, white balancing, and shooting. Even the best photographic algorithms can be fooled, however, and none of them really know how to do anything but take "correct" pictures. For tricky lighting situations, or for times when you want to break the rules, you're going to have to take control of your camera—and that's the subject of the next chapter.

.

# MANUAL EXPOSURE

**In This Chapter**

- Motion Control
- Depth of Field
- Shutter Speed and Depth of Field
- Tonal Control
- Adjusting Exposure
- Of Brackets and Histograms
- Exposing to Avoid Purple Fringing

Ａs you've probably already discovered, your digital camera's automatic shooting features can—and usually do—produce great pictures. Some of today's sophisticated matrix metering systems go far beyond simple light metering and offer a level of sophistication that's roughly akin to having an experienced photographer with a spot meter standing by your side.

However, like all automated systems, the light meters in your camera have to make certain assumptions, and most meters assume that you want to take a "correct" photograph. That is, most cameras will produce images with good tone and contrast and with the subject clearly in focus. There will be times, however, when you might disagree with your camera about what the subject of your image is. Or, perhaps you have different ideas about focus, contrast, or tone.

In these instances, you need to throw your camera into manual override and start making some exposure decisions on your own. Manual exposure controls allow you to create images that are very different from what your camera's automatic features might deem "correct." They also allow you to shoot higher-quality images by affording you more control of the color and contrast that your camera will produce.

Your exposure choice determines more than just how bright or dark your image will be. By changing your camera's exposure, you can alter four characteristics of an image:

- Motion control
- Depth of field
- Tonality
- Detail

Selecting the proper exposure involves balancing these choices against what your camera is capable of under your current lighting. To get the most out of this chapter, you'll need to have an understanding of the reciprocity concepts discussed in Chapter 3, "Basic Photography: A Quick Primer," and the basic metering theory introduced in Chapter 7, "Shooting."

## MOTION CONTROL

Controlling motion in your image—that is, controlling how much your camera freezes motion as opposed to letting it blur—is an intuitive process. Simply set your shutter speed higher to freeze motion, lower to let things blur. Once you dip below 1/30th of a second, you'll need a tripod to hold the camera steady; otherwise, camera shake will introduce unwanted blur into your image. (See Figure 8.1.)

**FIGURE 8.1**    Normally, your camera aims to freeze motion by using a fast shutter speed. By choosing slower speeds you can introduce blur into your images.

Slow shutter speeds are also handy for shooting in very low light. By leaving the shutter open for several seconds, or even minutes, your camera's image sensor can gather enough light to create an image. However, be warned that at longer shutter speeds, your image will get noisier and noisier. (See Figure 8.2.) The sensors in most consumer digital cameras are designed for exposures of less than one second. In addition to producing noisier images, at longer shutter speeds, many of the individual pixels in the camera's sensor might begin to behave strangely, sometimes getting "stuck" so that they appear bright white.

Some cameras employ special noise-reduction schemes when you shoot at speeds longer than one second. Most of these schemes employ some form of *dark frame subtraction.* When this feature is enabled, any time the camera shoots an image longer than one second, the camera automatically shoots a second frame, this time with the shutter closed. Because the exposure is the same, the pixels in the camera's CCD have time to malfunction in exactly the same way they did in the first image. However, because the shutter is closed, the resulting black frame is essentially a photograph of only the stuck, noisy pixels from the first image. The camera then combines the images, essentially subtracting the second frame from the first. Because the second frame contains only the noise, the resulting image is much cleaner.

If your camera doesn't have such a feature, you can perform it yourself by simply putting your lens cap on and taking a second image with the same exposure settings. In Photoshop, you can subtract the black

**FIGURE 8.2** During long exposures, your images will get noisier and noisier, unless your camera offers some form of long-exposure noise reduction.

frame from the image frame. Chapter 13, "Essential Imaging Tactics," covers the details of performing dark frame subtraction.

The amount of noise in an image is strongly affected by the temperature of the camera's image sensor, so be sure to shoot your dark frame right away to ensure that both images are shot with the camera at the same temperature. A difference of even one or two degrees will result in enough change in noise that the technique won't work.

Because long-exposure images are usually noisier, when shooting such images it's best to use a lower ISO speed, so as to not introduce any extra noise. (Remember, higher, more sensitive ISO speeds produce noisier images.) However, for really long exposure times, you might want to switch to a higher ISO to cut the exposure time.

 *SHOOTING OUTSIDE AT NIGHT? COOL YOUR CAMERA BEFORE YOU SHOOT.*

*The noise that a digital camera produces is directly related to the temperature of the camera's image sensor. For every 6°F to 8°F increase in the temperature of the CCD, the noise will double. Therefore, if you know you're going to be shooting long exposures outside, take your camera out 20 to 30 minutes early and let it cool down to the outside temperature. As the camera cools, you should see a marked decrease in noise. Do not try to cool down your camera by putting it in the refrigerator or putting it on ice! Cooling it too quickly can cause damaging condensation to form inside the camera.*

If you don't have a tripod handy, try leaning against something or setting the camera on a sturdy object. If you must shoot with the camera handheld, switch on the camera's LCD viewfinder, put the camera's neck strap (if it has one) around your neck, and pull the camera taut. You might find that the strap offers a good amount of support. Remember to squeeze the shutter gently to prevent shake, and *don't* hold your breath when you shoot. Holding your breath usually causes your body to tense up, resulting in more shake. Instead, shoot while gently exhaling, or make long inhalations and exhalations and shoot in the slight pause that occurs between them.

## DEPTH OF FIELD

Depth of field is the measure of how deep the focused area of your image will be. In an image with deep depth of field, everything will be in focus. A more shallow depth of field will yield blurry backgrounds or foregrounds.

It is important to understand that the depth of field in an image is centered on the area on which you are focusing. In other words, if you currently have a depth of field that is about 10 feet deep, that doesn't mean that things farther than 10 feet from your lens will be out of focus. Rather, it means that things *within 10 feet of the point on which you are focusing* will be in focus.

Figure 8.3 shows the same image shot with varying depths of field.

**FIGURE 8.3**   In the second image, our depth of field is shallower than in the first image. To achieve shallower depth of field, we used a larger aperture and slightly longer focal length.

Depth of field is a function of three parameters: aperture size, focal length, and distance to the subject. *Smaller apertures and shorter focal lengths yield deeper depths of field*. Therefore, for the greatest depth of field you'll want to choose a higher f-stop and zoom *out* as far as possible.

In the first image in Figure 8.3, a small aperture and medium focal length were used. For the second shot, the camera was positioned farther from the subject and zoomed in to increase the focal length, and a very large aperture was selected. Notice that, as discussed earlier, the longer focal length resulted in an image with compressed depth—the trees in the lower image appear closer. However, because the background is out of focus, this change in depth is not too noticeable. Balancing depth of field against focal length is one of the considerations you'll have to weigh when you shoot.

In general, when you're closer to your image, the distribution of depth of field in front of and behind your subject will be fairly even. That is, there will be a roughly equal distance of focused area in front of and behind your subject. As you move farther away from your subject, the area of blurred focus will extend more behind than in front.

*DEPTH OF FIELD AND FIELD OF VIEW*

*The rule that a lens with a long focal length produces a shorter depth of field than a lens with a short focal length assumes that both lenses are positioned to produce the same field of view.*

If you have some experience with 35mm or larger formats, it is important to realize that because of the tiny focal lengths found on most digital cameras (which are inherent to the small designs of most models), digital camera depth of field is much deeper than you might be used to. On a typical digital camera, the depth of field produced by an f5.6 aperture works out to be more like the depth of field produced by an f16 aperture on a 35mm camera. This is great news for users who want really deep depths of field. However, photographers who are used to being able to separate foregrounds from backgrounds using very shallow depths of field might be frustrated. (See Figure 8.4.)

As with any camera, to get shallow depth of field from a digital camera, you'll first need to use the widest aperture possible. If your camera has an aperture or manual mode, open the iris wider. (This might be limited by the light in your scene.) If your camera lacks these types of manual override, you might be out of luck. Next, zoom in to your camera's full telephoto setting, and position the camera as far from your subject as possible. (Note that depending on the framing that you want, this might not

**FIGURE 8.4**    Most digital cameras are not capable of capturing very shallow depth of field. Although this is great for maintaining sharp focus, you might be frustrated if you want to intentionally blur out the background. The slight blurring of the background in this image is about the most you can expect from a small digital camera (except for when shooting in macro mode). This image was shot using a Nikon Coolpix 990.

be very far.) If you're using a digital SLR with interchangeable lenses, you'll have an easier time achieving very shallow depths of field. Although the sensor in a digital SLR is still smaller than a piece of 35mm film, the longer focal lengths provided by an SLR's larger lenses make for shorter depths of field. In Chapter 14, "Special Effects," we'll look at some ways of simulating depth of field in Photoshop.

Note that any zoom lens is more prone to softening when you get to the extreme limits of its aperture range. Therefore, you'll be better off qualitywise if you can get the depth of field you want without going to extreme wide or narrow apertures. Similarly, image quality degrades when you get to the extremes of your lens's focal length range.

*DEPTH OF FIELD AND FOCAL LENGTH MULTIPLIERS*

*If you're using a digital SLR with interchangeable lenses, your camera probably has a focal length multiplier. (See Chapter 5, "Choosing a Digital Camera.") Note that depth of field is not impacted by this multiplier.*

No matter what type of camera you have, it can be difficult to achieve shallow depth of field in bright daylight, because you won't be able to open the aperture wider without overexposing. If your camera provides very fast shutter speeds you might be able to compensate for the larger aperture. If not, you might want to consider using *neutral density filters,* special filters that screw onto the end of your lens and serve to cut down the amount of light entering your lens, without altering the light's color. By cutting down the light, you might find that you have some extra flexibility with regard to exposure.

Neutral density filters are usually rated using an ND scale, where .1ND equals 1/3 stop. Therefore, a .3ND filter will reduce the incoming light by one full stop. Neutral density filters can be stacked on top of one another to selectively add or subtract more stops. However, even the best filters are not optically perfect, so it's better to use as few as possible to reduce the chance of introducing optical aberrations into your lens system. In other words, if you want a 1-stop filter, use a single .3ND filter instead of three .1ND filters.

Here's a great neutral density filtering trick: say you want to photograph a building on a busy street corner at noon, but you don't want to include any of the people who are pouring into and out of the building. Stack up a few neutral density filters until you have an 8- to 10-stop filter. This will increase your exposure time to 10 or 15 minutes, meaning that anything that's not stationary for at least that long won't be included in the shot. Obviously, you'll need a camera that provides a manual shutter speed control and allows for such long exposures. When the exposure is finished, you'll have an image of just the building.

## Shutter Speed and Depth of Field

Because of the reciprocal nature of apertures and shutter speeds (again, see Chapter 3), you can trade depth of field for more motion-stopping power. That is, you can go to a wider aperture (less depth of field) to use a higher shutter speed (more motion stopping). Conversely, you can switch to a slower shutter speed (less motion stopping) to use a smaller aperture (more depth of field).

These are the types of trade-offs and considerations that you need to consider when you choose your exposure settings. Because there can be many different aperture/shutter combinations that will work for a given lighting situation, understanding the effects of different combinations will allow you more creative freedom.

*NEARSIGHTED?*

*If you are nearsighted enough to need glasses, try this quick little depth of field experiment. Take off your glasses and curl up your index finger against your thumb. You should be able to curl your finger tight enough to create a tiny little hole in the curve of your index finger. If you look through the hole without your glasses, you will probably find that everything is in focus. This hole is a very tiny aperture and, therefore, provides very deep depth of field—deep enough, in fact, that it can correct your vision. On the downside, it doesn't let a lot of light through, so unless you're in bright daylight, you might not be able to see anything well enough to determine if it's in focus. The next time you're confused about how aperture relates to depth of field, remember this test.*

## STAYING SHARP

Today's high-resolution digital cameras are capable of delivering very sharp images with lots of fine detail. The biggest contributing factor to the sharpness of your image is the quality of your lens. However, even if you have an extraordinary lens, it's still easy to shoot soft or blurry images. To ensure maximum sharpness in your images, there are some additional steps you can take.

- **Use a tripod.** Although you learned earlier that shutter speeds of less than 1/30 of a second are difficult to shoot without a tripod, your images will tend to be sharper if you *always* use a tripod, even when shooting at faster shutter speeds. No matter what shutter speed you're using, even a little motion can impact the sharpness of your images.
- **Use a remote control or self-timer.** As long as your camera is on a tripod, you might as well get your potentially shaky hands completely off of the camera by using a remote control or the camera's built-in self-timer.
- **Don't use an aperture at the extreme end of your camera's range.** Stopping your lens down all the way can introduce diffraction effects that can affect image sharpness. Similarly, the sharpness of most lenses suffers when the aperture is set to full wide. Sharpness-wise, most lenses perform best with an aperture two or three stops below full wide.
- **Use an image-stabilized lens.** If you're shooting with a higher-end camera that supports interchangeable lenses, spend the extra money for image-stabilized lenses and use the stabilization even when tripod-mounted.
- **When appropriate, use mirror lockup.** If you're shooting a long-exposure using a digital SLR, activate its mirror lockup feature, if it has one. This feature prevents small extra vibrations caused by the mirror flipping up and down.

Although these rules are true for all cameras, they're not going to be as effective on lower-resolution models (where there simply aren't enough pixels to render extremely sharp images) or on cameras with cheaper lenses.

## TONAL CONTROL

In addition to motion control and depth of field, the exposure you choose has a large impact on how much contrast there will be in your image, how much—and which—detail will be present in your image, as well as the accuracy of color rendition. For most situations, you'll probably find that your camera's default metering yields an ideal exposure. As you saw in the previous chapter, there will be times when you need to over- or underexpose from the default metering to restore proper tone to an object within your scene. You also saw how underexposing can cause color tones to appear richer.

In the previous chapter, you also learned that there will be times when you'll face a scene that includes more tonal range than your camera can capture. For these instances, you have to make some decisions about which parts of the tonal range you want to protect and which you're willing to risk losing.

To capture the best tonality and saturation—and to improve your options when you correct and adjust an image—you want to expose your image to capture the widest contrast range that you can manage. That is, you want good solid blacks, nice white whites, and everything in between. The trick is to not over- or underexpose too far.

When you underexpose an image, shadow areas get darker. If you underexpose too far, those areas will turn to solid black. Once your shadows become solid black, you will be unable to adjust those areas to restore detail, because there simply won't be any detail there. Similarly, if you overexpose an image too far, its highlight areas will blow out to solid white and will lose all of their subtle light-toned details. (See Figure 8.5.)

However, good photographs contain more than just black blacks and white whites. Because most of the image in a good photo occurs in the tones *between* black and white, you want to ensure that your image contains a wide tonal range. If you expose for a wide tonal range, you'll have a broad range of middle tones between those black and white extremes (that is, the image will have a lot of contrast), which will allow you to control detail across the image.

The danger, of course, is that if you choose an exposure that will preserve your shadow details, you might not get good highlight details. Similarly, if you expose to properly render the bright areas of your image, your shadows will most likely turn completely black. Figure 7.20 shows an extreme example of this problem.

As a general rule, when in a situation with a wide range of latitude, it's best to underexpose to ensure that your highlight areas don't get over exposed and blow out to complete white. As you'll see later, your image editor can manage to pull a lot of detail out of the shadow areas of your image, but

**FIGURE 8.5**    If you overexpose an image too far, you'll lose detail in the bright midtones and highlight areas, as colors wash out to complete white. Similarly, if an image is underexposed too far, it will lose shadow detail, as those areas darken to complete black.

once an overexposed area turns white, that's it—you won't be able to re-trieve any image information. Of course, your final exposure choice will also be affected by your depth of field concerns, the exposure compensation con-cerns discussed in Chapter 7, and some additional factors discussed here.

Like color and slide film, your digital camera does not have a tremendous amount of color *latitude*, so there is very little margin for error when pushing your exposure near the limits of your camera's highlight or shadow points. For example, if you underexpose too far, you'll lose both shadow detail and highlights. Fortunately, unlike film, many digital cameras have an extraordinary built-in exposure tool.

### Don't Know Much about Histograms

A *histogram* is a simple graph of the distribution of all of the tones in your image. Histograms can be easily created by most image-editing applications and are a great way to understand exposure.

Look at Figure 8.6 and its accompanying histogram.

**FIGURE 8.6**    With a histogram, you can analyze your images to determine which type of exposure corrections they might need.

Grayscale images normally contain up to 256 shades of gray ranging from solid black to solid white. A histogram, such as the one shown in Figure 8.6, is simply a bar chart showing how much of each shade of gray

is present in the image, with each vertical line representing one shade. Black is at the far left and white is at the far right.

From the histogram, you can see that the image in Figure 8.6 is fairly well exposed. It has a good range of tones from black to light gray, which means it has a lot of contrast. Most of the tones are distributed toward the lower end because of the dark grays and shadows in the background. However, even though the background is dark, there is still a good range of middle gray tones and lighter tones from the gray of the baby flamingo.

Notice that the shadow areas do not *clip*. That is, they curve down to nothing by the time the graph reaches the left side. This means that the shadowy details in the image have not gone to solid black. In fact, there is very little solid black in the image at all. This is an indication that there is plenty of detail in the shadow areas. Also notice that there are a large number of tones overall, meaning the image has a good dynamic range and, therefore, a lot of editing potential. Although the brighter areas are a little weak, we can correct for this in our image editor.

Now, look at Figure 8.7.

**FIGURE 8.7**    An underexposed image has a very characteristic histogram.

You can probably tell by looking at Figure 8.7 that the image is underexposed, but the histogram still provides some interesting information. As you can see, there is no white in this image at all and very little medium gray, but at the lower end there is a preponderance of solid black. Notice that the shadow areas don't curve down to black as they do in Figure 8.6. Rather, they are "clipped" off the edge of the histogram. In a well-exposed image, the shadow areas would be spread over a large number of darker tones, with only a little solid black. If you look in the shadow areas of the image, you'll see that they look completely black, rather than having any variation or range in their dark tones. In other words, the shadows have lost detail.

In a grayscale image, a histogram is literally a graph of the gray tones in an image. As you saw in Chapter 7, colors have a tone that roughly corresponds to the tonal qualities of a shade of gray. When you take a histogram of a color image, such as the one in Figure 8.7, the resulting graph shows a composite of the red, green, and blue channels in the image. The practical upshot is a graph that is still an accurate gauge of the contrast and tonal information in your image.

An image that is overexposed will exhibit a similar histogram but weighted on the other end, with tones grouped in the white areas and with clipped highlights. (See Figure 8.8.)

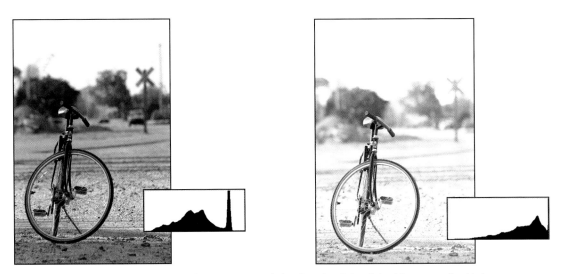

**FIGURE 8.8** An overexposed image—the tones are weighted to the right of the histogram. In this image, you can see that the highlights are clipped—they get cut off by the right side of the histogram.

Now look at Figure 8.9.

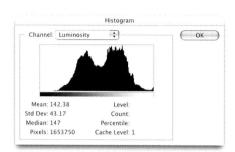

**FIGURE 8.9**    In a low-contrast image, the tones will be in the center of the histogram. Notice the lack of dark black or light gray tones.

The image has little contrast and appears "flat." A quick look at the histogram shows why. Most of the tones are grouped in the middle of the graph—they don't cover a broad range—and there are no white or black tones at all.

Just as careful processing and printing is essential to producing good photographic prints, your digital images sometimes need some special adjustments to take advantage of the tonal information that your camera captures. In Chapter 13, you'll see how you can use the tools in your image-editing application to adjust and correct an image, so that a low-contrast image like the one in Figure 8.9 can be turned into something more like the image shown in Figure 11.28 in Chapter 11.

Many digital cameras can show you a histogram of any image you've taken. Figure 8.10 shows a histogram display from a Canon EOS 10D. In

addition to displaying the histogram, the thumbnail display flashes any areas that have clipped highlights or shadows. The histogram is an exceptional exposure tool for shooting in a difficult lighting situation. Set your exposure, shoot a test shot, then take a quick look at the image's histogram. If you see clipped highlights or shadows, you'll need to try a different exposure and shoot again. (If your camera has a live histogram feature like the one shown in Figure 5.7, you can watch the histogram *while* you change exposures.)

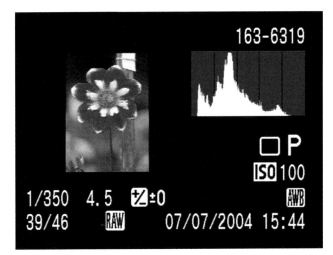

**FIGURE 8.10**    Many cameras can display a histogram of any image you've shot. In addition to this histogram, this display from a Canon EOS 10D also shows date, time, and all exposure parameters. In over- or underexposed images, the display also flashes areas in the image thumbnail that are "clipped" in the histogram.

In addition to the RGB composite histograms shown in these examples, most image-editing applications can also produce separate histograms for each color channel, or a histogram of just the brightness (luminosity) in an image. As we'll see later, these can be useful for identifying some types of problems. For general exposure analysis, though, the normal RGB composite histogram is fine.

## Details, Details

Earlier, you learned that some autofocus mechanisms work by detecting contrast within an image. The fact that more contrast means sharper focus—and therefore, more detail—is an important concept to remember when you choose an exposure for an image.

Figure 8.11 shows the same image shot with a range of exposures. Notice how the level of detail and sense of texture changes from exposure to exposure.

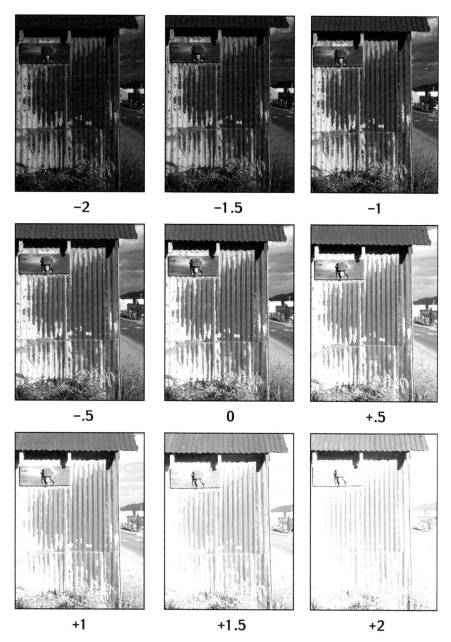

**FIGURE 8.11**    This heavily textured wall was shot with a variety of exposure-compensation settings. In addition to looking brighter or darker, notice how the level of detail and texture changes with different exposure settings.

As you learned earlier, when an image is underexposed, the shadow areas lose detail because they go down to solid black. Similarly, when an image is overexposed, the highlight areas wash out to complete white, reducing contrast in the highlight areas. Fine texture and detail is often defined by the small highlight and shadow areas on the texture's surface. Consequently, you'll want to expose to reveal these highlights and shadows. In general, to preserve texture, you'll want to capture as broad a tonal range as you can.

### *LOWER YOUR CAMERA'S SHARPENING*

*Sometimes, in high-contrast situations, you can get better tonal range by setting your camera's contrast or sharpening setting to low (assuming your camera has a contrast or sharpening setting). As you've seen, an image with more sharpness has greater contrast between individual pixels. This can sometimes mean less tonal range, because more pixels are represented by high-contrast shades than by a broad range of tones. All cameras are different, of course, so do some experimenting with your camera's sharpness controls. Take some test shots with identical exposure settings but different sharpness settings, and examine the resulting histograms to learn how each setting affects tonal range.*

To sum up, in addition to depth of field and motion control, your goal when you choose an exposure is to pick settings that will produce the broadest tonal range while preserving shadow and highlight detail. In most situations, it's safe to assume that if you protect your shadow areas when you shoot, you can always save the highlights later in editing.

---

## SIDEBAR: OVEREXPOSURE

There is a new school of thought among some digital photographers that *overexposure* is the preferred technique for capturing maximum dynamic range. This theory is based on the fact that image sensors are more sensitive to brighter tones—substantially more sensitive. As you've already learned, your camera captures images using 10 or 12 bits of information per pixel to record color. At 12 bits per pixel, you can record up to 4,096 different colors. Though you might assume that those 4,096 colors tones are divided evenly among the five or six stops of exposure latitude that your sensor has, the unfortunate truth is that half of those tones are used up in just the upper (brightest) stop. (For those of you wondering, this is because CCD and CMOS chips have a linear response to light, as opposed to film's nonlinear response.)

In other words, your camera can record much finer detail from the bright areas of an image than from the dark areas. So, the theory goes, if you overexpose, you're shifting your overall tonal range into the brighter areas that your camera is more capable of reproducing. This means that you're capable of capturing much more data and that gives you more to work with when correcting and adjusting your image later.

Bear in mind that for this technique to work, you need to be shooting using a camera that provides a raw mode. Because your image will be overexposed, you'll have to do some extra adjustments to it using your camera's raw image software (or by using the Camera Raw feature that's built in to Photoshop CS and Photoshop Elements 2).

If you want to give this technique a try, put your camera into raw mode and set your exposure compensation to +2 stops. Center your camera's light meter on the brightest thing that you want to preserve in your image and meter, then reframe and take your shot. If you look at the histogram for the image, you should see that all of the tones are shifted to the right of the histogram, but you shouldn't see any clipping of the highlights. Later, you'll need to use your raw conversion software to adjust the image's black point to shift the tones back down to where they belong. You'll learn how to do this in Chapter 13.

The downside to this technique is that if your light meter is in any way wrong, you're definitely going to be overexposing your image by too much and, therefore, ruining your highlight details. In addition, because not all color channels will be exposed by the same amount, you might find that the information in some channels will get clipped, resulting in some possible color troubles. Because of these potential pitfalls, be sure to shoot some additional frames with normal exposure. Also note that, because you're overexposing by two stops, you're effectively lowering the ISO rating of the camera, which will require slower shutter speeds and/or larger apertures.

## ADJUSTING EXPOSURE

As you've seen, there are many creative options to weigh and choices to make when you choose an exposure for an image. For example, you might know that you want a shallow depth of field, so you will select a long focal length and wide aperture. However, perhaps your images include many dark-colored objects that you feel need to be underexposed. At this point, you would probably choose to adopt a shorter shutter speed—rather than a smaller aperture—to preserve your shallow depth of field. Of course, if there are some fast-moving objects in your scene that you were hoping to blur, you'll have to consider just how much you can slow down your shutter speed. All of these different factors must be weighed and balanced.

Once you've made your decisions, you can begin to use your camera's controls to adjust your exposure accordingly. Fortunately, even if you have a less-expensive camera, you probably have enough controls to make some simple adjustments.

In this section, we'll cover all of the ways that you can adjust exposure on your digital camera. Which adjustments to make will depend on your image, of course, and which controls to use to make your adjustment will depend on which exposure characteristics you want to change and which you want to preserve.

### Exposure Compensation

Nowadays, most digital cameras provide exposure compensation controls, even if they don't include priority or manual exposure modes. Exposure compensation controls give you a quick, easy, and very effective way to adjust the exposure that your camera's light meter has chosen. What's nice about exposure compensation tools is that they let you think about exposure in terms of over- or underexposing, without worrying about how to achieve those changes in exposure. In other words, you can simply think "I want to overexpose by one stop" instead of thinking along the lines of "I want to overexpose by one stop but in this mode I don't have control of aperture so I'll have to change the shutter speed; I'm currently at 1/250th so overexposing by one stop would be 1/125th". (See Figure 8.12.)

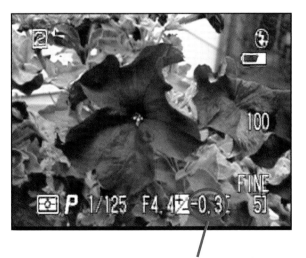

## Exposure Compensation Display

**FIGURE 8.12**    Most cameras simply indicate exposure compensation with a numeric readout of the current amount of compensation (in this case, −.3 stops).

The downside to exposure compensation is that you have no control over *how* the camera achieves its new exposure. In other words, if you tell it to overexpose by two stops, you don't know if this overexposure will come through changes in aperture or shutter speed. Consequently, you can't predict if the compensation will change your image's depth of field (through aperture change) or motion control (through shutter speed change). Because of the tiny focal lengths of the average digital camera, a change of a stop won't make much—if any—difference in depth of field. However, if you're shooting in low light—low enough that an extra stop could push you into a slow shutter speed—you might want to carefully review your images after shooting to make sure they're sharp. Fortunately, these days most cameras will warn you if they think they've chosen a shutter speed that's slow enough to result in a shaky image.

If you throw your camera into automatic mode and watch its exposure choices (assuming your camera displays its selected shutter speed and aperture) while you change exposure compensation settings, you will probably think that there's no seeming logic to whether it adjusts aperture size or shutter speed. Typically, a camera will adjust shutter speed first and only adjust aperture if a change in shutter speed would result in a blurry image. If your camera only has two or three apertures, adjusting shutter speed might be its only choice.

## Priority and Manual Modes

Priority modes are a great balance of manual control with some automatic assistance. Typically, you'll select shutter priority when you want to control motion and aperture priority when you want to control depth of field. You can select either aperture or shutter if you want to change tone and saturation, texture, or detail. Alternatively, you can combine a priority mode with your camera's exposure compensation controls. For example, you might use a shutter priority mode to ensure the motion control that you want, but then use exposure compensation controls to intentionally over- or underexpose. (See Figure 8.13.)

Using a priority mode is simple: just select the aperture or shutter speed that's appropriate for what you're trying to achieve, and let the camera calculate the other value. Most cameras will warn you when they think you've chosen an exposure combination that will result in over- or underexposure. Don't worry, the camera will still shoot the picture; it's just trying to tell you that your settings don't conform to its idea of a good picture. Check your manual for details on how your camera indicates a bad exposure combination.

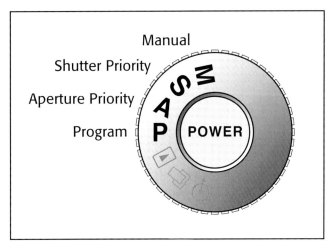

**FIGURE 8.13**   Most cameras offer a simple dial or switch for changing the camera from full automatic mode to a priority or completely manual mode.

Full manual modes give you control of both aperture and shutter speed and offer more flexibility than any other shooting mode. However, because some digital cameras have cumbersome manual controls, you might find it easier to simply use a priority mode.

### Automatic Reciprocity

Many cameras allow you to automatically cycle through reciprocal apertures after the camera has metered, allowing you to easily scroll through all the other aperture and shutter speed combinations that yield the same exposure. In this way, you can quickly choose an equivalent exposure with a shutter speed or aperture that is more to your taste. Note that because these are reciprocal exposure settings, they will still yield the same middle gray exposure as the camera's initial setting. If you want to over- or underexpose, you'll have to perform those adjustments separately. (See Figure 8.14.) An automatic reciprocity feature combined with the camera's exposure compensation controls usually provides all of the manual control you'll ever need, because you can usually achieve any exposure you want by using these simple adjustments.

### ISO Control

When you put a roll of film in a film camera, you're stuck with that film's ISO rating for the entire roll. That is not always true with a digital camera.

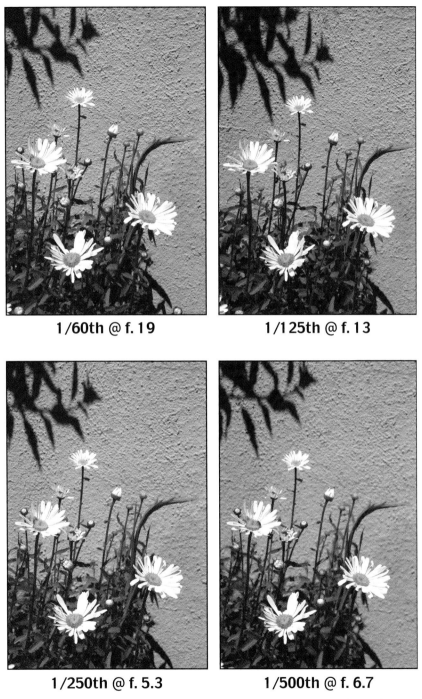

1/60th @ f. 19

1/125th @ f. 13

1/250th @ f. 5.3

1/500th @ f. 6.7

**FIGURE 8.14**    A large series of images of the same subject matter, each shot with a reciprocal setting.

If your camera has an adjustable ISO feature, you can change the ISO for each picture you take. Higher ISOs mean you can take pictures in less light, but you can also look at ISO adjustments as an additional exposure control.

ISO 200 is twice as sensitive to light as ISO 100 is. Moreover, as you might expect, ISO 400 is twice as sensitive as ISO 200 and four times as sensitive as ISO 100. As you learned in Chapter 3, every doubling of light is measured as a stop. Therefore, when you change from ISO 100 to 200, it's as if you've opened your camera's aperture one more stop or cut your shutter speed in half. This extra stop can often be what you need to save a shot.

For example, let's say you're shooting at dusk at ISO 100 and you have your camera's aperture open pretty wide to reduce depth of field. Unfortunately, with your current aperture, your meter has recommended a shutter speed of 1/15th of a second, too slow to be shooting with a handheld camera. Although you left your tripod at home, you don't have to compromise your depth of field choice. Just increase your ISO to 200 to pick up an extra stop, allowing you to set your shutter to 1/30th.

Or, maybe you're shooting a football game on a somewhat cloudy day, and even with your aperture open all the way, the fastest shutter speed your meter recommends is 1/60th. Crank the ISO up to 200 or 400 and you can shoot as fast as 1/250th for plenty of action-stopping power.

Of course, as you increase ISO rating, you'll be increasing the amount of noise in your image. Different cameras produce different amounts and qualities of noise, so you'll want to experiment with your camera to determine if you can accept the noise it produces at higher ISOs.

*TINY ISO CHANGES*

*Some cameras that only have a few apertures will make tiny changes to ISO sensitivity to create additional stops, usually without introducing noticeable noise.*

Just as there is a reciprocal relationship between aperture and shutter speed, when you start manipulating ISO you must think of reciprocity between all three factors. As you increase ISO, you might need to close your aperture or increase your shutter speed.

## Exposure Practice

Over the last few chapters, you've read a lot of theory and ideas about how exposure works. Now it's time to actually go out and practice some of it by doing some shooting. However, for your practice to do you much good, you need to take the time to annotate your images. You won't

learn much about which exposure calculations work if you can't remember what the exposures were when reviewing your images.

For each picture you take, you'll want to record all of the camera's exposure settings—shutter speed, aperture, ISO setting—as well as your white balance setting. If you tend to change compression settings while you shoot (to save storage space, for example), you might want to note this as well, because knowing the compression settings for an image might provide a clue to any annoying artifacts or contrast changes. In addition, if you've made any changes to the camera's sharpening, contrast, or saturation settings, you'll want to take note of those.

You can choose to make these notations the old-fashioned way (that is, write them down), but the odds are that your camera will remember them for you. Most digital cameras record a number of parameters when an image is stored to disk. Figure 8.15 shows the information screen from a Nikon Coolpix 990.

**FIGURE 8.15**    The Nikon Coolpix 990 stores several screens of information and parameters about each shot. This data is stored with the file and can be read using special software.

This information is stored using a standard format called *Exchangeable Image File (EXIF)*, which was created by the Japan Electronic Industry Development Association in 1995. If your digital camera is EXIF compatible (and most are), all of its files are EXIF files, whether they use JPEG or TIFF compression.

The great thing about EXIF files is that their image data can be read by any program, even if that program isn't specifically EXIF compatible.

The EXIF data is simply stored in the header information of the file, so any application that can read JPEG or TIFF files can still read an EXIF-compatible file.

If your image-editing or cataloging applications don't allow you to look at an image's EXIF data (as shown in Figure 8.16), you'll need to find an application that does. The Image Browser in both Photoshop CS and Photoshop Elements 2.0 provide EXIF displays.

| **File** | |
|---|---|
| Media Type | Image |
| File Size | 1.5 MB |
| File Creator | |
| File Type | JPG |
| Encoding | Photo – JPEG |
| Created | |
| Modified | 4/26/02 9:06:52 AM |
| Archived | 7/6/02 11:08:37 AM |
| Annotated | |
| **Media** | |
| Width | 2272 pixels |
| Height | 1704 pixels |
| Resolution | 180 pixels/inch |
| Depth | 24 bits |
| Compression | 1:7 |
| Color Space | RGB |
| Color Profile | |
| Pages | 1 |
| **Device** | |
| Maker | Canon |
| Model | Canon PowerShot G2 |
| Software | Firmware Version 1.00D |
| Format | |
| **Photo** | |
| EXIF Vers. | 2.1 |
| FlashPix Vers. | 1.0 |
| Capture Date | 2002:04:26 16:06:54 |
| Shutter Speed | 1/40 sec |
| Aperture | f7.1 |
| Exposure Bias | 0.0 |
| Exposure Prg. | Aperture Priority |
| Focal Length | 17 mm |

ON THE CD

**FIGURE 8.16**    The EXIF display from iView Multimedia, a shareware image cataloger included on the companion CD-ROM.

## An Intentional Underexposure

The good news is that there is no "right" or "wrong" way to take a picture. There might be "better" or "worse" ways, but the only thing that makes an image right, or correct, is whether the result serves to reveal what you saw in the scene that you were photographing.

You could argue that an image is "right" if it resembles the subject that was being photographed, but the question of what something *actually* looks like is subjective. True, you could get a color meter and a luminance meter and carefully measure everything in a scene to quantify its appearance. However, even if you managed to perfectly reproduce that color and luminance, you still wouldn't necessarily have a good picture.

You also wouldn't necessarily have an image that matched what you *saw*. Remember that your eyes have very different sensitivities than your camera does. You might often have to force the camera to see things the way your eyes do.

For example, look at Figure 8.17.

**FIGURE 8.17**   This street scene was shot with the camera's default metering and is, consequently, a little "flat" in tone, lacking contrast and good tonal range.

This matrix-metered exposure is probably fairly close to what this street scene actually looked like. The sun was low and there were some dark shadows, but they weren't too dark. Because of a slight haze in the

air, there were no strong white highlights. In general, it was a fairly medium-toned scene, and the medium-oriented light meter in the camera did a good job of recording those tones.

When looking at the scene in person, however, there was a marked perception of a dark swath being cut through a lighter area. This was a purely geometric/tonal perception that can be reduced to a very simple illustration as seen in Figure 8.18.

**FIGURE 8.18**    While actually standing at the scene of this photograph, one couldn't help perceiving large shapes of dark and light.

To capture this idea, it was essential to reveal the contrast between the dark street and the brighter houses, which meant that it was necessary to underexpose the image to plunge the street into deeper shadow.

Dialing –.3 into the camera's exposure compensation control created just enough underexposure to render the image the way it was envisioned without compromising either shadow or highlight detail. (See Figure 8.19.) (By the way, a second image was also shot using an exposure compensation of –.7, just in case –.3 wasn't enough, but the second image was too dark.)

**FIGURE 8.19**    With a simple underexposure, the shadows were plunged into darkness, and the desired contrast was created.

## Manual Override

The rooftop greenhouse shown in Figure 8.20 presented a few exposure concerns. First, there was the bright white panel on the roof of the green-house, which ran the risk of being blown out to complete white. Second, the misty background and white sides of the greenhouse presented a situation with many subtle gray shades. To smoothly render the subtle striations of the mist-shrouded hillside and to preserve the deep yellow of the greenhouse windows (which would lose saturation from the afore-mentioned overexposure), it was essential to capture as much tonal range as possible.

With the camera's light meter set to matrix mode, we shot a frame with the camera's recommended metering and then took a quick look at the histogram, shown in Figure 8.21.

With the default exposure, the camera did a good job of metering the scene. The dark shadows are not clipped, which would be our main con-cern because this scene is far too neutral-toned to have the potential for blown highlights. However, because most of our correction will occur in the midtones—where we want to bring out the texture and striations of the fog—it would be nice to have a broader range with more to play with in the middle areas. So, we set an overexposure of .5 stop and shot an-other frame, this one yielding the histogram shown in Figure 8.22.

**FIGURE 8.20** To capture all of the subtle gray tones and variations in this image, it was essential that the camera get as much tonal information as possible, a task made much easier through diligent use of the histogram.

As you can see from the second histogram, the half-stop of exposure yields slightly more range and better coverage of the image's midtones. This setting will afford us more editing latitude when trying to work with the fog in the image. Granted, the shadow tones are now not as dark as they were, but it's much easier to restore the shadows in this image than to work with the middle gray areas of the first image. What's more, because images tend to darken when printed, the shadows should fall back to where we want them during the printing process.

**FIGURE 8.21**    Our first histogram shows just what one would expect from a camera's automatic mode: a good exposure. However, it would be better to have a little more range.

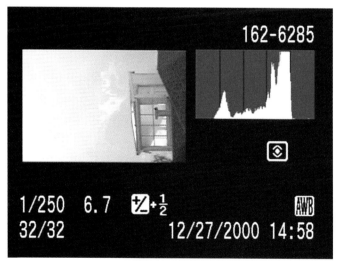

**FIGURE 8.22**    This histogram reveals data that's more to our liking. With a slightly broader range than the first image and more data in the midtones, this exposure will yield more editing flexibility.

## OF BRACKETS AND HISTOGRAMS

As you can see from the previous examples, a number of decisions go into choosing an exposure. The good news is that you don't necessarily have to

be right about your choice, because you can always shoot multiple shots, each with a different exposure, just as Margaret Bourke-White did. *Bracketing* is the process of shooting one or two extra exposures above and below your target exposure to provide yourself with a margin of error in your exposure calculation. If you've made a somewhat accurate, educated guess about exposure, one of your bracketed images will most likely be good, even if your original guess was off. Bracketing is a tried-and-true practice of film photographers, but it's much easier with a digital camera.

With digital bracketing you don't have to worry about the waste and expense of shooting extra film. Sure, storage might be a concern, but after bracketing, you can quickly check the histogram for each image using your camera's LCD, then throw out the images that are obviously wrong. Therefore, if you've bracketed two shots on each side (resulting in five pictures) and two of the pictures are obviously bad, you can simply delete them.

Many digital cameras offer *auto-bracketing* features, which let the camera take care of bracketing for you. On the Canon EOS 10D, for example, you can dial in a bracketing range. (See Figure 8.23.) Then, when you press the shutter, the camera will automatically shoot three exposures, one at your chosen exposure, one stopped down a stop, and a third overexposed by one stop. (You can also change the bracketing interval.)

**FIGURE 8.23**   If your camera has an auto-bracketing feature, you can set it to automatically shoot a series of bracketed exposures.

Even if you don't have an auto-bracketing feature, your camera's exposure compensation controls make it simple to quickly bracket your shots. If your camera's compensation controls are located externally (rather than buried within a menu), learn to change them without moving the camera.

This will allow you to shoot, make a quick compensation, and then shoot another shot right away. It's best to always perform your brackets in the same order to prevent confusion. Most auto-bracketing features start with the desired exposure, then shoot one interval under, then one interval over, then the next interval under, the next over, and so on.

If the meaning and use of the histogram is a bit confusing for you now, don't worry; it will become more clear when you start correcting some images in Chapter 11, "Correcting Tone and Color."

## EXPOSING TO AVOID PURPLE FRINGING

If your camera has a problem with purple fringing (as discussed in Chapter 4), there are some things you can do to reduce the chance of this artifact occurring. (See Figure 8.24.)

**FIGURE 8.24**    Some digital cameras suffer from a type of color aberration that causes purple fringing along areas of high contrast in an image.

Purple fringing usually occurs when you shoot into a high-contrast situation using your camera's full wide angle (or close to it). For these reasons, landscape shots usually suffer the most from purple fringing. Skies often create troublesome contrast situations, and landscapes typically prompt you to use a wide angle. Trees are also particularly bad subjects when it comes to purple fringing. Because they typically have a bright sky behind them, and because they include so many high-contrast details, you'll often find that shots taken from beneath a tree or through a tree (for example, on a horizon) will have bad purple fringing around the small foliage details.

If you're in such a situation and you know that your camera is subject to this problem (not all cameras will be), try the following solutions:

- Zoom in to a longer focal length. In fact, shooting several images at different focal lengths might be best.
- If you can't get a framing you like without shooting at full wide, try closing down your camera's aperture. You will, of course, have to adjust your shutter speed appropriately. Be careful if you make this adjustment using your camera's exposure compensation controls, because they won't necessarily compensate with an aperture adjustment. It's better to use your camera's manual controls (or automatic reciprocity control, if your camera has one).
- Some cameras seem to exhibit purple fringing only in the edges of their photographs. If this seems to be true of your camera, try to frame the image so that particularly troublesome subject matter (trees, bright shapes, fine details) are away from the edge of the frame.

Obviously, no matter how careful you are, you won't always be able to avoid these purple fringing artifacts. As you might expect, there are some ways to remove these problems using your image-editing program. You'll learn some purple fringe removal techniques in Chapter 13.

## Taking Control

The good news about many of the techniques described in this chapter is that you probably won't have to rely on them very often. The fact is, modern digital camera meters and preprogrammed modes are *very* good. Nevertheless, if you're serious about photography, there will be times when taking control will be the only way to get the shot you envision. After working through this chapter, you should be comfortable with the concepts of manual exposure and you should understand how your camera meters. Most important, you should know how to use and read a histogram, because we'll be relying heavily on histograms later in the book.

CHAPTER

# 9

# SPECIAL SHOOTING

**In This Chapter**

- Macro Photography
- Black-and-White Photography
- Shooting Panoramas
- Shooting for the Web
- Shooting for Video
- Using Filters
- Shooting in Extreme Conditions

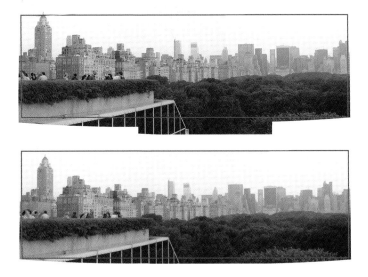

At the end of the Apollo 11 moon landing, Neil Armstrong and Buzz Aldrin blasted off from the moon in their tiny lunar module, aiming for a rendezvous with crewmate Michael Collins in the orbiting *Columbia* service module. As the tiny speck of a spaceship rose up from the moon, ground controllers recorded Collins saying "I got the Earth coming up behind you—it's fantastic!" Back on Earth, after the rocks and spacesuits and Hasselblad cameras were all unloaded, and the film was developed, Armstrong and Aldrin were able to see what Collins had been so excited about: a photograph of the earth rising above the moon, with the lunar lander flying close by in the foreground. In other words, a single picture encompassing all of humanity except for one man: Mike Collins, the photographer.

Like all of the astronauts, in addition to having the "right stuff," Collins had to have a comfortable knowledge of basic photographic principles. A quarter of a million miles from earth, he still had to worry about f-stops, shutter speeds, and film stocks in addition to worrying about asphyxiation, burning up on re-entry, and drowning in the ocean.

Hopefully, you won't ever have to face such photographic concerns. However, it is important to realize that certain types of photography require special equipment, techniques, and preparation. In the case of lunar photography, you would need a massive government-funded space program in addition to your digital camera and a decent computer. Web photography, on the other hand, requires a camera with appropriate resolution and a good understanding of how your images will be sized and compressed for delivery.

In this chapter, you'll learn about all types of special shooting considerations, ranging from shooting in black and white to shooting in extreme weather.

## MACRO PHOTOGRAPHY

Although the term *macro photography* would seem to describe a process of photographing very large objects, it's actually just the opposite. With your digital camera's macro feature, you can take high-quality images of extremely small things.

Digital cameras are particularly well suited to macro photography. Their generally excellent optics make for sharp, clear images, and their low light sensitivity means you can get them into small spaces to capture images up close. The macro features of some cameras allow for amazingly close shots—as close as 1 inch in some cases! A 35mm film camera would normally require a very expensive, specialized macro lens for such photography and often need a lot of extra lighting. (See Figure 9.1.)

**FIGURE 9.1**   Your digital camera's macro feature lets you take close-up photos that would require a very expensive lens if you were shooting with a film camera.

Nevertheless, when you shoot macro with your digital camera, there are some things to remember.

### Finding the Optimal Macro Focal Length

Most macro features are optimized for a particular range of focal lengths. Although most cameras will let you shoot macro pictures with your lens zoomed to any point, you'll get much better results if you put your camera in the macro "sweet spot." (Note that some cameras won't focus at all in macro mode unless they are set within a particular focal range.) Most cameras indicate when you are within the optimal macro focal length through a display on the camera's LCD. So, after switching to macro mode, you'll want to zoom the lens until the camera indicates that you have hit the optimal focal length.

## Macro Focusing

Your camera's autofocus mechanism should work normally when you shoot in macro mode. However, be aware that at very close distances, even slight, subtle changes in camera position can ruin your focus.

When shooting macro photographs, your camera must be extremely close to your subject, which means that you and your camera will be blocking out much of the light in your scene. Because of the low light levels, your camera will tend to use a slower shutter speed. Therefore, to get the best results when you focus at macro distances, use a tripod. Doing so will ensure that the camera remains steady in the event of a slow shutter speed and will also prevent you from accidentally making slight movements after the camera has already focused. You can also increase the camera's ISO to give it some latitude to select a faster shutter speed, though you might be introducing more noise into your image.

If you don't have a tripod, consider activating your camera's continuous autofocus feature, if it has one. This will help keep the image in focus even if you accidentally jiggle the camera.

It's usually easier to hold the camera steady if you *don't* try to press the camera's zoom buttons. Instead of using the camera's zoom controls to frame your shot, simply move the camera in and out. At macro distances, you won't have to move it very far to get a reframing.

The best rule of thumb is simply to work quickly. Get the image framed, prefocus, and then shoot right away. Finally, just to be safe, shoot a few frames. If your first is out of focus, perhaps the second or third will be okay. If your camera has a drive mode (also known as *burst mode* or *continuous mode*) that is capable of shooting at the resolution you want, consider turning it on. If you're facing a difficult macro shot, shooting a burst of images will improve your chances of getting a good image.

Some Nikon cameras include a unique "Best Shot Selection" feature that is ideal for macro photography. This feature shoots a burst of images and tries to identify the one that is in sharpest focus. The others are automatically discarded.

## Poor Depth of Field

Be warned that when you are in macro mode, your camera will have a *very* shallow depth of field. Although this can create very nice effects and excellent isolation of your subject, if your subject is large enough, you might have trouble keeping all of it in focus.

Consider the image in Figure 9.2.

The depth of field in this image is so shallow that the flower's petals are out of focus. In fact, the depth of field is short enough that this image might

**FIGURE 9.2**    This flower was shot with the camera's macro mode. Although it's not a particularly large flower, it is deep enough that, at macro photography distances, the image has a depth of field problem. The flower's stamen is in focus, but the petals are blurry.

have been better served by switching out of macro mode, pulling the camera back, zooming in, and shooting the image normally. Another option would have been to autofocus on the petals and reframe the shot. However, the stamen in the center of the flower would then be out of focus.

If you're shooting a flat subject, depth of field won't be a problem, of course. If you're shooting something that's even a few inches deep, though, you need to start thinking about which parts will be in focus. Judging depth of field on your camera's LCD can be very difficult, because the screen is simply too small to reveal which parts of your subject are in focus. Sometimes you can use your camera's playback zoom feature to examine different parts of your image up close. Even with a 4x magnification, however, you still probably won't be able to see subtle changes in focus. If you're concerned about depth of field, your best option is to protect yourself by shooting multiple shots with a number of different focal lengths—including some non-macro shots. You should also take some shots with your autofocus locked onto different parts of the subject.

If you're shooting a flat subject, try to keep the camera parallel to the plane of your subject. Any tilt will introduce extra depth into your image. Those areas of depth might be rendered blurry by your camera's shallow depth of field.

## BLACK-AND-WHITE PHOTOGRAPHY

Some digital cameras offer special black-and-white modes for shooting grayscale images. Because you can always convert your color images to grayscale using your image-editing program (you'll learn more about this in Chapter 14, "Special Effects"), the idea of shooting in grayscale might seem kind of strange. However, there are some advantages to using your camera's black-and-white feature. First, because a black-and-white mode doesn't require your camera to interpolate up to 24-bit color, you can—theoretically—get better detail than when you shoot in color. Your camera can ignore its color filters and simply treat each pixel as a true pixel, so your images might be sharper than when you shoot in color.

In practice, as shown in Figure 9.3, you might find little difference between shooting in a black-and-white mode and shooting in color and then converting to black and white. Because black-and-white images take up the same amount of space as color images, there is no storage advantage to using black-and-white mode. If you find there is no difference with your camera, go ahead and shoot color to preserve your options.

The main advantage to shooting in black and white is that you can immediately review your image as a black-and-white image. If you have

**FIGURE 9.3**    As you can see, there is often little differences between an image shot in black-and-white mode and an image shot in color and converted to grayscale later. If you have trouble visualizing in grayscale, though, the immediate feedback can be invaluable.

trouble visualizing a scene in black and white, this immediate grayscale review can be very helpful.

## Infrared Photography

Infrared light is not visible to the human eye. However, special infrared-sensitive films can be used to capture infrared light, allowing you to capture scenes in a very different… er, light. Skies and foliage are particularly well suited to infrared photography—leafy greens will appear white and skies will be rendered with much more contrast. Digital infrared photography is possible with any digital camera, although some cameras will produce far better results than others. (See Figure 9.4.)

**FIGURE 9.4**    With an infrared filter, you can capture just the near-infrared spectrum of light. In infrared, vegetation appears very bright whereas skies turn very dark.

Most image sensors are so sensitive to infrared light that camera makers have to put a strong infrared "cut" filter between the lens and the sensor. Without this filter, the sensor will yield images with very strong color casts. Despite these filters, though, some infrared does get passed through to the camera's sensor, allowing you to use your digital camera for infrared photography. Unfortunately, there's no hard-and-fast rule for how strong a camera's IR filter is—the only way to find out is to experiment. You can get a rough idea of a camera's infrared sensitivity with the help of the remote control from a TV, VCR, or stereo. Just point the remote at the camera's lens, press and hold a button on the remote, and take a picture. If the camera can see the light of the remote (Figure 9.5), you'll know that the sensor is picking up some IR. The brighter the light, the better your camera will be for infrared shooting.

To shoot infrared images, you'll need to put an infrared filter on your camera's lens. (The "Filters" section at the end of this chapter has a lot of general information on filters and how to mount them.) A number of filters are available for infrared photography, but the most popular are the Kodak® Wratten™ 89b, 87, and 87C filters. Hoya® makes two filters, the R72 and RM72, which are equivalent to the Kodak 89B. B+W® also make Wratten equivalents, the 092 and 093.

The right filter is partly a matter of taste, because different filters yield different levels of contrast. Depending on your camera's infrared sensitivity, you'll need either a brighter or darker filter. Note that infrared filters are expensive, and the larger the diameter, the more you'll have to pay. Before buying a particular filter, you might want to poke around some of the more popular digital photography online forums for advice from other users who have shot infrared with your type of camera. If you can't find any usable advice, you'll simply have to experiment with different filters. Because they are so dark, you can expect infrared filters to cut four to 10 stops from the available light! That means you'll be using very long exposures even in bright daylight. Obviously, a tripod is essential for infrared photography. To pick up some extra stops (and reduce lengthy exposure times), you can set your camera to a higher ISO, but this will make your images noisier. Typically, Wratten 87 exposures in bright daylight at ISO 200 start at around five seconds. Because the filter can confuse your camera's light meter, you might have to do a little experimenting to find the right exposure.

When they shoot film, infrared photographers often have to worry about the infrared filter causing a focus shift that can result in the camera focusing beyond its focal plane. Fortunately, the deep depths of field of a typical consumer digital camera greatly reduce the chances of focus troubles. Just to be safe, though, you might as well lock your camera on in-

**FIGURE 9.5**   You can get a pretty good idea of the infrared capabilities of your camera by taking a picture of a remote control's infrared emitter. Note that, in the second image, the remote's emitter is "lit up" with infrared light.

finity when you shoot landscapes, and if you seem to be having focusing troubles, put your camera in manual mode and decrease the aperture to increase depth of field.

You don't have to have a black-and-white mode on your camera to shoot infrared images. When you shoot color through an infrared filter, most images will appear in brick red and cyan tones, rather like a duotone. (See Figure 9.6.) You can easily convert these to grayscale later.

**FIGURE 9.6**   When you're shooting with an infrared filter, the image that comes out of your camera will be color, and will need a good amount of processing.

Because of the bright light required, you'll typically shoot infrared only outdoors. Any incandescent objects—glowing coals, molten metal— will emit a lot of infrared radiation. The thermal radiation produced by the human body, however, is way beyond the sensitivity of the near-infrared capabilities provided by your camera.

## Shooting Panoramas

At one time or another, you might have tried to capture a wide vista or panoramic scene by shooting a series of overlapping images like the ones shown in Figure 9.7.

Although this can be a very nice, stylized way to represent a very wide-angle view, it's obviously not an *accurate* image. The seams don't join together properly, some elements are repeated from one image to the next, and each frame has its own perspective—notice how all the lines in each image recede to separate vanishing points.

**FIGURE 9.7** These two images were shot separately with the idea that they would be stitched into a panorama. Panoramic images can be stitched together from any number of overlapping images.

If you want a panorama that looks like a single image, you can use your computer to correct the aforementioned problems and produce an image like the one shown in Figure 9.8.

Panoramic software can take a series of overlapping images and stitch them together to create a single image. Besides hiding the seams of an image, panoramic software corrects the perspective of each image by essentially mapping the images onto the inside of a giant virtual cylinder. (See Figure 9.9.) The curvature of the imaginary cylinder corrects the perspective troubles in your image.

In addition to printing wide panoramic prints of your images, you can also deliver your panoramas as *virtual reality (VR)* movies that present a window onto your panoramic scene and allow the user to "navigate" the scene by pivoting and tilting their view. (See Figure 9.10.)

**FIGURE 9.8** The finished, stitched, and color-corrected panorama.

**FIGURE 9.9** Your panoramic software performs complex cylindrical distortions of your images to correct the perspective in each frame.

**FIGURE 9.10**    If you store your images as VR movies, users can use special viewing software to pan and tilt around your scene. With more advanced authoring tools, you can build fully navigable VR environments.

You'll learn all about stitching in Chapter 14, but getting a good-looking panorama begins with your shoot.

## Preparing Your Camera

To shoot a panorama, you need a wide-angle lens. Although you can use a telephoto lens, you'll have to shoot more images to get the same coverage. Moreover, telephoto lenses tend to compress depth a little too much. The deep sense of space that a wide-angle lens produces is much more appropriate to the proportions of the wide field of view that you'll capture with a panorama.

The good news is that the wide angle on your digital camera's zoom lens is probably wide enough to take good panoramas. For even better results, consider purchasing a wide-angle attachment, if the camera supports such an option. With a wider angle, you won't have to shoot as many images to get the same coverage. What's more, if you shoot vertically (or in "portrait" orientation) with a wide-angle lens, you can get more vertical coverage than you would with a more telephoto lens.

There are two ways to shoot panoramas: the correct way, which involves a lot of special equipment but produces very precise, accurate images for stitching; and the sloppy way, which is prone to error but can still produce fine results.

For almost all occasions, shooting "sloppy" panoramas will work fine. For best results, mount your camera on a tripod and set the tripod to be level. Note that if your camera's tripod mount is positioned off-axis (Figure 9.11) from your lens, you're not going to be able to use your tripod for shooting full 360° panoramas. Because of the off-axis rotation, the ends of your panoramas won't necessarily fit together. For smaller panoramas, though, you should be fine no matter how your tripod mount is positioned.

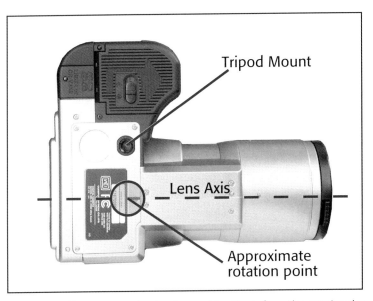

**FIGURE 9.11**   If your camera's tripod mount is off-axis from the rotational center of the lens, you'll have a hard time shooting full 360° panoramas from a tripod.

When you shoot with the camera handheld, remember to pivot the *camera*, not your head or body. Your eyes are a few inches in front of the center of rotation of your neck, and your camera's lens will be even further removed from your neck or body's rotation, meaning that if you simply turn your head or body, you'll actually be rotating around a point several inches *behind* the camera. Therefore, between shots, rotate the *camera* properly and then—if necessary—reposition your body behind the camera's new position. Your main concern when you rotate the camera is to keep its bottom parallel to the ground. If you tilt the camera in addition to rotating it, you'll run into some problems when you are stitching. (See Figure 9.12.)

When you pivot the camera, remember that your images must *overlap,* not sit adjacent to each other. Most stitching software recommends a 15 to 30 percent overlap between images, and some vendors recommend a 50 percent overlap. Many cameras feature panoramic assist modes that offer on-screen cues as to how much you need to overlap. If your camera has such a feature, it's definitely worth using. A little experience with your stitching program will give you a better idea of how images need to overlap.

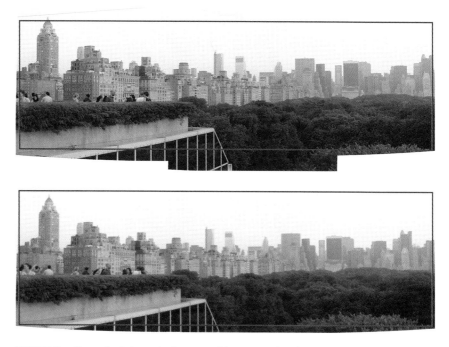

**FIGURE 9.12**    If you don't keep the bottom of the camera level as you rotate it, you'll end up with lots of unusable, wasted content in your final panorama that will have to be cropped. When your camera is level, you end up with more usable image for your final crop.

### BUYING A WIDE-ANGLE LENS

*If you have a camera that supports removable lenses, you might want to consider buying a wide-angle lens for shooting panoramas. Any lens between 20 and 28mm equivalent will make for a good panoramic lens. Because your camera probably has a focal length multiplier (see page 94), you'll actually need to shop for a lens with a 14 to 20mm focal length. Note that extremely wide-angle lenses come in two flavors: fisheye lenses, which produce tremendous amounts of distortion; and recti-linear lenses, which include optical corrections to yield a more "normal" image. Few stitching programs know how to handle images from fisheye lenses, so stick with rectilinear wide-angles.*

If you're a stickler for extreme precision, or if you're shooting full 360° panoramas for use as VR movies, you're going to have to do a little more work when you shoot to ensure that your source images are accurate enough to yield the results you want. You will absolutely need a tripod (preferably one with a built-in level), and you'll probably want to invest in a panoramic tripod head. A pano head is a special mount that attaches to

your tripod and includes preset rotation controls that allow you to quickly rotate your camera by a specified amount. Such heads typically sell for $100 to $300 (depending on the size of the camera they must support) and are worth the money if you do a lot of panoramas. (See Figure 9.13.) (See *www.completedigitalphotography.com/tripodmounts* for more info.)

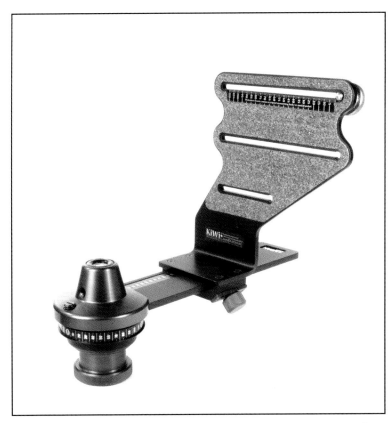

**FIGURE 9.13** This panoramic tripod head properly positions your camera for extremely accurate panorama shooting.

To ensure that you're rotating your camera precisely around its focal plane, you'll want to identify the camera's *nodal point*, the optical center of the camera's lens. (See Figure 9.14.) Most panoramic mounts include special adjustments for ensuring that the camera's nodal point is positioned directly above the tripod's axis of rotation, even if the camera's tripod mount is off-center. If your camera's nodal point is not marked, you might have to do a little experimentation to determine the best axis around which to rotate the camera.

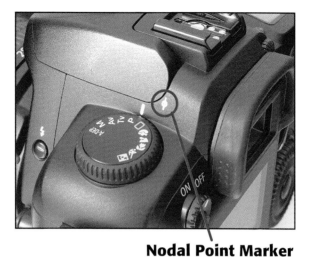

**Nodal Point Marker**

**FIGURE 9.14**    The nodal point indicator on the Canon EOS D30.

### Panoramic Exposure

Because you will be pointing your camera in many different directions as you shoot a panorama, it's important to plan your exposure ahead of time. Your goal is to have an even exposure across all of the images in your panorama to prevent *banding*—bright strips of incorrect exposure that will appear along the seams of your stitched image. (Refer to Figure 9.15.)

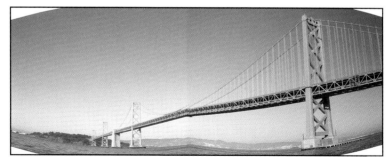

**FIGURE 9.15**    There are many things wrong with this image: we didn't input the correct focal length when stitching our frames together, so the individual frames are heavily warped and distorted; we didn't provide enough overlap in the individual frames, which contributed to the distortion problem. Finally, because our exposure was off, the final panorama has a very visible banding problem along its seam.

In general, if you've got more than a one- or two-stop difference in exposure between two adjacent images, you're going to see a band along the seam when the panorama is stitched.

In an evenly lit scene, such as the one in Figure 9.8, maintaining exposure is fairly simple, because there are no dramatic changes in lighting between one frame and the next. However, you still need to keep an eye on your exposure, especially if you're using your camera's automatic exposure mechanism. For example, because the first frame contains more sky, your camera might choose an exposure that's a little different than what it selects in the second frame. If the exposures are too far apart, you'll see a band.

If your camera provides an exposure lock feature, you can lock your exposure after the first frame, to ensure that the second frame is exposed with the same values. Or, you can meter off of a more intermediate part of the image, lock that exposure, then shoot each individual frame with that metering. If your camera includes a panoramic assist mode of some kind, it probably automatically locks the exposure after each frame.

If you're shooting a scene that encompasses a bright light on one end (say, the sun, or the lamp in a room) and ambient light or dark shadow on the other end (Figure 9.16), things are going to be a bit more complicated. The simplest way to handle this situation is to shoot the same way you would an evenly lit scene: choose an intermediate exposure, lock your camera's exposure settings, then shoot your panorama. Your bright light source will be overexposed, but your midtones and shadows will probably be okay (unless you have some exceptionally dark areas). However, despite these potential issues, your finished panorama will be evenly exposed and free of banding.

If you're willing to do a little more work, take an initial, intermediate exposure reading and lock it into your camera. Then, for frames that are significantly brighter or darker, use your camera's exposure compensation control to over- or underexpose on particularly bright or dark frames. To prevent banding, keep your compensations to within 1/2 to 1 1/2 stops.

### Shoot with Care

When you shoot around people, animals, or other moving objects, pay attention to where you position the seams of your image. A person who is present in one image and gone in the next might turn partially transparent if they fall on a seam in the final panorama. (See Figure 9.17.)

If the objects in your panorama are moving in a particular direction, shoot in the opposite direction. That is, if a person is walking across your scene from right to left, shoot your images from left to right. This is

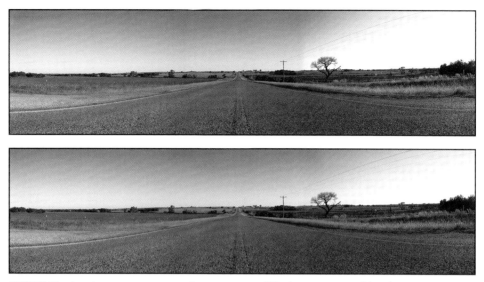

**FIGURE 9.16**  Landscape panoramas often present a difficult exposure problem because, invariably, the sun is sitting at one end or the other of your scene. In the top image, we used the camera's automatic meter for each of the four frames we shot. Unfortunately, when we stitched, the right-most end (the side the sun was on) ended up heavily overexposed, thus spoiling our stitch. For the lower image, we pointed straight ahead—to what would be our middle frame— metered, then locked the exposure using our camera's exposure lock. We then reframed for our left-most image, focused, shot, then rotated to shoot each of our three other frames. The exposure lock created a uniform exposure that made for a more successful stitching operation.

**FIGURE 9.17**  When shooting a panorama, be certain that moving images do not fall on a seam, or you'll end up with weird, split objects in your final panorama.

assuming that you don't *want* to see multiple copies of the person across your panoramic field of view. If you *do*, then by all means, shoot from right to left and ensure that the person is in the middle of each shot when you shoot. (See Figure 9.18.)

**FIGURE 9.18**   Because we were shooting our panorama images from left to right, we shot the Jeep twice. Consequently, when stitched, there are two identical Jeeps in the shot.

Finally, learn to think of the panoramic process as a complex—but free—super-wide-angle lens. Don't just use panoramas for capturing wide vistas; use them for any occasion where you'd like to have a wide-angle or fisheye lens. (See Figure 9.19.)

**FIGURE 9.19**   Panoramas aren't just for landscapes. Think about shooting them any time you would normally opt for a really wide-angle—or even fisheye—lens.

## SPECIAL PANORAMA ATTACHMENTS

If you regularly need to shoot panoramic images, you might want to invest in a special, single-shot panoramic attachment. Products such as the Kaidan® 360 One VR adapter and the SunPak® SurroundPhoto™ adapter allow you to shoot full 360° panoramic images with a single shot from your digital camera.

Both devices attach to the front of the camera through the use of a special adapter ring. At the time of this writing, adapters are available for a number of cameras, including Digital SLRs. (See Figure 9.20.)

These contraptions work by positioning a parabolic mirror in front of the lens. When the camera—with the device—is pointed straight up, the mirror reflects a full 360° down into your camera lens. The resulting image is somewhat strange (Figure 9.21), and so requires special "dewarping" software (included with the device) to dewarp the image into a normal panoramic picture. (See Figure 9.22.) As with any other 360° panorama, these files can be used to create a QuickTime® VR movie in addition to simple panoramic images.

The only downside to these devices is that they are very large. The Kaidan 360 One VR, for example, is about the size of a large mayonnaise jar—not the type of thing you want to travel with, but a great solution if you shoot panoramas for a living. For more information, check out *www.completedigitalphotography.com/360One*.

**FIGURE 9.20**   The 360 One VR panoramic attachment lets you capture full 360° panoramas with a single shot. Using a special parabolic mirror and custom software, this type of lens attachment is a must-have for users who need to shoot lots of panoramic images and movies.

**FIGURE 9.21**   Single-shot panoramic devices such as the 360 One produce an image that looks like this. A parabolic mirror reflects an entire 360° perspective into the lens of your digital camera.

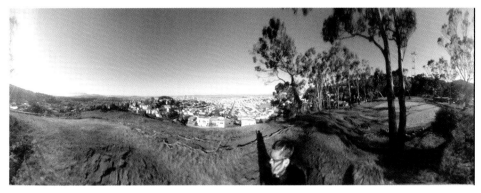

**FIGURE 9.22** Special dewarping software is used to turn the spherical image shown in Figure 9.21 into this full panoramic image.

## SHOOTING FOR THE WEB

Shooting with the highest resolution and quality that your camera affords will allow you to use your images for anything from print to video to the Web. However, there might be times when you know that your images will be used only for the Web. In these instances, there are a few Web-specific settings to consider.

*THINK TWICE BEFORE SHOOTING LOW-RESOLUTION!*

*As you might have already guessed, this author thinks that it's best to always shoot at the highest quality possible. Although the extra resolution might be overkill for your intended output, the extra resolution will afford you more editing and cropping power, and allow for printing if you later find a reason to repurpose your images. Storage is cheap these days, so why not hedge your bets against future need, and shoot all of your images as if you intended to print them?*

### Image Size and Quality

If you plan to shoot only for the Web, you might as well switch your camera to a lower resolution to save space. Resolution will be discussed in more detail in Chapter 15, "Output," but for now it's safe to say that XGA resolution (1024 × 768) will probably be all that you'll ever need for Web images. Note that if you plan on blowing up part of your image—for example, if you can't get near enough to your subject to get a really good close-up shot—you might want to shoot at higher resolution, to provide more data for enlarging.

Every time you save an image using JPEG compression, you lose some image quality. Hopefully, it's an imperceptible loss of quality, but you never know. Assuming your camera is saving in JPEG format, your images will get compressed once before they even leave your camera. You'll most likely make some edits to your image—color or tonal corrections, cropping, and resizing—and then save the image out as a JPEG file for Web posting, which means it will get compressed again and lose more data. Therefore, it's best to shoot at the compression level that provides the best level of quality. In Chapter 10, "Preparing Your Images for Editing," you'll learn more about moving and resaving your images.

### Consider the Legibility of the Image

Give some consideration to the final image size that you'll be posting. Smaller pictures can be harder to see, so to help improve the legibility of the image at small sizes, you'll want to strive for clean compositions with good lighting. Consider shooting with shallow depth of field (if your camera can manage it) to provide good separation of foreground and background.

### Finally, a Use for That Digital Zoom!

If you're shooting at a lower resolution, it might be okay to go ahead and use your camera's digital zoom. Many digital zoom features work by simply taking a smaller area of the image and interpolating it up to full resolution. However, because you'll typically be shooting at lower resolution—XGA or VGA resolution—the camera won't necessarily have to enlarge its digitally zoomed crop. The result: no image degradation when you digitally zoom—up to a point.

On the Coolpix 990, for example, you can digitally zoom up to 2x at XGA resolution with no degradation. At VGA resolution, you can go up to 3.2x.

If you'll be shooting a lot of Web-resolution images, it's worth experimenting with your digital zoom to learn how and when it degrades your image.

## SHOOTING FOR VIDEO

If your still images are destined for video, you're in luck, because even a one-megapixel camera produces far more resolution than you need for

video. For most video formats, you can get away with shooting at 640 × 480 (VGA) resolution. High Definition footage will require higher, XGA resolution.

When you shoot for video, it's important to be aware that there are *action-safe* and *title-safe* areas in a video image. Anything outside of these areas might be cropped by the viewer's monitor or television. Most video-editing programs provide guides that show the boundaries of these areas. Ask your video producer to provide you with a reference for these areas. (See Figure 9.23.)

**FIGURE 9.23**    If you're shooting images for video, be aware of the action- and title-safe areas. Any important action should be kept within the outer square, whereas titles should be kept within the inner square.

## USING FILTERS

When you edit and correct your images, you'll often use a lot of filters, small bits of programming code that can add functionality to your image-editing program. There's another type of filter, however: the kind that screws onto the end of your lens and modifies the light passing into your camera. Filters can be used for everything from creating special effects to correcting image problems, but before you can start using a filter, you have to figure out how to get it onto your camera.

First, check the lens on your camera for lens threads; if it isn't threaded, you won't be able to attach any filters, unless the camera provides some kind of filter adapter that attaches using some other kind of mount. The filter size for your lens is probably written on the end of the lens. (See Figure 9.24.) If not, check your manual.

**FIGURE 9.24**    If your lens has threads, you can find out what size filters you need by looking for a thread-size marking on the end of your lens. The lens shown here needs 49mm filters.

When you buy filters, be sure to get filters that have the same thread size as your lens. Most filters will have threads of their own, which will allow you to stack filters.

Other filters might not be available in the right size for your lens and so might require the use of a *step-up ring,* a simple adapter that screws onto the front of your lens and provides a bigger (or sometimes smaller) set of threads for accepting filters with different thread sizes. (See Figure 9.25.) Be careful with step-up rings, though—if they're too big, they might block your camera's metering sensors, flash, or optical viewfinder.

Lens filters are completely flat, meaning they don't add any magnification power to your lens. Although optically they are simpler than a lens, you still want to be careful about your choice of filter. There *is* a difference between a $100 ultraviolet filter and a $35 ultraviolet filter. Just as an element in your lens can introduce aberrations, a poorly made filter can introduce flares and color shifts. Although it can be tempting to go for the less expensive filter, spend a little time researching the more costly competition. You might find that there is a big difference in image quality.

**FIGURE 9.25** Many cameras, such as this Olympus C2500, require a step-up ring or adapter to use lens attachments or filters. When using a lens attachment such as this telephoto adapter, you usually need to set a special menu option to let the camera know that the attachment is being used. This setting alters the focus and metering functions of the camera.

## Types of Filters

In Chapter 8, "Manual Exposure," you read about neutral density filters, noncolored filters that you can use to cut out a few stops' worth of light to increase your exposure options. In addition, earlier in this chapter you read about infrared filters that can be used to photograph objects in infrared light. There are many other types of filters—too many to cover here. However, if there is a group of "essential" filters, it would probably include the following:

**Polarizers:** *Polarizers* allow light that is polarized only in a particular direction to pass through your lens. The practical upshot is that polarizers can completely remove distracting reflections from water, glass, or other shiny surfaces. To use a polarizer, you simply attach it to the end of your lens and rotate it until the reflections are gone. Polarizers can also be used to increase the contrast in skies and clouds. (See Figure 9.26.)

**FIGURE 9.26**    These images show the difference in shooting with and without a circular polarizing filter. In the top images, you can see how a polarizer lets you control the color and contrast of skies and clouds, whereas the bottom images show how you can use a polarizer to eliminate reflections. No postprocessing was applied to any of these images.

**Ultraviolet filters:**    Ultraviolet filters are used to cut down on haze and other atmospheric conditions that can sometimes result in color shifts in your image.

**Contrast filters:**    You can increase contrast and saturation in your images by using simple colored *contrast filters*. Yellow filters will typically

darken skies and shadows, and yellow-green and red filters will increase such contrast even further. Conversely, blue filters will lighten skies and darken green foliage and trees.

**Effects filters:**   There are any number of *effects filters*, ranging from filters that will render bright lights as starbursts to filters that will soften, or haze, an image. Major filter manufacturers such as Tiffen®, B+W, and Hoya publish complete, detailed catalogs of all their filter options.

If your camera does not have a TTL light meter, you're going to have to do some manual compensating when you use a filter. Because the metered light is not passing through the filter, the meter will lead you to underexpose. Most filters will have a documented *filter factor*, which will inform you of the exposure compensation (in stops) required when you use that filter.

Similarly, if your camera does not use a TTL white-balance system, your white balance might not be properly adjusted for the filter's effect. The only way to find out for sure is to do a little experimenting.

Obviously, if your camera is not an SLR, you won't see the effects of the filter when you look through the camera's optical viewfinder. Switch to the camera's LCD.

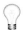 *BEWARE OF ULTRAVIOLET FILTERS*

*It's fairly common practice to mount an ultraviolet filter on your lens and leave it there to protect your lens from bumps and scratches. Be aware, however, that an ultraviolet filter can affect the white-balance presets on your camera. You might find, for example, that your daylight white-balance preset becomes too warm, because the camera will be expecting more ultraviolet light to be coming through the lens. If this seems to be true of your camera, either remove the filter when you use this setting, or use automatic white balance or a manual white balance when you shoot with the filter in bright sunlight. If your camera does not have a TTL white-balance system, you might have difficulty getting good white balance when shooting with filters.*

### Cheap Filters

*Gels* are thin pieces of plastic that are usually placed in front of lights to create colored lighting effects. Available at any theatrical lighting supply store and at many photography stores, gels can also be used as inexpensive filters. Simply hold the gel in front of your lens and fire away.

On the downside, holding a gel in front of your lens can be tricky, because any buckles, folds, or reflections in the gel will introduce distortion

into your image. You'll also need to be wary of fingerprints on the gel material. To avoid such troubles, you can always try sandwiching gel material between two ultraviolet filters and then mounting the whole contraption onto your lens.

### Lens Extensions

Some cameras support screw-on lens extensions that attach to your camera's filter threads, or to a special bayonet mount on the front of the camera, to create a more telephoto or wide-angle lens. As with filters, these extensions might require a step-up ring. Also note that some cameras require you to choose special settings—usually accessed through a menu option—when using a lens extension. If you don't let the camera know that an extension is attached, its focus and metering operations can become confused.

Spend some time experimenting with your camera's extensions to determine their idiosyncrasies. For example, some lenses might have bad barrel or pincushion distortion or vignetting problems.

Finally, if the extension or step-up ring is very large, it might obscure the camera's optical viewfinder or onboard flash. If the extension protrudes too far in front of the flash, it will cast a shadow when you take the shot. Usually, the only solution is to use an external flash.

## SHOOTING IN EXTREME CONDITIONS

One great advantage of film cameras over digital cameras is that they can be incredibly simple machines and, thus, very durable. Because all of the imaging and storage technology in a film camera is contained in the film, the camera itself can be little more than a box. This is not true with a digital camera, which requires batteries, silicon chips, LCD screens, and many more potentially fragile components.

When you shoot in extreme heat or cold, or in very wet or dusty situations, you need to take a number of precautions to ensure that you don't damage your camera. Obviously, as with any mechanical apparatus, dirt, dust, sand, water, and extreme temperatures are definite hazards.

If you do a lot of shooting in extreme weather, you might want to consider a weather-resistant camera. Whether you need a simple point-and-shoot or full-blown SLR, there are cameras available that include special weatherproof seals around their controls and extra durable bodies for photographing in harsh conditions.

### Dirt, Dust, Sand, and Digital Cameras

Be particularly cautious about dirt, dust, and sand, because even if it doesn't get inside the camera, a single grain of sand can be abrasive enough to scratch your lens. Even with deep depths of field, minor lens scratches on smaller lenses are enhanced rather than downplayed.

### Water and Digital Cameras

Digital cameras and water definitely do not mix. Although a few sprinkles are nothing to worry about, you absolutely do *not* want to submerge your camera. The rule of thumb for manual film cameras has always been: if it falls in the water, grab the camera and put it in a bucket of that same water. Keeping a film camera submerged will prevent rust until you can get the bucket and camera to a repair person who can take it apart, clean it, and dry it. (Of course, carrying a bucket in your camera bag can be a bit of a hassle.)

Unfortunately, this doesn't apply to today's electronics-laden digital and film cameras. If your camera goes in the drink, fish it out immediately and do everything you can to get it dry. Immediately remove the battery and media card; open all port covers, lids, and flaps, and wipe off any water you can see, no matter how small. Set the camera in a warm place and do *not* turn it on until you're sure the camera has had time to dry off, both inside and out. At the least, give it a couple of days to dry.

If you know you're going to be using your camera in potentially wet situations (kayaking, canoeing, taking your convertible to the car wash), consider buying a *drybag*—a sealable, waterproof bag that will keep your camera dry even if it gets submerged.

If you absolutely have to shoot in the rain, try sticking your camera in a Ziploc® bag. You'll still be able to access the controls, and you can always cut a hole for the lens. (See Figure 9.27.)

### The Camera That Came in from the Cold

Shooting in cold weather presents a number of problems for the digital photographer. First, there are the LCDs on your camera. Remember that the "L" in LCD stands for liquid. As temperatures drop, your LCD will become far less "L," and the last thing you want is for it to turn into a solid crystal display. Although the LCD won't necessarily be damaged by cold weather, it might prove to be unusable.

Other, smaller, electronic components might actually be damaged if you try to use them in cold weather. Extreme cold might cause small

**FIGURE 9.27** If you're shooting in light rain, consider using a Ziploc bag to protect your camera. Be warned, though, that your camera is very sensitive to cold and damp.

electronic components to expand or contract enough that using them will cause them to break. Your camera's documentation should list a range of operating temperatures and, although you *might* be able to push these an extra 20° on the cold end, it's safe to say that such use won't be covered by your warranty.

Even if you're shooting within your camera's proscribed operating temperatures, be very careful when you move the camera from cold temperatures to warm. Walking into a heated house from a day of shooting in the snow can cause potentially damaging condensation to form inside the camera. If you know you're going to be shooting in cold weather, take a Ziploc bag with you. Before you go into a warm building, put the camera in the bag and zip it up. Once inside, give the camera 20 or 30 minutes to warm up to room temperature before you let it out of the bag. If you don't have a bag, be sure not to turn it on until any condensation has had time to evaporate.

If the temperature is cold enough to freeze your camera, then it's probably cold enough that you'll be wearing gloves. Because gloves tend to reduce your manual dexterity, be absolutely certain your camera has a neck or wrist strap and that it's securely attached to some part of your body.

In addition, if you're shooting in icy, slippery conditions where you might be prone to falling, attach a UV filter to the end of your lens. This will add an extra level of scratch and shatter protection that might save your lens in the event of a fall.

As discussed in Chapter 7, "Shooting," batteries can be greatly affected by cold weather. Take a look at the cold-weather battery tips in Chapter 7 in the section "Power and Storage Management."

### Hot Weather and Digital Cameras

Hot weather can also affect your camera and, again, the first thing to go will be the LCD screen. If you turn on your camera and your LCD appears black, it's safe to say that your LCD has overheated—they're not very reliable above 32°C (90°F). Turn off your camera and try to get it somewhere where it can cool down. If you must shoot in high temperatures, consider keeping your camera in some type of dry cooler (an ice chest with some blue ice) until you're ready to shoot.

If you haven't exceeded the camera's recommended operating temperature, but your LCD has overheated and isn't working, it's probably safe to keep shooting using the camera's optical viewfinder (if it has one). Turn off the picture-review function because your LCD won't be visible anyway.

---

## ASTRO-PHOTOGRAPHY

Although you might not have the massive space program necessary to shoot like the Apollo astronauts, there's no reason you can't photograph the same subject matter. The Hubble Telescope, after all, is really just a giant, orbiting digital camera. Because of its extreme sensitivity to light, your digital camera is an ideal tool for photographing astronomical objects through a telescope. (See Figure 9.28.) In fact, many astronomers are finding that even cheap $100 Web cameras produce good astro photos.

In addition to providing you with a way to record your astronomical observations, your digital camera can help you capture images of subjects that you normally can't see, and it can let you see those objects in color. Your eye has to gather a lot of light to discern the color of an object, and it simply cannot gather light fast enough to see the color of objects millions of miles (or light years) away. Because your digital camera can sit and gather light for a long time, it can discern the color of objects that would appear black and white if you simply looked at them through a telescope.

Some quick astro-photography tips include:

- Obviously, you'll have to buy a lens mount that will allow you to attach your camera to your telescope. There are many such mounts and adapters; check with your telescope dealer or camera manufacturer for details. You might need a number of different step-up rings and adapters depending on the type of camera and telescope you have.
- Your camera will need to have a manual mode that allows for shutter and aperture control and that provides for long exposures (greater than 30 seconds). Open the aperture all the way. Your light meter will be useless for this type of photography, so you'll be doing everything manually.
- To prevent vibration, you'll want to use a remote control or self-timer to fire your camera's shutter release. In addition, if your camera has a mirror lockup feature, use it, because this will further reduce camera vibration when you shoot.
- If you're using a digital SLR with removable lenses, consider using a very fast prime lens rather than a zoom lens. Because zooms are usually slower than primes and not quite as sharp, a prime lens will yield better resolution when you shoot point-light sources such as stars.
- Ideally, you'll want a camera that has a long-exposure noise reduction feature. If your camera doesn't have such a feature, you'll want to perform a manual dark frame subtraction, as explained in Chapter 13, "Essential Imaging Tactics."
- As your camera gets warmer, the noise in your images will increase. Let your camera cool down outside before you start shooting. As your camera cools, its propensity for noise will decrease. Some astro-photographers even modify their cameras with special cooling units. (See Figure 9.28.)

To learn more about astrophotography, check out *www.completedigital photography.com/astro.*

**FIGURE 9.28**    These four images show what can be done with a digital camera and a good telescope. The lunar photos on the left were shot by Greg Konkel using an Olympus 2020. The nebula and galaxy photos were shot by Gary Honis using a custom-modified, air-cooled Olympus camera. For a detailed description of their techniques—as well as many more excellent pictures—check out *www.completedigitalphotography.com/astro*.

# 10 PREPARING YOUR IMAGES FOR EDITING

**In This Chapter**

- Moving Pictures: How to Transfer and Organize Your Images
- Preparing Your Image Editor
- Opening an Image
- Preparing Your Image
- Understanding Resolution
- Cropping and Resizing an Image
- Moving On

In the rest of this book, you will learn about what happens after you've finished shooting. From color correcting to editing to printing, the following chapters will cover the processes that have traditionally happened in the darkroom but now happen inside your computer.

Although your image-editing application is capable of amazing photographic feats, it's also capable of producing really terrible images. To get the best results—and to get them in a predictable, reproducible manner—you need to make some preparations to both your images and to your computer. In this chapter, you will learn how to configure your system to get the best results from the processes you'll learn in the rest of the book.

Before you can begin editing, though, you need to move your images into your computer.

## MOVING PICTURES: HOW TO TRANSFER AND ORGANIZE YOUR IMAGES

No matter how serious you are about your photography, there has probably been some time in your life when you've gone on vacation, shot a bunch of pictures, brought your film back home, and then never had it developed. For some reason—jet lag, going back to work—you never got around to taking the film down to the lab, and so the film sits in a drawer where it will remain for years until your children eventually inherit it, develop it, and have no idea what they're looking at.

This problem is even more pronounced in the digital world. Because you don't have to worry about wasting film, you'll probably find yourself shooting many more pictures than you would with a film camera. In no time at all, you can have hundreds of images on your hard drive, each with a vague name like DSC00453.JPG that offers no idea of what the image is. Eventually, you'll burn these images to CDs, which you'll throw in a drawer where they will remain for years until your children eventually inherit them, dig an old computer out of the closet, open the files, and have no idea what they're looking at.

With just a little effort and some special software, you can save yourself (or your descendents) from one day facing a 60-GB drive full of unlabeled images.

### Make the Transfer

As discussed earlier in this book, there are a number of ways that you can transfer images from your camera to your computer. Your camera probably

includes a serial port of some kind, usually USB or possibly even FireWire. Using the special cable and software included with your camera, you can transfer your pictures to your computer.

This is usually the least convenient and most time-consuming method of transferring digital images. Depending on the size and number of your images and the speed of your connection, transferring a single image can take anywhere from a few seconds to several minutes. In addition, using your camera's cable connection will drain your camera's batteries

A speedier option is to use a media drive or PC card adapter like those discussed in Chapter 5, "Choosing a Digital Camera." With these devices, your media card will appear on your desktop just like any other disk or drive. You can then quickly drag and drop files to your hard drive.

Because both the Mac and Windows operating systems can now automatically recognize an attached camera or media card, file transfer is much easier than it used to be. Simply attach your camera via cable, or insert a media card into your card reader, and your computer will automatically copy the files from your media card to your computer's hard drive. If you're using an older operating system (or if you're using Windows XP and you don't have a driver for your camera), you'll need to use the transfer software that came with your camera.

If you find yourself using your camera's custom software, be sure that it is doing a straight copy of the files from your storage card to your computer. You don't want to be opening images and resaving them, because this method can introduce more JPEG compression degradation. We'll be resaving images later; right now we're just trying to get them transferred to your computer with no further compression.

No matter how you move your images, it's essential to stay organized and to keep your images labeled. If your camera's image-transfer software includes a *light table* or *image-cataloging* function, you can quickly generate a page of thumbnails showing the contents of an entire media card.

If your camera's included software doesn't include such a function, or if you'd like more power, consider using a third-party media-cataloging application such as iView Multimedia (Figure 6.6) or the Image Browser that's built into Photoshop and Photoshop Elements.  Demos of both the Mac and Windows versions of Photoshop are included on the CD-ROM.

## APPLE iPHOTO

Apple's free iPhoto® application is an excellent tool for managing, cataloging, and organizing your photos. However, to integrate iPhoto into your image-editing workflow, you need to understand a few things about how it works. When you import photos into iPhoto, either from a camera, a media card, or a folder on your hard drive, it copies them into its own internal library, which is usually stored in the Pictures > iPhoto Library folder of your Home directory. If you go dig around in the iPhoto Library, you'll find a weird assortment of oddly named files, alongside folders called Thumbs and Data. All of these, in turn, are spread among gobs of numbered folders. In other words, iPhoto does not expect you to be able to retrieve any of your photos on your own.

So, once you've added an image to your iPhoto library, if you want to use it in another application, you have to ask iPhoto to export it for you. Fortunately, iPhoto has excellent export features that can automatically resize and process your images for particular applications. For example, if you want to e-mail an image, iPhoto will automatically resize it to something more appropriate for e-mail, and attach it to an e-mail message in Apple's Mail program. Similarly, iPhoto can automatically export images as Web-based catalogs.

If you want to edit an image in your iPhoto library using another application—Adobe Photoshop, say—you'll need to export the image to a file. iPhoto's Export command includes an Original option (Figure 10.1) that writes out the original image data, without performing any additional compression.

Note that the iPhoto Library still contains a copy of the image you just exported, meaning that iPhoto becomes something of a repository of "digital negatives."

iPhoto's approach has a few drawbacks. In addition to having to ask it for any files you want copies of, you can't use it for cataloging offline volumes (such as CDs of archived images), so all of your images have to remain on your hard drive. Nevertheless, as a cataloger and organizer, it's a very good application, and it's hard to beat the price. Just be sure that you integrate its Export facility into your workflow properly, so that you don't introduce unnecessary compression.

## Organize Your Digital Media

Although everyone will have different ideas about organization and workflow, here are a few tips and suggestions for managing your digital media.

- Start by grouping images into folders, by subject. If you're in a hurry, don't worry about naming every file—just quickly sort by subject. You can always label individual files later. With your images grouped into subjects by folder, it will be easier to back up particular files or transfer all files related to a particular subject or shoot.

**FIGURE 10.1**    If you want to move a photo from iPhoto into another image-editing program, you need to use iPhoto's Export command. Be sure to select a full-size original to get an exact copy of your original image, with no additional compression.

- With your images sorted, you're ready to tell your image-cataloging software to build catalogs of those newly created folders. Once the catalog is made, you can begin to easily rename images according to their contents (assuming your cataloger allows you to rename files). If you have a lot of images, you may not want to bother with renaming. Your folder organization and cataloging will be enough to find the image you want.
- If you have a series of bracketed images, label each file with the appropriate exposure; this is the easiest way to keep track of how each image was exposed. (See Figure 10.2.) You can look up the settings using your camera's information display, or by using an EXIF-compatible application.
- Similarly, sort panoramic images into folders. Whether or not you stitch them right away, it's a good idea to keep related images together.
- Lock valuable images before editing. Because most images are stored as JPEG files, you want to be sure that you don't accidentally save them again as a JPEG file and introduce more compression. Locking your original file gives you the equivalent of a digital negative. You can then save new copies as you make edits.

**FIGURE 10.2**    If you have a group of bracketed images, change their filenames to reflect the degree of exposure adjustment in each image. This will make it easier to keep track of which image is which.

- If your image cataloger doesn't support raw files, there's still a way you can catalog your raw images. Most cameras that offer raw files are also capable of saving separate small thumbnails for viewing. When you transfer images, be sure to copy both the thumbnail files and the raw files. You can drop these small thumbnail files into your browser and use them as a reference to your raw files.

Once you settle on a system of organization, use it! Although it might seem strange to devote several pages to this one topic, it's very easy to become overwhelmed by the number of images that your camera will produce in a heavy day of shooting. With a well-designed system of organization, you can quickly keep image glut under control.

## PREPARING YOUR IMAGE EDITOR

Editing and correcting images digitally is a lot easier than using traditional darkroom techniques, but there are still some technical challenges you have to wrestle with. The biggest of these is the issue of getting the colors on your printer to match the colors on your screen. As you may have already discovered, prints can often look very different from the image on your computer monitor. *Monitor calibration* is the process of tuning your system so that your printed output better matches what you see on-screen. How much effort to spend on calibration depends on how picky you are, what kind of workflow you expect to have, and what kind of gear you use.

Fortunately, there's been a lot of good work done on improving color calibration hardware and software, so getting good results from your printer is not as complicated as it used to be. Overall, with the current generation of printer drivers from Epson®, Canon, and HP®, you can get very good results by simply using the automatic color-correction features built in to the drivers. Note that these drivers are not going to produce prints that exactly match the color on your monitor, but they will produce prints that are very good in a consistent way. In other words, if you notice that your printer consistently produces images that are a little too green, you can simply tell the driver to back off a bit on the green every time you print. You'll also probably find that with practice, you'll learn how things on your screen correspond to what comes out of your printer. For example, you'll get better at eyeballing when shadows in an image are too dark.

If you want your output to more exactly match your monitor—whether to improve the efficiency of your printing process, or because you're working in an environment where you're moving images across multiple systems, each with a different monitor—you're going to have to engage in a more serious hardware and software calibration process.

In the following section, you'll learn how to configure the color management tools in Adobe Photoshop CS to more accurately represent colors on your monitor and printer. (Note that these techniques also work for Photoshop 6 and 7, although there might be some subtle differences.) Even if Photoshop is not your image editor of choice, it's worth installing the Photoshop demo from the companion CD-ROM to follow the instructions in this text more easily. Remember that you don't *have* to perform this calibration; this is only for users who want to try to run a calibrated system for the sake of improved accuracy and efficiency.

*ON THE CD*

### A Little More Color Theory

As you saw in Chapter 2, "How a Digital Camera Works," light mixes together in an additive process so that as colors are added together they appear more and more white. Ink, on the other hand, mixes in a subtractive manner. That is, as colors are mixed they appear darker. While the primary colors of light—the fundamental colors from which all other colors can be made—are red, green, and blue, the primary colors of ink are cyan, magenta, and yellow. (See Figure 10.3.)

This difference in the way colors are made is what makes accurate calibration of your monitor and printer so difficult. Each time you print, your computer has to figure out how to take your image—which it represents as a combination of red, green, and blue light—and convert it into the mix of cyan, magenta, and yellow ink that your printer expects.

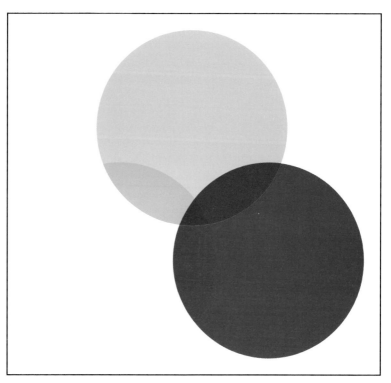

**FIGURE 10.3**   The primary colors of ink: cyan, magenta, and yellow. These colors differ from the primary colors of light—red, green, and blue—that your camera uses to create images. This difference is one of the things that makes monitor/printer calibration so complicated.

*SPECIAL K*

*As you might already know, color printing uses four colors: cyan, magenta, yellow, and black. Black is not a primary color, of course, but black ink is added to the mix because it is impossible to create perfectly pure ink pigments. Therefore, although the theory says that if you mix cyan, magenta, and yellow together you will eventually get black, the truth is you'll just get very dark brown because of impurities in the color pigments of your inks. Adding a little black ink is the only way to get true black. This is why most color printing is a four-color process called CMYK.*

As if converting colors between these two different color spaces wasn't difficult enough, accurate color reproduction is further complicated by the fact that not every monitor is the same. If you've ever looked at a wall of TVs in an appliance store, you've seen that an image can vary greatly even between identical models. There are a number of reasons

why, ranging from differences in color adjustments on each set, to differences in age, to differences in manufacturing. Computer monitors vary in the same way, which is why a digital image or Web page on your monitor might look completely different on someone else's monitor.

Printers have their own collection of troubles. Each manufacturer might take a different approach to reproducing colors, and different brands of ink and types of paper have their own unique color qualities as well. Further complicating matters is the fact that different printing technologies can use completely different approaches to reproducing color. Some printers use four colors, some add extra colors to reproduce lighter tones, some use ink, some use solid wax, and so on.

So, how in the world will you manage and account for all of these variables? Fortunately, if you properly configure your software, you won't have to.

## Color Management Systems

There are a number of ways that you can try to calibrate your monitor with your printer (or another monitor if you will be moving your images to different computers). Some people simply print a sample from their printer and then fool around with their monitor controls until the on-screen color matches the print. This is just about the worst way to approach color management because, in addition to being wildly inaccurate, your monitor adjustments won't necessarily be appropriate for all colors.

Another approach is to print an image using your preferred printer and paper, then look at what's wrong with the print and adjust the color in your image accordingly. This works okay (and even in the best of circumstances, you'll always have to output test prints and make adjustments), and over time you'll probably begin to better understand the idiosyncrasies of your monitor and printer. However, it will take a lot of printing and practicing to learn the color characteristics of your system, and if you ever change monitors or printers, everything you will have learned about what looks right on-screen will be wrong.

The best approach to color management, therefore, is to use a *color management system*, or *CMS*. A CMS is a set of software components that work together to compensate for the differences in your monitor, printer, and scanner, so that your images are displayed and printed as accurately as possible.

Using a CMS is pretty simple, but it does require a little time to gather the appropriate data and configure your software properly. With this small investment of time, though, you'll have a much better chance of reproducing your images correctly.

## Color Management Workflow

A color management system works by adjusting the *display* of the colors in your image file (also referred to as your document in this text) so that they appear correct on the particular monitor you are using. Note that the color values of the pixels in your document are not being changed. Instead, the colors are being adjusted on the fly, as they make their way to your monitor or printer. To make these adjustments, your color management system needs to know some details about the color characteristics of your monitor, your printer, and the device that produced your image. With Photoshop 6 or later and a properly configured color management system, you can make your monitor do a fairly accurate job of simulating a particular printer, allowing you to perform on-screen proofing, sometimes called *soft proofing*.

To perform these color manipulations, your CMS needs to have accurate *device profiles*. Also referred to as *ICC profiles* or simply *profiles*, these small data files describe certain color characteristics of each device in your color management workflow. Obviously, for your CMS to work properly, you'll need accurate device profiles.

In Chapter 2 you learned about color models—the different approaches to representing color in an image—and were introduced to the RGB and CMYK models. Different color models have different *gamuts*, or ranges of colors, that they are capable of representing. For example, a CMYK offset printing process has a very particular gamut of colors that it can reproduce, so if any of the colors in your image fall outside the color gamut of the press, they won't print properly. Part of the job of your color management system is to properly translate colors between different gamuts.

Photoshop performs most of its color calculations and manipulations in an RGB color space. Although you can choose to convert to another color space—CMYK or L*A*B, for example—for most digital photography and desktop printing applications you'll stick with RGB. In fact, some of Photoshop's functions don't work in any color space *but* RGB. However, because the RGB color space defines a range of colors that is smaller than the total number of colors that are out there, you can have variations of the RGB color space. For example, Microsoft and Hewlett-Packard defined the *sRGB* color space, a rather small RGB color space that attempts to reflect the color gamut of the average color monitor. Adobe, meanwhile, created the Adobe 1998 color space, a slightly larger color space that is more appropriate for typical desktop and offset printing jobs. Remember, when you're working with a particular color space, it is impossible to represent colors that lay outside of the color space's gamut, so your choice of color space is very important.

To ease its color management chores, Photoshop asks you to select a default RGB color space that it will use for its color management calcula-

tions. Adobe provides several options, and you can even add more if you want. In general, though, you want to choose a space that is large enough to support the colors produced by your camera. Photoshop also adds an extra wrinkle to the normal color management process: it attaches a profile to your image. This profile contains information about the RGB space used by the image.

Once you've selected a color space and installed your device profiles, Photoshop—with help from your *color-matching engine*—can start managing color. By examining the profile from your camera (if you have a camera profile) and the profile attached to your document, the CMS has a much better idea of what the colors in your image are supposed to be. By examining the profile for your monitor, it can figure out how to represent your colors on-screen, whereas your printer profile will provide the information necessary for your CMS to more accurately print those original colors.

What's more, if you take your image to another monitor and printer, it should look exactly the same on those devices as it did on yours—assuming those new devices have accurate profiles.

It's important to realize, however, that although a CMS can do a good job of accurately displaying colors, it still can't exactly represent printed output on your screen—or vice versa. Color created by a self-illuminated computer monitor is going to be inherently brighter and simply have a different quality than color ink on paper.

In the next section, you'll learn how to configure your color management system.

## Configuring Your Color Management System

A number of different color management systems are available, but the most popular are ColorSync, which comes built into the Macintosh operating system, and Windows' Integrated Color Management, which comes built into Windows. One of the nice things about color management in Photoshop is that, from the Color Settings dialog box, you can choose to use any CMS. Photoshop even includes a built-in CMS of its own. Although extreme color fanatics will argue the merits of one CMS over another, it's safe to say that for almost any application, the CMS that's built into your operating system—or Photoshop's built-in color manager—will be all that you'll ever need.

Your most important CMS-related concern is to configure your CMS settings properly by specifying which profiles you want to use for your monitor and printer (and, ideally, your camera, although you probably won't be able to find a camera profile) and tweaking a few settings. Most of your CMS configuration will happen inside Photoshop, but before you head there, you need to select a profile for your monitor.

If you're a Macintosh user using an Apple-brand monitor, your operating system probably shipped with an appropriate profile. If you're a Mac or Windows user using a third-party monitor, check your vendor's Web site to see if they offer a profile for your CMS. If they don't, you can build one yourself as described next.

---

## WHAT A COLOR LOOKS LIKE VERSUS WHAT IT IS MADE OF

Unfortunately, although CMYK or RGB color spaces can represent many colors, they don't describe what a color actually looks like; rather, they simply describe what a color is made of. In other words, a set of RGB values is nothing more than a recipe for displaying a certain color. In theory, this might seem like a great idea. In practice, though, it doesn't really work very well because there's no guarantee that your chosen monitor or printer has the right ingredients to properly make your color recipe.

For example, if your computer says that a particular pixel is supposed to be 50 percent red, 30 percent green, and 70 percent blue. Unfortunately, the red gun in your monitor is no longer the nice pure red that it once was, so what gets displayed might be closer to 40 percent red, 50 percent green, and 75 percent blue.

Fortunately, in 1976, CIE, the Commission Internationale de l'Éclairage (the International Commission on Illumination) came up with the L*A*B color model (actually, L*A*B is a modification of a color model created by CIE in 1931). Rather than describing how a color is made, L*A*B describes what a color looks like. Because L*A*B has nothing to do with any actual color reproduction method (such as the red, green, and blue electron guns used by your monitor, or the four different inks used by a printer), it is referred to as a *device-independent color space*.

A CMS works by using the profile of your camera or scanner to convert your image into a device-independent color space such as L*A*B. In other words, your camera's profile helps the CMS understand what the colors in your image are supposed to be, and L*A*B mode provides a reference space for modeling those colors.

---

### Specifying a Monitor Profile on a Macintosh

If you're using OS X on a Macintosh (or System 8.6 or later), ColorSync, Apple's color management system, is already installed on your computer. (If you're using OS 8.6 or later, ColorSync is probably installed on your system. Look for a ColorSync Control Panel. If it's not there, you need to install it from your original operating system disks. Though the dialog boxes in the rest of this explanation will appear slightly different from what you will see, you should have no trouble following along.) ColorSync ships with a number of predefined profiles including profiles for Adobe RGB and LCD screens, among others. If you're using a third-party

monitor, you should check with your vendor to see if they offer Color-Sync profiles.

If you don't have a profile for your monitor, you can always create one. Special hardware calibrators—such as the $150 Spyder™ from Color-Vision®—can be used to measure the characteristics of your display and create a monitor profile. Alternatively, you can build a profile by eye using Apple's Monitor Calibration Assistant software, shown in Figure 10.4.

**FIGURE 10.4**   Apple's Monitor Calibration Assistant provides a way to build a monitor profile by eye. Although less accurate than a hardware-calibrated profile, it's better than nothing.

Although it is not as precise as a hardware calibrator, Apple's calibrate-by-eye approach is still much better than not using a profile. Even if you have a predefined profile for your monitor, you might want to build a new profile from scratch. If your monitor is old, it might have changed enough from its original design specifications that the predefined profile no longer matches. To use the Monitor Calibration Assistant, follow the on-screen instructions.

Once you've found or created and installed a monitor profile, you use the Displays control panel (or Monitors control panel if using Mac OS 8 or 9) to select the appropriate profile from the list of available options. (The Monitor Calibration Assistant will do these two steps for you.)

That's it. Your monitor profile is now configured and you're ready to move on to the settings in Photoshop's Color Settings dialog box.

### Specifying a Monitor Profile in Windows

Before you can specify a monitor profile in Windows, you'll need a profile. Windows ships with only one default profile—which is unlikely to be the perfect match for your monitor—so it's better to try to build your own. You'll get the most accurate profile by using a hardware calibrator of some kind such as the ColorVision Spyder. You can also build a reasonable profile using the Adobe Gamma control panel. (See Figure 10.5.) Simply follow the on-screen instructions to build a profile by eye.

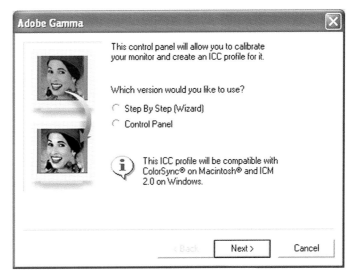

**FIGURE 10.5**   The Adobe Gamma control panel walks you through the process of creating a monitor profile by eye.

Monitor profiles in Windows 98 and 98 Second Edition need to be stored in the Windows/System/Color folder, whereas monitor profiles for Windows 2000, Millennium Edition (ME), and Windows XP need to be stored in the Windows/System32/Spool/Drivers/Color folder.

After you've placed your profile in the right folder, you need to attach it to your monitor. Open the Display control panel and click the Settings tab. Click the Advanced button at the bottom of the window, then click the Color Management tab. (See Figure 10.6.) From this screen, you can simply click the Add button to choose a profile.

**FIGURE 10.6**    After you've installed your monitor profile in the proper folder, you can use the Display control panel to define it as your current profile.

As on the Macintosh, the rest of your color management settings will be defined from within Photoshop.

---

### MONITOR CALIBRATION TIPS

Before you calibrate your monitor, whether by eye or with a hardware calibrator, let the monitor warm up for half an hour or so. This will give it time to get up to its usual operating temperature. For best results, turn down the lights in the room and block any reflections or glare that might be striking the monitor.

Set your desktop background or pattern to a neutral gray. (When you do any precise color manipulation or editing, you should set your desktop to gray to keep your eyes from getting confused.) If you want to get really picky, it's a good idea to move any large, brightly colored objects out of your field of view. In general, you want your working space to be neutrally colored.

### Photoshop's Color Settings Dialog Box

Figure 10.7 shows the Photoshop CS Color Settings dialog box. Although it might look a bit complex, you really need to make only one or two adjustments if you're printing to a desktop printer. If you have more complex, offset printing jobs, you'll need to delve into your Photoshop manual to learn more about CMYK settings.

**FIGURE 10.7**    You define the color spaces you want to use for different types of editing using the Working Spaces section of the Color Settings dialog box.

Your first choice is to configure your working spaces. A color space is just a mathematical model of a particular range of colors. As such, you can simply tell your computer to use one model or another. When you work in a particular color space, you won't be allowed to pick colors outside of that space, and when you perform corrections and other color-altering operations, your colors will be kept "legal." That is, they won't ever extend beyond the colors of that space.

The Working Spaces section of Photoshop's Color Settings dialog box lets you specify the color spaces you want to use for different types of editing. Therefore, you can select a particular color gamut for all of your RGB editing, another for all of your CMYK editing, and others for your grayscale editing or spot color work. (See Figure 10.8.) If you're going to be outputting only to a desktop color printer, you need to worry only about choosing an RGB color space.

**FIGURE 10.8**    Photoshop includes several color management presets that will automatically configure your color settings for specific printing situations.

*"I THOUGHT MY PRINTER USED CMYK INKS"*

*Although your desktop printer uses CMYK inks (or, in the case of a six-color ink-jet photo printer, CMYK with extra C and extra M), the driver software for the printer expects to receive RGB data. The driver takes care of making the appropriate conversion to a CMYK color space. Therefore, from your computer's point of view, your color printer is an RGB device.*

Photoshop provides four RGB spaces that differ slightly in the size of their gamuts. For most uses, the Adobe RGB (1998) space is probably the most appropriate. It's bigger than the sRGB space and has a wide enough gamut to handle all of the colors a digital camera can produce.

If your work is ultimately destined for output to a CMYK offset printing process, you'll need to choose a CMYK space. For most uses, the best CMYK choice is to choose one of the Prepress Default presets from the Settings pop-up menu in the Color Settings dialog box. (Refer to Figure 10.7.) Before getting too far into your work, though, you should consult with your printing service bureau to learn more about the color gamut of their particular press.

Photoshop tags your documents with the working space that you define in the Color Settings dialog box. These tags are part of the document's profile, and any new documents that you create will automatically be tagged with this working space profile. Later in this chapter, you'll see how these tags are used to proof your documents on-screen. First, though, you need to learn a little bit about profile management.

### Making Policy

Because not everyone will choose to use the same color space, Photoshop allows you to set policies that govern how to handle documents that are tagged with a different color space than your chosen working space. For example, let's say you've chosen to use Adobe RGB (1998) as your default working space, and a friend who does a lot of Web design gives you a Photoshop document. Most likely, your friend will have selected sRGB as his default working space, and his document will be tagged as such. Photoshop will handle the document in different ways, depending on how you've set your color management policies.

With Photoshop's default policy options, any time you open a document that has been tagged with a color space that is different from your default working space, Photoshop will present the message box shown in Figure 10.9.

**FIGURE 10.9**   If a document's profile doesn't match your default color working space, Photoshop lets you change to a new profile upon opening the document.

Simply put, Photoshop doesn't know what to do with the discrepancy between the document's color space and your stated color space preference. Therefore, it lets you choose to use the attached (embedded) document profile, change the profile to your working space, or discard the profile completely. In Figure 10.10, the discrepancy has occurred because the document's attached sRGB profile doesn't match the Adobe RGB working space defined in your Color Settings dialog box.

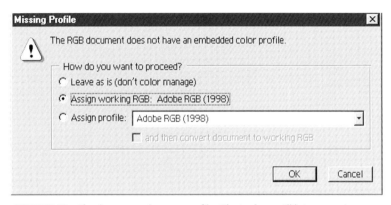

**FIGURE 10.10**   If a document has no profile, Photoshop will let you assign one upon opening.

You could choose to use the document's profile, but your printed results might not be as good as they would be if you converted the document to your chosen RGB space. It's better to go ahead and retag the document with your working space. Be aware, however, that you might want to warn the owner of this document that you've changed the working space, if you have to return the document to him.

The Color Settings dialog box lets you specify how mismatches in profiles should be handled. The bottom of the Color Settings dialog box provides detailed descriptions of each setting, and it's worth spending some time learning about the different policies. In general, though, Photoshop's default settings are the best for general use.

Finally, if you open a document that doesn't have a profile attached, Photoshop will present the message box shown in Figure 10.9 (unless you've specified different behavior in the Color Settings dialog).

At this point, you can choose to not attach a profile, meaning that Photoshop will perform no color management functions, or you can attach your default working space or another profile of your choice. In

most cases, you'll probably want to attach your default color space. Photo-shop presents similar documents if there is a profile mismatch when you paste something from one document into another.

When you change the profile of a document, Photoshop converts the document's colors into the new color space. Thanks to your color man-agement system, this is a nearly lossless process, but there is—techni-cally—a little loss of data when this occurs. Although you probably won't ever notice this loss, it's best not to go wantonly converting your images from space to space.

### TROUBLE MOVING IMAGES INTO OTHER APPLICATIONS

*If you're using Photoshop's color management features, you might find that an image looks different in Photoshop than it does in another application. This is because Pho-toshop is "correcting" the color before it hits your monitor. This can create problems if you're trying to pick or edit colors to match color elements in another application—for example, a page-layout or Web-design package. To prevent this, you can choose to not tag an image with a profile when you first open the image, or you can select Color Management Off from the Settings pop-up menu in the Color Settings dialog box.*

### "Aaaarrrgh! This Is Too Confusing!"

You can choose to ignore color management altogether. Although there's no way to completely disable Photoshop's color management, choosing Color Management Off from the Settings pop-up menu at the top of the Color Settings dialog box will select some good, all-purpose color spaces and will disable Photoshop's color management policies. However, if you open a document with a profile that's different from your chosen work-ing space, Photoshop will still present you with the Embedded Profile Mismatch message box shown in Figure 10.9. When this happens, choose the "Use the embedded profile" option. This will prevent color conver-sions and will leave the document's profile intact so that, if you return the document to its original owner, it will still behave as expected.

### CHANGES FROM PHOTOSHOP 5

*It's important to realize that the Color Settings dialog box in Photoshop 6, 7, and CS are very different from the color settings in Photoshop 5, which were spread across four dialog boxes. The newer versions of Photoshop also differ from version 5 in their ability to have multiple documents open, each with a separate RGB space, and in their ability to easily perform soft proofing. Therefore, if you're using ver-sion 5, you'll probably need to review your Photoshop manual to learn more about*

*that version's color settings. If you're using a previous version, now is a good time to upgrade. Earlier versions of Photoshop used a very different, greatly inferior method of color management.*

## Soft Proofing in Photoshop CS

Here's the payoff for all of this tedious color management theory. With your color settings configured and your profiles assigned, Photoshop can now do a pretty good job of generating a screen image, or *soft proof*, of what your image will look like when it is printed on a particular printer. Although Photoshop's soft proofs won't exactly match your printed page, they'll be pretty close and most likely will save you a few test prints.

To generate a soft proof, you'll need the appropriate printer profiles. These are most likely available from your printer vendor's Web site or were included in the software that shipped with your printer. Epson, HP, Canon, and many other vendors are diligent about generating profiles for their color printers, and you should install these profiles in the same folder as your monitor profiles.

With the proper profiles installed, open the document you want to soft proof and choose View > Proof Setup from the Photoshop menu bar. In the Proof Setup dialog box, select Custom from the Setup pop-up menu. (See Figure 10.11.) Choose the appropriate printer profile from the Profile pop-up menu. Most printers install separate profiles for each type of paper that the printer supports. For example, if you are using an Epson printer with Epson's Heavyweight Matte Paper, you'll want to select that profile.

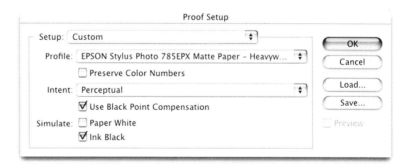

**FIGURE 10.11**   In the Proof Setup dialog box, you can create special soft-proof settings for all of your printers.

The Intent pop-up menu lets you control how Photoshop will deal with colors that fall outside the gamut of your device's color space. For images with strong saturated colors, choose Perceptual from the Intent menu.

For other images, select Relative Colorimetric. If you're not sure which is the best choice, you'll want to try a little experimentation. Odds are, you'll find Perceptual to be the best choice for most images. (See Figure 10.11.)

If you select the Paper White and Ink Black boxes, Photoshop will simulate both the color of the paper and the black point of the paper/ink combination to which you will be printing. Click the Save button and give this proof setup the same name as your printer; then click OK.

Now, click View > Proof Colors. You should see the colors in your image shift and the resulting image should be closer to what your printed output will look like. Note that you can select a default proof setup by clicking View > Proof Setup when there are no documents open. A discussion of the other Proof Setup settings is beyond the scope of this book, but you can learn more from your Photoshop manual or Photoshop's online help, or by simply checking the settings and doing some test prints to determine which configuration generates the most accurate proof.

Your CMS also comes into play when you print. You'll learn more about this in Chapter 15, "Output."

*THE RIGHT PROFILE FOR THE JOB*

*Note that many vendors include printer profiles designed for specific types of paper. Be sure to choose the profile that matches the type of paper you'll be using, because different types of paper can produce very different colors.*

## OPENING AN IMAGE

As we discussed earlier, with well-organized photos and a good image-cataloging program, you don't have to meticulously rename every file. But, without meaningful names, how will you know which file to open when you're finally done organizing and are ready to start editing? If you followed the advice in Chapter 6, you selected an image cataloger that can automatically open an image using your image editor of choice. So, going into your image catalog becomes the first step in your workflow.

Open the catalog that that contains the image you want to edit (or, if you're using Photoshop CS or Elements, open the Image Browser and point it at the relevant folder), then browse through the thumbnails to find the relevant file. When you find the image you're looking for, you simply tell your browser to open it using your image editor, and you're ready to edit.

If you are trying to select an image from a bracketed series, you might want to select all of them in your image cataloger and open them simultaneously. You can then quickly work through them, examining their histograms until you find the image you want to work with. Then simply close the other versions to maximize your RAM usage.

Using an image cataloger in this way is the easiest method for staying organized as you heap more images onto your hard drive. If you've chosen your cataloging software carefully, you can use this workflow even if you shoot raw format files. We'll have much more to say about workflow in Chapter 13.

## PREPARING YOUR IMAGE

In the next chapter, you will begin to correct and adjust the tone and color of your images. However, there are a few things that you might need to do to your image before you start editing. No matter how many pixels your camera captures, it probably doesn't create files that have a resolution that is right for your printer, and your image as you shot it might not be cropped quite the right way. In this section, you're going to learn how to get your image properly sized and cropped.

### New Image Resolutions

Although your camera may capture millions of pixels, it doesn't necessarily create files that have a resolution that is appropriate for your intended output. In imaging terms, resolution is simply the measure of how many pixels fit into a given space. For example, if your image has a resolution of 72 *pixels per inch (ppi)*, the pixels in the image are sized and spaced so that 72 of them lined up alongside each other cover a distance of one inch.

The average computer screen has a resolution somewhere between 72 and 96 ppi, so almost all digital cameras output files at 72 ppi. At 72 ppi, an image from a four- or five-megapixel camera will have an area of several square feet. When viewing on-screen, this huge size isn't a problem, because the computer can zoom in and out of the image to fit it onto your screen. For printing, though, this is far too large an area to fit on a typical printer, and 72 ppi is too low a resolution to yield good quality. No matter what your intended output—print, web page, DVD—you'll usually have to resize your image.

*PPI VERSUS DPI*

*Pixels (short for pixel elements) are the colored dots that appear on your computer screen. It's very important to understand that, when speaking of printing from your computer, there is a difference between the pixels on your screen—which are measured in pixels per inch—and the dots of ink that your printer creates—which are measured in dots per inch. We'll be discussing this in more detail later. For right now, take note that we're measuring our images in pixels per inch.*

## Resizing an Image

Most image-editing applications let you resize an image in two ways: by squishing the dots in your image closer together or by stretching them apart to achieve different sizes—in other words, by changing the resolution in your image—or by making up or discarding data to change the number of pixels in your image.

Let's say you have a three-megapixel digital camera that outputs an image with dimensions of 2160 × 1440 pixels and a resolution of 72 ppi. That is, if you line up 72 of your image's pixels side by side, you will cover one inch of space. At this resolution, 2160 × 1440 pixels will take up 20" × 30". Obviously, this is too big to fit on a piece of paper.

If you want to print this image on an 8" × 10" piece of paper, you could tell your computer to throw out enough pixels so that it only has 8" × 10" worth of pixels at 72 ppi. It would then discard every third pixel, or so, to reduce the pixel dimensions of the image from 1440 × 2160 pixels to 576 × 720 pixels. (See Figure 10.12.) This process of changing the amount of data in the image is called *resampling* (or, more specifically, *downsampling*) because you are taking a sample of pixels from your original image to create a new, smaller image. Resampling can also be used to scale up images, but, just as downsampling requires your computer to throw away data, *upsampling* requires your computer to make up data.

For example, if you have an image that is 4" × 6" at 200 ppi and you want to enlarge it to 8" × 10" at 200 ppi, you'll need to resample it upward, which will force the computer to interpolate new pixels. Most applications offer a variety of interpolation techniques. Photoshop, for example, offers five interpolation methods: *nearest neighbor, bilinear, bicubic, bicubic smoother,* and *bicubic sharper*. For 99 percent of your resampling needs, bicubic interpolation is the best choice.

The problem with our previous printing example is that 72 ppi is too low a resolution to get a good print. It should be obvious that, after you've spent all that money for all those megapixels, the last thing you want to do is to throw them out. So, rather than resampling your image

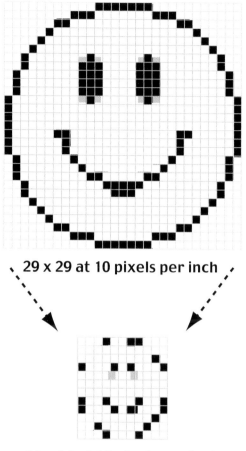

**29 x 29 at 10 pixels per inch**

**11 x 11 at 10 pixels per inch**

**FIGURE 10.12**    To resize an image down to a smaller size with the same resolution, you have to throw out some pixels (or resample) to fit your image into the smaller size.

from 20" × 30" down to 8" × 10", it's better to change the resolution of your image so that the dots are closer together, allowing you to cram more of them onto a page.

Imagine the same 20" × 30" image printed on a sheet of rubber graph paper. If you wanted to shrink this image to 8" × 10", you could simply squeeze down the sheet of paper. You would not throw out any pixels, but now your pixels would be much smaller and more of them would fit into the same space. That is, the resolution of your image—the number of pixels per inch—would have increased. This is what happens when you resize your image *without* resampling. (See Figure 10.13.)

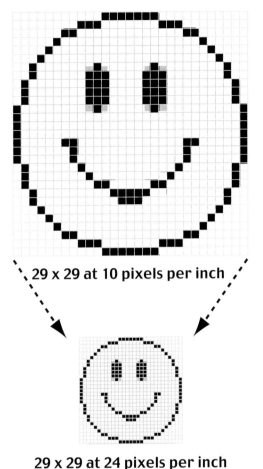

**29 x 29 at 10 pixels per inch**

**29 x 29 at 24 pixels per inch**

**FIGURE 10.13**   If you don't resample an image when you resize, all of its pixels are kept, but they're squeezed closer together, resulting in a smaller, higher-resolution image.

Similarly, if you have a 4" × 6" image with a resolution of 200 dpi and you scale it up to 8" × 10" without resampling, you're effectively stretching the image. Its pixels get larger, and fewer of them fit into the same space—that is, the resolution goes down—as the image gets larger. This is what happens when you resize up without resampling.

Most of the time, when you scale up, you'll want to resize without resampling to prevent the computer from making up new data. However, if your camera did not produce a big enough image to start with, you might not be able to achieve the size you want with the resolution you need unless you resample.

## UNDERSTANDING RESOLUTION

In addition to providing controls for resizing your images, Photoshop's Image Size dialog box provides a great tool for understanding the relationship between pixel dimensions, resolution, and image size. In this tutorial, we're going to take a quick look at this control, and hopefully arrive at a better understanding of resolution, size, and resampling.

*PHOTOSHOP OR ELEMENTS?*

ON THE CD

*Both of the tutorials in this chapter work with either Photoshop or Photoshop Elements. A demo version of Photoshop CS is provided on the companion CD-ROM, or you can download a demo version of Photoshop Elements at* www.completedigitalphotography.com/pselements. *You'll need either one installed for these tutorials. For the rest of this chapter, when we refer to "Photoshop," we mean either Photoshop or Photoshop Elements.*

### STEP 1: OPEN THE IMAGE

In Photoshop, open the flower.jpg image, located in the Tutorials/Chapter 10/Resizing folder on the companion CD-ROM. This image was shot with a Canon G3, a three-megapixel digital SLR.

ON THE CD

### STEP 2: OPEN THE IMAGE SIZE DIALOG BOX

From the Image menu, select Image Size (or Image > Resize > Image Size if you're using Elements). (See Figure 10.14.) For the purpose of this step, make sure the Resample Image checkbox is unchecked. Take a moment to familiarize yourself with the contents of this dialog box. In the Pixel Dimensions section, you can see the actual pixel dimensions of the image—in this case, 2160 × 1440—as well as the total size of the image—8.9 MB. Note that right now, these pixel values are *not* editable.

The Document Size section of the dialog box shows the resolution of the image in pixels per inch and the resulting print size in inches.

### STEP 3: RESIZE THE IMAGE WITHOUT RESAMPLING

Notice that width, height, and resolution are linked by a thick black line. This line is to indicate that you cannot change one of these values without changing the others. For example, if we enter 10 in the Width field, then press the Tab key to apply the entry, Photoshop will automatically calculate a new height of 6.667" at 216 pixels per inch. (See Figure 10.15.)

Photoshop has automatically adjusted the height to preserve the aspect ratio of the image and has calculated a new, higher resolution. Because Resample Image is *not* checked, Photoshop is not allowed to add or

**FIGURE 10.14**  The Photoshop Image Size dialog box shows the actual pixel dimensions of an image, as well as the print size at the current resolution.

**FIGURE 10.15**  After entering 10 in the Width field, Photoshop automatically calculates a new height and resolution, as indicated by the linking bars next to the pop-up menus.

remove any data, so the only way it can fit the image into our requested size is to increase the resolution—that is, cram the pixels closer together.

When Resample Image is unchecked—when Photoshop is not allowed to add or remove data—it is as if your image is on a giant rubber sheet

that can be stretched and compressed. As it gets compressed, resolution goes up because the pixels get pushed closer together. As it stretches, resolution goes down because the pixels get pulled farther apart.

## STEP 4: RESIZE WITH RESAMPLING

As you'll learn later, the optimum image resolution for printing on many ink-jet printers is 240 pixels per inch. Enter 240 into the Resolution field and press Tab. At that resolution, Photoshop calculates an image size of 9" × 6" for our image. Suppose, though, that you want to print the image at 3" × 5". Enter 5 into the width field and press Tab. Photoshop calculates a new height of 3.3" and a resolution of 432.

This resolution is much too high for our printer, but if you enter 240 in the Resolution field, your print size will change back. This image simply has too much data to print 3" × 5" at 240 pixels per inch.

Click the Resample Image checkbox. Note that the Width and Height fields in the Pixel Dimensions area are now editable. With Resample Image checked, it is now possible to change the number of pixels in the image. Note, too, that Resolution is no longer linked to Width and Height. It is now possible to change the resolution independent of the width and height, because *it is now possible for Photoshop to throw out data if it needs to.*

With your Document Size width still at 5" × 3.3", change your resolution to 240. (See Figure 10.16.)

**FIGURE 10.16**    With the Resample Image checkbox selected, resolution is no longer tied to print size because Photoshop is free to add or remove pixels. This lets you change resolution independently of print size.

Note that several things have happened. First, the pixel dimensions dropped from 2160 × 1440 to 1200 × 800. Our file has gone from 8.9 MB to 2.75 MB. More important, our print size did not change. We now have the width, height, and resolution we want.

When using the Image Size dialog box, pay attention to which fields are editable and which are linked. This will give you a better understanding of how pixel dimensions, print size, and resolution are all interrelated.

---

**TUTORIAL**      ## CROPPING AND RESIZING AN IMAGE

Because you usually can't get both you and your camera into exactly the right position to frame an image, your pictures often need to be cropped. Moreover, because most cameras create images at 72 dpi, your images usually need to be resized before printing. In this tutorial, we'll cover both topics by cropping and resizing an image for printing.

Although Adobe Photoshop and Photoshop Elements are used in this tutorial, you can use any image editor that provides a Crop tool and a resizing/resampling function.

### STEP 1: OPEN THE IMAGE

*ON THE CD*

The image for this tutorial is included on the companion CD-ROM and is located in the Tutorials/Chapter 10/Cropping folder. Open the image kittycrop.jpg. (See Figure 10.17.) You should be able to open the document in any editor that supports TIFF files.

### STEP 2: EVALUATE THE IMAGE

Let's take a quick look at the image so that we can formulate a plan of action. The original intent when we were shooting this image was to frame the picture so that only the window was visible. Unfortunately, our camera didn't have a long enough lens to zoom in to this second-story window. Even after zooming to full telephoto, the image area was too large. It will need to be cropped.

### STEP 3: CROP THE IMAGE

Photoshop provides a couple of ways to crop an image but the easiest is with the Crop tool. Click the Crop tool in Photoshop's tool palette. Use your mouse to drag a rectangle that crops out everything outside of the window pane. (See Figure 10.18.)

When you get the crop the way you like it, press the Enter key on your keyboard or double-click inside the crop area to perform the crop.

**FIGURE 10.17**    Although this is not the most compelling image, with a little cropping we can make it more interesting, whereas a little resizing will make it more appropriate for printing.

### STEP 4: EDIT THE IMAGE

If there were any edits, corrections, or adjustments that we wanted to make to the image, we would do them now. We'll be covering editing in great detail in later chapters, and there aren't any edits we want to make right now, so there's really nothing to do in this step. However, it's important to understand where editing fits into the whole image processing workflow.

### STEP 5: SAVE A COPY OF YOUR IMAGE

With your image cropped and edited, you're ready to save a *copy* of your image by choosing Save As from the File menu. Save in a lossless format, such as TIFF or Photoshop, to ensure that no additional compression occurs. Now you've got your original JPEG image as well as a cropped, edited copy. We're now going to continue working on the copy by resizing it for printing.

**FIGURE 10.18** The Photoshop Crop tool shows you a preview of your crop while you're cropping.

### STEP 6: RESIZE THE IMAGE

We've decided we want to print our image at 4" × 6". If you look at the Image Size dialog box after you crop, you'll probably find something like that shown in Figure 10.19.

**FIGURE 10.19** Image size after cropping.

Two things are wrong here. First, our document size (the size in which the image will print) is too big. Second, our resolution is too low. Let's begin by changing our resolution to our target resolution. Make certain that the Resample Image checkbox is unchecked so that resolution and document width and height are all linked. With the Resample Image checkbox unchecked, Photoshop cannot change the number of pixels.

Enter 240 in the Resolution box. You should see the document width and height change. (See Figure 10.20.)

**FIGURE 10.20**    After changing our resolution, our document width and height have changed because Photoshop has not been allowed to resample the image.

Now our document size measures 4.8" × 3.25". It has gotten smaller because we've increased the resolution. With increased resolution, the pixels in our image are crammed closer together, resulting in the image consuming a smaller area.

Let's see what happens if we enter our target print size. Enter 4 in the Height field. Photoshop automatically adjusts the Width field to a corresponding value, because the Image Proportions are currently constrained. (Constrain Proportions cannot be unchecked because we've currently forbidden Photoshop from resampling the image, a step that would be necessary to change the dimensions of the image.) Depending on how you cropped your image, it might have entered a width greater than 6. This simply means that you didn't crop your image to a perfect 4" × 6" aspect ratio. This is no big deal—simply enter 6 into the Width dialog.

Photoshop will automatically calculate a new height. Your image will now fit within your target print size.

Note that it has also automatically calculated a resolution of 198. In other words, to get the dimensions we've specified, Photoshop is telling us that our image has to have a resolution of 198.

We now have two choices: we can either accept the 198 resolution and proceed, or we can sample upward to our target resolution. In terms of print quality, you could probably get away with not resampling, but we're going to do it anyway, because Photoshop can do a very good job of upsampling, and the amount of resampling that we have to do is fairly small.

Click the Resample Image checkbox. Notice that the Pixel Dimensions fields are now editable. In other words, you're now allowed to change the number of pixels in the image. Enter 240 in the Resolution Field. (See Figure 10.21.)

**FIGURE 10.21**    With the Resampling checkbox selected, we can enter the print size and resolution we want.

Photoshop now changes the Pixel Width and Height fields to indicate the new pixel dimensions of the image (they're larger because it had to add pixels to achieve our target width, height, and resolution), and it shows the new document size of our image. In our case, our image went up to 3.94 MB from 2.68. (Your numbers might vary slightly depending on how you cropped the image.)

This image is now ready to print, a topic we'll cover in greater detail in Chapter 15. 🎱

## When Should You Resample?

Downsampling your image data is a fairly pain-free process. In fact, downsampling tends to improve sharpness and contrast in your image. Upsampling is another story, though. As you learned earlier, many digital cameras use interpolation to increase the resolution of their images. As explained, these interpolation schemes often degrade the quality of an image by introducing artifacts. Simply put, calculating new image data is a tricky, difficult thing to do. When it's done poorly, aliasing artifacts, loss of sharpness, and other image problems can appear.

The Photoshop bicubic interpolation algorithm is *very* good, and you can usually resize your images quite a bit before they noticeably degrade. If you're starting with a three- or four-megapixel image, you'll usually find that you can acceptably resize to 8" × 10".

If your image has more resolution than you need for printing at your target print size, you don't need to resample your picture until after you've made all of your edits. In other words, you'll edit and correct your image, save that version, then downsample to your target print size right before printing. You'll probably want to save a copy of this resized version so you can make more prints later.

## MOVING ON

As you shoot and edit more, you'll find the workflow that works best for you, and transferring and arranging images will become easier and easier. Image sizing is something that is confusing for many beginners, so spend some time getting to know your image editor's resize tools. Remember that one of your main image-editing workflow concerns is to avoid re-compressing your image.

# CORRECTING TONE
# AND COLOR

**In This Chapter**

W ith your image-editing software, you can perform some amazing manipulations (some would say "deceptions") of your images. The most powerful features of your image editor, however, are not its capabilities to alter the content of an image, but its capabilities to alter the tone and color so that the image—no matter what its content—looks better on the printed page.

In Chapter 8, "Manual Exposure," you learned how you can use your light meter and histogram to select the range of tones that you want to capture, as well as how to capture an image with more dynamic range. In this chapter, you're finally going to get to take advantage of all that work you did when you were shooting. Using the tools in your image editor, you will be able to exploit that tonal information that you meticulously exposed for to produce images with better contrast and color.

In terms of fundamental image editing, little has changed since the first edition of this book. The main tools you'll use to achieve your adjustments are Levels and Curves controls. These two tools provide very similar functionality using two different interfaces. Most image-editing programs include a Levels adjustment, and higher-end applications include both Levels and Curves. For the purposes of these tutorials, you can use either Photoshop Elements or Photoshop CS for Levels adjustments. Elements, however, does not have a Curves feature, so you'll have to use Photoshop CS for those sections. A demo of Photoshop CS is included on the companion CD-ROM. Even if you won't regularly be using a Curves-equipped image editor, it's worth going through the Curves tutorials simply for the theory that is explained.

*ON THE CD*

To get started, let's quickly revisit the histograms that you saw in Chapter 8 and look at how the information in the histogram is manipulated by the Levels control.

## HISTOGRAMS REVISITED

In Chapter 8, you learned about histograms—graphical representations of the tonal values within an image. If you'll recall, a histogram is essentially nothing more than a bar chart of the distribution of different colors or tones in a picture. Some cameras can produce histograms of images you've shot, making it easier to determine if you have over- or underexposed an image while you're in the field.

Your image editor can also produce a histogram of an image. Consider the image in Figure 11.1.

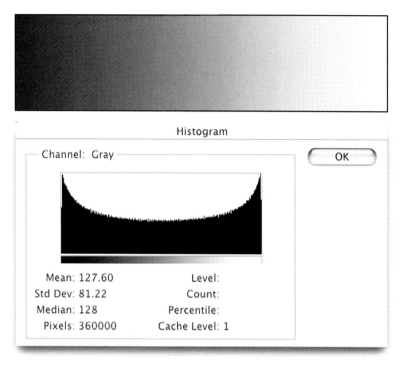

**FIGURE 11.1**   This gradient from black to white yields a simple histogram.

Figure 11.1 is a simple gradient from black to white, created using the Photoshop Gradient tool. The histogram confirms that the image goes from complete black to complete white, with most of the tones distributed at either end of the spectrum. You can also see from the histogram that there is a lot of contrast in this image—that is, the range of black to white covers the entire spectrum of the histogram.

Now look at Figure 11.2.

Also created in Photoshop, this gradient was specified as being 80 percent black to 20 percent black instead of pure black to pure white. If you look at the histogram, you can see that the tones in the image fall in the middle of the graph. There are no dark or completely black tones, nor are there any really light or completely white tones. In other words, there's not much contrast in this gradient—the range from lightest to darkest is very small.

What if we wanted to adjust this image, though, so that it *did* go from full black to full white? That is, what if we wanted to greatly improve the contrast of this image?

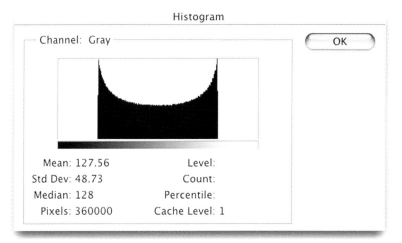

**FIGURE 11.2**    This grayscale ramp from 80 percent black to 20 percent black yields a histogram similar to the one shown in Figure 1.1, but the tones are centered in the middle of the spectrum.

**TUTORIAL**    ## CORRECTING AN IMAGE WITH BRIGHTNESS AND CONTRAST (OR TRYING TO, ANYWAY)

Many applications include a brightness and contrast control that is similar to the brightness and contrast dials on a television set. Photoshop is no exception; you can open the control by clicking Image > Adjust > Brightness and Contrast. In this tutorial, you will use Brightness and Contrast to try to correct the grayscale ramp in Figure 11.2 so that it looks like the grayscale ramp in Figure 11.1. As you might have already guessed from the title of this tutorial, you're not going to have much success in this endeavor. Like many less-enjoyable activities, however, you'll probably learn a lot.

### STEP 1: OPEN THE IMAGE

ON THE CD    Open the file grayramp.tif, located in the Tutorials/Chapter 11/Brightness & Contrast folder of the companion CD-ROM. Use your image editor's

Histogram feature to view a histogram of the image. In Photoshop, you can open the control by clicking Image > Histogram. Or, in Photoshop CS, you can activate the new Histogram palette. Its tab should be grouped in the same palette as the Info and Navigator tabs. (See Figure 11.3.) You can also open it by clicking Window > Histogram.

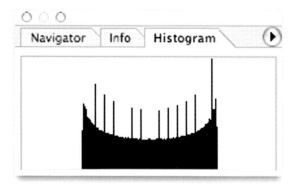

**FIGURE 11.3**   Using the new Photoshop CS Histogram palette (which yields the same histogram that we would get from the normal Histogram dialog box found in both Photoshop CS and Photoshop Elements), we can see that this 80 percent to 20 percent gradient lacks full black and full white. We'll use Brightness and Contrast to try to extend its range to a full black to white gradient.

### STEP 2: ADJUST THE IMAGE'S BRIGHTNESS

Now, open the Brightness and Contrast control in your image editor. In Photoshop or Photoshop Elements, click Image > Adjust > Brightness and Contrast. (See Figure 11.4.)

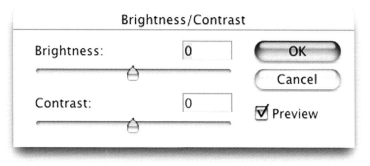

**FIGURE 11.4**   The Photoshop Brightness and Contrast control.

Brightness and Contrast provides two sliders, one for brightness and the other for contrast. By sliding each in either direction, you can increase or decrease either property.

In this image, the black is not black enough, so begin your adjustments by lowering the brightness, to drop the darkest tone down to black. In Photoshop, slide the Brightness control until it reads approximately –75.

Unfortunately, in doing this, you also lowered the brightness of all the other tones in the image, including the whites. (See Figure 11.5.) In the histogram you'll see that the image has no more contrast than it did before. Rather, the whole tonal range has just been shifted down toward the bottom of the scale.

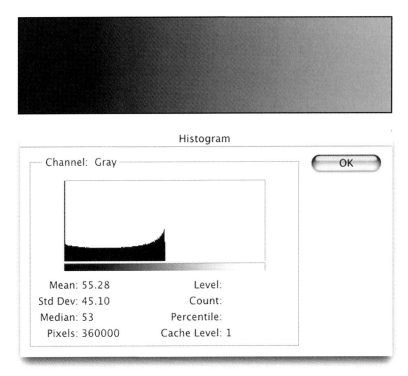

**FIGURE 11.5** After a –75 brightness adjustment, the blacks in the gray ramp are darker, but unfortunately, so are all of the grays and whites. All of the tones have been uniformly shifted down the gray spectrum.

This is the main problem with a Brightness and Contrast control: every pixel is adjusted in exactly the same way. Consequently, if you want to only correct the shadows or highlights of an image, you're out of luck. What's more, if you enter a brightness change that is too extreme,

some tonal values might get pushed completely off the scale, resulting in clipped highlights or shadows.

### STEP 3: ADJUST THE CONTRAST OF THE IMAGE

So far, you've darkened the entire image to restore the blacks to true black. Now you need to try to restore the whites by increasing the contrast of the image. Move the contrast slider to around +66. You have now restored the white to full white, but the image is a far cry from the gray ramp shown in Figure 11.1. A quick check of the histogram (Figure 11.6) shows why.

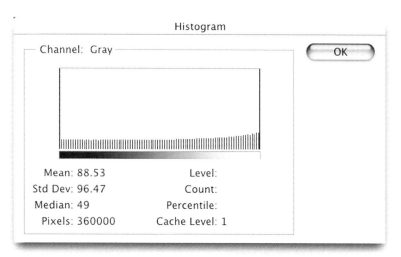

**FIGURE 11.6**    After both brightness and contrast adjustments, the image has lost a lot of tonal information, and the distribution of the remaining tones has been changed.

First, notice how there are far fewer lines in the histogram than there were before. In the process of stretching out the tones to create more contrast, Photoshop has had to throw out some tonal information. In other words, it has had to redistribute the tonal values in the image to make them stretch all the way down to black and all the way up to white.

Data loss is an unfortunate side effect of any tonal adjustment, and you'll read more about it later. Notice the distribution of the curve of the histogram: it no longer has the same shape that it had before. Tones are not predominantly distributed at the top and bottom of the curve but have been flattened out over the entire range of the curve. The original image had much more black and much more white, whereas this image has a pretty even distribution of everything. This is why the ramp itself appears to have less contrast.

### STEP 4: GIVE UP

That's really about the best you can do with Brightness and Contrast. Yes, you could try to not stretch the blacks or whites so far, so that fewer tones would drop out, but there's simply nothing you can do to preserve the original *distribution* of tones—Brightness and Contrast is always going to flatten out the distribution of tones in the image. The fact is, Brightness and Contrast is simply a bad tool (so bad that Adobe didn't even grace it with a keyboard shortcut in Photoshop!). Don't worry, though, there is something better.

---

### TUTORIAL   POSTERIZATION

Before we move on to a better way of adjusting our gray ramp, we're going to pause for a moment to introduce a new term. *Posterizing* is the process of reducing the number of tones in an image. Earlier, you read about how JPEG algorithms divide your image into groups of pixels and average the color in each group down to a single tone. This is one example of a posterization process. Let's take a look at another.

### STEP 1: OPEN THE GRAY RAMP IMAGE

If you have the grayramp.tif image open from the previous tutorial, close it but don't save changes. Now open the original again. (In Photoshop or Photoshop Elements, you can use the File > Revert command to revert to the original image.)

### STEP 2: POSTERIZE THE IMAGE

In Photoshop, or Elements, click Image > Adjustments > Posterize to open the Posterize dialog box. The dialog box should default to a value of 4. Enter 16 in the Levels field. Your gray ramp should now be reduced to 16 different tones of gray (Figure 11.7), ranging from your original darkest value to your original lightest value.

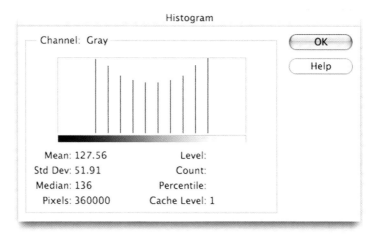

**FIGURE 11.7**    By using the Photoshop Posterize command, we reduced our original 256 tone gray ramp to 16 tones.

Photoshop has attempted to preserve a smooth transition between these tones by making a slight dissolve between each tone, but each dissolve is still composed of only two tones.

### STEP 3: ASSESS THE DAMAGE

A histogram of the resulting image would look something like the one shown in Figure 11.8.

**FIGURE 11.8**    A histogram of our posterized ramp reveals that we do indeed have far fewer tones in our image.

The simple histogram may look a little strange, but it's really just a more extreme version of the same type of data loss that you saw before. The Posterize command had to throw out a lot of data to reduce the smooth grayscale ramp to 16 tones. Photoshop tried to remove data in an even distribution, so we have a histogram that's still mostly the same shape as what we had before. The significance of posterization will become clearer shortly.

## Levels

In Chapter 8, you saw that different exposure settings let you capture more or less tonal information, from one part of the tonal range or another. Through the use of a histogram on your camera, you saw that it is possible to measure this tonal information, both to determine how much contrast is in an image and where that contrast lies along the tonal spectrum.

If you followed along with the last tutorial, though, you saw that when you are correcting and adjusting an image, preserving the distribution of those tones is fundamentally important, as is ensuring that too much data doesn't get thrown out while you are making adjustments. Typically, the problem with a Brightness and Contrast control is that its actions affect the entire tonal range, resulting in edits that are too broad in scope and thus severely alter the tonal relationships within the image.

Fortunately, if your image editor has a Levels control, you have a solution to these problems. The Photoshop Levels control can be opened by clicking Image > Adjust > Levels. In Photoshop Elements you'll use Enhance > Adjust Brightness/Contrast > Levels. (In either program, you can also invoke the Levels dialog box with Command/Ctrl+L.) The Levels dialog box is shown in Figure 11.9.

First, you can see that a Levels control is built around a histogram of your image. Figure 11.6 shows the histogram from the grayscale ramp we saw in Figure 11.2. Directly beneath the histogram are three input sliders. The left slider shows the position of black in the histogram—that is, it points at the location on the graph that represents 100 percent black. The right slider shows the position of white, whereas the middle slider shows the *gamma*, the midpoint of the image. The Input Levels fields above the histogram are simply numeric readouts of the positions of the three input sliders—0 represents black, white is represented by 255, and shades of gray are somewhere in between.

The easiest way to understand what these sliders do is to use them. Therefore, let's go back to the image shown in Figure 11.2 and try again to correct it so that it looks like the one shown in Figure 11.1.

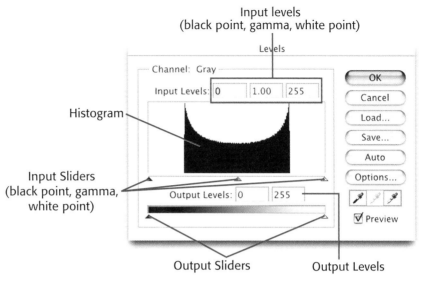

FIGURE 11.9    The Photoshop Levels dialog box offers a number of features. Right now, you'll be using only the histogram, input sliders, and Input Levels fields.

## TUTORIAL    USING LEVELS INPUT SLIDERS

Once again, we're going to try to correct the grayscale ramp shown in Figure 11.2 so that it has better black and white values and improved overall contrast; we want it to look like the smooth gradient in Figure 11.1. This time, instead of using a Brightness and Contrast control, we're going to use a Levels control. Although we'll be using Photoshop for this example, you can easily follow along in any image editor that provides a Levels control.

### STEP 1: OPEN THE IMAGE

Again, open the same gray ramp image that you used in the Brightness and Contrast tutorial (grayramp.tif). Once the image is up, open your Levels control.

### STEP 2: ADJUST THE BLACK POINT

As you can see from the histogram in the Levels dialog box shown in Figure 11.9, the darkest tone in this image is not full black, but is closer to 80 percent black. Make sure the Preview checkbox in the Levels dialog box is checked. Drag the black triangle at the far left of the histogram to the right until it is directly beneath the left value of the histogram. (See Figure 11.10.) The black point readout should be around 52.

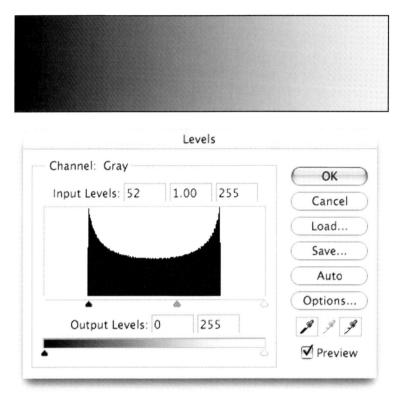

**FIGURE 11.10**    Setting the black point using the Levels control results in a gray ramp with correct black levels.

Now look at your image. The left side—that is, the black side—of the grayscale ramp should be black. With our Levels adjustment, solid black is no longer at 0 on the histogram—it's now at 52. (Remember, the histogram is a graph of values from 0 to 255.) Therefore, everything to the left of our new black point is considered black. Notice that our gamma point—the middle slider—has automatically moved to the right to preserve the relationship between black, midpoint, and white.

Now look at the right side of the image. Our lightest value has not changed! Unlike a Brightness and Contrast adjustment, which adjusted every value in the image uniformly, our Levels adjustment has moved the black and midpoints but has left the white point alone.

To understand this better, click OK to accept the changes. Now, open the Levels control again to see a new histogram of the image. (See Figure 11.11.)

**FIGURE 11.11**    After our black point adjustment, our histogram looks different. The darker tones have been stretched all the way to black, but the overall shape of the histogram has remained the same.

You might be a little surprised to see that the histogram looks different than it did when you closed the Levels box before. Remember, though, that even after you performed your black point adjustment, the image still had a full range of tones from 0 to 255. This histogram is a graph of those new, adjusted tones.

As you can see, some bars are missing, indicating that we've lost some data. This makes sense when you think about what your black point adjustment did. You moved the black point in to indicate the value that you wanted to be black. The Levels control placed that value at 0 and stretched all of the values between 0 and your midpoint (the gamma slider) to fill the space. Unfortunately, there wasn't enough data to fill the space, so some tonal values were left empty. Fortunately, Photoshop has spaced these missing tones across the tonal spectrum, so their absence is less noticeable.

The good news is that, so far, the distribution of tones within the image—as represented by the shape of the histogram—is better preserved than it had been with the Brightness and Contrast control.

### STEP 3: ADJUST THE WHITE POINT

Now we need to do the same thing to the white point that we did to the black point. Open your Levels control and take another look at your

histogram. The white values in your image—the right of the grayscale ramp—are not really white, they're light gray.

Drag the white slider to the left so that it points to the right data in the image. The white point display should read approximately 190. (See Figure 11.12.)

**FIGURE 11.12** After adjusting the white point, your Levels dialog box should look something like this.

Now look at the right side of your image. It should be a brighter white. The good news is that your shadows are still nice and dark! As with the black point adjustment, adjusting your white point also adjusted the midpoint, to keep the relationship between the white point and midpoint the same. The black point was left untouched.

Clicking the Auto button in the Levels dialog box does the same thing that you have just done in these two steps. It moves the black point to the leftmost tonal value in the histogram, and it moves the white point to the rightmost value. Why not just use Auto every time? Because sometimes

the rightmost point on your histogram is not what you want as white in your image. It might be a specular highlight or bright flare, whereas true white is further to the left. As you'll see later, for printing purposes you might sometimes want to leave a little "headroom" above and below your tonal range.

The Load and Save buttons allow you to save your Levels adjustments for reuse later. For example, if you've shot a series of images in the same lighting or exposure situation, you might find that the same Levels adjustment is appropriate to all of them. In this case, you could save a Levels adjustment that could be loaded and applied to all your images. (However, there are easier ways to batch process images in Photoshop.)

Click OK to accept your new white point, then open the Levels dialog box again to see the new histogram. (See Figure 11.13.) As with the black point adjustment, we've lost some more image data, but as before, we've preserved the overall tonal distribution in our image.

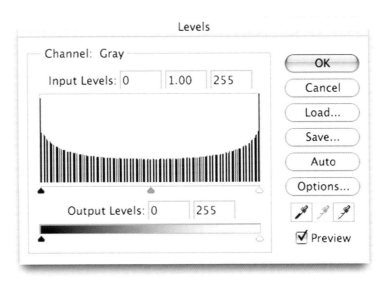

**FIGURE 11.13**    After adjusting our white point, a new histogram shows that we have lost some data, but notice that the overall distribution of tones has retained its original shape.

### STEP 4: PLAY WITH THE GAMMA SLIDER

This particular image doesn't need a gamma adjustment, but there are some interesting things to learn by moving it around and observing the results. Slide the gamma slider to the left and watch what happens to your image. (See Figure 11.14.)

**FIGURE 11.14** As we move the gamma slider, the midtones in our image shift toward black or white.

As you move it, the midtones in your image become much lighter. Slide it back to the right, past its original location, and you'll see your midtones get darker. As you move the gamma slider, though, your black and white values stay locked down at black and white. Gamma lets you adjust the midtones of your image to shift contrast more toward shadows or toward highlights. With it, you can often bring more detail out of a shadowy area, but you'll never have to worry about your blacks or whites turning gray.

Type 1.0 into the gamma readout (the middle text box above the histogram) to return the gamma slider to its original location.

With the Levels dialog box still open, zoom in on your image. (In Photoshop you can do this by pressing Command-+ on a Mac, or by pressing Ctrl-+ if you're using Windows.) Now, drag the gamma slider to the left. Again, you'll see your midtones lighten, but now watch what's happening in the shadow areas. If you look closely, you'll probably see some slight banding.

This banding is the result of the data that's being thrown out as the Levels control stretches the tonal values in your image. In other words, as you stretch the tonal values, Photoshop is discarding data and your image is posterizing, just like you saw in the previous tutorial. Drag the slider in the other direction and you'll begin to see banding in the highlights of your image as you darken the midtones, causing the highlights to stretch to fill in the now empty space.

Play around with these controls to get a feel for their effect, and to see how the image changes and degrades. These changes and problems are particularly easy to see in this document because it is a simple linear gradient.

## SHOULD YOU WORRY ABOUT DATA LOSS?

In the last two tutorials you engaged in image-editing operations that removed data from your image. That really sounds like something you should be worried about, doesn't it? In some cases it is.

Fortunately, the type of data loss that you saw in the last tutorial was not readily apparent on-screen—you had to make a fairly extreme adjustment and zoom in very close to the image—and the data loss was certainly far too slight to appear in a printout. Most of the printers you'll be using can't generate a complete range of 256 shades of gray anyway, so if you've thrown out 5 percent of them it won't really matter.

However, if you were to make the change you just made, and then go back and make two or three more edits that also produced some data loss, your image might visibly degrade. This is why it's so important to capture as much data as you can *when you're shooting*. If your image has a lot of tonal range to begin with, you won't have to make adjustments that are too extreme when you're editing, and your image editor won't have to throw out so much data as it manipulates the image's tones. Controlling data loss is just one more reason why it's important to choose a good exposure when you take a picture.

Once you have your image in your image editor, you'll want to think carefully about your edits to minimize your data loss. When you are editing, try to achieve as much as possible with the fewest tonal corrections. In other words, don't use a Levels command to fix your black point, and then use an additional Levels command later to adjust your white point. Make your tonal corrections count by accomplishing as much as you can with each correction. (In the previous tutorial, we used two separate commands, but that was only for the sake of getting to look at the intermediate histogram. Normally, we would have done the white and black point adjustments in one single command.)

Posterization is the key to knowing when you've exhausted your tonal range. If you're wondering if your adjustments are too extreme, look for posterization along high-contrast transition areas in your image. Though it's rather an extreme example, Figure 11.15 shows how posterization can appear in a real image. Remember, though, that posterization that shows up on-screen may not be visible in print.

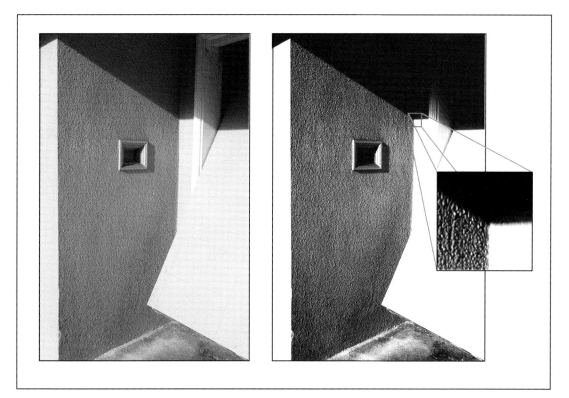

**FIGURE 11.15** In this intentionally extreme example, we've performed a levels adjustment on the image on the left to produce an image on the right with bad posterization. Notice that most of the gradations have been removed from the shadows, and the texture on the wall has almost become pixelated. These sorts of artifacts are the signs that we've thrown out too much image data.

## TUTORIAL    REAL-WORLD LEVELS ADJUSTMENTS

Hopefully, working in the controlled space of a linear gradient has helped you to better understand exactly what a Levels control does. In this tutorial, we're going to apply that knowledge to an image we looked at earlier.

### STEP 1: OPEN THE IMAGE

ON THE CD

Open the street.tif image located in the Tutorials/Chapter 11/Levels folder of the companion CD-ROM. (See Figure 11.16.) As you'll recall from Chapter 8, there was a very particular vision in mind for this image, that of the dark line of the street cutting across the gray and white field of houses. To achieve that goal, this image was intentionally underexposed so as to plunge the street into deep shadow. Unfortunately, the entire image is a little dull.

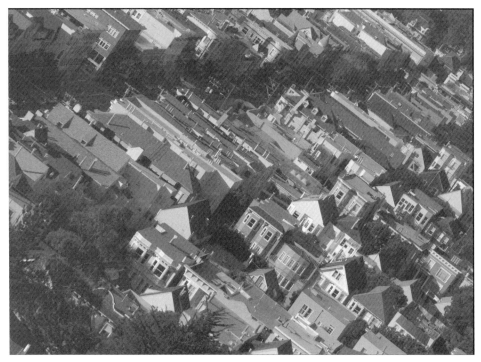

**FIGURE 11.16**    Our goal when we were exposing this image was to emphasize the shadowy line of the street. By underexposing, we captured nice, dark shadows. Unfortunately, this exposure resulted in the rest of the image being much too dark.

A quick look at the histogram (Figure 11.17) shows that the image has a good amount of tonal information (dynamic range). Though the image goes almost all the way to complete black, it's not quite there, and our white point is far too gray.

A second, slightly overexposed image was also shot, and its histogram showed that it had a wider dynamic range. However, its shadow detail

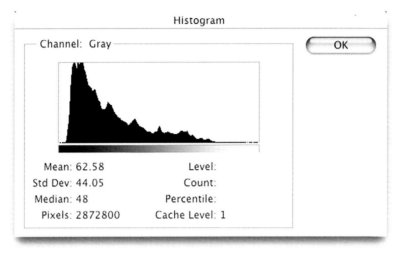

**FIGURE 11.17** The histogram shows a good amount of tonal information but poor highlights.

was not as strong, making it more difficult to achieve our original intent. Wide dynamic range isn't everything; you have to be sure that your exposure places the tones in your image in the correct tonal zone. For this reason, it's better to choose the underexposed image.

## STEP 2: SET THE BLACK POINT

In Photoshop, click Window > Info. (See Figure 11.18.) When it is used in conjunction with the Photoshop Eyedropper tool, the Info palette can provide handy information about the colors and tones in your image. We'll use this information to refine some of our Levels adjustments.

**FIGURE 11.18** As you move the Photoshop Eyedropper tool over an image, the Info palette displays the values of each pixel, using a number of different measures.

Open the Levels control in your image editor. In the Levels dialog box histogram, you can see that the black levels in the image don't descend all the way to 0. That is, they don't go to complete black, but end at about 10 (or about 4 percent, if you want to think in percentages of black).

We're going to leave the black level where it is because we intend to print this image. Unfortunately, most images tend to get darker when they go to print, so it's a good idea to leave a little room for the shadows to darken up a bit. As you'll see later, the same is true for highlight areas.

## STEP 3: SET THE WHITE POINT

There are a couple of simple considerations to make when you are setting the white point for this image. First, we know that we want to generally brighten the image because it was underexposed. The question is, how far do we want to go?

Drag the white point to the left until it is at the edge of the right histogram data. The white point readout should read about 198.

This definitely removes the underexposed pall that covered the image before. (See Figure 11.19.) Our shadows have brightened up a bit, so let's make a quick gamma adjustment.

## STEP 4: ADJUST THE GAMMA

Although our blacks are still nice and black, our white point adjustment did affect enough of the midtones that the image has lost some of the nice dark areas that it had before. Drag the gamma slider to the right until it reads about .83.

This step should darken the shadows without affecting our blacks or whites.

## STEP 5: READJUST THE WHITE POINT

With the gamma adjusted properly, we have a better idea of what our whites really look like. Your white point should still be set around 198. Although the image looks good with this white point, there are a few considerations to weigh.

The whitest thing in the image at this point is the white house in the bottom-right center of the image. The question to ask at this point is, "Just how white do we want it to be?"

Click the Eyedropper tool in the Photoshop's toolbox and hold it over the white in the house. The K field in the Info palette shows you the actual black value of the pixels in that area. (See Figure 11.20.)

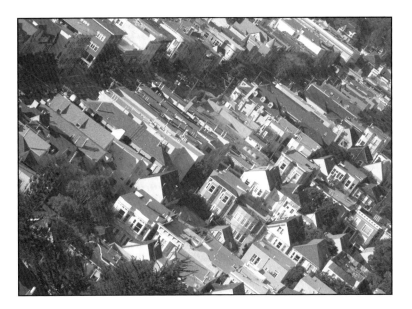

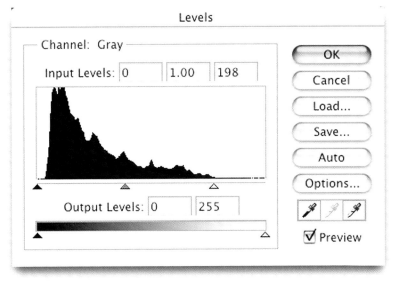

**FIGURE 11.19** White point adjustment.

The house is reading about 5 percent black. If you hold the Eyedropper tool over the door, you'll see that the house is reading 0 percent, meaning that area will simply be paper white, with no ink.

As bright as it is, the house is a little distracting with this white point. What's more, there is little detail between the house and the door. Pull

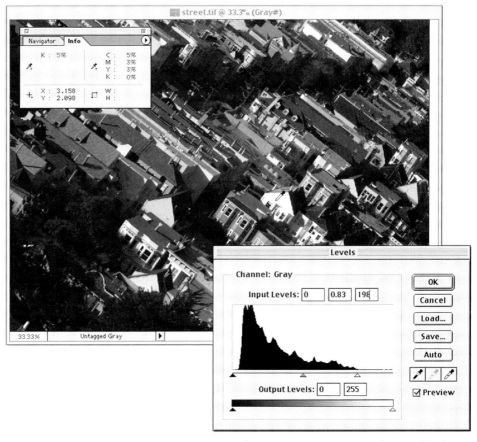

**FIGURE 11.20**   With the Eyedropper tool and the Info palette, you can find out the exact black values of any pixels in your image. With this information, you can make more intelligent decisions about your tonal adjustments.

the white point to around 210. This takes the harsh whiteness out of the house as well as some of the other white details throughout the image. If you measure the house now, you'll see that it reads about 12 percent whereas the door is still at 0. The door will now provide a nice specular highlight in the image. (See Figure 11.21.)

### STEP 6: SAVE THE IMAGE

Click OK to accept your Levels changes, and you're done for now. Save this adjusted image to your drive. Although the tones are now properly adjusted, the image could use a little sharpening before printing. You'll learn more about sharpening in Chapter 13, "Essential Imaging Tactics."

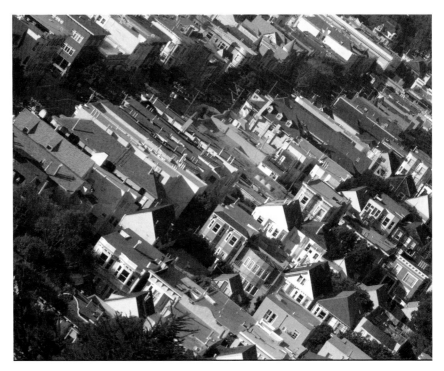

**FIGURE 11.21**  The final image, readjusting our white point.

## CURVES

The Levels control provides the simplest way for performing the basic tonal adjustments that you will regularly need to make, but it's not the answer for all corrections. Curves is a tool that can do everything that Levels does, but it also provides a few other capabilities. Unfortunately, Photoshop Elements does not provide a Curves control—Curves is one of the features that makes the full-blown Photoshop worth the extra money—so if you're using Elements, you'll need to install the Photoshop CS demo included on the CD.

You can open the Curves dialog box by clicking Image > Adjust > Curves.

A typical Curves interface (Figure 11.22) is really just a different interface to the same adjustments that you were making with the Levels control.

Like a Levels dialog, the Curves dialog box also presents a graph of the data in your image. Instead of graphing distribution of tones, how-

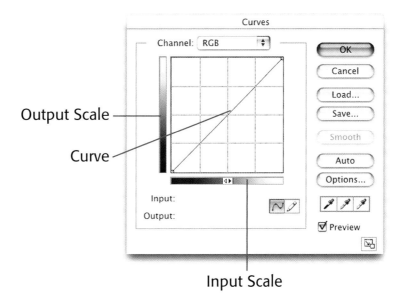

Output Scale

Curve

Input Scale

**FIGURE 11.22**    The Photoshop Curves dialog box is typical of most Curves tools, offering a simple graph of input (the tonal values before the edit is applied) values to output (after the edit is applied) values.

ever, it shows a graph of the unaltered versus altered pixels in your image. The horizontal gray ramp along the bottom of the Curves dialog box represents the tones in your image before they are altered by the Curves command. The vertical gray ramp along the left side of the Curves dialog box represents the tones in your image *after* they are altered.

When you first open the Curves control, the Curves graph shows a 45° line from black to white, indicating that the input tones (the ones along the bottom) are identical to the output tones (the ones along the side). If you change the shape of the line, you change the correspondence of the input tones to the output tones. (See Figure 11.23.)

When you adjusted the black point using your Levels control, you told your image editor that there was a new value that it should consider black. The image editor then stretched and squeezed the values in your image to make your desired adjustment. The curve in the Curves dialog box, which starts out as a straight line, lets you see clearly how all of the tones in your image are being stretched and squeezed. To redefine your black point using Curves, for example, you move the black part of the

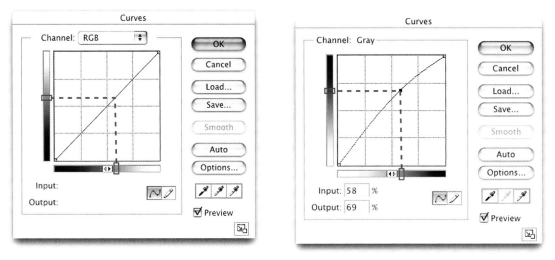

**FIGURE 11.23**    In the upper diagram, before editing, each point on the input ramp corresponds to the same spot on the output ramp. After adding a point, the corresponding spot on the input graph in the lower diagram is equal to a lighter spot on the output graph. What's more, all of the surrounding points have been altered along a smooth curve.

curve to a new location. Figure 11.24 shows the Curves adjustment required to turn the gray ramp shown in Figure 11.2 into the full ramp we saw in Figure 11.1. In other words, this curve performs the same correction that we created with the Levels control in the last tutorial. (See Figure 11.24.) The black and white points—the ends of the curve—have been dragged inward, remapping the not-quite-black and not-quite-white tones in our image. All of the other tones on the curve have been adjusted accordingly.

The main advantage of Curves is that, whereas Levels lets you edit the white, black, and midpoints of an image, Curves lets you edit as many points as you want.

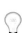

*WOULD YOU LIKE A HISTOGRAM WITH THAT CURVE*

*One disadvantage of the Curves dialog over the Levels dialog is that it doesn't display a histogram of your image while you're editing your curve. Fortunately, the new Photoshop CS Histogram palette solves this problem. Open the Histogram palette before you open the Curves dialog, and you'll be able to keep an eye on the histogram while you set up your Curves adjustment.*

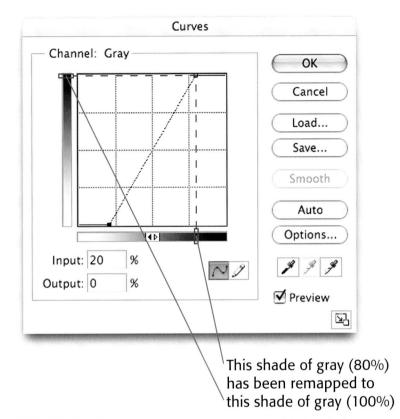

This shade of gray (80%) has been remapped to this shade of gray (100%)

**FIGURE 11.24**    This Curves adjustment performs the same black-and-white correction as the Levels adjustment you saw earlier, effectively turning the 80-20 gray ramp shown in Figure 11.2 into the black to white gray ramp you saw in Figure 11.1.

## A QUICK WORD ABOUT TONE

When you are correcting and adjusting color, it's important to remember that when you add more red, green, or blue to an image, you're adding more light—your color will get lighter. In other words, some colors are inherently brighter than others. A light blue, for example, in addition to being a different hue and having a different saturation, is also lighter than a dark red or dark blue. Therefore, if you perform adjustments that change the color in your image, you might also be changing the overall lightness or darkness of your image.

**TUTORIAL**   **CORRECTING TONE WITH CURVES**

The easiest way to learn how the Curves control works is to try it out. In this tutorial, we're going to use the Curves tool to color-correct an image.

### STEP 1: OPEN THE IMAGE

*ON THE CD*

In Photoshop, open the image prague.tif located in the Tutorials/Chapter 11/Correcting Tone with Curves folder on the companion CD-ROM. (See Figure 11.25.) As mentioned earlier, Photoshop Elements does not have a Curves control, so you'll need to use the full version of Photoshop for this tutorial. You can use any version of Photoshop for this lesson, or install the Photoshop CS demo included on the CD.

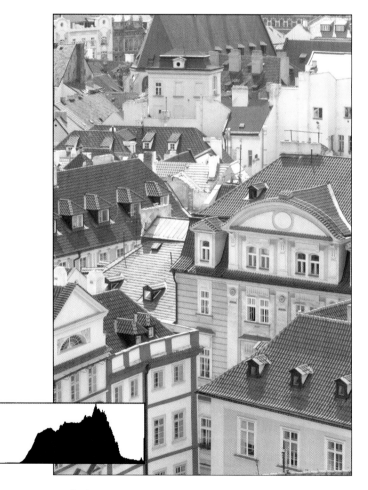

**FIGURE 11.25**   The histogram confirms what your eyes will tell you: this image is flat and needs better contrast.

As you can see from the histogram, the image has a good amount of dynamic range. However, as is obvious from both the image and the histogram, the picture lacks contrast, so we need to reset the white and black points.

### STEP 2: SET THE BLACK POINT

Open the Curves dialog box. In Photoshop, you can open it by clicking Image > Adjust > Curves, or by pressing Command/Ctrl+M (Command if you're using a Macintosh, Control if you're using Windows). The black point on the curve is the point at the bottom of the 45° line. This point indicates that black on the input scale corresponds to black on the output scale. We want to change it so that dark gray—the darkest tone in the image—on the input scale corresponds to black on the output scale. Because the input scale goes horizontally from black to white, we need to move the black point to the right.

Click the black point and drag it to the right. If you have the Histogram palette open, you can watch the black point on the histogram shift to the left, indicating that we are effectively moving the darkest point toward black. Remember, we don't want to clip the blacks, so don't let the tones in the histogram fall off of the left side. (See Figure 11.26.) When adjusted properly, the Input box should read approximately 35, and Output should stay at 0. With this move, you're saying that values at 35 or lower are equivalent to 0, or black. The dark areas in your image should now look black. What do those numbers mean? The 35 value that you just selected in the Curves dialog box is equivalent to about 87 percent black.

### STEP 3: SET THE WHITE POINT

Correcting the white point in this image is a little bit trickier because, as you can see from the histogram, there is already some pure white information in the image. If we shift the white point, we will risk blowing out the highlights even further. However, the image could be a little brighter, so let's try a white point adjustment anyway.

The histogram indicates that there are some white pixels in the image already, so let's begin by identifying them, so that we can keep an eye on them while making our adjustment. With the Curves dialog still open, click and drag the cursor around the image. The Curves dialog will display a small circle on the curve to indicate the value of the particular pixel that you're pointing at. In this way, you can easily see which parts of the curve correspond to particular colors in your image. The white point is the point at the other end of the curve, in the top-right corner. As

you drag around the image, you'll quickly see that the roof of the white building near the top-right of the image falls mostly near the white point of the curve. This is the area to watch while we edit. Though it's okay if it loses a little detail, we don't want to posterize it or blow it out completely.

Just as you moved the black point directly to the right, you want to move the white point directly to the left to indicate that light gray should become white.

Click the white point and drag it to the left until the Input box reads about 238. The Output value should still read 255. In other words, the value 238 has been stretched out to 255. (See Figure 11.26.) So far, this is no different than the type of adjustment you make when you move the black and white points in the Levels dialog.

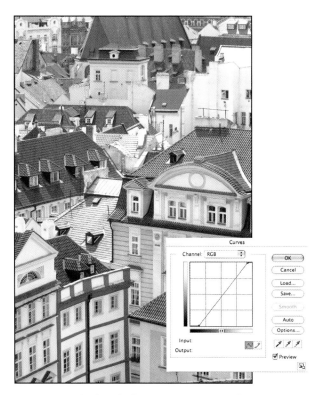

**FIGURE 11.26**    Black and white points are set in the Curves dialog box by sliding the endpoints toward the center of the graph.

With the black and white points adjusted, the image should have better contrast and be slightly brighter. We've sacrificed a little detail on the white roof, but it's not obtrusive. Now we're ready to make further corrections.

## STEP 4: ADJUST THE GAMMA

In the Levels tutorial, you saw how you could use the midpoint, or "gamma," slider to adjust the midtones in an image. Because this image could use a little more contrast in the midtones, we're going to perform a gamma adjustment by adding a new point to our curve.

The gamma point is the point on the curve in the middle of the graph. Normally, it lies at the intersection of the two middle gridlines, but because of our white and black point adjustments, the midpoint has shifted down and to the right a bit. Move your pointer over the curve until the Input display reads about 132. This is roughly the midpoint. Now, click and drag down and to the right a tiny bit to darken the midtones. (See Figure 11.27.)

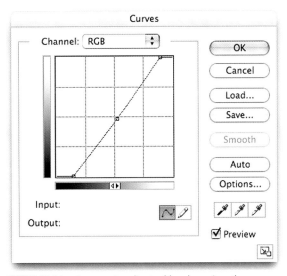

**FIGURE 11.27**    Gamma is adjusted by dragging the midpoint of the curve to lighten or darken the image.

As you move the point, notice that the curve changes shape. Remember when you tried to use the Brightness and Contrast controls and were hampered by the fact that your adjustments were applied evenly to the entire image? With Curves, as you can see, your adjustments create a smooth curve of change throughout the tonal range. What this means is that in addition to adjusting that single gamma point, you have also adjusted the nearby points by varying degrees. Levels works the same way, but with Curves you can really see how other tones are affected. Click OK to accept your Curves adjustment.

Finally, you might want to perform a slight crop of the bottom of the image. Your finished image should look something like that the one shown in Figure 11.28.

**FIGURE 11.28**    The final Prague image after setting white, black, and midpoints with the Curves tool.

## LEVELS AND CURVES AND COLOR

So far, you've seen how Levels and Curves controls can be used to adjust tone and contrast, whether in color or grayscale images. These tools, however, can also be used to adjust, correct, and change color. In previous chapters you read about many ways in which color can go wrong when you shoot. Levels and Curves are two tools that allow you to fix color problems that arise from bad white balance, improper exposure, or a bad camera.

To understand how Levels and Curves affect color, you have to understand how color is stored in an image. In Chapter 2, "How a Digital Camera Works," you learned that digital cameras make color by combining red, green, and blue information. These separate red, green, and blue components are referred to as *color channels,* or just *channels,* and many image editors allow you to perform corrections and adjustments on these individual channels.

In Photoshop, you can access the different color channels through the Channels palette (click Window > Show Channels). The Channels palette includes separate rows for the Red, Green and Blue channels as well as for your image—the RGB channel. (See Figure 11.29.) By clicking each channel, you can view its contents.

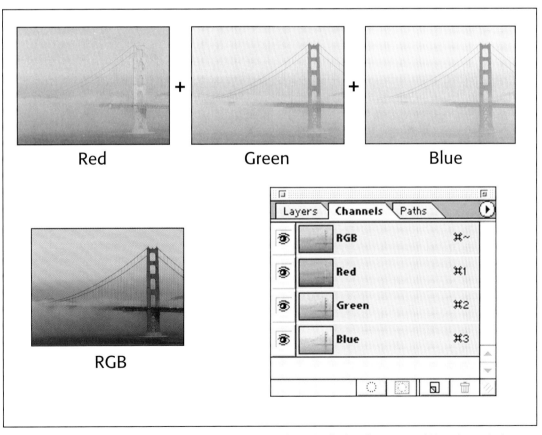

**FIGURE 11.29**   The Channels palette lets you view and edit the individual Red, Green, and Blue channels that make up your RGB documents.

If you click the Red channel in the Channels palette, you'll see a grayscale image that represents all of the red in your image. Why is it grayscale? Because, if you'll recall, one *24-bit image* is made up of three separate *8-bit images*, and with 8-bit images you can have up to 256 shades of gray. When you look at an individual color channel, you're looking at the grayscale image where that particular component color information is stored. A bright white pixel in a Red channel equates to full red in your final image (because bright white has a value of 255, the maximum allowed in an 8-bit image). Combine a bright red pixel in a Red channel with identical pixels in the Green and Blue channels and you'll have a white pixel in your final image, because full red, plus full green, plus full blue equals white.

When you view a channel in Photoshop, you can use all of the editing, painting, and manipulation features that you would normally use. This is a very handy feature for digital camera users, because digital cameras often have trouble with specific channels. For example, many cameras produce more noise in one channel than another. With your image editor, you can try to attack the noise in an individual channel directly by applying special noise reducing filters or blurs—or even painting by hand—directly into that channel.

Similarly, you may find that the color in your final image is off because one particular channel is out of balance. When this happens, you can correct the color in your final image by manipulating an individual channel.

In the next tutorial, you'll see how you can use Levels and Curves corrections in specific color channels.

---

**TUTORIAL**        **CORRECTING COLOR WITH CURVES**

Whereas Levels lets you edit the black, white, and midpoints, with Curves you can set up to 14 different points at any location along the curve, allowing you to precisely edit particular tonal ranges. In the last tutorial, you saw how to use Curves to achieve a Levels-like correction. In this tutorial, you're going to use Curves to perform a color correction that would be impossible with Levels.

### STEP 1: OPEN THE IMAGE

In Photoshop, open the image bud.tif located in the Tutorials/Chapter 11/Correcting Color with Curves folder on the companion CD-ROM. (See Figure 11.30.)

*ON THE CD*

**FIGURE 11.30**    Using a single curves control, we're going to brighten this image, as well as adjust the color to make the yellow stand out a little more.

### STEP 2: CHECK THE HISTOGRAM

A quick look at the histogram shows that our blacks are not clipped, meaning we don't really want to move the black point. Nevertheless, the image is too dark so the shadow areas are going to need to be lightened. As you've already seen, the background of the Curves dialog box provides a reference grid that shows midpoints and quarter-points along the curve. Click the bottom-left quarter-point and drag up to brighten the shadow areas. (See Figure 11.31.)

There's no right or wrong place to start when correcting this image. But it's usually a good idea to begin with either the highlights or shadow areas to map out the extremes of contrast in your image before you worry about the midtones.

### STEP 3: ADJUST THE WHITE POINT

With this single adjustment the image already looks better, but we've lost a little contrast (a fact that is confirmed by the histogram). Lessened contrast means less information between the black and white points, so we're going to restore our highlights by adding a point in the upper quarter of the curve. (See Figure 11.32.)

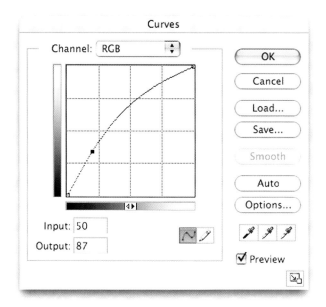

**FIGURE 11.31**    For this image we're leaving our white and black points where they belong and beginning our editing by adding a point to brighten the shadow details.

### STEP 4: ADD MIDPOINT AND TWEAK

As is clearly visible in the Curves dialog, a change in one part of the curve can greatly affect another part of the curve. Consequently, correcting with curves is not usually a straight procedural process. You often have to move between points, tweaking and retweaking them as you reshape the curve into just the right shape. For this final step, we moved the first point to deepen the shadows a little more, and added an additional point to brighten some of the middle tones to produce the image in Figure 11.33.

### STEP 5: WARM UP THE FLOWER

For our final correction, we want to add some warmth to the flower to separate its yellowish/green tone from the predominantly green background. Earlier, you saw how you could use the Channels palette in Photoshop to view individual color channels in your image. Because some edits are easier to perform on individual color channels than on the entire composite image, the Curves dialog allows you to adjust the curve of individual color channels. (Similarly, the Levels dialog lets you perform levels adjustments on individual color channels.)

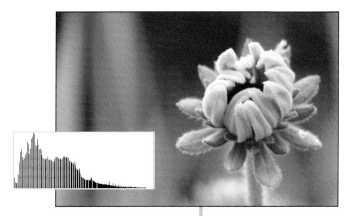

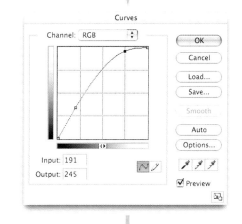

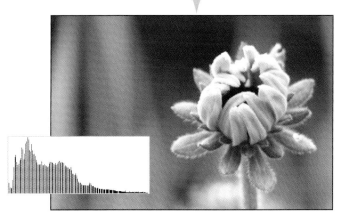

**FIGURE 11.32**   Because the image has lost contrast, we apply another point in the highlight region of our curve to improve the contrast of the image. Our curve now has two points, and our image is greatly improved.

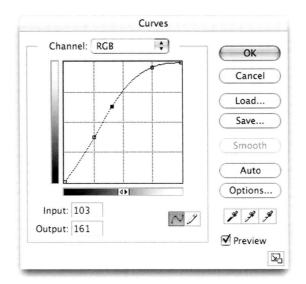

**FIGURE 11.33**   Because the image has lost contrast, we apply another point in the highlight region of our curve to improve the contrast of the image. Our curve now has three points.

Therefore, to warm up the flower, we want to add some red to the yellow tones that make up the flower. In the Curves dialog, open the Channel pop-up menu and select Red. You should see a new flat curve. Don't worry, the curve you just built is not gone—you can switch back to it by selecting RGB from the Channels pop-up menu. The Curves dialog lets you keep separate curves for each channel, plus the RGB composite.

Your goal is to shift the curve to the top left to add more red. However, you only want to move the part of the curve that contains the yellow information of the flower, so as not to adjust the red in the green tones of the background.

With the Curves dialog open, click in the image and drag it around. A circle will appear on the curve and move around as you drag the mouse. This circle is showing you where the selected pixels map onto the curve. In this way, you can easily identify the part of the curve that needs editing.

Command-click (or Control-click if you're using Windows) on part of the yellow flower. Photoshop will automatically add a point to the part of the curve that corresponds to this color. Drag this point up and to the left to add more red. This will warm up the flower, but it will also add a red cast to your image. To compensate for this, add one point on each side of your first point, and drag them back down to flatten the curve. (See Figure 11.34.)

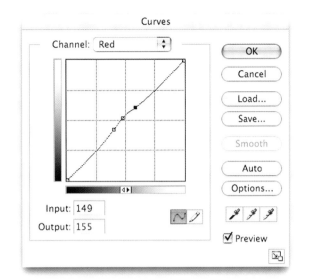

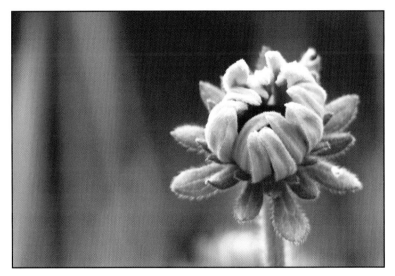

**FIGURE 11.34**   The final Red channel adjustment shown here isolates a very small part of the curve and boosts the red just a tiny bit, resulting in our final image which has a much warmer flower.

---

**TUTORIAL**     **HUE/SATURATION**

Photoshop CS and Elements both include a lot of color-correction and adjustment tools, but Levels and Curves will be the tools you use most often for everything from simple contrast adjustment to complex color corrections. In fact, because you can do almost everything you'll need to do

using Levels and Curves, you might not ever even look at some of the other color controls.

However, though both Levels and Curves are great for altering color and improving tone, when it comes to adjusting the saturation of an image or altering a specific color, there is a better choice: Hue/Saturation. In this tutorial, we're going to take a quick look at saturation adjustment using Hue/Saturation. Later, we'll see more about altering color using this powerful tool.

The goal of this tutorial is to fix up the image shown in Figure 11.35. To begin with, we cropped the image to eliminate some of the space at the bottom of the image, and then used the Rubber Stamp tool to remove the small post and wire from in front of the stones. (You'll learn how to use this tool in Chapter 12.) The resulting edited image is what you will work on in this tutorial.

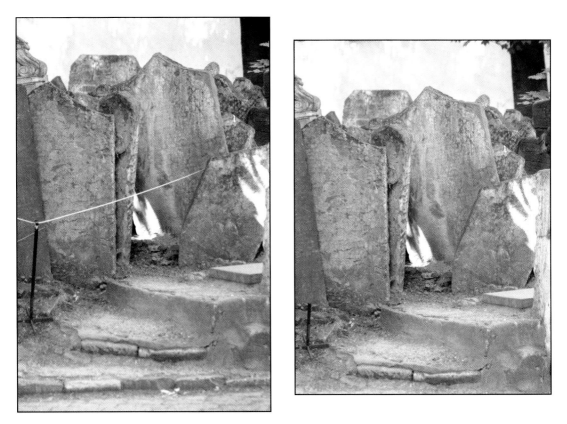

**FIGURE 11.35**   On the left, you can see the image as it was shot. We performed a little cropping to bring to the foreground, and some cloning to eliminate the post and wire. All that remains now is to improve the contrast and color.

### STEP 1: OPEN THE IMAGE

In Photoshop, open the image cemetary.tif located in the Tutorials/Chapter 11/Saturation folder on the companion CD-ROM.

### STEP 2: PERFORM LEVELS ADJUSTMENT

The histogram should confirm what your eyes are already telling you: this image has very low contrast. A simple Levels adjustment should let you bring some texture and drama back into the image. Because the whites are already clipped, you'll really only need to adjust the black and midpoints. (See Figure 11.36.)

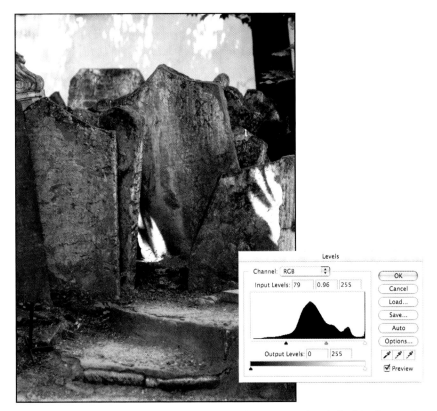

**FIGURE 11.36**    After our first Levels adjustment, the image is already looking better. But it's a little too "glossy."

### STEP 3: PERFORM SATURATION ADJUSTMENT

Though the image looks much better after our Levels adjustment, it's just a little too glossy and colorful. We don't want to make a depressing

image, but we could possibly make a more dramatic image if the palette were more gray than green and pink. If you want to see what it would look like as a black-and-white image, you can click Image > Mode > Grayscale in Photoshop CS or Elements to convert the image to grayscale. As a black-and-white image, it's a little too gray. The colors in the image are nice—they're just too strong, so let's try desaturating them

Open the Hue/Saturation dialog box by clicking Image > Adjustments > Hue/Saturation in Photoshop CS, or Enhance > Adjust Color > Hue/Saturation in Photoshop Elements. You should see the dialog box shown in Figure 11.37. The Edit pop-up menu lets you select which color ranges you want to adjust, whereas the sliders allow you to specify what type of adjustment you want. The color bars at the bottom are for refining the color you're selecting to alter. We don't want to edit a specific color; we just want to desaturate everything equally, so leave the Edit menu set on Master and drag the Saturation slider to the left to desaturate the image. (See Figure 11.37.)

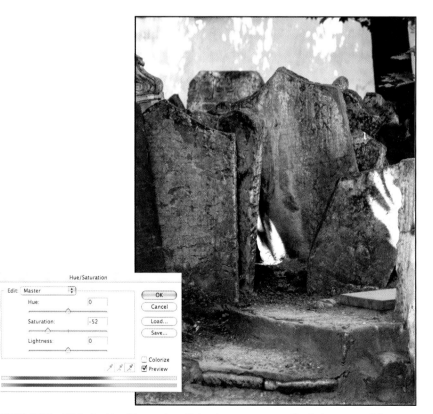

**FIGURE 11.37**　With the Hue/Saturation dialog box, we can easily drain some of the color out of the image to create a picture that's a little more subdued.

Trying to reduce the saturation of colors using Levels or Curves is difficult because as you pull out color with those tools, you end up darkening the image. As you'll see later, Hue/Saturation can be a real lifesaver for a number of operations that Levels and Curves can't handle.  ✄

## THE STORY SO FAR

At this point you should feel very comfortable reading histograms to help assess what corrections are necessary in an image. You should also have a grasp on performing basic contrast and tone corrections using Levels and Curves, and you should feel comfortable adjusting some of your own images. Before you head off to your photo archive, though, take a look at one more example that might save you a little frustration.

As you've already seen, you can use Levels, Curves, and Hue/Saturation to adjust the tones and colors in your image. However, it's important to note that even though Curves provides a lot of flexibility in terms of being able to limit your corrections to a particular color, there will still be times when you cannot set enough control points on the curve to constrain your edit to a particular part of the image.

Consider Figure 11.38. The two figures in the foreground are way too dark and need some major midtone adjustments. However, using Curves there's no way we can select a part of the curve that targets only their midtones, because there are other parts of the image—the ground and the grass—that fall on the same part of the curve. So, as we boost the midtones in the figures, we end up wrecking the contrast in the ground and grass and quickly posterizing it.

Remember that the points along the curve in the Curves dialog aren't related to a specific *part* of your image. Rather, they represent *all of the pixels* in your image that have that color. Right now, we haven't covered the tools necessary to fix this particular image, but you'll get to them soon enough. In the meantime, try out some Levels and Curves adjustments on your own images to get a better feel for the effects of these tools.

**FIGURE 11.38** As powerful as the Curves tool is, it still doesn't provide a way for us to isolate only the tones in the two figures in the foreground. As such, there's no way to change their tones without also changing the tones in other parts of the image.

# BUILDING YOUR EDITING ARSENAL

**In This Chapter**

- Brushes and Stamps
- Cloning Video Tutorial
- Masks
- Creating Complex Masks
- Layers
- Other Editing Tools

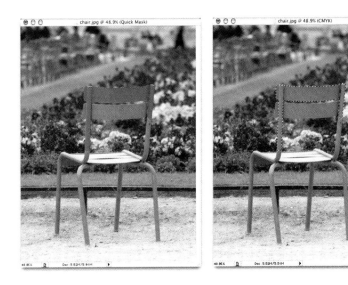

In the previous chapter you learned about Levels and Curves, two important tools that you'll use in almost all of your everyday editing tasks. In this chapter, we're going to add to your toolbox by covering more of the basic tools and functions that you'll use in everyday editing. These are the features you'll turn to again and again—in many different combinations—to perform your corrections, adjustments, and modifications. As in previous chapters, although the examples and tutorials in this chapter are built around Photoshop and Photoshop Elements, any decent image editor should provide equivalent functions. Even if you're using a different image editor, you should have no trouble translating the workflows and approaches presented in this and the following chapters to your program of choice.

## BRUSHES AND STAMPS

Many of the retouching and editing tasks that are performed in a real darkroom are dependent on brushes, masks, and paint. Your image editor is no different, except that your brushes and tools are digital. To get good results from them, you still need a good hand, a trained eye, and well-designed tools—just as in a real darkroom.

The documentation that came with your image editor should offer plenty of information on how to use your editor's tools. In this section, therefore, you're going to learn what each tool is good for—you'll need to refer to your image editor's manual to learn the details of how to modify and adjust each tool. Being able to identify the right tool for a particular job will often save you a lot of time.

### Brushes

Hopefully, your image editor includes a good assortment of paintbrushes and airbrushes. A good Brush tool is one that offers an easy way of selecting different brush sizes and shapes, has *antialiased* (smooth) edges, pressure sensitivity when used with a drawing tablet, and variable opacity. (See Figure 12.1.)

You'll use these tools for everything from painting out unwanted elements in a scene to performing certain types of color correction, creating masks, and "brushing in" different special effects.

To use a Brush tool well you need—obviously—good hand-eye coordination and a feel for the brush. Your brush skills will develop over time and will be greatly aided by the use of a drawing tablet. In addition to providing a more intuitive interface, a drawing tablet is *much* easier on your hand

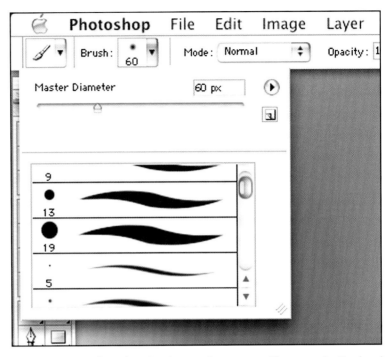

**FIGURE 12.1**    The Photoshop Brush controls—scattered between the Brush palette and the toolbar—let you select brush size, transfer mode, and opacity.

than is a mouse. If you plan to do a lot of image editing, consider investing in an inexpensive pressure-sensitive drawing tablet such as the Wacom® tablet shown in Figure 12.2. At the time of this writing, you can get a good Wacom pressure-sensitive tablet for less than $100.

You'll also want to spend some time learning the different keyboard shortcuts that augment your Brush tool. Learn your brush's features, including parameters such as opacity, *spacing* and *repeat rate.*

If you're using Photoshop, you'll quickly become dependent on these brush-related keyboard shortcuts:

**B:**    Selects the Brush tool
**Shift-B:**    Toggles between the Brush and the Pencil tools
**[:**    Shrinks the size of the current brush
**]:**    Enlarges the size of the current brush

### Airbrushes

Airbrushes are similar to normal paintbrushes, the main difference being that they don't lay down a full load of paint with one pass. Instead, they

**FIGURE 12.2** A pressure-sensitive drawing tablet such as this Wacom Graphire® is a must-have for serious image editing.

work like a real-world airbrush—they spray on a fine layer of color that can be darkened by repeated strokes. Airbrushes are ideal for fine shading and detail work. Touching up shadows and highlights, trying to match the color and tone of an existing element in your image, or trying to soften an effect or composite are all potential uses for your application's airbrush tool. In general, the airbrush is ideal for any application where you don't want to "commit" to a particular color or tonal value, but instead want to build up color or tone with multiple strokes.

The airbrush requires a finer touch than the normal paintbrushes, and the tool's sensitivity can usually be adjusted with simple parameter sliders. As with the paintbrush, learn to control the sensitivity of your airbrush and spend some time practicing to get a feel for how it applies color.

### Rubber Stamp or Clone

One of the most powerful—and seemingly magical—tools in your image-editing toolbox is a Rubber Stamp tool (also known as a Clone tool), which provides a brush that performs a localized copy from one part of your image to another, as you brush. (See Figure 12.3.)

You'll use the Rubber Stamp tool for everything from removing dust and noise to painting things out of your image to painting things into

**FIGURE 12.3** When you paint with a Rubber Stamp (Clone) tool, your image editor copies paint from your source area (the crosshairs) to your target area (the circle).

your image. The advantage of a Rubber Stamp tool over normal copying and pasting is that the tool's brush-like behavior lets you achieve very smooth composites and edits.

Study your Rubber Stamp tool's documentation to learn the difference between absolute and relative cloning and to learn how to set the tool's source and destination points. When you rubber-stamp an area, you want to be able to quickly select a source area and then start painting, so it's imperative to learn the tool's controls.

Your image-editing application provides many more tools and functions, but brushes and stamps are the ones that you'll be using the most.

These are also tools that will not be heavily discussed or documented in the rest of this book. For the rest of these tutorials, it is assumed that you know how to follow an instruction such as "Rubber-stamp out the telephone wires." If you don't know how to use these tools, consult your manual.

| TUTORIAL | CLONING VIDEO TUTORIAL |

To learn more about cloning, watch the Cloning Tutorial movie located in the Tutorials/Chapter 12/Cloning folder on the companion CD-ROM. (See Figure 12.4.)

ON THE CD

**FIGURE 12.4** We used nothing more than the Photoshop Rubber Stamp (or Clone) tool to remove the wires from in front of this hippo. A Clone tool is a must for even the simplest touchups, so make sure you know how to use one. You can see how this image was corrected by watching the Cloning Tutorial movie located on the CD-ROM.

## PATCH AND HEAL

Two of the extra features you get when you opt for Photoshop CS over Photoshop Elements are the Healing Brush and Patch tool. The Healing Brush works just like the Rubber Stamp tool but with a bit more intelligence. Rather than copying pixels directly from the source location to your brush position, copied pixels are automatically adjusted for texture, lighting, transparency, and shading, so that your cloned pixels blend more seamlessly with the surrounding parts of your image. You can achieve the same results with a regular Rubber Stamp tool, but the Healing Brush is much easier to use.

The Patch tool uses the same underlying technology as the Healing Brush tool, but it lets you patch an area by drawing around it with a lasso and then dragging that area over a part of your image that contains the texture you'd like to have in your selection. That texture is automatically copied and blended into your selection.

If you do a lot of complex retouchings, these two tools can be worth the extra money for a full-blown copy of Photoshop.

### Dodge and Burn

In traditional darkroom work, dodging is the process of holding something in front of your print while it is being exposed in the enlarger, to underexpose a particular localized area. Burning is just the opposite—blocking out all of your image but one part to overexpose a particular localized area.

Both Photoshop and Photoshop Elements include excellent Dodge and Burn tools that work just like normal brushes. When you paint, the exposure of the underlying brushed part of the image is increased or decreased, depending on which tool you're using. Dodge and Burn tools are essential for facial retouchings, removing artifacts and blotches, and many other corrections, as you'll see in Chapter 14.

## MASKS

Masks are used for everything from compositing images together to constraining your edits and adjustments to particular parts of your image. Masks are much easier to understand once you realize that they are just

like stencils that you would use in a real darkroom or painting studio. The only difference is that, as you'll see, digital masks are much, much better.

Many photographers feel that masking is not such an important tool because they're not interested in creating weird special effects or wacky composites. Masking, however, can be an essential color-correction tool, allowing you to create adjustments and corrections that would otherwise be impossible. For example, if you want to color-correct only the background of an image, you might build a mask over the foreground elements. (See Figure 12.5.)

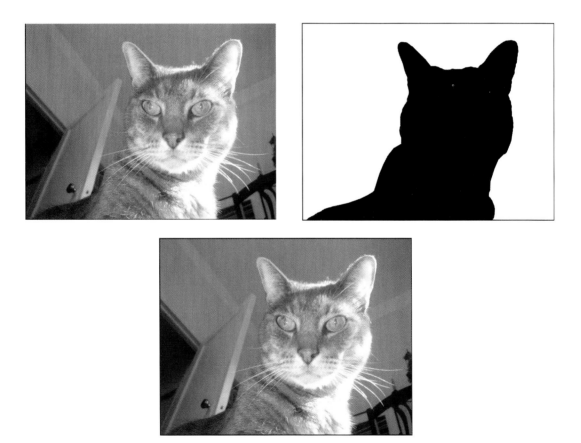

**FIGURE 12.5** To correct the background of this image without altering the cat in the foreground, we created a mask that protects the cat during the Hue/Saturation adjustment that alters the background.

Similarly, a mask can serve as a stencil when you're combining separate images to create a single composite. If you want to superimpose a new element into an image, or replace a background image, good masking skills and tools are essential. (See Figure 12.6.)

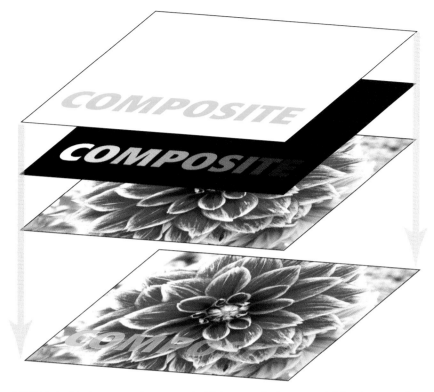

**FIGURE 12.6**    Masks are used to control which parts of a layer are visible when creating composites. You can think of a digital mask as sitting between two different elements in an image, to control how those two elements fit together. Similar to stencils, digital masks have the advantage of allowing for varying degrees of transparency. Although masks are essential for complex special effects work, they're also useful for basic color corrections and adjustments. Here, the top layer is being composited with the bottom layer, with a mask knocking out the background of the top layer so that only the blue text gets combined with the flower.

Like many editing tasks, knowing how and when to use a mask is a skill. However, learning the basics of your masking tools is pretty simple once you understand a few simple concepts.

## Mask Tools

Most image-editing applications offer many tools for creating masks, and you'll often find yourself using these tools in combination. Some tools, for example, are more appropriate for masking complex subjects, such as hair or fine detail. Other tools are more appropriate for masking geometric shapes or large areas of color. For building complex masks, you'll use a mixture of these tools.

## Selection Tools

The simplest mask tools are the selection tools—the lasso and rectangular and circular marquees—that let you create simple selections by outlining areas of your image. You might not think of these as mask tools, but the selections they produce work just like a mask. Create a rectangular selection around an object, for example, and your editing tools will work only inside that selection. In other words, everything outside of the selection is masked out. (See Figure 12.7.)

**FIGURE 12.7**    Creating a selection in your image editor is the easiest form of masking. Any operation—including simple paint strokes—are constrained within your selection. In other words, the selection is masking your image, just as a stencil would.

What makes these simple selection tools effective for complex masking is that most applications let you add and subtract from the selections you make. In Photoshop, for example, you can add to a selection by holding down the Shift key while you select more of the image. This method allows you to use different tools for different parts of your image. For example, you can use the Circle tool to select a curvy section of an object, then hold down the Shift key and use the Lasso tool to outline the rest of the object. (See Figure 12.8.)

**FIGURE 12.8**    By holding down the Shift key when you use a selection tool, you can add to a selection. The ability to add to a selection allows you to use different tools to select different parts of an image. In this image, we used the Rectangular Marquee to select a rectangular-shaped area of the chair, and then the Lasso tool to trace around the edge detail.

Similarly, Photoshop lets you use the Option key (Alt if you're using Windows) to subtract from a selection. The ability to keep adding and subtracting to and from a selection with different tools is essential for building complex masks.

In the same family as the selection tools are Magic Wand tools that automatically hunt down similar colors to create selections automatically. As with other selection tools, Photoshop allows you to combine Magic Wand selections with selections made using other tools, by simply holding down the Shift or Option (Alt) keys.

## Mask Painting

The Photoshop QuickMask mode lets you create a mask by painting. (This feature is not included in Photoshop Elements.) To use QuickMask, you click the QuickMask icon at the bottom of the main tool palette. In

QuickMask mode, any areas that you paint black will be selected when you exit QuickMask mode, and any areas that you paint white will be unselected. (See Figure 12.9.)

**FIGURE 12.9** In QuickMask mode, you can select areas simply by painting. Areas painted red in QuickMask mode are selected when you switch back to normal mode. QuickMask is an easy way to make odd-shaped selections.

You can switch in and out of QuickMask mode as much as you like, meaning that you can combine its mask selection tools with your image editor's other masking and selection tools.

### Color-Based Selection Tools

Many applications provide special tools for automatically selecting certain colors. Photoshop CS, for example, includes a Color Range command that can automatically select all occurrences of a particular color in an image. (See Figure 12.10.)

**FIGURE 12.10**    The Photoshop Color Range command lets you select all of the occurrences of a particular color in your document.

Color Range will almost always select more pixels than you want, but the extra pixels can usually be easily removed with another selection tool.

## Special Mask Tools

Some applications include special dedicated tools, such as the Photoshop Extract tool, which can perform complex extractions of difficult subjects, such as hair or transparent surfaces. (See Figure 12.11.) Extract doesn't create a mask, but it does let you isolate an image for compositing with another image.

There are also several third-party masking plug-ins that can be added to any image editor that supports Photoshop plug-ins. Programs such as Corel® KnockOut or Extensis™ Mask Pro™ provide a simple way of creating complex masks. If you find yourself consistently trying to mask difficult subjects such as hair or other objects with fine detail or transparency, it might be worthwhile to look into one of these options.

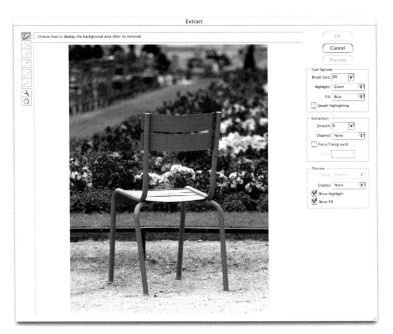

**FIGURE 12.11** The Photoshop Extract tool includes sophisticated edge-detection capabilities for extracting part of an image. The result can then be composited with other images.

## Saving Masks

Once you've used the various tools at your disposal to create a selection, you can save that selection as a mask for later use. In Photoshop, selections can be saved by clicking Select > Save Selection. At any time, you can use the Select > Load Selection command to restore your selection.

In Chapter 11, "Correcting Tone and Color," you saw how separate red, green, and blue channels are used to create a full-color image. You also saw that you can access and manipulate those individual color channels. Selections, or masks, are stored in a similar fashion. When you save a selection, your image editor creates a new channel in your document—called an *alpha channel*—and stores an image of your selection. (See Figure 12.12.)

As you can see, any selection can be represented by a grayscale image—areas within the selection are stored as white pixels; areas outside are stored as black. (Another way of thinking of it is "black conceals, white reveals.") In Photoshop CS, you can create as many different selections as you want and store each in its own alpha channel. From the

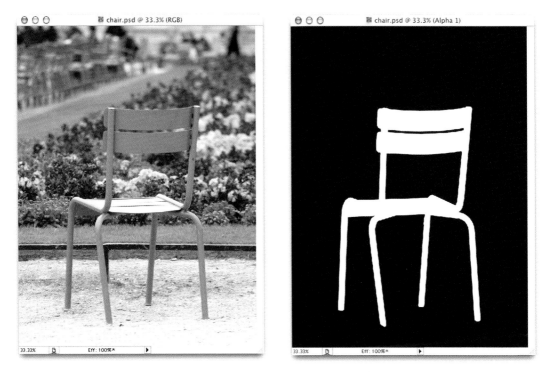

**FIGURE 12.12**    When you save a selection, Photoshop stores a grayscale, 8-bit alpha channel. Black areas of the image are masked, but white areas are not. If you load this alpha channel as a selection, the white area will be selected, just as if you had traced it with a Lasso—or any other selection—tool.

Channels palette, which you can open by clicking Window > Show Channels, you can access each mask by simply clicking its name. (See Figure 12.13.)

### Sort of Masked

So far, we've discussed masks as if they were simple stencils—edits are kept to either the inside or outside of the mask. Digital masks, however, are much more powerful than real-world masks, because in addition to masking an area, they can *partially* mask an area. Just as black pixels in a mask are completely opaque, gray pixels are only *partially* opaque, meaning that you can use masks to apply effects and adjustments that vary across an image.

The easiest way to understand masks is to use them. In the following tutorial, you'll use a series of complex masks to alter an image.

Load channel as selection

Save selection as channel

Create new channel

**FIGURE 12.13** You can see and access the alpha channel from the Photoshop Channels palette.

## CREATING COMPLEX MASKS

In this tutorial, you'll create and use a mask to perform a complex color correction. Photoshop CS is required for this tutorial, because Photoshop Elements does not provide access to individual color channels. A demo of Photoshop CS is included on the CD. Even if you plan on using only Elements, it's worth working through this tutorial to get a better understanding for how masks work, as well as to learn about the Photoshop masking workflow.

### STEP 1: OPEN THE IMAGE

ON THE CD

Open the image tree.jpg, located in the Tutorials/Chapter 12/Creating Complex Masks folder on the companion CD-ROM. (See Figure 12.14.) Your goal in this tutorial is to try to emphasize the foreground elements—the tree and the bent wrought-iron cage—by lightening the background. To edit the background without disturbing the foreground, therefore, you need to mask out the tree.

**FIGURE 12.14**    Because we want to edit the background of this image without disturbing the tree, we need to create a tree mask.

## STEP 2: CREATE A MASK

Using your choice of masking techniques, create a mask for the tree as well as the entire wrought-iron cage that surrounds the tree. Save the mask by clicking Select > Save Selection. To save time, the file tree with mask.psd has been included in the Tutorials/Chapter 12/Creating Complex Masks folder. This image includes a prebuilt mask that you can use for the rest of this tutorial. (See Figure 12.15.) (In case you're wondering, this mask was created by simply painting over the tree and fence using the Photoshop QuickMask tool.)

**FIGURE 12.15** This mask was built using the QuickMask tool and is included in the Tutorials/Chapter 12/Creating Complex Masks folder.

### STEP 3: LOAD THE MASK

Before you can use a mask, you must load it. Open the Channels palette. You should see separate channels for red, green, blue, and your mask (called Alpha 1). At the bottom of the Channels palette are a series of buttons. The far left button is the Load Channel as Selection button. (See Figure 12.16.) Drag the Alpha 1 channel on top of this button; Photoshop will load the channel as a selection. (If you end up clicking the Alpha 1 channel, your document will switch to a view of that channel. Click the RGB channel at the top of the Channels palette to return to viewing the entire, full-color image. Then, try again to load your selection.)

Sometimes, after loading a mask, it can be difficult to tell what is selected and what isn't. For example, with the tree mask loaded, it's difficult

**FIGURE 12.16**    You can load a mask as a selection by dragging its icon in the Channels palette to the Load Channel as Selection button at the bottom of the Channels palette.

to tell whether the foreground or background is masked. To find out, click the Paintbrush tool and brush around on the image. You should see that the paint is going only into the background because the tree is completely masked. Click Undo to remove your brushstrokes. (If Undo doesn't undo all the strokes, use the History palette to remove the brushstrokes.) If the paint is going into the foreground, your mask is backward. From the Select menu, click Invert Selection to reverse your mask. Now when you brush, your paint should go into the foreground.

### STEP 4: FADE THE BACKGROUND

With your mask loaded, you can now start manipulating the background. If the goal is to emphasize the foreground, you should try lightening the background using a simple Levels command.

Click Image > Adjust > Levels to open the Levels dialog box. In previous tutorials, you used the Input controls exclusively and learned how they allow you to change the distribution of tones within your image. So far, though, your Levels adjustments have redistributed the tones in your image so that they fit between full black and full white.

However, what if your printer can't print full black? Many offset printers can't hold more than 85 percent black—any more ink and they jam up. Therefore, Levels includes a pair of output sliders that allow you to adjust the limits of the tonal range in your image. The distribution of tones specified by the input levels remains the same.

Let's eliminate many of the darker tones without changing the tonal relationships in our image. Slide the left output slider to roughly the midpoint (around 126) and click OK. This step should create a faded background. (See Figure 12.17.)

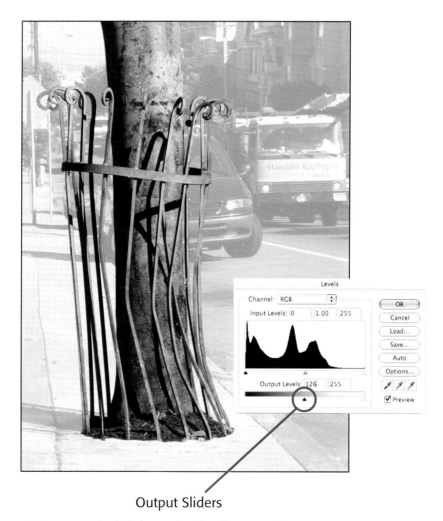

Output Sliders

**FIGURE 12.17** We've faded everything but the tree. Unfortunately, we've faded more than just what was behind the tree in the scene. The sidewalk in front of the tree has been faded as well.

### STEP 5: ASSESS THE CHANGE

Now it's time to assess if this was the right edit. With all of those selection lines marching around, it can be difficult to see the image clearly. Click Select > Hide Selection to hide the selection lines; the selection is still active, you just can't see it. You can always click Select > Show Selection if you need to double-check that the selection is still active.

Sure enough, as we planned, the adjustment faded the background. Unfortunately, because we faded everything but the tree, our edit has also caused elements in front of the tree to fade. This is not really the desired effect. Click Undo to remove the Levels adjustment.

What we want is a Levels adjustment that won't affect the entire image uniformly but will be stronger in parts of the image that appear farther away. It's time to create another mask.

Choose Deselect from the Select menu to deselect the current selection. We don't want anything selected right now.

### STEP 6: CREATE A GRADATED MASK

Although you can use any number of selection tools to create masks, you can also paint them by hand, directly into an alpha channel. In the Channels palette, click the Create New Channels button (the second button from the right). A new channel will be created, selected, and filled with black.

Remember that black areas in a mask are completely opaque, white areas are completely transparent, and gray areas are somewhere in between. We want a mask that fades from fully opaque to fully transparent.

Set the foreground and background colors to black and white by clicking the Black/White switch next to the Photoshop color swatches in the main tool palette. (See Figure 12.18.)

**FIGURE 12.18** The Black/White switch lets you immediately set the foreground and background colors to black and white, respectively.

Now select the Gradient tool and drag from the top of the image to the bottom to create a complete black to white gradient. To make it easier to drag a straight vertical line, hold down the Shift key while dragging to constrain movement to 45° angles.

### STEP 7: TRY THE NEW MASK

Click the RGB channel in the Channels palette to switch back to full-color view. Now, load the new channel by dragging the Alpha 2 channel to the Load Channel as Selection button. A selection will appear that covers about half the image. Don't worry—Photoshop has loaded the complete mask; it's choosing to outline only areas that are more than 50 percent masked. Click Select > Hide Selection to hide the selection and then apply the same Levels adjustment that you did in Step 4. (See Figure 12.19.)

**FIGURE 12.19**    We get a better fade with a graduated mask, but now our tree is fading along with the background.

This is the effect we wanted—a lightening of the image that gets stronger from bottom to top. Unfortunately, the effect is no longer confined to just the background, it's fading the tree as well. Click Undo to remove the Levels adjustment, and let's make another new mask.

### STEP 8: CREATE YET ANOTHER MASK

Go back to the Channels palette and delete the Alpha 2 channel by dragging it to the trash can at the bottom of the palette. Now make a new channel.

We want to create a gradient that fills all of the document *except* where the tree is. Unfortunately, the Gradient tool will fill the whole channel unless we *use the tree mask we already created*. Load the first mask (the tree) by dragging the Alpha 1 channel to the Load Channel as Selection button. You should see the outline of the tree mask.

Now, click on the Gradient tool and make a top-to-bottom, black-to-white gradient. You should end up with something like the mask shown in Figure 12.20. The tree is completely black, meaning it's completely masked and will not be affected by any editing operations, whereas the background is masked with a gradient, meaning the effect of any editing operations will vary from top to bottom. Click the RGB channel to view your color image.

**FIGURE 12.20**    This mask provides the gradient we need to create our fade while masking out the tree.

### Step 9: Fade the Background

Now, load your new mask by dragging it to the Load Channel as Selection button on the Channels palette, and apply your Levels adjustment. You should see a Levels change that affects only the background but varies from the bottom to the top of the image.

With this mask, you can now independently edit the foreground and background of your image. Try experimenting with different color corrections and filters. The image in Figure 12.21 has had a more severe Levels adjustment applied to it, as well as some subtle desaturations of the foreground and background.

**FIGURE 12.21** Our final tree image includes some extra color desaturations and levels adjustments.

## Layers

Layers are pretty easy to understand. If your image editor provides a layer facility, you'll be able to stack images—and parts of images—on top of each other within a document. A robust layer facility provides you with the ability to more easily make the types of corrections that you saw in

the last tutorial, and—if you structure your layers properly—allows you to go back and tweak your edits later.

## Some Layer Basics

If your image editor provides layer controls, you'll need to spend some time learning how they work. Following are some of the basics of using the Layers control in Photoshop and Photoshop Elements. (Note that Layers weren't added to Photoshop until version 3. If you're using an earlier version, it's time to upgrade!)

### Creating, Deleting, and Moving Layers

Fortunately, layer management is very simple in Photoshop or Photoshop Elements—you simply use the Layers palette. On the bottom of the palette are all the controls you need to create and delete layers. (See Figure 12.22.) Right now, you need to worry only about the Create layer and Delete layer buttons located on the right side of the palette.

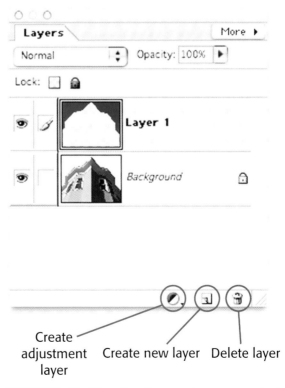

**FIGURE 12.22**   The Photoshop Elements Layers palette includes simple button controls for creating and deleting layers.

When you create a new layer, it will appear as part of the layer stack in the palette. Because new layers are empty, your image won't look any different. All edits—whether painting, filters, or image adjustments—happen in the currently selected layer. Note that you can turn off the visibility of a layer by simply clicking its eye icon.

Layers that are higher in the Layers palette obscure any lower layers, and you can rearrange layers by dragging them up or down the stacking order. Note that you cannot change the order of the lowest layer—the Background—unless you double-click it to turn it into a normal, floating layer.

New layers are completely transparent, whereas the Background layer is completely opaque. (Obviously, as you paint into a layer, Photoshop changes the opacity of that part of the layer so that your paint is visible.)

### Opacity and Transfer Modes

You can change the opacity of the currently selected layer by simply sliding the Opacity control in the Layers palette back and forth.

You can also change how the currently selected layer interacts with layers that are lower in the stacking order by selecting a *blending* (or *transfer*) mode from the pop-up menu in the Layers palette. Normally, the pixels in a layer simply overwrite any pixels that are lower down the stack. By changing the blending mode, you tell Photoshop to mathematically combine pixels, instead of simply replacing lower pixels with higher pixels. (See Figure 12.23.)

As you work more with blending modes, you'll get a better idea of what they do. At first, don't worry about being able to predict their results. Just start playing around with them until you find the effect you like. You can lessen the effect of a mode by lowering that layer's opacity.

Blending modes are essential for creating some types of compositing effects. Figure 12.24 shows the creation of a virtual tattoo. When the tattoo image was layered directly on top of the body image, it looked like a simple overlay. Changing the tattoo layer's opacity helps some, but to create a realistic blending of the colors, we need to change the tattoo's transfer mode to Multiply.

In addition to compositing, you can use layer modes for hand-coloring grayscale images (Figure 12.25) and creating certain types of color corrections.

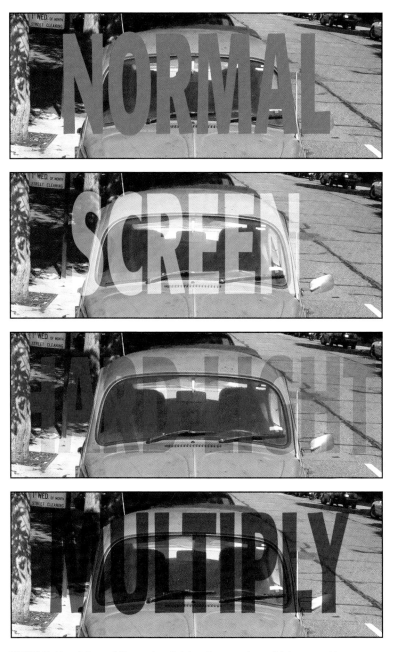

**FIGURE 12.23**    A few of Photoshop's blending modes, which control how one layer—in this case, the text—mixes with a lower layer.

100% Opacity, Normal Transfer

48% Opacity, Normal Transfer

100% Opacity, Normal Transfer

**FIGURE 12.24** To create this tattoo effect, we used a combination of an opacity change with a Multiply transfer mode to blend the tattoo layer with the skin.

**FIGURE 12.25**    We created this hand-painted image by converting our photo to grayscale, and then hand-painting color into a new layer that was blended with our grayscale image using a transfer mode.

*WATCH THAT RAM!*

*As you add layers to your image, its RAM requirements will quickly skyrocket. Nothing affects Photoshop performance as much as RAM, so if you find your computer getting sluggish, it might be that Photoshop is running out of memory. The easiest way to shrink the RAM requirements of your document is to eliminate extra layers. If you think you've finished editing an individual layer, consider merging it with other layers using the Merge Linked or Merge Visible commands, located in the Layers menu.*

### Adjustment Layers

One of the most powerful editing features in Photoshop and Photoshop Elements is their Adjustment layers, which let you apply Levels, Curves, and many other image-correction functions *as layers.* For example, when you add a Curves Adjustment layer to your document, Photoshop presents you with a normal Curves dialog box. You can adjust your image as desired but, when you click OK, instead of applying the Curves adjustment to the image—and altering the pixels in your document—it stores the adjustment in a new Adjustment layer that appears in your Layers palette. (See Figure 12.26.)

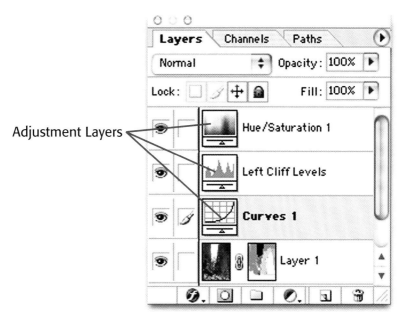

Adjustment Layers

**FIGURE 12.26**    The top layers in this image are Adjustment layers. They apply, respectively, Hue/Saturation, Levels, and Curves adjustments to the underlying layer. Their settings can be altered or changed at any time.

An Adjustment layer affects all of the layers beneath it. (You can constrain the effects of an Adjustment layer by grouping it with underlying layers; see the Photoshop online Help for details.) The real strength of Adjustment layers, though, is that you can go back at any time *and change the Adjustment layer's settings*. Therefore, if you decide at some point that you need a different Curves adjustment, you can simply double-click your Curves Adjustment layer and change its Curves parameters. In addition to providing flexible editing, Adjustment layers keep you from reapplying effects that result in data loss. You'll be using Adjustment layers extensively throughout the rest of this book.

### DESTRUCTIVE VERSUS NONDESTRUCTIVE EDITING

*If you open a Levels or Curves control (or any of the other adjustment tools mentioned in this chapter) and apply a change to your image, you are actually changing the original pixel data in your image. This is called destructive editing because you are destroying your original pixels. Adjustment layers do not affect your original data. Instead, they are adjustments that are applied on the fly to your image data as the data is written to the screen or output to a printer. These types of corrections are called nondestructive edits because your original image data is still there, allowing you to go back and change your edits and adjustments later.*

## Layer Masks

In the previous tutorial, you saw how alpha channels can be used to create masks. As powerful as alpha channels are, there is an easier way to perform many types of masking operations.

Photoshop CS allows you to attach a layer mask to any layer to create complex mask effects. From the Layers palette pop-up menu you can choose to attach a layer mask to a layer. (See Figure 12.27.)

Layer Content

Layer Mask

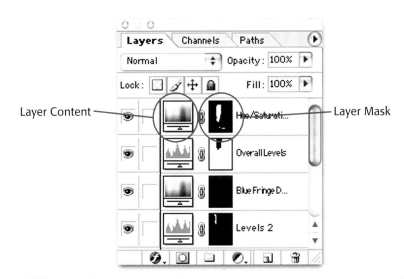

**FIGURE 12.27**    You can paint masking information directly into a layer's layer mask by clicking the layer mask thumbnail in the Layers palette.

Each layer entry in the Layers palette has a Document thumbnail and a Layer Mask thumbnail. You can click these thumbnails to switch between editing the layer or editing its layer mask. As you paint or edit a layer mask, you create masking information that works exactly like the alpha channel masks you saw earlier. Paint black into a layer mask and the pixels in that part of the layer will be masked and, thus, invisible.

The complex masking effects that you created in the previous tutorial could have also been created using Layer masks and Adjustment layers. The final tree.psd document included on the companion CD-ROM (Tutorials/Chapter 12/Creating Complex Masks) includes all of the Adjustment layers used to create the image shown in Figure 12.21.

You'll get a lot of first-hand layer masking experience in the next chapter.

*ON THE CD*

## OTHER EDITING TOOLS

Although Levels and Curves provide controls for editing individual color channels, targeting a specific range of yellow can be difficult when you have to think in terms of red, green, and blue.

Fortunately, most image-editing programs provide other tone- and color-correction tools. Here is a brief rundown of some other tonal correction facilities provided by Photoshop. Each of these functions can be applied through an Adjustment layer. (As noted, some of these effects are not available in Photoshop Elements.)

### Selective Color

The Photoshop CS Selective Color control lets you adjust the cyan, magenta, yellow, and black levels of a specific tonal range. The Selective Color dialog box provides a choice of nine different tonal ranges (reds, yellows, greens, cyans, blues, magentas, whites, neutrals, and blacks) that can be adjusted using simple sliders.

Because the color ranges it targets are so broad, Selective Color is not a very subtle tool—you'll almost always need to run this operation through a mask to limit its effects.

### Unique Tools

Most image-editing applications also include an assortment of additional, special editing tools, ranging from red-eye removal to text editing and shape drawing. In addition to specialized brushes, many programs include automatic-tone and color-adjustment features, such as the Variations dialog box in Photoshop CS.

Although all of these tools can be a boon for certain editing tasks, it's still important to understand basic editing concepts and tactics. Such an understanding will help you better use specialized tools and will afford you a level of "manual override" for times when automated tools don't work or don't provide the level of control you need to make a particular edit. You will be spending the rest of this book learning advanced editing and correction procedures from the basic concepts you learned in this chapter.

CHAPTER

# 13

# ESSENTIAL IMAGING TACTICS

**In This Chapter**

- Advanced Masking

- Workflow

- Initial Cleanup

- Color and Tone Adjustment

- Editing

- Scaling

- Sharpening

Now that you have a handle on how to use some of the tools and functions of your image editor, we're going to start building those tools into more sophisticated editing solutions. In this chapter, we're going to address specific problems that you'll frequently encounter, as well as discuss the workflow and order of operations you should use when editing and correcting.

Because every editing task is different, it's difficult to create a comprehensive list of problems and solutions. Consequently, the tutorials in this chapter will also lead you through some low-level techniques that will help you approach and solve other problems that you may run into on your own.

*ON THE CD*

In addition to the printed tutorials, there are a few video tutorials included on the CD-ROM, as well as PDF files covering additional subjects. Ideally, these should be viewed in the order presented herein. To get started, we're going to build on the masking tutorials you previously read, to reveal some more sophisticated masking techniques.

## ADVANCED MASKING

Though Curves and Hue/Saturation allow you to limit your editing operations to specific tonal ranges, as you saw in Chapter 11 (Figure 11.34) these tools don't allow you to constrain your edits and corrections to specific parts of an image. For this reason, and for the creation of composites and special effects, good masking skills are essential to effective color correction. In Chapter 12 you were introduced to alpha channel masks and Adjustment layers. In this section, we're going to show you how to create complex alpha channel masks using new methods that augment the masking skills you learned earlier.

## TUTORIAL     MASKING WITH LAYER MASKS

It's confession time: there is an easier way to perform some of the masking tasks that you worked through in earlier chapters. However, even though the method you're about to learn facilitates simpler masking, it's important that you understand the masking concepts you explored earlier, both for the creation of more complex masks and to help you better understand our next topic.

In Chapter 12 you were introduced to the Photoshop Adjustment layers, special types of layers that don't contain image information but that let you apply image adjustments in an easily editable manner. In addition to allowing you to adjust your edits after the fact, Adjustment lay-

ers also include powerful masking features in the form of Layer masks. The easiest way to learn how Layer masks work is with a quick tutorial. Note that this tutorial requires either Photoshop 7 or later, or Photoshop Elements 2 or later.

### STEP 1: OPEN THE IMAGE

ON THE CD

Open the image underexposed.jpg in the Tutorials/Chapter 13/Underexposed folder of the companion CD-ROM. Because of the camera's matrix metering, the foreground figures are very underexposed. (See Figure 13.1.) We can improve their contrast with a levels adjustment, but because the background—especially the sky—is reasonably exposed, doing so would quickly blow out the clouds. We need to create a mask to limit our edits to only the figures in the foreground. As you learned in previous chapters, we could select the figures by outlining them with the selection tools (Lasso, Magic Wand, and so on) or paint over them in QuickMask mode, then use that selection as a mask to constrain your Levels operation. We're going to take a very different approach for this image.

**FIGURE 13.1**   Our camera's matrix meter favored the sky in this image, resulting in the foreground figures being overexposed. (To avoid this problem, we should have used the camera's center-weight meter.)

### STEP 2: CREATE AN ADJUSTMENT LAYER

Add a new Levels Adjustment layer by opening the Adjustment Layer pop-up menu at the bottom of the Layers palette. (See Figure 13.2.) You might need to open the Layers palette if it's not visible. After creating the

**FIGURE 13.2**    You can create an Adjustment layer in Photoshop CS or Elements by clicking the Add Adjustment Layer icon at the bottom of the Layers palette.

Adjustment layer, you will be immediately presented with a standard Levels dialog box. This is where you define what adjustment the Adjustment layer will make to your image. While looking *only at the figures,* make your adjustment to improve their exposure. This will adversely affect the background exposure, but don't worry about that right now. To heighten the contrast, you'll want to move both the black and white points, and you'll need a severe midtone adjustment to brighten their details. Consider a black point around 11, midpoint around 1.83, and a white point of roughly 234. Click OK when you're finished.

### STEP 3: PREPARE YOUR LAYER MASK

In the Layers palette, each Adjustment layer is represented by an icon that tells what type of adjustment it performs. Next to this icon is another icon that represents the Adjustment Layer's mask. (See Figure 13.3.) Each Adjustment layer has a built-in, associated alpha channel into which you can paint directly, just as you painted into an alpha channel in Chapter 12. If you paint black into the mask, the Adjustment layer will not affect those areas of the image. Select the Paint Bucket tool and choose black as your foreground color. Because we have the Adjustment layer's mask currently selected (you can tell because it has a black high-light around it in the Layers palette), painting operations will affect only

the Adjustment Layer mask. With the Paint Bucket tool selected, click somewhere in your image to fill the Adjustment layer mask with black. Your image should return to its original state, because we have completely masked out the Adjustment layer. In other words, it's not affecting any part of your image.

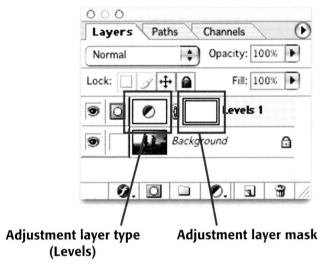

**Adjustment layer type    Adjustment layer mask**
**(Levels)**

**FIGURE 13.3**    Adjustment layers show two icons in the Layers palette: one indicates what kind of Adjustment layer it is, the second shows a thumbnail of the Adjustment layer's mask.

### STEP 4: PAINT IN THE FIGURES

Now select white as your foreground color and grab a Paintbrush tool. Begin painting on the figures in the image. As you brush, you will be punching a hole in that part of the layer mask, allowing the Adjustment layer's effect to filter down to your image. As such, the figures should brighten up according to your Levels adjustment. (See Figure 13.4.)

(If, at any time, you see actual paint going into your canvas, it means that you've clicked on the image thumbnail in the Layers palette. Click Undo, then select the mask icon in your Adjustment layer.)

### STEP 5: PAINT IN THE FOREGROUND

The ground in the foreground could also use some adjustment, though not as much as what we applied to the figures. We could create another Adjustment Layer specifically tailored to the ground, but there's an easier way. Remember that in an alpha channel mask, black masks completely,

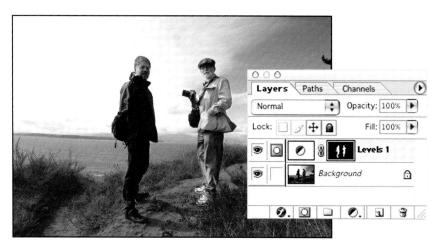

**FIGURE 13.4**    By painting into the Adjustment layer's mask, we can punch a hole in the mask, so that the Adjustment layer's effect filters through only to the figures.

white unmasks completely, and shades of gray fall somewhere in between. Adjustment layer masks work in the same way. So, if we want to apply only *half* the adjustment that we applied to the figures, we need to do nothing more than paint with a 50 percent gray color.

Select a roughly 50 percent gray foreground, and paint over the ground. (See Figure 13.5.) Note that you can use any painting tools. If you want to cover a large area quickly, grab the rectangular selection tool, select the bottom of the image, and then use the Edit > Fill command or Paint Bucket tool. You can then switch back to a paintbrush to paint the borders and fine detail.

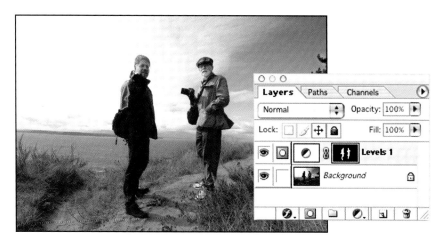

**FIGURE 13.5**    For our finished image, we used various shades of gray to paint more or less effect into different parts of the image.

Note that if you make any mistakes, you can simply grab the appropriate color—black, white, or gray—and repaint the damaged areas of your mask.

The advantage of Adjustment layers with Layer masks is that you don't have to go through separate masking and filter steps. What's more, because your mask is dynamically applied to your Adjustment layer, you can go back and edit it at any time. With normal masking techniques, you'd have to make your mask, select it, apply your adjustment, and then, if it wasn't right, click Undo and then start over. We'll be returning to Layer masks again later to explore more functionality.

**TUTORIAL**

## IMAGE-BASED MASKS

As you've already seen, Photoshop has a number of excellent masking tools that let you paint, select, or outline masks. However, you've also seen that Photoshop has some great analysis tools that let you quickly identify particular tones and color within an image. So, if the goal of masking is to select particular parts of an image, and Photoshop already knows how to identify particular colors, you should be able to use the image data that's in the image *to create masks.*

Consider the image in Figure 13.6.

**FIGURE 13.6**   Because we metered to ensure that the sky wouldn't blow out, the building in this picture ended up a little dark and dull. We want to apply a Levels adjustment to the building, without editing the sky at all.

As in our previous example, the building is underexposed, but the sky looks okay. We need to perform a midtone adjustment on the building, but if we open up a Curves dialog box and click around with the Eyedropper tool, we'll find that the sky and the building share many midtone values. So if we start adjusting the building, there's a good chance we'll ruin the sky. A better choice is to build a mask for the building. This shape is simple enough that it wouldn't take too much work to paint it out—either into the mask of an Adjustment layer like we saw in the previous tutorial—or using any of the other Photoshop selection tools.

But because we want to achieve a slightly different effect, we're going to take a different approach. The texture of the building contains a wide variety of midtones of slight variation. To achieve better contrast on the building, we don't want to adjust all of those midtones uniformly. This means we need to create a very complex mask, which we're going to do using the image data that's already there. We know that we want to target the midtones. What's more, we know that alpha channel masks are simply 8-bit grayscale pictures. Photoshop, of course, is a great tool for creating 8-bit pictures, so we're going to create a modified version of our image that we will use to mask our original image.

Note that this tutorial is not possible using Photoshop Elements.

### STEP 1: OPEN AND PREPARE YOUR IMAGE

*ON THE CD*

Open the file initial building.jpg located in the Tutorials/Chapter 13/ Building Mask folder on the CD-ROM. This is the file that we will ultimately edit. Right now, though, we want to make a copy of this file that we will manipulate into our mask. In Photoshop, click Image > Duplicate to create a new document containing the exact same image data. Now we want to convert this copy into a grayscale image. (Remember, this copy is going to become the basis for our mask, and masks are grayscale.) As you'll see in the next chapter, there are many ways of converting an image to grayscale. For this example, we're going to isolate the luminance information in the image, because we're interested in isolating the subtle changes in brightness on the surface of the building. Click Mode > Lab to convert the image to L*A*B color mode. Rather than being represented by separate red, green, and blue channels, L*A*B images are represented by a lightness channel and two separate color channels. If you click the Lightness channel in the Channels palette, you should see a nice grayscale image.

### STEP 2: CREATE YOUR MASK

This Lightness channel will serve as a starting point for our alpha channel mask, but to use it, we need to move it to our original image. With the

Lightness channel selected, open the pop-up menu in the top-right corner of the Channels palette and select Duplicate Channel. (See Figure 13.7.)

**FIGURE 13.7**    Open the Layers palette menu to access the Duplicate Channel command.

In the resulting dialog box, select initial building.tif from the Document pop-up menu in the Destination box. Then click OK. Now close the copy—don't bother saving, because we won't need it for anything else—and return to your original document. Selected in the Channels palette should be the new alpha channel that we just copied. Because it's selected, your image will appear in grayscale. You can drag this channel to the Load Channel as Selection button at the bottom of the Channels palette (just as you did in previous tutorials), and it will actually load as a selection. In other words, it's a perfectly usable mask. However, before we start using it, we want to make some modifications to it. If you loaded the mask as a selection, deselect it by pressing Command+D (Ctrl+D if you're using Windows).

### STEP 3: ADJUST THE MASK

As previously discussed, we want this mask to exclude the sky completely, because we're pleased with the sky exposure. We want to create a mask that focuses on the midtones. In an alpha channel mask, black areas are completely protected ("black conceals, white reveals"), so we know that if we can get the sky reduced to absolute black, it will be completely masked.

We've already learned about several tools that can be used to adjust tones within an image, and this grayscale mask is no different than any other image, so let's put our toolset to work. With the Alpha 1 channel selected, click Image > Adjustment > Curves to open the Curves dialog box. (We can't use a Curves Adjustment layer, because there's no way of limiting an Adjustment layer to a particular channel.)

We know that for the time being, we don't want to alter our midtones, so click the midpoint to lock it down with a control point. We also know that the tones we want to darken are the brightest tones in the image, so bring the white point all the way to the bottom. (See Figure 13.8.)

**FIGURE 13.8** We will use a Curves adjustment to edit our mask. We begin by trying to reduce the sky to complete black, a process that begins by lowering the white point.

This is a good starting point. Our building has not been masked at all, and the sky is much darker. However, it's not completely masked out. To eliminate it completely, we want to clip all of its tones out of the curve, which we can do by moving our white point directly to the left. Don't be timid—slide it all the way, almost until it collides with the midpoint. The sky will turn completely black, but our building will turn completely white. To correct the building, slide the midpoint to the left, to the next gridline.

Now you should have a gray building on a black background. If used as a mask, this mask would partially select the building, leaving the sky completely blocked. What should be apparent at this point is the procedure of using the Curves control to zero in on precisely the tones we want to mask.

### STEP 4: FINISH THE MASK

As it is right now, the building is not sufficiently selected. Remember, the whiter the building is, the more selected it is. Right now, with its predominantly middle-gray tones, this mask will not create a very strong selection—it's still mostly opaque. We want a higher-contrast mask, and so should adjust our curve accordingly. (See Figure 13.9.) We know that we want the white parts of the building to go whiter, so we're keeping an eye on those areas of the mask and adjusting our midpoint to make them as white as possible.

**FIGURE 13.9**   Our final curve results in a mask that isolates only certain midtones in the image.

### STEP 5: LOAD AND USE THE MASK

In the Channels palette, click RGB to return to viewing and editing the full image. Now load the new mask by dragging it to the Load Channel as Selection button at the bottom of the Channels palette. Press Command+H to hide the selection (Ctrl+H if you're using Windows) so that it's easier to see our upcoming edits. If we've built our mask properly, we should have a selection that is grabbing only certain midtones in our image. At the beginning we said that the building midtones needed to be brighter, so now that we've selected them, we're going to lighten them up.

In the Layers palette, create a new Levels Adjustment Layer. When you create a Layers Adjustment Layer with something already selected, Photoshop automatically uses that selection to create a Layer mask for

the new Adjustment layer, meaning that our new Adjustment layer will affect only the areas defined by our mask.

In the Levels dialog box, increase the contrast of the image by shifting the white point to the left. As you move the sliders, you should see the midtones in the building brighten and change without altering the shadow tones or the sky. (See Figure 13.10.)

**FIGURE 13.10**    After loading our final mask, we can apply a Levels adjustment that is constrained to a specific range of midtones.

### STEP 6: EDIT THE SKY

After editing the building, you might decide that the sky could be a little more dramatic. Using the same technique, you can easily create a mask that protects the building but knocks out the sky. Create a new luminance channel from a duplicate of the image, copy that channel into your document, then use a Curves adjustment to drastically increase the contrast of the mask, until the building is black and the sky is white. You probably won't be able to increase the contrast to the point where all of the windows and details will go black, but you'll get a good edge on the building. You can quickly paint out the windows by hand. Then load the new mask, and alter the sky to taste. The image in Figure 13.10 has had the contrast in the sky beefed up, using the mask shown in Figure 13.11.

This technique of using adjusted, altered channels to create masks for editing is one we will return to for other operations. Though it may seem complex at first, as you gain more experience with masks, it will be easier to envision ways you can use your image itself to create usable masks.

**FIGURE 13.11**    With an additional mask, we can edit only the sky to boost the contrast and make the clouds slightly more dramatic.

## WORKFLOW

For maximum flexibility and to preserve image quality, you should perform your edits in a particular order. For example, you almost always want to perform any sharpening operations *after* you've performed all of your other corrections and edits. Because sharpening can be a very destructive operation, you want to do it only once, after you're sure nothing else in your image will change. Presented in this section is a typical image-editing workflow. Note that the process presented here is for JPEG or TIFF files. If you're shooting raw format, you'll need to make a few modifications, as described in the next section. With that said, your typical image-editing workflow will progress something like this:

1. **Open the file.** In Chapter 10, we discussed a procedure for using your image cataloger to both identify the image you want to edit and to open it in your image editor. Whether you're shooting JPEG, TIFF, or raw, this will be the first step in your image-editing workflow. If you're opening a raw file, you'll want to skip ahead to the next section to perform your raw processing.
2. **Save a copy.** After opening your original file, immediately do a Save As to ensure that you don't write over your original file. Save the copy using an uncompressed format such as TIFF or the Photoshop native file format (.PSD). The only time you need to resave your image as a JPEG file is if you're going to post it on the Web or send it via e-mail.
3. **Noise reduction and initial cleanup.** You will first attempt to remove any excess noise as well as any spots or dirt from the image. By removing these elements first, you won't exaggerate them with later

operations. This is also the stage where you'll correct any barrel or pincushion distortion caused by your camera's lens.

4. **First sharpening.** This step may not be necessary, depending on how you have your camera configured. Because of the filtering and interpolation that your camera has to perform, the images that come straight out of your camera's processor need to be sharpened. As we've already explored, your camera includes a built-in sharpening mechanism. If you have it turned off, you may need to do some sharpening at this stage, just to bring the image up to a base level of sharpness. We'll discuss sharpening in detail later in this chapter.

5. **Cropping.** Next you'll want to crop your image to achieve your desired composition.

6. **Color and tone correction.** Once your image contains only the pixels you're interested in, you can begin to perform your first color and tone adjustments. After a few adjustments, you may find that your shadows have brightened enough to reveal some noise that was not removed earlier. Consequently, color and tone adjustment will sometimes be followed by a little more cleanup.

7. **Editing.** With all of your colors adjusted, you can begin to perform any additional editing such as compositing, collage work, special effects, or other manipulations. Often, to make these edits blend seamlessly together, you'll need to perform additional color and saturation adjustments.

8. **Scaling.** If you didn't crop and scale your image during the initial cleanup, you can perform those operations after you've finished all of your adjustments and edits. For the Web, you'll probably need to scale down your image, whereas printing may require sizing up.

9. **Sharpening.** Finally after everything's finished and your image is the correct size, it's time to apply any requisite sharpening. If you scaled down your image in the previous step, that process probably served to sharpen the image. If you scaled up your image, it could very well need additional sharpening.

Obviously, this workflow is not carved in stone, and you'll often move back and forth between different steps.

## WORKING WITH RAW FILES

If you shoot raw files, your workflow is going to be a little bit different than that just described. (If you're unclear what a raw file is, or what the advantages are, see page 104 in Chapter 5.) For the sake of this discussion, we're assuming that you'll be

using the raw conversion software that's built into Photoshop CS. If you're using an-other package, you'll still want to perform the operations described here at this stage in your workflow.

If you've been following the workflow advice presented in this book so far, you should have used your image browser to open the file you want to edit in Photoshop. Photoshop will automatically recognize it as a raw file and present the Raw Conversion dialog box. (See Figure 5.24.) (Note that this feature is available only in Photoshop CS and Photoshop Elements 2 or later.)

Photoshop's Camera Raw import feature is very robust, and a thorough description of all of its features is beyond our scope. Fortunately, the documentation built into the Photoshop Help system is very thorough. Consequently, you're going to simply learn the key issues and capabilities here, to help you better understand the advantages and procedures for working with raw files.

To begin with, configure the pop-up menus in the bottom-left corner. (See Figure 13.12.) Select the same color space you choose as your default color space. You can choose to alter image size and resolution here, or you can wait and do your resizing later—there's no difference in quality. Depth is probably the most important parameter. If you want the maximum color fidelity throughout your editing process, choose 16-bit. Note, however, that not all Photoshop operations are possible in 16-bit mode, though with Photoshop CS, all of the functions that we'll be discussing in this book are 16-bit enabled. Note, too, that 16-bit images are substantially larger than 8-bit images, so if RAM is a concern, you may want to stick with 8-bit images.

| Space: | Adobe RGB (1998) | | Size: | 3072 by 2048 | |
|--------|------------------|--|-------|--------------|--|
| Depth: | 16 Bits/Channel | | Resolution: | 240 | pixels/inch |

**FIGURE 13.12**    At the bottom of the Camera Raw dialog box are simple pop-up menus for selecting color space, size, bit depth, and resolution.

You might decide that you don't need the extra color fidelity. Perhaps your printer isn't good enough to print the expanded range, or perhaps you don't feel you can see the quality difference. If that's the case, stick with 8-bit. It's worth doing some experimentation with 16-bit images, though, to see what the extra data is good for.

For the most part, the best approach to camera raw processing is simply to follow the sliders from top to bottom. (See Figure 13.13.) So, begin your processing by setting white balance. Remember, raw files have had no processing of any kind done to them, not even white-balance correction. Photoshop defaults to applying the white balance that your camera's white-balance system had selected, but you're free to change this by selecting a different preset from the pop-up menu or by sliding the Temperature slider to make your image warmer or cooler. Once

you've selected an appropriate overall color temperature, you can use the Tint slider to correct for any green or magenta tint in the image. Sliding to the left adds green; sliding to the right adds magenta.

The histogram at the top of the window is a bit different from what you're used to seeing in the Photoshop Levels dialog box. Rather than a single composite histogram, it shows separate red, green, and blue histograms, letting you track whether an individual color channel is clipping. The extra cyan, magenta, yellow, and white tones are simply places where the three primary channels are overlapping. As you adjust white balance, the histogram will update in real-time. There's no right or wrong histogram when adjusting white balance, though as you slide to extremes in one direction or the other, your individual channels will most likely spread farther apart. As you would expect, it's a good idea to try to avoid clipping any particular channel.

If there is a pure white area in your image, you can use the Eyedropper tool from the left side of the palette and click one of the white pixels. This tells Photoshop to automatically generate a white balance that will render that tone neutral. Be sure you're picking something that's supposed to be white and not a bright specular highlight (a bright reflection such as what you would find in chrome on an automobile).

The Exposure and Shadow sliders are analogous to the white and black point sliders in the Levels dialog box. In the histogram shown in Figure 13.13, you can see that our image is slightly low-contrast, lacking real blacks and true whites. We can correct for that here, just as we would in the Levels dialog. Slide the Exposure slider to the right to shift your histogram more toward the right side, the white point. With these adjusted, your histogram should spread out to cover more tonal range.

The Brightness slider is analogous to the Gamma, or Midpoint, slider in the Levels dialog. With it, you can brighten the midtones of the image. Contrast and Saturation perform the same types of adjustments that the Contrast and Saturation settings your camera performs. The difference is that rather than simply two or three settings, you have a large, fine-tunable range. Contrast has no analog in Levels or Curves. It stretches or compresses the tones in your image to cover more range, without altering your white point. If you had trouble setting the Exposure or Shadows slider without clipping the histogram, try backing off on both of those settings, and sliding the Contrast slider to stretch your data.

It might seem strange to hassle with these controls when we've already spent so much time with the Levels dialog box. However, remember that in the Levels dialog, after we adjust the white, black, and midpoint, we've used up some of our image data. Photoshop usually has to discard data to stretch our tones to our desired range, resulting in a "combed" histogram with missing values, which means our final image might suffer from some posterization. But in our Camera Raw dialog, it's as if the image hasn't even left the camera yet. Remember, we're working with more data in Camera Raw than in an 8-bit Photoshop image, which means we have a lot more latitude to adjust. When we're editing as normal in Photoshop, we won't have to perform a white or black point compensation, which means that we're one step ahead as far as

**FIGURE 13.13**    The Camera Raw sliders let you set the black, white, and midpoint of your image *before* you import the final data into Photoshop. This affords you cleaner data to work with for your other edits.

our image data goes. The edits that we would normally perform *after* a Levels or Curves command will have more image data to work with. This is one of the reasons that raw images can yield better results than JPEGs or TIFFs, even if you ultimately decide to work in 8-bit. But it gets better!

Click the Detail tab. You'll find a Sharpness slider and two sliders that help you remove noise.

Next, click the Advanced button to reveal two more tabs of controls. In the Lens tab are sliders for correcting Chromatic Aberration—the strange color fringing that can occur when a lens doesn't focus all wavelengths of light onto the same point—as well as sliders for reducing or eliminating vignetting. The Calibrate tab controls sliders for adjusting the Camera Raw color interpretation. If your particular camera is significantly different than Adobe's reference models, these sliders can help you compensate.

At this point, we're going to leave you to your own Camera Raw explorations, and remind you that the built-in documentation should explain the rest of the Camera Raw features. In particular, you'll want to look at the Automation features, which allow you to automatically save camera raw settings for easy batch processing of multiple images. With these features and a fast computer, dealing with raw images can be as speedy and seamless as dealing with JPEG files.

Once you've finished your raw processing, click OK, and the processed image will open in Photoshop. Do a Save As, and save the image in an uncompressed format such as TIFF or Photoshop (.PSD). You're now ready to return to the workflow outlined in the previous section, starting at "Cropping and Initial Resize."

Of course, the ultimate goal of the workflow presented here is to preserve the highest-quality image data throughout your editing cycle. A slight variation is not going to destroy your image—in fact, you might do things very much out of order and still not see a difference. However, if you later want to make more edits, or different edits, you might wish you'd been a little more careful with your data.

In the next sections, we're going to detail some techniques for handling each of the sections in our workflow outline.

## INITIAL CLEANUP

No matter how careful you were when you were shooting, your image might have some troublesome artifacts that will need to be removed before you begin more complex edits. These artifacts can include anything from noise to lens flares and dirt. If you don't remove them now, they may become more exaggerated as you make additional edits and adjustments later in your workflow.

### Straightening

Let's face it: most of us are too lazy to lug a tripod, even when we know we should, so you will occasionally shoot images that need to be straightened. Though straightening an image in Photoshop Elements is very simple (just click Image > Rotate > Straighten), straightening in Photoshop is not so straightforward. There are several techniques you can use to straighten, but this is one of the easiest:

• In the main tool palette, click the Eyedropper tool and hold to pop-out its submenu of tools. (See Figure 13.14.) Select the Measure tool.

**FIGURE 13.14**    In addition to its normal measuring functions, the Photoshop Measure tool provides a simple mechanism for straightening an image.

- Find something in your image that is supposed to be horizontal. Click one end and drag to the other end with the Measure tool to drag out a ruler. (See Figure 13.15.)

**FIGURE 13.15**    To straighten this image, drag the Measure tool across an element in the image that is supposed to be horizontal. Photoshop will use this data to automatically calculate a rotation amount that will rotate the area you measured to horizontal.

- Now click Image > Rotate Canvas > Arbitrary. Photoshop will automatically fill in an amount that will rotate your image so that the line you measured will end up horizontal.

As you can see in Figure 13.16, the downside to straightening an image is that after rotating, you'll have to crop your picture to return it to a rectangular state. All the more reason to shoot it right the first time.

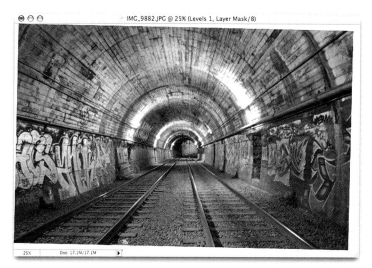

**FIGURE 13.16**    After straightening, you'll usually need to crop your image to return it to a rectangular shape.

### Removing Noise

Noise is the most troublesome artifact to get rid of and, unfortunately, the most prevalent. Although modern digital cameras are getting much better in their ability to produce images with low noise, most cameras will still generate some noise, particularly in shadow areas and bright skies, and especially when you shoot at higher ISOs.

Noise is produced by any number of components in your camera, ranging from the image sensor to the support circuits to the analog to digital converter. In Chapter 2 you saw how image sensors measure light by measuring the voltage of electrons released when light strikes a photosensitive metal. Unfortunately, the semiconductors used in your camera can generate electrical signals that are indistinguishable from the signals produced by your camera's sensor. These extra signals can leak into your image in the form of noise.

There are two types of noise that you'll encounter in your image. *Luminance noise* does not alter the color in your image at all but instead looks very similar to the static "snow" that you see on an untuned TV set. Luminance noise is almost always caused by the type of ambient electrical

signals described previously. The good news is that it's not an unattractive noise—it looks a lot like traditional film grain—and though it might be easily visible on-screen, it probably won't show up in print.

*Chrominance noise* is more troublesome. If you see blue or red dots in an image—and these will be especially prevalent in low-light/high-ISO images—then you've got some chrominance noise to deal with. Many image sensors, especially CCDs, are more sensitive to red and infrared light than to blue light, so special filters are used to cut certain frequencies of red light to improve the blue response. (As discussed in Chapter 9, the strength of this filter will govern how capable the camera is at infrared photography.) Unfortunately, because the sensor is weak in its blue perception, the blue channel is the first thing to be compromised when you start amplifying the sensor signal to increase ISO. These errors in blue perception show up as pronounced noise in the blue channel of an image. Consequently, chrominance noise is sometimes referred to as *blue channel noise.* (See Figure 13.17.)

In Chapter 2 you also learned that, because of the natural sensitivity of the human eye, there are twice as many green sensors on an image sensor as red and blue sensors. This means that the camera must perform much more interpolation for the red and blue color data than for the green color data. This interpolation can introduce further noise into the blue or red channels. The problem with trying to remove noise from an image is that there's no way to do it without altering your image. Removing luminance noise will tend to soften and smooth fine details, whereas trying to eliminate chrominance noise can alter the colors in your image. Noise reduction also often results in a loss of saturation.

Nevertheless, a slightly softer or less-saturated image is usually preferable to an image covered with distracting, ugly noise.

If you're using Photoshop CS, it's fairly easy to identify which type of noise troubles you might be facing—simply look at the individual color channels. If you do, in fact, have a problem with blue or red channel noise, it will be very apparent by looking at the individual blue and red channels.

### Noise-Reduction Software

These days, there are some excellent noise-reduction applications available and some at extremely reasonable prices. In the end, no matter what type of noise troubles you're facing, getting a dedicated noise-reduction application is probably the easiest and best solution for eliminating noise.

Though there are a lot of noise-reduction products out there, a list of the standouts follow. You can find links to demo versions of all of these products at *www.completedigitalphotography.com/noisereduction:*

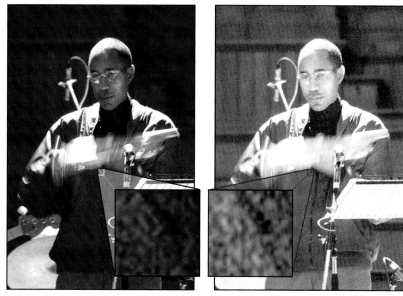

**RGB**                        **Red Channel**

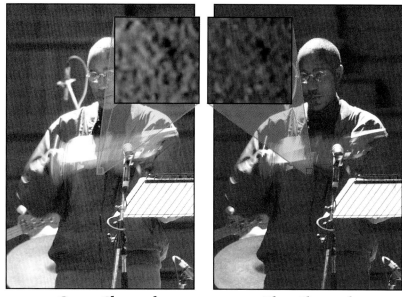

**Green Channel**            **Blue Channel**

**FIGURE 13.17** In a color image, different color channels can have different amounts of noise. Knowing which channels are noisiest can influence your noise reduction strategies.

**Visual Infinity® Grain Surgery™:**    Available for Mac and Windows for $179. (See Figure 13.18.)

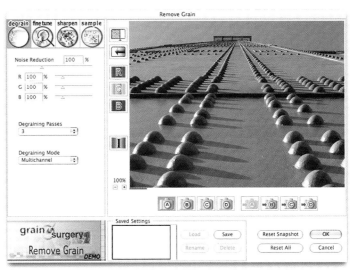

**FIG 13.18**    Grain Surgery provides sophisticated tools for targeting and removing noise, as well as adding noise and matching noise between different images—a necessary step when compositing images with differing noise qualities.

**PictureCode Noise Ninja:**    Windows only, this standalone program ships in a $29 8-bit version or a $69 16-bit version that includes batch processing.

**ABSoft® Neat Image:**    Available in several versions ranging from $30 to $75, this standalone Windows application is a little slow to process but does very good work on battling both luminance and chrominance noise.

**Fred Miranda Noise Reducer ISOx Pro™:**    This $15 Photoshop action can be used on either the Mac or Windows versions of Photoshop 7 or later. It offers seven levels of noise reduction, and you can't beat the price, but it's a tad weak when compared to more expensive standalone packages. Still a good solution at a fair price.

Don't expect these packages to turn noisy images into sharp, silky-smooth pictures. There will *always* be a price to pay for noise removal, usually in the form of reduced sharpness. However, these programs do a good job of trading ugly noise for softening and color shifts that are completely acceptable.

### Removing Noise Manually

If you can't afford or don't have access to noise-reduction software—or if you're just the type of person who likes to take matters into your own hands—it is possible to reduce noise using your image-editing application. Although the techniques presented here are more time-intensive and not as sophisticated as what a standalone application will do, they can still be effective at improving a noisy image.

Before you can remove noise you have to find it. In some images—particularly those shot at high ISOs—the noise will be strong enough that you won't have any trouble identifying it. In other images, noise might be less pronounced. Determining which parts of the image have noise problems will make it easier to develop a plan of attack.

Shadow areas are the most common locations for noise, even lighter shadows such as those found under a person's chin. Because low-light photos have lots of shadowed areas, you'll find much more noise in low-light images than in daytime images. Nevertheless, daylight skies are sometimes susceptible to noise, as are any flat, colored objects. When you identify noise, pay attention to what the noise looks like. Is it a simple grainy luminance noise? Or is it loaded with specks of color?

Remember, don't obsess too much about fine-grained noise. Depending on your printer, you may not be able to see the noise anyway. Similarly, if you shoot with a high-resolution camera (four megapixels or better), you probably don't need to worry about slight noise that becomes visible when you zoom in to 100 percent. Though it may look bad on-screen, it will probably be minimized or completely invisible in print. If you're unsure of whether your noise is a problem, do a test print to see how bad the noise is. Also, if you plan to greatly reduce the size of your image, there's a good chance that the noise in your image will be reduced or eliminated by the downsampling process.

Once you know where the noise is, you can begin to use any combination of the following procedures to remove it.

### Reducing Noise with Median

What's annoying about noise is that it mucks up otherwise fine colors, so that a field of perfectly nice blue pixels is marred by weird pixels of other colors. However, you can use these correctly colored pixels to reduce noise by taking advantage of a couple of filters that are built into Photoshop.

The first of these is the Median filter, located in the Filter > Noise menu. Median analyzes the pixels in an area to come up with a median statistical color value, which it then uses to adjust the color of each pixel. Figure 13.19 shows an image suffering from fairly typical sky noise. As

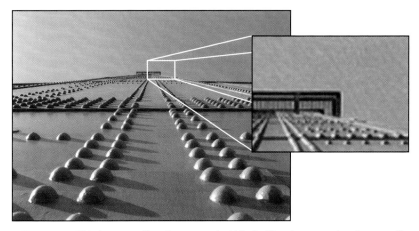

**FIGURE 13.19**    This image suffers from a typical kind of luminance noise that usually shows up in the blue channel, making it especially prevalent in skies.

you can see, it's predominantly a luminance noise and probably wouldn't show up in print. It's also a type of noise that will respond very well to Median filtering, so there's no reason not to give it a try.

Because the noise is not visible in the bridge itself, we don't want to filter it, because Median can introduce softness into fine detail. A single click of Photoshop's Magic Wand selects most of the sky when used with a tolerance setting of 32. We then click Select > Similar, and Photoshop automatically grabs the rest of the blue in the image, leaving the bridge unselected. Finally, we activate the Median filter with a Radius of 3 and, as you can see in Figure 13.20, the noise is nicely smoothed out, with no loss of detail in the bridge, though there has been a slight overall change in the color of the sky.

**FIGURE 13.20**    After running a three-pixel Median filter over the selected sky, our image is much less noisy.

### Protected Median Noise Reduction

In the previous example, we were able to easily constrain our noise reduction to the sky by using a simple selection. Because the Median filter

can greatly soften fine detail, being able to filter only particular areas can be critical when removing noise. Unfortunately, not all images have such an easily selectable target area as the bridge picture we just used.

Figure 13.21 is a low-light, high-ISO image that suffers from a fair amount of both luminance and chrominance noise. If we apply a one-pixel median blur to the image, we can successfully reduce the noise, but with a noticeable loss in sharpness. (See Figure 13.22.)

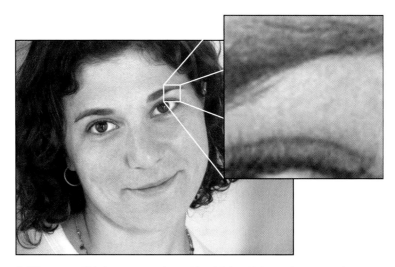

**FIGURE 13.21** This image was shot with a higher ISO, resulting in an image with a fair amount of both luminance and chrominance noise.

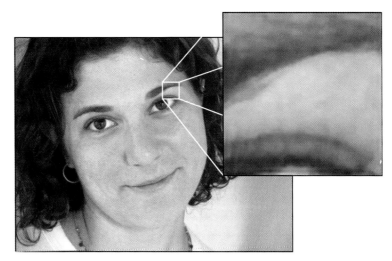

**FIGURE 13.22** We can use the same Median filter technique to reduce the noise in this image, but we lose a conspicuous amount of sharpness.

Ideally, we would like to create a mask that protects all of the edges in the image, so that they don't suffer the blurring effect of the median filter. However, unlike our bridge image in the previous example, there are no simple areas of solid color that we can easily select using Photoshop's normal selection tools.

Instead, we're going to pull a trick from earlier in the chapter, and use the image data itself to create a mask. Figure 13.23 shows a mask we created by duplicating the Green channel and then severely altering its contrast with a Levels adjustment. We then loaded this mask as a selection and applied a one-pixel median filter through it. (See Figure 13.24.) As you can see, the mask protected many of the important hard edges, especially the eyes.

**FIGURE 13.23**   We selected the Green channel and applied a strong Levels Adjustment to alter the contrast to stark black and white. This mask will protect the edges of our image from the Median filter.

Though we used a specially created luminance channel in the example in our earlier masking tutorial, duping the Green channel works fine for our purposes here. We simply want to create a map that shows the changes in contrast in the image, because contrast changes follow edge details and don't need all of the fine luminance detail that we wanted in our earlier example. Also, because we can get away with using the Green channel, we don't have to go through the extra step of duplicating the image to derive a new channel. Based on what you learned in the Advanced Masking section in this chapter, you should have no trouble pulling off this technique.

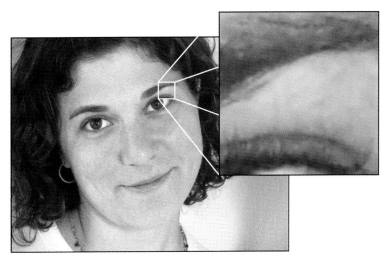

**FIGURE 13.24**   Our final image is less noisy but still maintains sharpness around the eyes, as well as other hard-edged details.

### Noise Reduction in L*A*B Mode

As discussed earlier, L*A*B mode stores your image as three channels: a Luminance channel and two color channels. Just as you can attack the separate Red, Green, and Blue channels of an RGB image, L*A*B mode lets you selectively denoise the color information in your image independent of the luminance. Converting to L*A*B mode and back again does result in a tiny bit of quality loss, but this loss will not be perceptible until you change modes a dozen times or so.

To reduce noise in L*A*B mode:

- First, convert your image to L*A*B by clicking Image > Mode > Lab color.
- In the Channels palette, switch to the A & B channel.
- Use a Smart or Gaussian blur (or any of the averaging filters discussed above) to attack the noise. (See Figure 13.25.)
- Now switch back to RGB.

Using Photoshop's History palette, you can easily jump back to the Blur operation to try different settings. This method of noise reduction often tends to reduce saturation in your image. Once you get back into RGB mode, you can use Hue/Saturation to try to restore lost saturation.

### Dark Frame Subtraction

In Chapter 8 you learned about shooting for dark frame subtraction, a method of removing the excess noise that can happen with long expo-

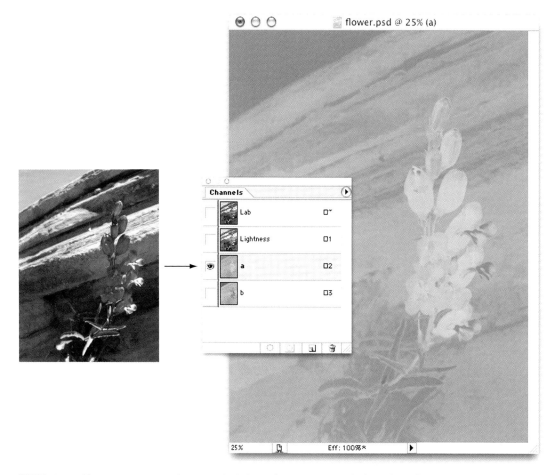

**FIGURE 13.25**    If you convert your image to L*A*B mode, you can attack the color information in your image independently of the lightness or detail of your image.

sures. As you'll recall, on very long exposures (greater than one second), some pixels in your camera's sensor can get stuck "on," appearing as bright white specks in your final image. (See Figure 13.26.) Unfortunately, because your camera interpolates the color of each pixel by examining the color of the surrounding pixels, one stuck pixel can mess up the color of several adjacent pixels. Some newer cameras have special *pixel-mapping* features that search the image sensor for bad pixels. These pixels are then excluded from the camera's color-processing algorithms.

Whether or not your camera has a pixel-mapping feature, you can minimize the effects of stuck pixels by using the following technique. In Chapter 8, you learned that when shooting exposures greater than one second you should shoot a separate frame immediately following the first

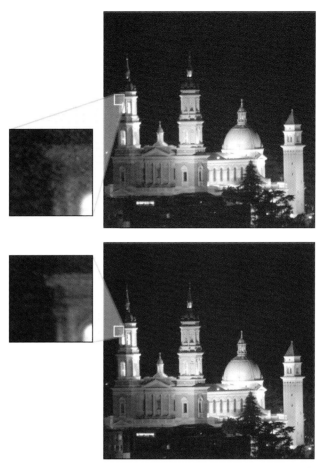

**FIGURE 13.26**    The noise in the first image was reduced using the dark frame subtraction technique. Many cameras now offer a Long Exposure Noise Reduction feature that performs this operation in-camera.

image, using the exact same exposure settings but with the lens cap on (unless your camera has a built-in dark frame subtraction feature, which creates this second frame for you automatically). The idea is to take a second image of only the noise that appears in the first image.

For that second frame to be useful, you need to subtract it from the first frame. This won't eliminate the noise from your image, but it will replace the distracting bright white specks with less distracting darker specks.

Open both your image and your corresponding dark frame. Copy the dark frame and paste it into a new layer in your image file. Give the dark frame a slight Gaussian blur and set its blending mode to Difference. This should remove much of the noise from your image.

## Removing Dust and Blotches

If you have a digital camera with removable lenses, it is possible for dust to get to your camera's sensor. Sensor dust will appear as dark blotches or spots on your final image. Check your manual for instructions on cleaning your sensor. (Don't just assume that you can blast it with compressed air!)

Sensor dust sometimes looks just like the artifacts that appear when you have dust on your lens. (See Figure 13.27.) The easiest way to determine if the problem is with your sensor is to change the lens on your camera. If the artifact is still there, you know it has nothing to do with your lens.

No matter what kind of digital camera you have, a pixel or two on the CCD can go bad. If one of the pixels in your camera's sensor dies, your images will consistently have a white or blue spot at the location of the bad pixel. Unfortunately, there's nothing you can do to fix the camera, and most vendors won't replace or repair a camera with only one or two bad pixels.

If your images are suffering from dirt on the lens, dirt on the sensor, or stuck pixels, you can quickly remove these erroneous pixels with your image editor's Clone tool by simply cloning from the immediately surrounding area. In Figure 13.32 you can see the cleaned version of the tree image shown in Figure 13.27.

## Removing Red-Eye

Because of their small size, many digital cameras are particularly prone to *red-eye*, that demonic look that can appear in your subject's eyes when the flash from your camera has bounced off their retinas and back into the camera's lens. Although there are ways to avoid red-eye when you shoot (see Chapter 7), there will still be times when you will face this problem in an image and need to remove it.

There are several effective methods for removing red-eye. Which one to use depends mainly on the capabilities of your image-editing software.

**Use a red-eye removal filter or tool:**   Many editing programs include special tools and filters for automatically removing red-eye. Photoshop Elements has a very good red-eye reduction tool and Photoshop CS now includes a Color Replacement brush that makes it simple to brush away red-eye. If you're using an earlier version of Photoshop (7 or earlier), there are some good third-party plug-ins for performing red-eye removal.

**Desaturate the red area:**   Because it's the pupil that turns red, and pupils are usually black or very dark brown, simply desaturating the red area will drain it of color and restore it to its normal dark tone.

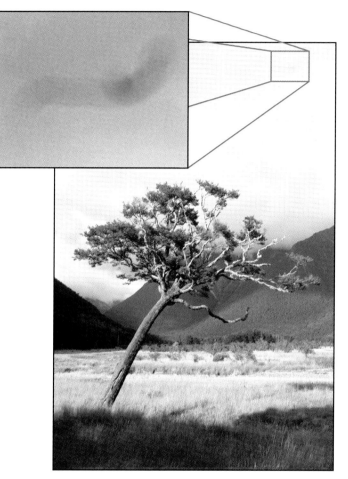

**FIGURE 13.27**    If you have a digital SLR with removable lenses, it will be possible for your camera to get dust or dirt on its sensor. If you notice strange smudges and blotches in your images—and they stay there even when you change lenses— it's probably time to clean your sensor.

Select the affected area (you'll probably want to feather the edge of the selection by a pixel or two), then use your desaturation method of choice. In Photoshop, you can use the Sponge tool or the Hue/Saturation dialog box.

**Copy the Blue channel information:**   As with the previous technique, use your selection method of choice to select the red area of your subject's eye. With the selection made, switch to the Blue channel and copy, then switch to the Red channel and paste. Because the Blue channel contains good data, it's okay to simply paste it into the Red channel.

**Repaint the area by hand**:   If there's any natural color visible in your subject's eyes, you can try to select it with the Eyedropper tool and repaint the rest of the area with a paintbrush or pencil tool. This is probably the most difficult technique because you will need to be careful to preserve any highlights or catchlights in the subject's eyes. An eye without a glint of light does not look natural. Examine some non-red-eye flash photos to see what this highlight should look like.

## Correcting Barrel and Pincushion Distortion

Barrel and pincushion distortions are simple geometric distortions that occur in images shot with extreme wide-angle or telephoto lenses. If you had to zoom way out when you were shooting your image, there's a good chance that the lines in your image will be bowed outward. Conversely, if your lens was zoomed in all the way, there's a chance that your image will be bowed inward. If you're using a wide-angle or fisheye attachment on your lens, your images will almost certainly be distorted (unless you're using a very expensive *rectilinear* wide-angle lens on a digital SLR).

These distortions don't occur in all lenses—in fact, the lack of them is the mark of a very good lens—and even lenses that do have trouble with geometric distortion probably exhibit these issues only in specific, somewhat rare, circumstances. If you find yourself facing distortion problems, check out the Geometric Distortion PDF located in the Tutorials/Chapter 13/Lens Distortion folder.

## Removing Color Fringing

In Chapter 8 you read about weird purple fringing artifacts that can occur when you shoot high-contrast areas with a wide-angle lens. Although opinions sometimes differ as to what causes these problems, everyone agrees that the results are ugly! Fortunately, there are several methods you can use to eliminate these weird color fringes.

### Desaturating Fringe

Most fringing artifacts can be eliminated with a simple Hue/Saturation Adjustment Layer. The idea is to simply target the color of the fringe and drain the saturation out of it to make it blend better with the background. The trick is to not mess up any of the other color in your image.

## TUTORIAL    DESATURATING A CHROMATIC ABERRATION

Open the image palace.jpg, located in the Tutorials/Chapter 13/ChromAbb folder on the CD-ROM. The chromatic aberrations are not terrible, but they are there. Take a look between the two right-most columns and you'll see a nasty red fringe on the left side of the right column, and a bad green fringe on the right side of the left column. (See Figure 13.28.)

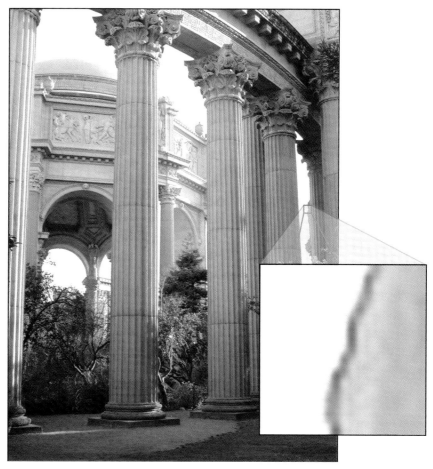

**FIGURE 13.28**    This image suffers from some bad fringing artifacts. In this tutorial, we'll remove them with some simple painting techniques.

Although the fringes aren't huge, the predominant colors in the image are red and green, so you'll have to be careful when you remove the extra colors.

### STEP 1: SELECT THE FIRST FRINGE

Using the Marquee or Lasso tool, select the right-most red fringe. You don't have to be really precise in this selection; your main goal is to protect the other red tones in the image. (See Figure 13.29.)

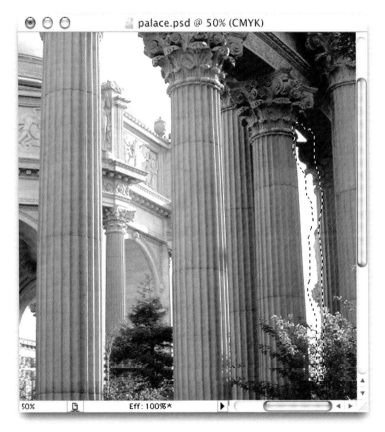

**FIGURE 13.29**    Use the Lasso tool to select the area of bad fringe in the image.

### STEP 2: CREATE A HUE/SATURATION ADJUSTMENT LAYER

With your selection active, use the Layers palette to create a new Hue/Saturation Adjustment layer. Notice that the Layers palette shows your Adjustment Layer with a Layer mask that matches your selection.

### STEP 3: TARGET THE OFFENDING COLORS

Now you need to select the colors of the fringe. To do this, you'll need to zoom in to your document to see some individual pixels. Press Command

and + (Control and + in Windows) a few times to zoom in to 200 percent. Because the fringe is kind of a pinkish-red you want to limit the effects of the adjustment to reds. Select Reds from the Edit pop-up menu at the top of the Hue-Saturation dialog box.

Now you need to sample the color of the fringe in the image. Using the Eyedropper tool, select one of the very light-colored pink dots within the fringe. The color selection scale will shift to the left to encompass the color that you sampled. Because the palace columns contain a lot of red, you want to narrow your red selection so as to not desaturate the columns. The color selection scale has four sliding controls, two on the left and two on the right. The inner sliders control the range of colors to select, whereas the outer controls create a color selection drop-off to ensure smooth color shifts.

Slide all four sliders inward to create a tight color selection. (See Figure 13.30.)

**FIGURE 13.30**    Targeting the fringe color.

### STEP 4: DESATURATE THE FRINGE

Now drag the Saturation slider to the left to suck some of the saturation out of the selected red tones. As they lose saturation, they may turn gray. If so, try backing off on the desaturation by moving the Saturation slider back to the right, and instead add a little lightening by moving the Lightness slider to the right.

### STEP 5: TARGET MORE COLORS

Although the image is probably looking better, there's still most likely a lot of red or pink. You want to now expand the target color range. Click the middle Eyedropper (the one with the + next to it) and click some of

the remaining fringe colors. This process will add these colors to the range of colors being desaturated. You may have to go deep into the shadows of the columns to get all of the colors. You may also have to adjust your Saturation and Lightness settings after you select more colors.

### STEP 6: CHECK THE RESULTS

When you're all finished, click OK, and zoom out to check the results. In addition to looking at the quality of the fringe reduction, look closely at the surrounding area of your selection to ensure that you haven't inadvertently desaturated any other parts of the column. If there's still visible fringing, double-click the Adjustment Layer to tweak your settings.

When you're all done, do the same thing with the other fringe, but this time target the greens.

This approach will work for most chromatic aberrations, although you need to be careful. Sometimes the color of your aberration will closely match the background of your image. For example, you'll frequently run into blue aberrations against a blue sky. Be certain to select your aberration first, to protect the rest of the sky. You'll also probably want to do less desaturation and more lightening to match the hue of the fringe to the sky.

### Removing Chromatic Aberration by Hand

Sometimes your aberrations might be bad enough that you simply need to go in and paint them out using a Paintbrush or Clone tone. With the Clone tool you can clone color from the surrounding area, but you'll need a steady hand. Use a soft-edged brush and set the opacity low. Using the Paintbrush tool is a similar process, but you'll need to sample the paint color by hand using the Eyedropper tool.

You can also use the Blur tool to blur a fringe out of existence. Set the Blur tool's opacity very low—around 15 or 20 percent—and change its mode to Color. Brush along the fringe, and you should see it slowly fade away.

If the fringe is the same color as the background—as in the sky example—you might be able to use the Dodge tool to lighten the fringe until it blends in with the sky. The risk here is dodging the sky, which will create light streaks.

### Removing Fringes by Shrinking Channels

Fringes are often pure red, green, or blue colors. Consequently, they're often confined to an individual color channel. If you examine your individual channels and find this to be true, you can always go in and edit the channels directly.

Fringes sometimes look just like a misregistration from a printing press. That is, if your image has red fringing, it can often appear as if the Red channel has slipped out of registration with the Blue and Green channels. It hasn't, but you can try to correct it using the same procedures you would use to fix a misregistration.

- Select the offending color channel.
- Shrink it to "scoot" the fringe under the other color channels. You can do this by clicking Edit > Transform > Numeric and entering a tiny value—99.7 or 99.8, for example. This will reduce the size of the channel and hopefully hide the aberration.

After shrinking a channel, be sure to examine your image closely for any new artifacts that may have been introduced by the transformation. In particular, make sure no new fringing has developed in other parts of the image.

## COLOR AND TONE ADJUSTMENT

After scrubbing the noise off your image and correcting any optical distortions, you're ready to move on to correcting the image's color and contrast. The idea is to start with as clean an image as possible so that you don't spend a lot of time making complex, subtle color corrections, only to have them undone by a noise-reduction process later. However, note that if you drastically increase the contrast in your image, you might bring out some noise that you couldn't see earlier. If this happens, you might want to consider an additional noise-reduction step.

Another option is to use a slightly modified workflow when faced with a dark image that you know will have a big Levels boost. For these types of images, throw on a Levels Adjustment layer *before* you start your noise reduction and brighten up your image to where you think you want it to be. Then you can attack your noise. Afterward, you can refine your initial Levels settings and add any further color correction.

Hopefully, such an example shows you that the workflow described previously is not rigid. There will be times when you have to move back and forth from step to step because your different operations affect each other. In the next section, we're going to look at some more techniques you can employ to keep your operations editable and your workflow malleable.

One workflow guideline remains rigid, though: perform your color corrections *before* sharpening! Sharpening should always be the last step before output.

As you saw in the previous two chapters, a good image editor provides color-correction tools that pack incredible power, and we've already

seen some examples of several color-correction techniques. There will be times, however, when a single well-crafted, well-masked Curves adjustment just doesn't cut it. For those times, you'll have to use multiple corrections targeted at specific parts of your image.

ON THE CD

For the sake of saving book pages for other content, and because we've already covered numerous color-correction examples, this next example is presented in PDF format on the companion CD-ROM (Tutorials/Chapter 13/Eagle Color Correction.pdf) In it, we tackle an incorrect white-balance problem, as shown in Figure 13.31.

**FIGURE 13.31**    We corrected this problematic white balance using a number of techniques. The entire process is explained in a PDF file included on the companion CD-ROM.

## Correcting Color with Layers

So far, all of the color correction methods we've looked at have involved special tools such as Levels, Curves, or Hue/Saturation. However, you can make a number of adjustments simply by stacking layers on top of each other and then changing their opacity or blending method. For example, we took the image in Figure 13.32, duplicated its layer by dragging it to the Create a New Layer button at the bottom of the Layers palette, and then set the newly created top layer to Multiply. (See Figure 13.33.)

Together, the two images blend to create a much more saturated image with extreme contrast. You could achieve the same thing using Curves or Levels, and Hue/Saturation, but this technique is much faster.

However, our resulting image is a little too dark—fortunately there's an easy way to tend to this.

Earlier, you saw how you could add a Layer Mask to an Adjustment layer to facilitate the painting of masking information directly into the Adjustment. Photoshop CS allows you to add Layer Masks to any other

**FIGURE 13.32** This image could use a bit of a saturation boost. We could use the Hue/Saturation tool, but there's a simpler way.

**FIGURE 13.33** If we stack two copies of the image on top of each other, and set the transfer mode of the top layer to Multiply, we get a much more saturated image.

kind of layer. Simply select the layer to which you want to add a mask, and then click Layer > Add Layer Mask and choose either Hide all or Reveal all, depending on whether you want the mask to be created completely black (hiding the entire layer) or completely white (revealing the entire layer). Now, just as you painted into the Layer Mask on page 394 using black, white, or shades of gray, you can paint into your top layer to reveal more or less of it. In this way, you can control how strong the blending effect is throughout different parts of your image.

In Figure 13.34 we created a Layer Mask on our top, "multiplying" image and painted our mask to apply the effect in varying degrees to various parts of the image. We left the sky alone so that it gets the full effect, but painted in varying degrees of effect on the grass. The most detailed painting occurred on the tree, where we used varying shades of gray to paint in differing amounts of shadows and highlights. Wherever we

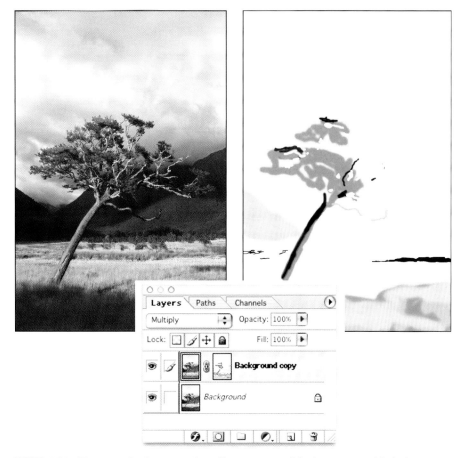

**FIGURE 13.34**    To constrain the saturation effect to parts of the image, we added a Layer Mask that allowed us to paint varying degrees of the effect into the image.

painted with white, we got the full, supersaturated multiply effect because we were allowing both images to multiply at full strength. Painting with black yielded no effect whatsoever, whereas painting with a shade of gray introduced some in-between amount of effect. In this way, we were effectively able to paint in perfectly toned light or shadow wherever we wanted it. Bear in mind that there's no real science to this masking. We're simply painting where we want effect. The resulting mask shows how much we applied to different areas.

For lighter, underexposed images that lack punch, setting the top copy to Screen will often help boost the tone of the image.

Now consider Figure 13.35. Here, we've used the same pair of blended images but this time we performed a Gaussian Blur on the top layer. Remember, changing the blending mode simply changes the mathematical

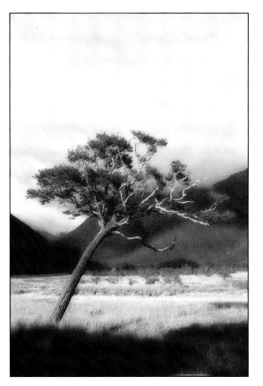

**FIGURE 13.35**   Here, we started with the same stack of layers but this time blurred the top, multiplied layer with a Gaussian Blur filter.

operation that's used to determine what color each pixel is. So, rather than the upper pixel overwriting the lower pixel, the two pixels are combined using a mathematical process. In the case of Figure 13.35, the pixels' color values are multiplied. When we blur the top layer, parts of the upper image effectively go "out of registration" with the lower image, which has the effect of lowering the detail and sharpness in some areas but not in others. Overall color is preserved, though.

As in the previous example, we have used a Layer Mask to control the strength of our blurred effect. In other words, we've painted more of the blur into our image in some places than in others.

Combining layers by stacking and controlling blend modes and layer masks is a quick, easy, and powerful way of performing color corrections both image-wide and locally. What's more, you can combine this method with the corrections you learned earlier by applying adjustments to your upper, blending layer. You can use apply Levels, Curves, Hue/Saturation or any other type of edit to one layer or the other. Or, you can attach an

appropriate Adjustment layer to the layer you want to modify. By performing tonal adjustments to one layer, you can change the look of the final blended effect.

You can limit an Adjustment layer so that it affects a specific layer rather than the entire image by stacking it directly above the layer you want to modify, linking it with that layer, and then grouping those layers together. In Figure 13.36, the Adjustment layer affects only the layer immediately beneath it. All of the bottom layers are untouched.

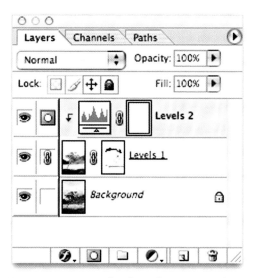

**FIGURE 13.36**    Using the Photoshop Layer Linking and Grouping features, you can constrain an Adjustment layer so that it affects only specific layers.

## Correcting White Balance

Like any type of correction or edit, there's no set method or rule for correcting a bad white balance, because each situation is unique. Levels, Curves, and Hue/Saturation adjustments will usually be your best tools for white-balance correction, and each image will usually have its own correction needs.

In general, though, there are some guidelines to follow when correcting white balance.

• Don't expect to be able to use a single correction to fix a bad white balance. Though white balance usually affects all areas of an image, it often affects one color range (highlights or midtones, for example)

more than another. You might need to use separate adjustments for each color range in your image.

- Use masks to isolate areas for corrections. If the color in one area of your image is particularly out-of-whack, you may have to mask it off and apply a strong color correction to fix it.

- Don't expect to restore accurate color. Though you can greatly improve the white balance of an image, you probably won't be able to restore absolute color accuracy. (See Figure 7.8.) In addition to changes in hue, you'll probably find that it's difficult to achieve full brightness in your colors.

As you may have guessed, the best way to achieve good white balance is when you're shooting. For those, hopefully rare, times when your images are poorly white-balanced, these tips should help you on your way to restoring proper color.

### Correcting Vignetting

Hopefully, you kept an eye out for vignetting when you went shopping for a camera. Nevertheless, you might find yourself occasionally facing a problem like the one shown in Figure 13.37.

**FIGURE 13.37**   This image suffers from vignetting, a darkening of the corners.

The easiest way to handle vignetting is to build a mask that mimics the darkening in your image. You can then apply a Levels Filter Through mask to compensate for the darkening. It may take some time to refine your mask, but once you have one that works, you can probably reuse it for any image with vignetting troubles.

You can paint a vignette mask by hand using a large airbrush, a soft-edged paintbrush, or a gradient tool. Or, you can use a selection tool such as the Pen tool or the Lasso tool to outline the edges of your vignette corners. Then, apply a strong feather to your selection to fade its edge.

Once you're satisfied with your selection, save it as an alpha channel. (See Figure 13.38.) With your mask still selected, create a Levels Adjustment layer and try to lighten the vignettes. If your mask needs adjustment, throw out the Adjustment layer, edit your mask, and start over.

**FIGURE 13.38**    If you have an image with a vignetting problem, consider building a mask that matches your camera's vignette, like the one shown on the left. By applying a Levels filters to the mask, you can usually correct the darkened corners of your image.

Once you have a mask that works, you can copy it into any image that has a vignetting problem.

If you're good with painting tools, you can use the Dodge tool to lighten the dark corners to reduce or eliminate the vignettes.

## EDITING

Your image is cleaned, your colors are adjusted—you have an image that is perfect raw material for your artistic license. Now is the time where you'll begin to create any composites or collages, or any radical touchups. Because you know that you've already removed any color fringes or other image artifacts, you can perform all of your artistic edits without concern of duplicating artifacts.

After your edits, you may find that you need to tweak your color-correction settings or perform another color-correction pass to blend and smooth out your edits.

In the next chapter, you'll explore many of the things that might transpire in this editing stage, from compositing to adding texture and tone to your image. For now, let's concentrate on the remaining steps of your image-editing workflow.

### Applying Effects by Painting

The great advantage of Adjustment layers is that they allow you to change your mind later. At any time, you can double-click an Adjustment Layer to change its settings, disable its visibility to see what your image looks like without it, or delete it altogether. And, as you've already seen, with the automatic masking that's built in to the Adjustment layer feature, you can easily create adjustments that are masked and constrained to a particular area.

Unfortunately, neither Photoshop nor Photoshop Elements provides Adjustment layers for many common operations such as sharpening, blurring, adding noise, or any of its fancier special effects filters.

However, now that you've got some experience with layers, there's no reason you can't implement many additional effects in an Adjustment layer–like fashion. With a little thought and planning (and a fast computer with a lot of RAM), you can keep almost every edit you make on a separate, discreet layer so that you can edit, hide, or remove it at any time. (See Figure 13.39.)

For example, if you need to paint onto an image, create a separate layer to hold your paint. This will allow you to repaint at any time, or get rid of your paint altogether, without affecting your original image. Throughout the rest of this book, we will be returning to this approach to editing, to control the placement of our edits and to preserve editability throughout our workflow.

**FIGURE 13.39**    This heavily collaged image is composed of more than 25 layers, each of which contains a discreet painting or image-editing operation. With this type of structure, we can easily change or alter any edit that we've made, at any time.

## SCALING

There are lots of reasons why you might need to resize your image, and in Chapter 10 we discussed the reasons why you might choose to resample when scaling. If you're going to be sampling upward, it's good to save the scaling step until after you've completed your color corrections and edits. You don't want to enlarge your image if it's full of noise and color artifacts because you'll end up enlarging those artifacts along with the image.

When you're finished with all of your edits and adjustments, you'll probably need to change the resolution and size of your image to something more appropriate for your printer (see Chapter 15). If your final destination is the Web, you'll definitely need to scale down your image, assuming you were shooting at one of your camera's higher resolutions.

You'll need to scale up if your image came out of your camera smaller than you'd like to print. You might also need to scale up the image if you're printing to a printer that demands higher resolution. Although your image editor can do a good job of scaling up an image, you can only go so far. Follow the next tips for best results.

### Scaling Down

If your images need to be output to the Web or video, or are for display on a computer, they most certainly will need to be scaled down, or downsampled.

Downsampling is a fairly worry-free process because your computer is throwing data *away* rather than having to make it up. About the only thing you need to know when you downsample an image is what size, in pixels, the final product should be.

Talk to your designer, Web master, producer, or whoever is responsible for your final graphics—if you're responsible, you'll need to study the resolution information presented in Chapter 15—and learn the desired pixel dimensions of your final image.

From the Image Size dialog box, select the Resample Image checkbox, enter the resolution required by your output, and enter your desired print size. (If you're outputting for the Web, you'll probably want to enter new pixel dimensions instead of a print size.) Click OK, then choose File > Save As to save a *copy* of your smaller file with a new filename. (Be sure to type in a new name, or you might save over your original!) You never know if you'll need a bigger image someday, so it's a shame to throw away all that extra resolution by writing over your original file.

*A WORD ABOUT FLATTENING*

*If your image is composed of multiple layers, Photoshop will offer you the option to flatten the image—render it into a single layer—before resizing. If you think you're done editing, flattening is a good choice because it will make for a smaller file. Just be certain that you've already saved a layered version, just in case you need to go back and re-edit later.*

### Scaling Up

As explained in Chapter 10, when you scale up an image, Photoshop has to interpolate new pixels to get the image up to your desired size. Fortunately, the Photoshop bicubic interpolation algorithm is very good at upsampling images up to about one-and-a-half times their original size. After that, the results can be a little soft. Fortunately, with today's high-resolution cameras, you usually don't have to scale up too much to boost your image to a fairly big print size.

To scale up, you need to know the target resolution of your printer (more on this in Chapter 15) as well as your desired print size. Open the

Image Size dialog box, be sure that the Resample Image checkbox is selected, then enter the appropriate resolution in the Resolution field and your desired print size in the Document Size fields. Click OK, and Photoshop will calculate your new image.

As with downsampling, it's a good idea to save your new, larger image as a copy. Your original-size image will be free from sampling artifacts, so you should save it for later use.

After scaling up, you may find that your image has softened somewhat. You'll get a chance to sharpen it in the next stage of the workflow. Poke around your image and look for any other artifacts that may have been exaggerated in the upsampling. In particular, look for *aliasing* (stairstepping) along diagonal lines, as well as exaggerations of any noise or aberrations that may have been left in the original image. These can be retouched using the techniques discussed earlier. Aliasing can usually be handled by brushing over the offending areas with a very small Blur tool.

If you need to enlarge by more than 1.5x, you can still manage this using the Photoshop bicubic up-sampling, but use *repeated* upsamples of 1.5x rather than a single large resizing.

Bear in mind that you often create a larger image because you want a picture that can be viewed from a greater distance. Consequently, super-fine detail is not so important. If you're creating a big image that will be viewed from several feet away, be sure to also evaluate your prints from several feet away. Don't get hung up on trying to see fine detail at a close distance.

## WHEN 1.5X ISN'T ENOUGH

If you need to enlarge an image a great deal, or if you find yourself routinely creating very large images, you might be well-served by Altamira's Genuine Fractals PrintPro, a Photoshop plug-in for blowing up images. Using a technology called wavelet compression, Genuine Fractals converts your image from a series of raster dots into a collection of tiny fractal curves. Because fractals reveal more detail as you expand them, and because they can be mathematically enlarged (rather like vector artwork), you can blow up a wavelet-compressed image by fairly extreme factors.

Altamira doesn't claim great results on images smaller than 2 MB, yet the program still does a very good job of enlarging digital camera images up to three or four times without great degradation. Wavelet compression can't perform miracles, though. After a point, if you need larger files, you'll have to upgrade to a higher-resolution camera.

## SHARPENING

With all your edits and corrections made, and with your image at its final output size, you're finally ready to apply any necessary sharpening. As with resizing, you don't want to sharpen too early because you'll run the risk of accentuating noise and other unwanted artifacts. Also, you won't know how much sharpening you need until you've adjusted the image's contrast—after all, an image with more contrast looks sharper—and until you've resized the image. If you shrink an image, it's going to get sharper; if you enlarge it, it will almost always get softer. Consequently, sharpening should be the last step you take before outputting the image.

Photoshop includes a number of sharpening filters. In addition to these, there are third-party sharpeners as well as procedural techniques you can use to sharpen your image. Unfortunately, Photoshop does not offer editable sharpening layers. Once you apply your sharpening effects, that's it. Consequently, it's a good idea to save a copy of your image before you sharpen, or to duplicate a layer before you sharpen it. By sharpening a duplicate, you can always throw it out and go back to your original if you change your mind.

Your biggest concern when you sharpen, however, is to not sharpen too much. Oversharpening can create a number of undesirable artifacts.

### How Sharpening Works

Photoshop, like most image editors, has several sharpening filters: Sharpen, Sharpen More, Sharpen Edges, and Unsharp Mask can all be found under the Filter > Sharpen menu. However, the Unsharp Mask (USM) filter is the only one of these that you ever need to consider. The rest are simply too uncontrollable and destructive for quality sharpening.

Unsharp Mask gets its name from a darkroom sharpening technique wherein a blurry copy of a negative (an "unsharp" copy) is sandwiched with the original negative and a print is made using a doubled exposure time. The unsharp mask negative and lengthened exposure time serve to darken the dark side of an edge and lighten the light side, causing the edge to exhibit a halo. This renders the edge more pronounced and the image appears sharper.

The USM filter works the same way. When you apply the filter, your image is examined one pixel at a time. Obviously, the filter can't really tell what counts as an edge in your image, so it looks for sudden changes in contrast. If there is a sudden change in value between two adjacent pixels, then that's probably an edge. The darker pixel will be darkened and the pixels around it will be ramped down, whereas the lighter pixel will be lightened and the pixels around it ramped up.

If you look at an edge in an image that has had a USM filter applied, such as the one in Figure 13.40, you'll see that one side of the edge is darker, whereas the other side is lighter. The result is a bit of a halo. As long as this halo isn't distractingly strong, the image will appear much sharper.

**FIGURE 13.40**    If you look closely at a sharpened image, you can see the halos that the Unsharp Mask process creates along the edges of shapes to make them appear sharper.

The key to good unsharp masking is to know when to quit. Too much sharpening and your image will appear unrealistically sharp, and the edge halos will be bright enough to be distracting. Your final picture will have too much contrast, and the preponderance of halos will add a type of visual noise to your image.

The Photoshop Unsharp Mask tool provides three controls: amount, radius, and threshold. (See Figure 13.41.) This is typical of USM controls, so even if you're using a different image editor, its Unsharp Mask tool probably offers the same options.

FIGURE 13.41 The Photoshop Unsharp Mask tool provides three simple controls for sharpening your images.

**Amount:** Controls how much the pixels along an edge will be darkened and lightened. The higher the number, the more the USM filter will change the pixels. Too much of a change and your edge will become unnaturally contrasty and will possibly posterize.

**Radius:**   Determines the width of the halo that will be created. The wider the radius, the more pixels that will be altered around an edge to create a halo.

**Threshold:**   Determines what the filter will consider an edge. A higher threshold value requires more contrast between two pixels before the filter will consider it a sharpenable edge. With a high threshold, USM will find fewer edges and perform less sharpening.

To learn what makes good sharpening, it's worth spending some time looking at some professional photos. Notice that even images that have lots of detail and contrast are not necessarily razor sharp. As you saw in Figure 4.5, your image editor can actually sharpen an image far beyond what looks realistic.

When you use a USM filter, start with a high Amount setting—300 to 400 percent—and a small Threshold. Then try to find a Radius that produces minimal halos. (See Figure 13.42.) Sharpening is a subjective process, of course, so find a level of halo that suits you. However, be sure to consider your entire image.

Amount: 100
Radius: 1
Threshold: 1

100 1 1

Amount: 100
Radius: 2
Threshold: 1

100 2 1

Amount: 200
Radius: 2
Threshold: 1

200 2 1

Amount: 200
Radius: 4
Threshold: 1

200 4 1

Amount: 400
Radius: 2
Threshold: 1

400 2 1

Amount: 400
Radius: 4
Threshold: 1

400 4 1

**FIGURE 13.42**   The right level of sharpening is a balance of all three Unsharp Mask parameters.

Once you've found a Radius that is right, you can back off the Amount and increase the Threshold. Your goal is to use these two sliders to apply your desired radius to the appropriate amount of edge detail in your image.

*ALWAYS SHARPEN AT 100 PERCENT*

*Be sure you're looking at your image at 100 percent, or 1:1, when sharpening. If you've zoomed out from your image, your image editor is already downsampling its screen image, which will serve to render the image sharper. Consequently, accurate sharpening may not be visible.*

### Not All Sharpness Is Created Equal

Note that some subjects can withstand more sharpening than others. Foliage and small, very detailed background elements, for example, usually don't stand up to a good deal of sharpening, whereas simple shapes with well-defined edges do. If these types of objects are mixed together, you might be better served by selectively applying different amounts of sharpening to different parts of your image.

Based on the techniques you've learned so far, there are a number of ways you can selectively apply sharpening. You can, for example, create selections using selection tools. Or, because sharpening is an effect that you want to apply to edges, you can use the luminance masking technique we learned earlier to build a mask from the image's edge detail and apply sharpening through that mask. For this tutorial, though, we're going to apply sharpening by painting, a technique discussed earlier in this chapter.

**TUTORIAL**      **PAINTING SHARPENING**

Figure 13.43 shows an original, unsharpened image that was pulled directly from a Canon EOS 10D. Like many higher-end digital SLRs, the 10D does not apply much sharpening to an image, leaving you in complete control of the sharpening process. After all, you can't remove sharpening once it's there, so it's often better for a camera to err on the side of too soft, because you can always sharpen later.

Because this image was shot with a shallow depth of field, there's really no reason to apply any sharpening to the background. Because there's no real edge detail there anyway, sharpening would only serve to exaggerate any noise or artifacts that might be lurking in the image. The woman's face, on the other hand, could definitely use some sharpening. However, even the face doesn't need equal sharpening all over.

Eyes are the most important part of any portrait, so we want to sharpen them up quite a bit. Skin tones, however, can suffer from sharpening, because it will intensify pores and wrinkles, so we'd like to apply less sharpening to those areas.

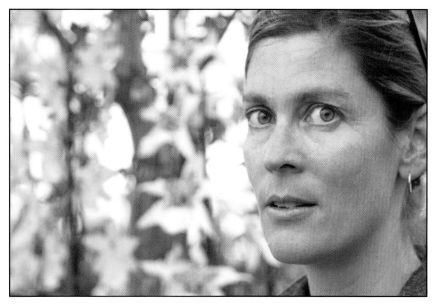

**FIGURE 13.43**    This image was taken with a Canon EOS 10D, a camera that, by default, performs very little sharpening. Here we want to sharpen some areas but not others.

ON THE CD

As already mentioned, sharpening is greatly affected by image size and printing technology, so to really see the subtle effects of the technique described here, you'll need to look at the image included in the Tutorial/Chapter 13/Selective Sharpening folder. It will reveal far more subtle detail than what is printed in this book.

### STEP 1: OPEN THE IMAGE

ON THE CD

Open the image Portrait.tif from Tutorial/Chapter 13/Selective Sharpening using Photoshop or Photoshop Elements. Because all sharpening should be performed at a zoom ratio of 100 percent, you might want to zoom into the image and take a look around to scope out the edge detail and begin to assess which areas could use more or less sharpening.

Our intent with this image is to print it out as an 8" × 10" print on an Epson photo ink-jet printer. As such, it has already been resized to 8" × 10" at 240 dpi. (Note that because this image was shot in the 3:2 aspect ratio of 35mm film, 10" wide results in a height of 6.6".)

### STEP 2: PREPARE THE LAYERS

In the Layers palette, duplicate the base layer by dragging it onto the Create a New Layer button at the bottom of the palette.

Add a Layer mask to the duplicate layer by selecting the layer and then clicking Layer > Add Layer Mask > Reveal All. In the next step, it will become clear why we selected Reveal All rather than Hide All.

### STEP 3: DETERMINE MAX AMOUNT OF SHARPENING

As you've already seen, by painting into a Layer mask with gray, we can make that layer more or less visible. Our plan here is to sharpen the top layer and then paint into its Layer mask to control which layers are visible in which parts of our image. In other words, because of our Layer mask, the sharpened layer will be visible in some parts of the image, and the original softer image will be visible in other parts. This technique effectively lets us "paint" sharpening into our image.

Our next step, then, is to apply sharpening to the upper layer. To determine correct sharpening settings, we want to pick the area where we want the most sharpening and sharpen it accordingly. This level of sharpening will be applied to the entire image. We will then use our mask to paint in lesser amounts in areas where the max sharpening is too much.

In the Layers palette, click the image icon in the top layer to select it. Remember, when you have a Layer mask attached to a layer, you can switch between editing the image data and the Layer mask data by clicking the appropriate thumbnail in the Layers palette.

We know we want the most sharpness in the woman's eyes, so zoom in on her eyes and click Filter > Sharpen > Unsharp Mask. (See Figure 13.44.)

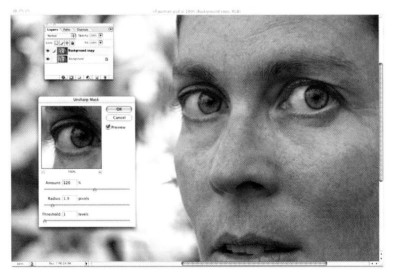

**FIGURE 13.44**    First, choose a sharpening level based on the area that needs the most sharpening. This maximum sharpen will be applied to a copy of the image, stored in a second layer.

As previously mentioned, digital SLRs often tend to produce soft images, so this picture can withstand a rather aggressive sharpening. Feel free to sharpen to your personal taste. We chose an Amount setting of 120 percent, a Radius of 1.9, and a Threshold of 1. Again, you need to be focusing only on the woman's eyes. Note, however, that the sharpening effect is making her skin more contrasty.

Once you've found the settings you like, click OK.

### Step 4: Mask the Entire Image

We're ready to start painting our mask, so click the mask icon in the upper layer. Select black as the foreground color, select the Paint Bucket, then click somewhere on the image. The image should go soft because the sharpened layer is now completely masked, revealing the original layer. (If your image turns black, you haven't properly selected the mask layer. Click Undo, and try again.)

### Step 5: Sharpen the Eyes

You can now apply varying amounts of sharpening by simply painting into the mask. With the mask still selected, choose white as the foreground color and begin painting over the woman's eyes. This will reveal the fully sharpened layer. (See Figure 13.45.)

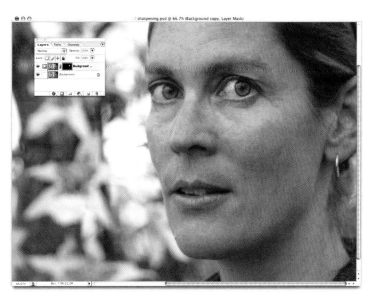

**FIGURE 13.45**    Here, the upper, sharpened layer has been completely masked. Next, a white brush was used to paint over the eye, knocking a hole in the mask to reveal the sharpened eye from the upper layer. With this technique, we can paint in sharpening only where we want it.

### Step 6: Mask the Edges of Her Face

The edge of her face and nose can also withstand full sharpening, though you might need to use a very small brush to keep from sharpening the skin tones around the edge. Her ear is far enough in the distance that it is soft simply because of shallow depth of field. It needs no sharpening.

### Step 7: Mask Hair and Skin Tones

Hair is a detail that looks nice when sharp, but the hair in this image does not need our full sharpening. Select a 50 percent white color (or, if you're more of a pessimist, select a 50 percent black color) and paint over the hair. This will effectively apply half the sharpening effect.

You might also want to experiment with applying a little sharpening to the skin tones, especially around the eyes. By selecting different gray tones, you can add more or less sharpening. What's more, if you don't like the effect, you can simply repaint it with a different color, or you can paint with black to eliminate it completely. Figure 13.46 shows our final image and our final layer mask.

This same approach can be used to apply any type of filter or operation. You can use it to variably add noise, blur, sketch effects, or any other alteration that can be made to a layer. Want to change the color of one element in an image? Just duplicate your base layer, alter its color, then use a layer mask to "paint in" only the altered areas that you want.

With your image sharpened, you're now ready to print, a topic that will be covered in Chapter 15.

## Video Tutorial: Painting Light and Shadow

As you've seen, learning to think of edits in terms of layers can provide a great amount of flexibility. Layers also let you take an approach to editing your images that is more akin to painting than traditional darkroom work. Located in the Tutorials/Chapter 13 folder of the CD-ROM is a tutorial movie (Color Correction.mov) that walks you through the process of adjusting the top image in Figure 13.47 so that it looks like the bottom image. This tutorial will introduce you to the idea of thinking about your image edits as placement of light and shadow.

ON THE CD

Hopefully, in this chapter you've seen that good workflow is not just following a particular order of operations; it also involves performing your edits and structuring your document in a way that makes it easy to make changes. When your document stays malleable, it makes each step of your postprocessing workflow easier, because you don't have to worry about getting each setting right the first time.

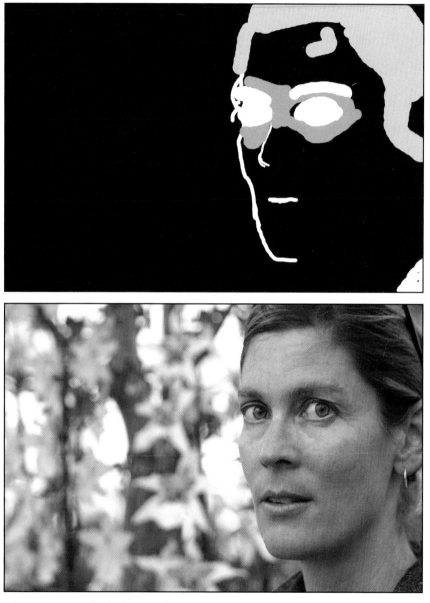

**FIGURE 13.46**    Our final, sharpened image, along with the mask that was painted to constrain the sharpening effect.

In the next chapter, you'll learn more of the types of edits you can make during the editing phase of your workflow.

**FIGURE 13.47** The top image doesn't look bad, but with some subtle color corrections, we can make it look much better. To learn how, watch the Color Correction video in the Tutorials/Chapter 13 folder of the CD-ROM.

# SPECIAL EFFECTS

**In This Chapter**

- Simulating Depth of Field
- Shortening Depth of Field in an Image
- Stitching Panoramas
- Converting Color Images to Grayscale
- Creating "Hand-Tinted" Images
- Adding Texture, Grain, and "Film" Look
- Adding Grain to an Image
- Cleaning Portraits
- Compositing
- Preparing to Print

Initially, most of your image-editing work centered around touching up and adjusting an image to correct problems caused by your camera, or to take advantage of exposure strategies that you might have chosen when you were shooting.

Your image editor is capable of much more than simple tonal corrections, of course. By now, you've probably already played with many of the filters and effects tools at your disposal, and have begun to see just how much you can manipulate an image.

In this chapter, you'll learn some of the typical editing operations that, as a digital photographer, you might want to use and explore. The lessons and examples in this chapter are not intended to help you create "trick photography" special effects. Rather, these techniques are intended to help you make up for deficiencies in your camera, to help you get good results from difficult shooting situations, and to help you make your images more "filmlike."

## SIMULATING DEPTH OF FIELD

To the experienced photographer, one of the most frustrating things about a typical digital camera is the deep depth of field. As you learned earlier, the tiny focal lengths on most prosumer cameras prohibit shallow depth of field effects. Fortunately, through some clever blurring, you can use your image editor to add a depth-of-field effect.

One of the most important things to remember about depth of field is that it is a *depth*. That is, the area in focus begins at one point and ends at another and is centered on either side of the plane of sharp focus. A shallow depth of field doesn't simply mean that your background will be blurry; it can also mean that part of your foreground will be blurry. In addition, different planes in your background will be more or less blurry, depending on how far away they are.

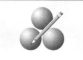

**TUTORIAL**        ### SHORTENING DEPTH OF FIELD IN AN IMAGE

Figure 14.1 shows an image with very deep depth of field—everything in the image is in focus. In this tutorial, we're going to create a very shallow depth of field that will blur both the foreground and background.

### STEP 1: OPEN THE IMAGE

ON THE CD

Open the image cosmo.tif located in the Tutorials/Chapter 14 folder on the companion CD-ROM. In any portrait, you want the eyes of your subject to

be in focus, so we're going to use the dog's eyes as the focal point of this shot. Your goal is to create an effect like the one shown in Figure 14.2.

**FIGURE 14.1**    This image has a very deep depth of field. It's time to make it more shallow.

**FIGURE 14.2**    With some controlled blurring, we can create a shallow depth-of-field effect.

## Step 2: Prepare a Gradient

The blurring effect is actually very easy; we'll simply use the Gaussian Blur filter. However, we want the blur to increase gradually in both directions as it extends away from our focal point. Consequently, we need to apply our blur filter through a mask.

In the Channels palette, create a new channel by clicking the New Channel button at the bottom of the palette. Our masking needs are very simple for this project. A simple gradient should be all that we need.

Type D on your keyboard to select black and white as your default foreground and background colors. Select the Gradient tool from the main tool palette (or press G to select it). Click the gradient sample on the Photoshop toolbar to open the Gradient Editor. Figure 14.3 shows the settings you will need.

**FIGURE 14.3**    Use the Gradient Editor to build a custom gradient that can be used to create a depth mask.

You want a gradient that goes from white to black to white. On the gradient bar, click the bottom-left color swatch and change its color to white. Change the bottom-right swatch to black, and drag it toward the center of the gradient. Now click the right end of the gradient sample to create a third swatch, and set its color to white. When you're finished, your gradient should like the one shown in Figure 14.3. Name the gradient, and click OK to save it.

### STEP 3: APPLY THE GRADIENT TO YOUR MASK

With your new channel selected in the Channels palette, click the eyeball icon next to the RGB channel in the Channels palette. This will allow you to see your full-color image, as well as your alpha channel in red. (It's empty so you won't see any red yet, but once you start using the Gradient tool, things will change.) Because the alpha channel is selected (the RGB channels are only "eyeballed"), your actions will affect only your new alpha channel.

Drag the Gradient tool in a diagonal line from bottom-left to top-right to mask the dog's eyes. Your gradient will appear on-screen as a red tint over your image. Position your gradient so that it looks like Figure 14.4. It might take a few tries, but each time you drag the Gradient tool, the new gradient will replace the old, so it's easy to quickly try many different gradients.

**FIGURE 14.4**    You want your gradient to blend into and out of the dog's eyes.

### STEP 4: APPLY THE BLUR

Remember, at this point, nothing has been selected; you've only created a mask by painting a gradient directly into an alpha channel. Now click the RGB channel to activate it, and drag your new alpha channel to the Load Channel as Selection button at the bottom of the dialog box to load

your alpha channel as a selection. Apply a Gaussian Blur filter by clicking Filter/Blur/Gaussian Blur. Enter a Radius of 7 pixels. The foreground and background of your image should go blurry.

Although the effect looks good, the hand in the background looks conspicuously in focus. (See Figure 14.5.) It's on a deeper plane than the dog's eyes, so it should not be in focus. Undo the blur and click your alpha channel in the Channels palette to select it. We're going to do a little mask alteration.

**FIGURE 14.5**   Although our blur is varying by the same amount, the hand and the dog's eyes are both in focus. Because the hand is actually farther away than the dog's eyes, it should be blurry.

### STEP 5: ALTER YOUR MASK

Right now the hand is not being blurred because lies on the same line as our gradient—it is being masked. We want to unmask it so that it will blur. Click the eyeball next to the RGB channel in the Channels palette so that you can see your image and your mask.

The thumb is masked an appropriate amount; we just need to get the rest of the hand to match. Using the Eyedropper tool, click the thumb to sample its color. This is the color you'll use to paint the rest of your mask. Click the Paintbrush tool, and paint over the hand, up until it bumps the dog. Use a very soft-edged brush.

When you're finished, click the eyeball next to the RGB layer so that you can see just your mask. It should look like something like Figure 14.6.

**FIGURE 14.6**   After editing, your new mask should look something like this.

### STEP 6: APPLY YOUR FINAL BLUR

Load your new mask and reapply your blur. Now your image should look something like Figure 14.2. With the hand blurred, the depth-of-field effect is much more realistic.

*BLUE EYES?*

*The dog's eyes are blue because, just as human eyes reflect red when a flash is fired directly into them, dog eyes reflect blue. To remove the blue eyes, add a Saturation Adjustment Layer, set it to desaturate completely, and paint a mask to limit the Adjustment layer to only the dog's eyes. (See Figure 14.7.)*

## Photoshop Lens Blur

If you're using Photoshop CS, you can use the new Lens Blur filter to add more realistic depth-of-field effects. (See Figure 14.8.) Like the technique you just learned, the Lens Blur filter can use an alpha channel as a map to guide how the image should be defocused. Unlike the technique you

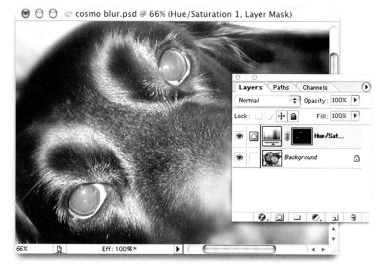

**FIGURE 14.7** This dog is suffering from the canine equivalent of red-eye. You can attack the problem just as you would red-eye in a human. Use a Desaturation Adjustment layer to drain the blue color from his pupils.

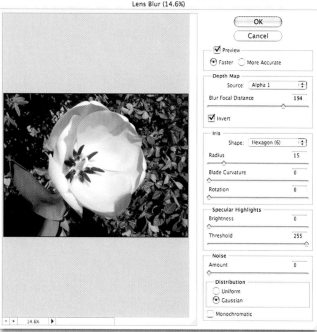

**FIGURE 14.8** The Photoshop CS Lens Blur tool creates very realistic depth-of-field effects. As in the previous technique, you can create special masks to constrain its effects, but the filter creates a blur that looks much more like the blur created by a lens.

just saw, Lens Blur uses more sophisticated blurring algorithms that create defocused effects that look much more like the types of blurring you get in a camera lens. Though the bulk of your audience may not be able to notice the differences in different types of blur, if you're an experienced photographer or a stickler for realism, this tool is a great way to go.

## Create Planes of Depth

Typically, when you choose to shoot with a shallow depth of field (if your camera is capable), the goal is to soften the background to bring more attention to the foreground.

If all of the objects in your background are a good distance behind your subject, you can usually get away with simply blurring the entire background. (See Figure 14.9.)

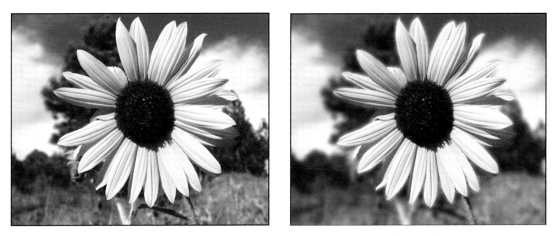

**FIGURE 14.9**    Depth of field can be easily added to this image by blurring the background.

If, however, the background elements in your image recede gradually, or lie in definite planes, from your foreground subject, simply blurring the background will look odd. In Figure 14.10, the blurred background reduces the image to two planes of depth: the foreground and the blurred background. It almost looks as if the woman is standing in front of a blurry backdrop of a street. Because the background recedes into the distance, you need to control the *falloff* of the blur so that it gets stronger for objects that are farther away.

The top image in Figure 14.11 was created using a simple layering process.

**FIGURE 14.10**    Simply blurring the background of this image looks odd, because everything in the background is equally defocused. Because the background recedes, the defocusing should increase with distance.

1. Duplicate the base layer (the layer to which you want to add the depth-of-field effect).
2. Apply a blur to the top layer. Choose a blur that is appropriate for the farthest elements in your image.
3. Now add a layer mask to the top layer that reveals the entire layer. Your image will appear blurry.
4. Using the Gradient tool and the Paintbrush tool, mask the blur to reveal the underlying sharp image. In the case of Figure 14.11, a gradient was used to create a depth of field that gets stronger from right to left.
5. Unfortunately, the gradient blended the background tree and buildings by the same amount. In reality, the tree should appear closer (less blurry) than the buildings that are next to it in the image. A paintbrush loaded with 70 percent gray was used to paint over the tree in the layer mask. This resulted in the tree getting only 70 percent of the blur.

If your image has very distinct planes in the background, you can use separate layers for each plane, blurring each by different amounts, and building layer masks to reveal the appropriate parts of each layer.

**FIGURE 14.11**    This depth-of-field effect works much better because of the more complex, hand-painted mask. In addition to a receding sense of depth, objects at different planes are blurred appropriately.

## STITCHING PANORAMAS

In Chapter 9, "Special Shooting," you learned about panoramic images: multiple shots that can be stitched together to create wide, panoramic pictures. Good panoramas require some thought when you shoot, and they sometimes require a little image editing before stitching.

Your camera probably came with stitching software (Figure 14.12), but if it didn't—or if you're not happy with it—consider a third-party alternative such as RealViz® Stitcher®.

**FIGURE 14.12**    Many cameras ship with panoramic stitching software such as Canon's Photostitch™, which can automatically stitch multiple, overlapping images into a single panoramic image.

No matter what software you use, your images might need a little cleanup before you start stitching. Variations in exposure from one image to the next can cause color banding and shift in your final panorama. Hopefully, you tried to compensate for this while shooting (see Chapter 9), but even the best-planned shots sometimes end up incorrectly exposed.

Before you stitch, open your panoramic shots and examine them for exposure differences. Are some images darker or lighter than others? Skies are particularly susceptible to saturation and hue changes from shot to shot. If you do see variations from one shot to the next, you'll need to color-correct your images. Typically, Levels or Curves adjustments are all you'll need. When you correct, consider the following:

- Choose the image you like most as a base image, and correct your other images to match.
- If the first or last image is very over- or underexposed (which sometimes happens because the sun is in the first or last image), consider throwing it out altogether and creating a smaller panorama.
- If you're having trouble matching tones and color from one image to the next, try stitching and then performing corrections on the completed panorama.

Because you sometimes shoot panoramic images with your lens at its widest angle, your individual images might suffer from barrel distortion. *Don't* try to correct this before stitching—let the stitching software worry about that.

In addition, don't worry about spotting or removing dust or other aberrations. It's better to do this after you've stitched the panorama.

Some stitching programs offer a combination of automatic and manual controls. If your images were well shot (and after reading Chapter 9, how could they not be?), your program's automatic functions might be all you need. At other times, though, you might have to resort to manual control.

To use manual stitching controls, you simply find corresponding points within an image. These points are then used to guide the software's stitching efforts. Typically, you need to identify two pairs of points along each seam. Try to pick pairs of points that are close to the top or bottom of the image.

Finally, after stitching, your panoramic software might want to crop the image to eliminate uneven boundaries at the top and bottom of the image. These boundaries often create a nice frame and frequently include image elements that you'd like to keep. Rather than letting your stitching software crop your panorama, leave the image uncropped. You can always crop it yourself in your image editor, or try to fill in missing information on your own to produce a larger usable image. (See Figure 14.13.)

### KNOW YOUR FOCAL LENGTH

*Some stitching programs want to know the focal length of the lens (in 35mm equivalency) that was used to shoot the panorama. If your camera has a fixed zoom lens, you might not know what the exact focal length was. If you were shooting at full wide (which you should usually do for panoramas), you can simply enter the widest angle that the lens provides (usually around 35mm). To be certain, use an EXIF reader to examine the header information in one of your images. (See Chapter 8, "Manual Exposure.") Many cameras store focal length in the EXIF header. Some programs can automatically identify focal length by reading the EXIF information on their own. (See Figure 14.14.)*

**FIGURE 14.13** The top image shows where we would need to crop this stitched panorama to give it a square edge. However, rather than cropping, we decided to use the Rubber Stamp tool to clone in missing information to create a final, square image. With this technique, we get a slightly larger image.

**FIGURE 14.14**    Some stitching programs need to know the focal length you were using when you shot your panoramic source images. Here, you can see that PhotoStitch has automatically determined the focal length.

After stitching, you might find that your image needs some more color correction. Again, skies can be especially problematic. If there is a color change from one image to the next, you'll see a short gradation along the seam of your panorama. Odds are that you won't be able to completely match the two images, but you might be able to create a smoother blend by adding a gradated Levels or Curves adjustment. Add the adjustment as an Adjustment layer, and use the Gradient tool to create a smooth transition.

After stitching is also the best time to remove dust, spots, or other aberrations.

## CONVERTING COLOR IMAGES TO GRAYSCALE

Although your camera might do a great job of reproducing color, there will be times when you'll want to convert your color images to grayscale, either for printing purposes or simply for artistic intent. Photoshop—and most other image editors—allows you to convert an image to grayscale simply by selecting a new color mode. (In Photoshop you can do this by clicking Image > Mode > Grayscale.) This type of conversion uses a stock recipe for mixing the image's Red, Green, and Blue channels to produce a grayscale result. In theory, the recipe produces an image that is well suited to the eye's different color and luminance sensitivities.

Often, this is the best way to convert your image; however, you might find that the resulting image lacks solid blacks and bright whites.

With its color removed, your image might be less "punchy." Fortunately, there are several other methods that provide more control and, frequently, better results.

## Conversion Methods

Color-correct your image before using any of these methods. This might sound strange because you're just going to remove all of the color, but an image with accurate color will usually produce a more pleasing grayscale image. In addition, be sure that you perform your conversions on a *copy* of your image. Although you might want a grayscale image now, you never know when you might need to go back to your original color version.

Figure 14.15 shows an image converted using each of the following methods.

### Channeling

You might have discovered this already, but sometimes one of the individual color channels in your image actually makes for a very good grayscale image. Just click through the individual channels in the Channels palette and see which, if any, looks best. Depending on the color content of your image, any one of the channels might look good, although the Red and Blue channels might suffer from noise.

If you find a channel you like, simply click Image > Mode > Grayscale, and Photoshop will toss out the other channels, leaving you with a grayscale image of your chosen channel.

### Converting to Luminance

Just as you can select a single color channel in RGB mode, you can convert your image to L*A*B mode and select just the Luminance channel. This will throw out all of the color information in your image. After you convert to L*A*B mode, click the Lightness channel in the Channels palette and select Image > Mode > Grayscale.

### Desaturating an Image

When you were playing with the Hue/Saturation control, you might have discovered that it is possible to completely desaturate an image to grayscale simply by dragging the Saturation slider all the way to the left. Photoshop provides a Desaturate command (Image > Adjust > Desaturate) that performs the same function.

Original

Gray Scale

Blue Channel

De-saturated

Color Mixer

**FIGURE 14.15**    There are many ways to convert a color image to grayscale. Here are samples of the four methods discussed in this section.

### Mix Your Own Color Formula

As explained earlier, your image editor can convert your image to a Grayscale mode by using a stock formula for combining the Red, Green, and Blue channels in your image. If that formula doesn't produce the image you want, you can always mix your own combination using Photoshop's Channel Mixer (Image > Adjust > Channel Mixer). If you like, you can also create a Channel Mixer Adjustment layer.

The Channel Mixer provides simple slider controls for adjusting how much of each channel (in percentages) will be used to create the final image. (See Figure 14.16.) Be sure to check the Monochrome text box at the bottom of the dialog box. Be aware that all three channels need to add up to 100 percent, or you'll lose luminance in your final image. Similarly, if your mixed channels add up to more than 100 percent, your image will brighten.

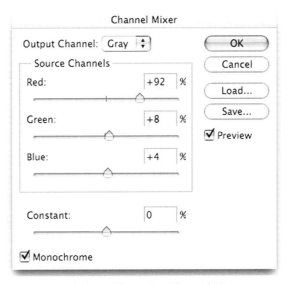

**FIGURE 14.16**  With the Photoshop Channel Mixer, you can create your own mix of red, green, and blue information to create a final grayscale image.

## CREATING "HAND-TINTED" IMAGES

Hand-tinting a photo is a painstaking process involving special tints and a lot of hard work. Fortunately, creating such an effect in your image editor is fairly painless and involves little, or no, painting skill.

The following techniques allow you to create a hand-painted look or combination of grayscale/color images. The following procedures assume

that your image is already a grayscale image, either because it was shot that way or because you converted it to grayscale using one of the techniques discussed previously.

## Painting with Light Opacity

The simplest way to tint an image is simply to paint over it using a brush with a very light (20 percent or lower) opacity. You can paint directly onto your image, but it will be difficult to make changes or corrections later. A better option is to create a second layer to hold the paint. If you choose this approach, set your brush to 100 percent opacity and change the opacity of the layer to 20 percent. This won't change the look of your results, but it will make it easier to repaint or change colors. What's more, it makes it possible to resample the colors you're using later. (You can simply set the layer opacity to 100 percent, then sample using the Eyedropper tool.) You can even create separate layers for separate colors, making for easy color changes and opacity control of each color.

One problem with this approach is that it tends to lighten up shadow areas and generally lessen the contrast of your image. You can try to put some of that contrast back by stacking a Levels Adjustment layer on the very top of your image, or you can choose to use a blending mode for your paint layer. Setting your painting layers to Multiply mode will cause your painted strokes to be multiplied with the underlying tones in your image. Because multiplying usually produces darker tones, your painted colors will darken, so you might have to overcompensate by choosing lighter colors. However, most of the shadow and contrast information in your image will be preserved. Figure 14.17 was hand-painted using multiplied paintbrushes.

## Painting Desaturated Images

The easiest way to produce a hand-colored look is to start with a real color picture. Shoot a color image and then add a Hue/Saturation Adjustment layer. In the Hue/Saturation dialog box, drag the Saturation slider all the way to the left to desaturate the image to grayscale.

With the Adjustment layer selected, select a black paintbrush and begin painting over the parts of your image that you would like to color. The paintbrush will mask those areas of the image, protecting them from the desaturation effect. Consequently, they'll return to their full saturation.

A fully saturated color element in the middle of a grayscale photo can sometimes look a little odd. After resaturating the elements of the image that you want colored, add another Hue/Saturation Adjustment layer

 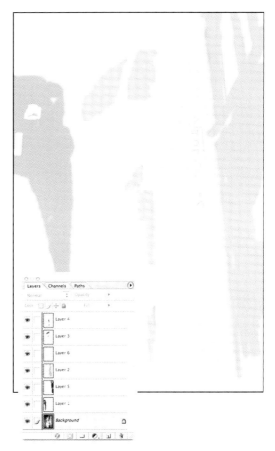

**FIGURE 14.17** Originally a grayscale image, this picture was colored by painting into separate layers and adjusting the opacity of each color layer. The right image shows the isolated paint layer. As you can see, the actual painting is very simple.

and apply a little desaturation to the entire image to tone down the color elements. (Alternatively, sometimes it's better to *increase* the contrast between the color and grayscale areas. Use your new Hue/Saturation layer to increase the saturation of the color areas.) (See Figure 14.18.)

### Painting with the History Brush

You can use the History brush to perform a variation of the previous method. Take a color image, convert it to grayscale, and then convert the grayscale image back to RGB. You'll still have a grayscale image, but because it's in RGB mode, it will be able to handle color information.

Select the History brush (available from the keyboard by pressing Y) and begin painting the areas you would like colored. The History brush

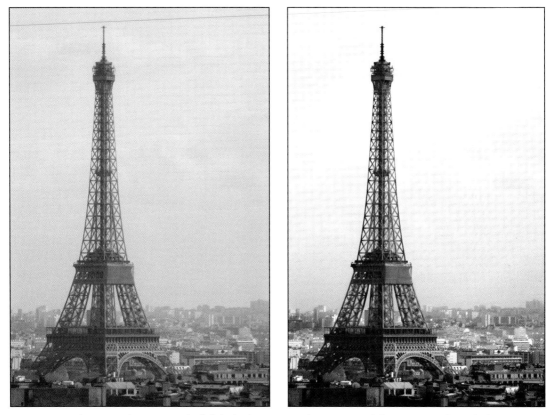

**FIGURE 14.18**    The original image on the left lacked some punch. We created the image on the right by boosting the saturation of the Eiffel Tower and by desaturating the sky to render it black and white, thus lending more focus to the foreground elements. Some additional color adjustments were performed to better integrate the foreground and background.

paints using the information stored in the last History snapshot—the History palette shows a thumbnail view of that snapshot. If you haven't intentionally set a new snapshot, the History snapshot should be your original, color image.

As with the previous coloring scheme, you might end up with an image that has color elements that look a little conspicuous. Consider adding a Hue/Saturation Adjustment layer and then dialing down the saturation.

## ADDING TEXTURE, GRAIN, AND "FILM" LOOK

After spending all of that time and money choosing the right digital camera, why in the world would you want to go to the trouble of making your

images look like they were shot on film? Despite all of the advantages of digital photography, film can have a texture and feel that is more attractive than what your digital camera might produce. Moreover, although they might not be conscious of it, most people are very used to the look of film.

There might also be times when you want to create a filmlike look—possibly an old, beat-up film look—for stylistic purposes. Whatever the reason, there are a number of things you can do to make your digital images look more like film.

Before adding any texture or grain, take a look at the color and depth of field in your image. Professional film images are usually shot with larger cameras that afford a fine control over depth of field. Consider using one of the depth-of-field adjustment methods discussed earlier to shorten the depth of field in your image.

Many films have very particular color and contrast characteristics. Some produce images that are very saturated, whereas others yield colors that are more pastel. Most of the time you can choose a color quality based on personal taste. However, if the image will be presented with images shot with a specific type of film, you might want to study that film with an eye toward mimicking its color characteristics. If you are trying to represent the look of a black-and-white film, you'll most likely want to use the Channel Mixing method of grayscale conversion. You might also have to spend some time adjusting contrast with Levels and Curves.

All color and tone adjustments need to be performed before you add any texture or grain, because these effects can complicate your correction process.

## Adding Grain

Film images have a noticeable grain caused by the clumps and particles of silver halide that are used to form an image. Films with faster ISOs have more grain, and different brands and formulations of film have different quantities and qualities of grain. Grain might sound like a bad thing, but it can actually be very beautiful, both for its inherent texture and because it serves to make the image a little more abstract, allowing the viewer's imagination to kick in.

The simplest way to add grain is with a noise filter. Photoshop includes a simple Add Noise command (Filter > Noise > Add Noise) that allows you to dial in different amounts of noise. (See Figure 14.19.)

Add Noise is a good choice for adding grain, but it does have limitations. First, it affects the entire image uniformly. Consequently, the resulting image can often look like it's being viewed through a simple screen of noise. Second, once you add noise, it's there to stay. As you saw in the last chapter, removing noise is very difficult.

**FIGURE 14.19**   With your image editor's noise filters, you can create simple filmlike grain.

You can apply varying amounts of noise using one of the layering techniques described in the previous chapter. Duplicate the layer you want to noise up, then apply the Add Noise filter and select parameters that add the maximum amount of noise that you want in the image. Next, add a layer mask to the image, and fill it with black to completely eliminate your noise effect. You can now paint into the layer mask with various shades of gray to reveal varying amounts of your noise layer.

**TUTORIAL**   **ADDING GRAIN TO AN IMAGE**

In addition to the method described in the previous section, the following technique provides another method of achieving filmlike noise in your digital pictures. Pick an image to which you would like to add grain, and then step through the following procedure.

### STEP 1: CREATE A LAYER OF NOISE

First, you need some grain. Create a new layer in your document and fill it with 50 percent gray. You can do this in Photoshop by pressing Command+A (Control+A in Windows) to select the entire layer, then click Edit > Fill. In the Fill dialog box, select 50 percent Gray from the Contents pop-up menu. Place the layer at the very top of your layer stack, above any Adjustment layers that might be affecting your image.

Now click Filter > Noise > Add Noise. Select Gaussian Noise and select the Monochrome checkbox. The amount of noise to use depends partly on the size of your image and on how grainy you want the image to look. In general, though, 25 to 30 percent should be plenty.

After clicking OK, your image should look like a gray image full of noise. (See Figure 14.20.)

**FIGURE 14.20**    A better way to add grain is to create a special noise layer and composite it with your document. This will afford you more noise control and editability, including the option to later remove the noise.

### STEP 2: CHANGE THE BLENDING MODE

As discussed earlier, simply adding noise to your image applies the same amount of noise to every pixel, no matter how bright or dark. What's more, the noise added by the Add Noise filter is often a little too contrasty. The noise can end up looking like a layer of pixels sitting on the top of your image. We want to create a texture that will blend in with the pixels in your image.

With your noise layer selected, choose Soft Light from the Blending mode pop-up menu of the Layers palette. You should now see a very noisy version of your image.

### STEP 3: LOWER THE NOISE OPACITY

As a last step, drop the opacity level on your noise level to about 25 percent. You should now have a very realistic-looking level of grain. (See Figure 14.21.) You can also change the grain level by simply readjusting the opacity slider. Want to simulate a higher ISO film? Just increase the opacity. Note that you can also turn off the noise altogether by unchecking the noise layer's eyeball icon, or by deleting the layer altogether. 

**FIGURE 14.21**    After compositing the noise layer using a Soft Light blending mode and an opacity adjustment, the image has a very realistic, filmlike grain that can be adjusted or removed at any time.

### Adding Texture and Damage

You can add more complex textures to your images using a method similar to the one described in the previous tutorial. First, you need a texture such as paper, wood, or stone. The best source for textures, of course, is your digital camera. Although no substitute for a good scanner, it can still do a fine job of photographing paper textures, wood surfaces, or stone. Clip art libraries of these types of textures are also available from stock photo agencies.

Once you've imported a texture into your image editor, place it on a layer above your image and use a Hard Light, Soft Light, or Multiply Blending mode to merge the texture into your image. You'll typically need to set a low opacity for your texture. If your texture is too strong, it will overpower your image.

Scratches, dirt, and other "damage" can be added by painting layers of damage onto a white canvas and then blending them into your image using a Multiply blending mode.

## CLEANING PORTRAITS

No matter how young and fit you are, there will be times when a little digital makeover is just the thing to turn a decent portrait into an exceptional one. Facial retouching can include everything from removing wrinkles and blemishes to altering shadow details so as to make facial contours less pronounced. As you've probably already guessed, Photoshop provides excellent tools for this type of cleanup. If you're using a different image editor, it probably has tools similar to the ones described here.

You mostly use two tools for the majority of your facial retouchings. The Rubber Stamp (or Clone) tool is good for completely removing features like dark wrinkles, assuming there's enough clear facial tone around the wrinkle to get a good clone. For the rest of your touchups you'll use the Dodge tool. (See Figure 14.22.)

The Dodge and Burn tools let you brush lighter or darker "exposure" into any part of your image. With a few simple dodges, you can usually lighten wrinkles or other fine lines to either make them less pronounced or to completely eliminate them. Dodge can also be used to lighten shadow areas to make contours less extreme. (See Figure 14.23.)

For the retouching shown Figure 14.23, blemishes and discolorings were removed with the Dodge tool, as were most faint wrinkles. For larger wrinkles, the Dodge tool was used to lighten the wrinkle and then the Clone tool was used to paint over the wrinkle with appropriate skin tone. The Dodge tool was also used to balance color overall. The whites of

**FIGURE 14.22**   The Dodge and Burn tools in Photoshop and Photoshop Elements are essential retouching tools for removing lines and blemishes.

**FIGURE 14.23**   Using a combination of the Rubber Stamp and Dodge tools, and a separate blur layer, we retouched the image on the left to produce the result on the right.

the eyes were dodged, and the teeth were whitened by using a Hue/Saturation layer. Finally, to selectively soften some skin tones, a copy of the

image was created in a second layer and blurred with the Gaussian Blur filter. A Layer Mask was applied to the blurred layer, allowing us to paint blurred texture into some areas, leaving other details—eyes, eyebrows—sharp. The entire process took about 45 minutes.

The downside to dodging and burning is that, like any of Photoshop's painting tools, once you make the stroke, your pixels are altered and there's no way to change your mind later if you decide you need more or less of an effect. As we've explored in other sections of this book, many effects can be isolated into individual layers, allowing you to paint effects into your image in a nondestructive manner that allows you to re-edit your image later.

Dodging and burning effects are no exception. To create a dodging and burning layer, add a new layer above the layer you want to edit, and change the layer's blending mode to Overlay. Painting into the layer with a color that's darker than 50 percent gray darkens the underlying image; painting with colors that are lighter than 50 percent gray will lighten the underlying image.

So, to remove a wrinkle, select a color that's lighter than 50 percent gray and begin brushing into your Overlay layer. For more control, it's best to lower the opacity of your paintbrush to around 20 or 30 percent, so that you can paint in your effects gradually. If you make a mistake, you can simply use the eraser to erase your brushstrokes.

For an interactive before-and-after view of this image, check out *www.completedigitalphotography.com/retouching.*

## COMPOSITING

Compositing—the collagelike process of layering multiple images together—is a mainstay of special-effects work. Using the simple selection and layering tools discussed throughout this book, you can create all sorts of fantastic or surreal composites. In addition to doctoring photos, you can also use compositing tools to solve more practical photographic concerns.

In Chapter 7 we explained how one way to handle the scene shown in Figure 7.20—a tricky exposure situation because of the extreme light and extreme dark—was to shoot two images, each metered separately, with the idea of sandwiching them together.

The same layer-stacking tricks you learned in previous chapters were used to create the composite shown in Figure 14.24. First we stacked the two images on top of each other. Because we were not using a tripod for these shots, the images were not framed identically, so they were slightly out of registration. We lowered the opacity of the top image, then se-

**FIGURE 14.24**    The final composite.

lected the Move tool. With the arrow keys, we were able to nudge the image one pixel at a time until the images were properly registered. At that point, we returned the opacity of the top image to 100 percent.

Next we added a Layer Mask to the top layer and began painting into it to control which parts of our top image were visible. Several other

ON THE CD

Adjustment layers were added to improve the effect and to provide color and tone correction. You can examine the final Photoshop file yourself, by copying it from the CD-ROM. It's located in the Tutorials/Chapter 14 folder.

## PREPARING TO PRINT

Photoshop is capable of much more than the few effects shown in this chapter. Hopefully, though, these tutorials provided you with a few starting points for creating more complex effects and introduced you to some effects that digital photographers frequently need to perform.

By this point, you probably have some finished images that are ready for output. Whether your destination is paper, Web, or video, the next chapter should help you with all of your outputting concerns.

# 15

# OUTPUT

**In This Chapter**

- Choosing a Printer
- Printing
- Web Output
- Conclusion

Whether you plan on delivering your images in print or via the Web, CD-ROM, or video, you will need to take some care when you create your output. As you saw in Chapter 10, color can vary widely between devices, and you'll almost certainly find yourself returning to your color-correction techniques to adjust your images for the vagaries of your target output device.

Printing is the most complicated output chore that you'll face. When outputting to an electronic format, you don't have to be so picky about color because there's simply no way of guaranteeing color on a particular monitor, no matter what you do. But printing is something you *do* have control over—after all, you're creating the final piece that will be viewed. Consequently, you'll spend time trying to get your printed colors correct.

Though we're going to cover many different forms of output in this chapter, we'll be spending the most time on printing, a process that begins with your selection of a particular printer.

## CHOOSING A PRINTER

With pixel counts climbing ever higher and prices continuing to drop, it's not hard to see that digital camera technology is constantly improving by leaps and bounds. But desktop printing technology has been making equally impressive advancement as evidenced by the fact that you can now buy a printer that delivers photo-lab-quality prints for around $150. Longevity and durability of prints has always been the Achilles' heel of desktop printing, but over the last couple of years, new pigment ink formulations have addressed this problem, and desktop ink-jets are now capable of producing prints that are *more* durable than traditional film printing processes.

Many new users are quick to point out that although the printers are cheap, ink cartridges are very expensive, and therefore, digital printing is a rip-off. This may be true when compared to having your film processed at your local Wal-Mart, but you need to remember that you get what you pay for. Odds are, you'll get better-looking prints from your desktop printer than you'll ever get from a cheapo drugstore photo lab.

Here's another way of looking at it. If you're like most people, when you shoot a roll of 36 exposures, you probably get five or six prints that you want to keep. If the film costs you $6, and processing costs you $15, you're effectively paying $3.50 each for those six prints that you like. And those are 4" × 6" prints! You can print out 8" × 10" prints on a typical ink-jet printer at a cost of somewhere between $1.50 and $2.

If you tend to keep most of the pictures that you shoot, a desktop printer will be more expensive per print. If this sounds like you, you

should think of your desktop printer as a replacement for a custom photo lab that you would go to for those times when you want enlargements, special prints, or precise control over color. Or, you might think of it as a replacement for a color darkroom that you'd normally have to keep in a closet or bathroom. When viewed this way, you'll see that desktop printing is much cheaper than using a custom lab, and definitely cheaper than the equipment and materials required for a wet darkroom.

What you may find is that the ideal printing solution is a combination of mail-order printing for your everyday prints, and a desktop printer for larger prints or for times when you want to tweak and adjust the color of a print.

We'll discuss both of these technologies in this chapter. Fortunately, all of the work you've done in the preceding pages should leave you well prepared for a discussion of printing. Most of the color theory that you learned when you were working with your camera will apply to your printer as well. This section begins with a discussion of the issues and questions that you'll face when you buy a printer. Following that, you'll learn more about how to adjust and prepare your images for printing.

There are many different ways to print a color image on a piece of paper, so your first choice when you shop for a printer is to choose a printing technology.

## Ink-Jet Printers

The best photo-printing solution is a color ink-jet printer. Ink-jets work by shooting tiny (*really* tiny—most ink-jets use a drop that is only a few picoliters) drops of ink out of a nozzle. As with any color-printing technology, different colored drops are combined to create full-color images.

Ink-jet printers have a number of advantages over other printing technologies. They have larger color gamuts, better sharpness, produce prints that are more durable, and provide much greater media flexibility than any other printing technology. With the right paper, a good ink-jet printer can create an image that's indistinguishable from a photographic print.

Ink-jet printers are typically far cheaper to buy than any other type of printer, although their cost per print can be expensive—up to $2 per page for a photo-quality 8" × 10" print. However, because of their ability to handle different media, you can also create lower-quality, less-expensive prints by using cheaper paper.

Ink-jet printers can currently be divided into two major categories: four-color printers and more than four-color printers. Four-color printers use the same cyan, magenta, yellow, and black colors that an offset printing press uses. These printers are usually considered general-purpose color printers. They're suitable for printing text at reasonable speeds and will do a very capable job of printing color photos.

Photo printers also use cyan, magenta, yellow, and black colors, but they augment them with additional colors. For example, six-color photo printers usually add an extra cyan and extra magenta cartridge to beef up the dark tones and provide smoother light tones. With these extra colors, the printer does a better job of printing light areas and subtle gradations without visible dots. Seven-color printers use those same six colors but usually add an additional black cartridge specifically for printing on glossy paper.

Photo printers are further divided into archival and nonarchival categories. Until recently, ink-jet printers exclusively used water-based dye inks. Though these inks produce beautiful-looking prints, they don't produce prints that are very durable. Consequently, the prints fade and the colors shift. How quickly depends on how much light the prints are exposed to. Even if you stick the image in a photo album it will still discolor and fade, because dye-based inks are greatly affected by humidity.

Archival printers usually use pigment-based inks that are much more light-fast and are resistant to color shift and fading. Lab testing rates many archival-based prints as offering light and colorfastness of well over 100 years. This is far better than what you can expect from even the best color film–printing processes. On the downside, archival printers are more expensive, and their color gamuts are slightly smaller, though this is improving with each new generation.

Some vendors offer semiarchival dye-based printers. These are usually six- or seven-color printers that can produce prints with roughly 20-year durability when used with certain papers. These are usually matte papers, so if you want to produce durable glossy prints you'll need to go with a full-blown archival printer.

If you need a general-purpose printer that can do text as well as decent photos, you'll want to go with a four-color printer. Photo-printers—printers that have more than four colors—often don't do as well with text as do four-color printers, and because their ink cartridges are smaller, they're not as economical for high-volume printing.

If photography is your main printing concern, a photo ink-jet printer is the best way to go. If fine-art printing is your primary application—and certainly it is if you hope to sell your prints—then it's worth spending the extra money for an archival-quality printer. If you are more of a hobbyist—that is, if you'll be making prints for your own enjoyment and for giving to family and friends— a semiarchival ink-jet should be fine.

You'll also want to consider paper size when you choose an ink-jet. Although most printers offer standard letter-size printing, you can also get models (four-color or photo, dye-based or archival) that print larger. Larger desktop ink-jet printers typically support sizes up to 13" × 19" (also known as A3 or SuperA3 size). Although a standard letter-size

printer is capable of printing an 8" × 10" print, if you're interested in fine-art printing, you may want to go for a larger printer. You'll pay more for the extra size, of course—usually about twice as much. You might also want to look for a printer that has an option for printing edge-to-edge (sometimes referred to as *full bleed* printing). You can trim prints yourself, of course, but an edge-to-edge printer allows you create borderless prints of varying sizes on precut pages with no manual trimming.

### *REALLY BIG PRINTING*

*If you need to print images with print sizes over 13" × 19", you'll need to go with a large-format printer. These giant ink-jet printers range in size from 24" wide to over 50" wide, offer dye-based or archival pigment inks, and typically accept sheets or rolls of paper, allowing you to create huge images. They also come with huge price tags. Don't expect to get a large-format printer for under $2,000.*

When shopping for a printer, look at a lot of output, including prints on different kind of media. Try to find samples printed on the paper you think you're most likely to use. If you suspect that you're going to do most of your printing on ordinary copier paper (not the best choice), you'll want to look closely at the printer's plain-paper printing ability. If quality is your highest concern, you should examine output printed on photo-quality glossy paper. If you have special printing needs—the ability to print on watercolor paper or cloth, for example—then examine output on those media as well. Just because a printer prints well on one kind of media doesn't mean it will perform as well on another.

As with examining images on-screen, when you evaluate prints, check the highlight and shadow areas to see how well the printer is preserving detail; examine areas of fine detail for sharpness and clarity. On pigment printers, examine glossy prints at an angle to look for *bronzing*, an annoying effect that causes darker tones to have more of a matte finish than colored areas. Finally, try to examine some grayscale output on glossy- and matte-finish media. Grayscale prints often come out with annoying color casts that make it difficult to get good black and white prints.

Of course, you'll want to determine if the printer provides the type of connectivity and networking that your computer requires, and you'll want to be certain that it includes a driver for your operating system. Print speed can vary greatly from model to model and from quality setting to quality setting, so if you think you have speed concerns (perhaps you need to print a high volume), you'll want to assess the printer's print speed.

Once you have a printer, you'll want to consider the various ink and paper choices that are available. Typically, you should experiment

with different kinds of media, because each will have its own imaging characteristics.

---

## STANDALONE INK-JET PRINTERS

One of the great advantages of digital photography is the ease with which you can edit and correct your image before printing. However, if you've been out shooting snapshots with a decent camera, then you might not care so much about finicky correction—you might just want a decent print. For these situations, having to transfer your images to your computer can be a frustrating time-drain. To address this issue, many vendors now make ink-jet printers with built-in media slots and the capability to print without any connection to a computer. The good news is that these printers use the same engines as printers that you connect to a computer, meaning you don't have to compromise on image quality to get this ease of use. And, of course, you can still print from your computer for times when you want to correct and fiddle with your images.

In addition to all of the usual print quality and connectivity concerns, when shopping for a printer with standalone capabilities, you'll want to be sure that it provides support for the type of media card that your camera uses. If you're looking at a printer made by the same manufacturer as your camera, there's a good chance that you'll be able to print to the printer directly from your camera, via your camera's serial cable. Some printers offer a built-in LCD—or an option for an LCD screen—so that you can easily select the images you want to print.

If the printer doesn't offer a screen, it should at least offer the ability to print out a contact sheet showing thumbnails of all of the images on the card. This will make is easy to select the images you'd like to print.

Several new HP photo printers offer an excellent standalone feature. These printers can print out a page of thumbnails, with check boxes for various print sizes. You can then check off the images you want—at specific print sizes—and feed that "order form" back into the printer. It will then print out the selected images according to your specs, all with no computer involvement.

Finally, some printers offer built-in image correction. These are usually simple tools such as Auto-Levels adjustments, or the ability to convert to black-and-white or sepia tone. Though no substitute for what you can do using your image-editing software, these features do provide a quick and easy way to punch up a simple snapshot.

## Laser Printers

You're probably familiar with using a laser printer to print text or simple graphics. If you already have a laser printer, or if you use one at work or at a service bureau, then you already know that, in addition to being very

speedy, laser printers can produce very high-quality output. However, their prints don't come close to the quality provided by even the cheapest ink-jet printer, so if you're looking to get photo-quality output, a laser printer is going to be the wrong choice. In general, color laser printer quality is about on par with what you'd see in a magazine, rather than what you'd get from a photo lab.

Though a laser printer costs substantially more than an ink-jet, your cost per print will be much lower than ink-jet printing, and they're much speedier than ink-jets, so if mass-production is your goal, a laser printer might be the best choice. Your prints will also be waterproof and will look good even on regular copier paper.

Whether you are buying a color or a black-and-white laser printer, your main concern should be image quality. Look at lots of output samples, and pay attention to how well the printer reproduces color. Make sure that it can reproduce all color ranges (reds, blues, purples, and so on) accurately. Also, keep an eye out for artifacts—dots and patterns—throughout the print but especially in the highlights and shadows. Finally, you'll want to check compatibility with your operating system, hardware, and image-editing software. If you have any special networking concerns (for workgroup use, for example), you'll want to evaluate the printer's networking options.

## Dye-Sublimation Printers

Sublimation is the process of converting a solid into a gas without passing it through a liquid stage. (For example, dry ice sublimes at room temperature, melting from a solid block into vapor without becoming liquid.) A dye-sublimation printer (also called a dye-sub) works by using special solid dyes that can be sublimed into a gas that adheres to special paper. As with any other printing technology, these primary-color dyes are combined during the sublimation process to create full-color images.

The advantage of a dye-sub printer is that it is truly continuous tone. That is, no dots or patterns will be visible in your final print because the ink hits the paper in a diffuse, gaseous form. Dye-sub paper also looks like real photo paper, giving your prints a true "photo finish."

The downside to dye-sub printers is that their prints can lack sharpness. The same soft, diffuse property that creates continuous tone also means that it's hard for a dye-sub printer to produce a very hard edge. Dye-sub printers are also a tad slow when you compare them to ink-jets or laser printers, and they typically have a high cost per print because of their expensive, proprietary media. Also, if you're looking for a printer that can be used for other tasks—printing text, for example—then a dye-sub is definitely not for you.

On the upside, dye-sub printers can be made very small, and their prints are very durable. Most of the dye-sub printers that you'll see today are small units that create 4" × 6" prints. Most of these printers, such as those made by Olympus and HP, can be attached directly to a camera, providing you with a Polaroidlike facility for getting instant prints from your digital camera. Because the media is somewhat pricey, these can be expensive prints, and of course, you have no option to color-correct when you print directly from your camera. If you need a portable (some of these printers can run off of batteries) 4" × 6" printing tool, a small dye-sub can be a good solution.

As with other printing technologies, when you shop for a dye-sub printer, image quality should be your highest concern. Try to look at a variety of samples that cover a full range of color and detail levels as well as a full assortment of light and shadow. Dye-sub resolutions are typically lower than laser printer or ink-jet resolutions due to the nature of their printing method. Three hundred and 400 dpi printers are common and perfectly acceptable.

As with purchasing any printer, make certain the printer provides the necessary connections for your computer and that its driver software is compatible with your operating system.

## Media Selection

You can, of course, stick any old paper in your printer, including the normal 20-pound copier paper that one typically uses for office correspondence. However, paper choice can have a huge bearing on the quality of your final image. In addition to providing a more photo-like finish, different papers respond differently to your printer's ink. For example, some papers absorb more ink than others, resulting in colors that are more muted and muddy than what you'd get from a paper with a more "opaque" finish.

Some papers are also brighter than others and will often yield brighter prints, whereas other papers will have a gloss or finish that results in a more continuous tone print and a more photolike finish. Finally, there are papers with unique, complex textures such as watercolor paper or handmade papers. These papers typically produce prints with darker colors and strange color textures. In addition to the texture of the paper itself, coarser papers typically absorb ink in very unique ways, resulting in smears and smudges that can be very attractive.

In general, you'll want to experiment with your paper selections to find out what works best for your intended output. Be *certain* to read your printer's manual before you shove an experimental piece of paper through your printer. Most printers have thickness limits and many printers—particularly archival-quality printers—can be damaged if you use media that wasn't specifically designed for the printer.

To get the best quality, you'll want to stick with a paper that is specially formulated for your printer. Epson printers, for example, include settings for specific types of Epson-manufactured paper. Because the printer driver knows exactly what kind of paper you're using, it can do a much better job of laying down a good image.

If archival quality is your highest concern, you'll want to choose an archival paper. Print longevity is not determined only by the ink that you're using. Special archival papers will also greatly extend the life of your prints. If longevity is your greatest concern, shop for an appropriate paper.

### Ink Choice

In general, you should always buy ink manufactured and certified by your printer manufacturer. There are cheaper, third-party inks available, and these frequently work just fine. However, be aware that it is possible for your printer head to be damaged by noncertified inks. More important, though, to get accurate color, your printer driver needs to know that the ink formulations in your printer will mix and blend in a particular way. If you use a third-party ink, there's no guarantee that they will have mixed their ink correctly.

If you do a lot of black-and-white printing, you might want to consider a set of quad-tone inks. Typically, the black ink included in a normal four-color or six-color printer doesn't allow for a full range of grayscale printing. Printer manufacturers get around this by trying to blend all four (or six) ink colors to create shades of gray. Unfortunately, this approach usually doesn't yield a full range of gray and often produces an image with a bad color cast.

High-quality black-and-white commercial printing—the kind used to print black-and-white photography books, for example—often uses combinations of multiple shades of black or gray ink. Such ink sets are also available for desktop ink-jet printers. Typically, these quad-tone ink sets provide four shades of black ink and special drivers for printing black-and-white images. For more information on quad-tone inks, check out *www.completedigitalphotography.com/quadtone*.

## PRINTING

In an ideal world, once you'd finished correcting and adjusting your images, you would simply hit the print button and out of your printer would pop a print that looked exactly like you had seen on-screen. In the real world, printing is a bit more involved than that. In addition to trying to manage the color differences that occur between your monitor and your printer, you

also have to spend some time resizing and sharpening your image so that it's appropriate for your intended print size on your particular printer.

In Chapter 13 you learned that you should resize your image after you've performed all of your edits, but before you've sharpened. (If you're unsure of how to resize an image, you might want to reread the section on scaling in Chapter 13.) What you *didn't* learn, though, was how to determine an appropriate resolution when resizing. After making all of those decisions about what resolution to buy, you want to be sure you're using all those pixels to your maximum advantage. Therefore, choosing a resolution is your first major decision when preparing to print.

## Choosing a Resolution

Before you can resize an image (as discussed in Chapter 13), you need to know the resolution that is best for your printer. Different printing technologies have different resolution requirements, so calculating optimal resolution differs from printer type to printer type.

If you've ever looked at a black-and-white newspaper photo up close, you've seen how dot patterns of varying size can be used to represent different shades of gray. (See Figure 15.1.) This type of image is called a *halftone* and, traditionally, was created by rephotographing a picture through a mesh screen.

The color photos in this book are printed using a similar process. To create a color halftone, four halftones are created, one each for cyan, magenta, yellow, and black. When layered on top of each other, these four halftones yield a full-color image.

All color printing processes use variations on this practice of combining groups of primary colored dots to create other colors. Nowadays, of course, halftones are usually created digitally, by scanning an image into a computer (if it didn't start out as a digital image in the first place) and letting the computer create a halftone.

Your computer monitor works differently, of course. Unlike a printer, your computer monitor can actually make a single dot that's any one of millions of colors. In other words, there is not a one-to-one correspondence between a pixel on your screen and a dot printed on paper. Although a single pixel on your screen might be defined as being dark purple, your printer has to print a combination of 50 different cyan, magenta, yellow, and black dots to reproduce that one purple dot from your monitor.

So, although your printer may claim to have 1,400 dots per inch of resolution, those are 1,400 *printer dots,* not 1,400 pixels. Choosing a resolution, then, is dependent on how much information your printer needs to do its job.

**FIGURE 15.1**   In a black-and-white halftone, patterns of differently sized black dots are combined to create the appearance of various shades of gray.

### Choosing a Resolution for an Ink-jet Printer

Rather than usual newspaper-like halftone patterns, ink-jet printers use special, seemingly random mezzogram patterns to create colors.

As you saw in Chapter 13, there is a relationship between print size and resolution. As resolution increases, print size decreases (assuming you're not resampling your image) and vice versa. So, as you try to make your image larger, your resolution will go down. If you don't have enough resolution for your intended print size, your prints can come out lacking detail and sharpness.

Conversely, if you have *too much* resolution for your intended print size, your printing process will go much slower, as the printer will have to slog through all of that extra data, sampling down on the fly to get just the information that it needs. What's more, when it samples down, you have no idea how the image might be sharpening up. It's much better to get the image to the proper size yourself, so that you can judge sharpness and true image quality. Consequently, choosing an appropriate resolution for your intended print size is an important step in preparing your image for print.

It is generally agreed that, at a normal reading distance of 10 inches, your eye cannot resolve much—if any—image detail past 300 pixels per inch. We say "generally" because this number is debated a little bit, with many detractors usually going *lower*, to say that you can't resolve better than 240 pixels per inch. Whatever the truth is, it's safe to say that if your image is sized at 300 dots per inch, you're going to get as much detail as it's possible to see (assuming that detail is there in your image).

However, note that we specify a specific viewing distance for that resolution claim. As you might expect, as you move farther from your image, the amount of detail that you can see goes down. This is actually good news for your digital printing efforts, because it means that larger images—which are usually viewed from farther away—can be lower resolution. (The best examples of this are billboards, which typically have resolutions of two or three pixels per inch, because they're designed to be viewed from distances of hundreds of feet.)

There are complex visual acuity formulas that can be used to determine the precise optimum resolution for a given print size at a given distance, but in general, you can use the information shown in Figure 15.2 to select a resolution for your prints, whether you're printing on a four-color ink-jet or a photo ink-jet with six or more colors.

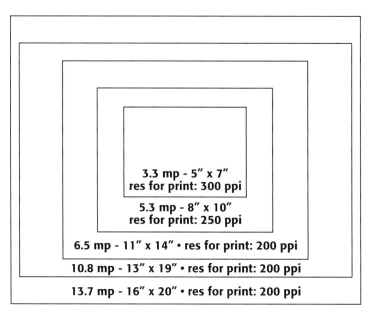

**FIGURE 15.2**    In general, you can follow this table when selecting a resolution for a given print size. Note that because larger images are usually viewed from farther away, you can usually manage just fine by selecting a lower resolution as print size increases.

These numbers are good news if you're using a camera with a lower resolution, because it means that you can still get a large-sized print. Obviously, there's nothing wrong with using higher resolutions (except for the potential slowdown in print-time), and if your camera packs enough pixels, you might want to print your 8" × 10" prints at a full 300 dpi so that they're razor-sharp, even up close. However, you should do some tests of your own to decide if you can discern a difference in detail in sharpness between 200 and 300 dpi. Depending on your subject matter and the quality of your camera, there may be little perceptible difference.

Paper quality is also a contributing factor in resolution choice. If you're printing on lousy paper, you can probably get away with going to a much lower resolution. The lack of resolution will often be hidden by the fact that the ink will bleed and smear when it hits the paper. Conversely, if you're using a higher-quality paper that does a better job of holding a dot, you'll need to stick with a higher-resolution image.

### Choosing a Resolution for a Laser Printer

Laser printers generate different tones—both gray tones and color tones—using the same type of halftone patterns that you see in offset presses. As discussed earlier, a halftone is a pattern of dots that when viewed from far away, appear as a tone of gray or color. How big the dots are (and hence, how far away you have to be to see tone instead of a dot pattern) is governed by the *line screen frequency* that is used to generate the halftone. In traditional halftoning, line screen frequency is controlled by selecting a particular screen to use when shooting the halftone. The line screen frequency of the screen—that is, how coarsely it is woven—is measured in lines per inch (lpi).

Digital halftoning doesn't involve a physical screen, of course, but the algorithms that create the halftone are still governed by a line screen frequency measured in lines per inch. For high-resolution printing (1,200 dpi or higher), this screen frequency is typically 133 or 166 lines per inch. This is a very fine screen that produces a magazine-quality image. Lower-resolution printers (300 to 600 dpi) typically use a much coarser screen, usually around 85 to 100 lines per inch. Many laser printers (and most high-resolution image setters) let you specify a line screen.

Why does this matter? Because different line screens require images of different resolutions. Typically, the rule for resolution (as measured in ppi) is that your image should be $1\frac{1}{2}$ to 2 times your line screen. In other words, if your printer uses a 133-line screen, then your image needs to have a resolution of 200 to 266 pixels per inch.

In practical terms, this means that if you have a laser printer that requires 200 ppi images (because it uses a 133 line screen) and you have a two-megapixel camera that produces 1,600 × 1,200 pixel images, you can

print your image at 8" × 6" at 200 dots per inch—1600 ÷ 200 = 8" wide; 1200 ÷ 200 = 6" high.

Let's say, though, that you want to print an image that can be copied on a photocopier. Images for photocopying typically need to be printed with a much coarser line screen, usually around 85 lines per inch, which means your image needs to be only around 150 dpi. At this resolution, the same two-megapixel image could be printed at $10^1/_2$" × 8". (An 85-line screen is also appropriate for newspaper or phonebook printing.)

Remember that when you print to a laser printer, it's best to turn off any special graytone correction features the printer may have.

## Using Your Color Management System When You Print

If you've been using a color management system for your editing work (see Chapter 10 for more information), you should have an appropriate printer profile installed and configured. You can use this profile for generating soft proofs as explained in Chapter 10, and you can also use it when you print from Photoshop to help ensure that the colors that come out of your printer match what's on your screen.

After selecting Print, simply set the Source Space to Document, and set the Output Space and Intent to the same settings you chose in the Proof Setup dialog. (See Figure 15.3.)

**FIGURE 15.3**    If you've been using your computer's color management settings, you'll want to pick the appropriate profile and other settings to ensure that your print more closely matches the soft proof that you generated on-screen.

Finally, it's important to turn off any color-correction routines that might be built into your printer driver. Many vendors, including Epson and Canon, include their own color-correction routines in their printer driver. If Photoshop is already manipulating the color in your image before it sends it to the printer driver, the last thing you want to have happen is for that driver to then manipulate the data further. The Print dialog box for your printer should have a command for deactivating the printer's built-in color correction. (See Figure 15.4.)

**FIGURE 15.4**    If you're using a Color Management System, be sure to deactivate any color correction that may be built into your printer driver. Shown here is the Epson printer driver running under Mac OS X. A similar option should be provided with any Epson driver running under any OS.

## Correcting Your Image for Print

When you print your image, whether or not you're using a color management system, you'll probably find that its colors don't exactly match what you see on your computer screen. This is simply a result of the difficulty of translating colors of light into colors of ink. No matter how hard

you try, how meticulous you are, and how good your hardware is, you will rarely get a print right the first time. Just as a darkroom photographer usually has to try many different exposure and development strategies when printing a picture, the digital photographer usually has to perform printer-specific color corrections and print several pages before a print looks correct.

So, if you find yourself printing many different versions of a print to get the color you like, don't worry, you're not doing anything wrong. However, there are some things you can do to improve your chances of getting a good print and to reduce your number of failed attempts.

After printing an image, you need to determine which areas of the print appear wrong. Perhaps the image has an overall color cast. Perhaps it has lost contrast or saturation. Perhaps some colors are outright wrong. Once you've identified the problem, you can start trying to concoct a correction that will eliminate it.

After you've performed the initial color corrections and adjustments on your image, but before you start printing, it's a good idea to save a copy of your image. This copy will be something like a negative. It is the original adjusted image that you can use as a base on which to add corrections for your specific printer and media. It is very likely that you will eventually end up with several versions of an image: your original corrected image and separate copies for each type of media on each type of printer that you print it on.

There are a couple of ways to make adjustments to your image when printing. If you're working in Photoshop, you can simply throw an Adjustment layer (or two) onto the top of your image. As you create test prints and refine your corrections, you can easily go back and tweak your Adjustment layers, or even build sets of Adjustment layers that are specific to particular types of media.

There's a good chance that your printer's color issues will be consistent. For example, perhaps a particular type of paper always prints with the same degree of color cast. If this is the case, you can always assume that you will need a correction for that cast. If you make the correction using an Adjustment layer in one image, you can simply copy that layer to other images that will be printed on the same media.

### Preparing Your Image for Professional Printing

If you are preparing images for professional, offset printing—for a professionally printed catalog, book, or mailer, for example—you will need to perform some extra editing steps to ensure your images print well. You've probably already done a bunch of work to get the tone and contrast range

of your image adjusted. Although the black point, white point, and gamma adjustments that you learned about in Chapter 11 have probably produced images that look good on your screen, they don't necessarily represent a contrast and tonal range that a professional printer is capable of printing. Fortunately, there's a pretty simple way to compress, or *target*, the tonal range of your image to fit you're the needs of a commercial printer.

As you've already seen, your computer monitor can display a bigger gamut of colors than most printers can print, and this holds true for commercial printers. Simply put, there are limits to the lightest and darkest dots that your printer can print. Some tones on your monitor are simply lighter than the printer's lightest shade of ink, whereas other are so dark that the printer cannot lay down enough ink to reproduce that tone. If the shadow and highlight tones in your image are beyond the limits of what your printer can print, highlights will posterize and shadows will turn to mud. (See Figure 15.5.)

**FIGURE 15.5**   This image was not targeted for the printing process used in this book. As such, it's a bit out of whack. In particular, the shadow areas have gone too dark.

In Chapter 12, you used the Output sliders in the Levels dialog box to lighten an image to create an effect. We're going to return to the Output sliders now to compress the tonal range of the image into a range that is acceptable for a printer.

**TUTORIAL**      **TARGETING AN IMAGE**

Although your images may look great on-screen, your printed images may often leave you unpleasantly surprised. Unfortunately, your computer monitor is capable of displaying many more colors than your printer can print. Through targeting, you can adjust the tonal range in your image so that it better matches the capability of your printer.

In this tutorial, you're going to target the image shown in Figure 15.5 for an offset press.

### STEP 1: OPEN THE IMAGE

*ON THE CD*

Open the cemetery.tif image located in the Tutorials/Chapter 15 folder of the CD-ROM.

When you look at the image on-screen, you'll see that it is not nearly as dark as this printed version and has much better tone and contrast range. The printing process darkened up the image and in the process messed up the contrast.

### STEP 2: TALK TO YOUR PRINTER

At this stage, you would want to find out from your printer the minimum and maximum ink densities that their offset printing press can hold. In other words, what are the lightest and darkest dots that the press can print. Typically, they'll respond with something like 5 percent and 95 percent. That is, the lightest tone the printer can print is 5 percent gray whereas the darkest is 95 percent gray. Anything brighter than that will simply be the white of the paper. If you're printing to newsprint or other low-quality paper, you may see numbers more like 15 percent and 85 percent.

Paper white is fine for the *specular highlights* in your image—the bright white glints and reflections that occur on very shiny surfaces and on the edges of objects. However, if the brightest spot a printer can make is 15 percent, there will be a sudden change from 15 percent gray to paper white, which will appear as posterization in the highlights of your image. It's better to keep your white areas confined to what's printable so as to maintain control of the highlights in your image; after all, you can't adjust the white of the paper.

### STEP 3: TARGET THE IMAGE

We're going to perform our targeting using a simple Levels adjustment, so your first step is to add a Levels Adjustment layer to the image. As you've already learned, the histogram in the Levels dialog box is a graph of the 256 tones in your image. We want to set the black Output slider (which currently has a value of 0) to 95 percent, or 13 (255-(255 × .95)). Drag the left Output slider until it reads 13. (See Figure 15.6.)

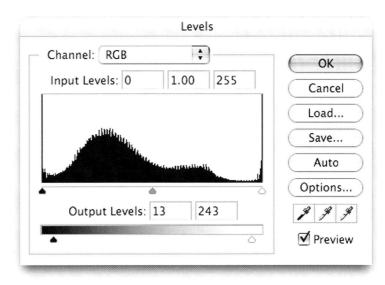

**FIGURE 15.6**    After targeting, your Levels Adjustment layer should look like this.

The white Output slider should be 5 percent, or 243 (255-(255 × .05)). Slide it into place.

### STEP 4: EVALUATE THE IMAGE

On-screen, the image probably looks rather flat now. However, when it is printed, all of the tones are going to go darker at the low end, as the ink is absorbed into the paper. At the high end, this adjustment will hopefully protect your highlights (white points) from posterizing and blowing out to completely white. (See Figure 15.7.)

## Web-based Printing

There are a number of Web sites that offer photo printing services. After you upload your images to these sites, they will print the images and mail

**FIGURE 15.7**    After targeting, the image prints much better.

them back to you. These services typically use pictrographic processes—traditional chemical-based printing processes that expose a piece of photographic paper using a laser or LED device.

The advantage to these services is that they're very simple to use. The downside is that you have to wait for your prints, and you don't know what sort of color and tonal corrections the service will make to your images. In other words, what you see on your screen may not be close to what you get in your prints. Typically, a particular printing service will be

consistent about the type of adjustments that they make to their images. So, once you've figured out a particular service's idiosyncrasies, you can adjust your images accordingly before you submit them.

Pay close attention to a service's cropping guidelines. Some services will blow up your image to fill an entire print. If your original was a different aspect ratio than the final print, then your image will be cropped. Most services allow the option of blowing up to full print size or padding the image to preserve your original aspect ratio.

Most services also provide photo-sharing facilities, which allow you to create one or more online photo albums. You can send the address of these albums to other people who can view your images and, if they want, order prints. Posting images to a Web site is convenient because you only have to upload them and then send out a link. You'll have no concerns as to whether a particular recipient can receive large amounts of data through e-mail. Photo sharing and printing can also save you the hassle of preparing prints for a bunch of people, because they can simply order their own.

Finally, some services offer much more than simple paper printing. Coffee mugs, T-shirts, banners, cakes, and cookies can all be adorned with your photographs.

## WEB OUTPUT

Fortunately, Web output is much simpler than outputting to print. Unfortunately, this is because there simply are no color controls for the Web. Because there's nothing you can do but post your images and hope that your viewers are using decent monitors, you don't need to target the color in your images as you do for print.

Your main concern when you prepare an image for the Web (or for e-mail) is file size. You probably already know what it's like to wait for a large image to download, either from the Web or from your mail server. Don't inflict the same data glut on other people by posting or e-mailing really large files. Obviously, if you and your recipient have high-speed connections, you can probably get away with creating larger files. Be aware, however, that the mail servers provided by many Internet service providers put a limit on the maximum size of an e-mail attachment. If you absolutely *have* to e-mail a large image to someone, consider segmenting it using a file-compression utility.

Fortunately, images for the Web tend to be very small. Most users don't have screens that are wider than 1,024 pixels, and most Web images clock in around 300 or 400 pixels wide. Save a copy of your image

(be careful not to recompress it), and resize it to an appropriate pixel size. Be sure to set the resolution to 72 dpi.

The two most common graphics file formats on the web are GIF and JPEG. For photos, JPEG is really the only format you need to use. Fortunately, Photoshop offers an excellent Save for Web option that lets you experiment with different JPEG compression ratios and compare the effects of different compression settings side-by-side. (See Figure 15.8.)

**FIGURE 15.8** The Photoshop Save for Web feature makes it simple to try out different JPEG settings to balance size and quality.

If you're sending your images to post on another person's Web site, consider sending an uncompressed image. That person may have his own size and compression requirements and so will want to perform his own resizing and compression. If you send him an uncompressed file, he'll be able to compress it to his specifications without introducing further image degradation.

If you'd like to have your own photo Web site but don't have access to any Web space, consider using a photo-hosting Web site. Many of these sites offer template-based Web page creation and links to printing services. If you do a Web search for "photo hosting" or "image hosting," you should find plenty of free photo-hosting services.

Or, if you already have a Web site, or if your Internet Service Provider includes Web serving in your account, you can create your own online photo gallery using the Photoshop CS and Photoshop Elements Web Photo Gallery feature. In Photoshop CS, click File > Automate > Web Photo Gallery. In Elements 2, click File > Create Web Photo Gallery. (See Figure 15.9.)

**FIGURE 15.9**   The Photoshop Web Photo Gallery feature can automatically create a Web-based photo album from a collection of images.

Web Photo Gallery offers many options for gallery layout and image size. When you've configured it the way you want, it automatically re-sizes and recompresses your images according to your specifications and creates a single folder containing your new images and all relevant HTML files. You then upload this folder to your Web server.

## CONCLUSION

Once you start using a digital camera, it becomes hard to imagine that film cameras have much of a future—not because film cameras produce inferior results, but simply because digital cameras provide such enormous creative flexibility. Hopefully, this book has helped you understand more about the specific issues and concerns that you'll face when you shoot digital, as well as provide you with solutions for working around those concerns.

Your next step? Start shooting and editing! Your skill with both your camera and image editor will greatly improve as you shoot more and

more pictures. Take your camera with you wherever you go and don't hesitate to fire away.

If you'd like to read some more about photography in general, take a look at the suggested reading list in Appendix A.

For more articles about digital photography, as well as additional tutorials and discussions, check out the companion web site at *www.completedigitalphotography.com*.

# A SUGGESTED READING

The following list will provide you with further reading on the "artistry" of photography, as well as on more specifics of digital editing and retouching.

*The Camera* **(Ansel Adams Photography, Book 1) by Ansel Adams, Robert Baker.** Excellent coverage of camera and photography basics. If you want to know more about exposure—particularly the zone system—this is a great place to start.

*Examples: The Making of 40 Photographs* **by Ansel Adams.** Whether or not you like his photos, reading details about his photographic process can be an invaluable way to learn how to think and see like a photographer.

*The Ansel Adams Guide: Book 1: Basic Techniques of Photography* **by John P. Schaefer.** Written by one of the trustees of the Ansel Adams archives, this book provides a very thorough overview of the entire photographic process from cameras to developing to printing.

*On Photography* **by Susan Sontag.** An excellent series of essays discussing the effects that photography has had on our way of seeing the world. A must-read for any would-be photographer.

*Understanding Comics* **by Scott McCloud.** Essential reading for anyone who engages in any type of visual storytelling. In the form of a 200-page comic book, McCloud covers the basics of the visual literacy of comics and, in the process, presents a lot of valuable information for photographers.

*Real World Color Management* **by Bruce Fraser.** As you may have noticed from this book, digital color management is a very tricky, very complex discipline. If you want to dive into the nuts and bolts of Photoshop-based color management, this is the book for you.

***Real World Camera Raw with Adobe Photoshop CS* by Bruce Fraser.** As you learned earlier, shooting in your camera's raw mode is the best way to ensure maximum quality. But capturing raw information doesn't do you any good if you don't know how to process it properly. This book will help you through the gnarly technical details of Photoshop CS' Camera Raw plug-in.

***Mastering Digital Printing* by Harald Johnson.** Nothing's more frustrating than diligently working to shoot a good image only to be frustrated by lousy prints. *Mastering Digital Printing* will take you deeply into the process of high-quality fine-art printing.

***The Rebel Angels* by Robertson Davies.** Has nothing at all to do with photography, but a very good novel, all the same.

# ABOUT THE CD-ROM

## OVERALL SYSTEM REQUIREMENTS

### Windows

Intel® Pentium® II or better; Microsoft® Windows® 2000 with Service Pack 3, or Windows XP; 192 MB of RAM (256 MB recommended); 300 MB of available drive space; color monitor with 16-bit color card or better; CD-ROM drive.

### Macintosh

PowerPC G3 or better; Mac OS X v. 10.2.4 or better; 192 MB of RAM (256 MB recommended); 350 MB of available drive space; color monitor with 16-bit color support, or better; CD-ROM drive.

## ADOBE PHOTOSHOP REQUIREMENTS

### Windows

Intel Pentium III or 4 processor; Microsoft Windows 2000 with Service Pack 3 or Windows XP (Adobe applications on Windows XP with Service Pack 2); 192 MB of RAM (256 MB recommended); 280 MB of available hard-disk space; color monitor with 16-bit color or greater video card; $1,024 \times 768$ or greater monitor resolution; CD-ROM drive; Internet or phone connection required for product activation.

### Macintosh

PowerPC G3, G4, or G5 processor; Mac OS X v. 10.2.4 through v. 10.3 with Java Runtime Environment 1.4; 192 MB of RAM (256 MB recommended); 320 MB of available hard-disk space; Color monitor with 16-bit color or greater video card; 1,024 × 768 or greater monitor resolution; CD-ROM drive.

## IView MediaPro Requirements

### Macintosh

PowerPC or newer, such as iMac G3, G4; Mac OS 9.x or Mac OS X; CarbonLib 1.5; QuickTime 6; 8 MB of RAM (OS 9 allocation); monitor set to Thousands or Millions; 3 MB of hard disk space for installation.

### Windows

Pentium II, III or higher [or equivalent]; Windows 98, ME, 2000 or XP; DirectX 7.0 or higher; QuickTime 6; Internet Explorer 5.5 (6.x); 128 MB of RAM; 640 × 480 display with 256 colors (1024 × 768 display with 16-bit color); 5 MB of hard disk space for installation.

## PhotoRescue Specifications

### Windows

Windows XP or Windows 2000 recommended.

### Macintosh

Mac OS X only

Works with SmartMedia, CompactFlash, Memory Sticks, SD, MMC, XD Card and Microdrives but also generally most other external storage devices.

Requires only 1.2 MB disk space—may require up to twice the size of the card being recovered as a workspace and, of course, space for the recovered pictures.

## DISK CONTENTS

### Tutorials

Contains all of the files needed to use the book's tutorial lessons, as well as additional tutorial movies (in QuickTime format) and additional tutorial articles (in PDF format, suitable for printing or viewing on-screen). All information is organized into sub-folders by chapters, and each piece of tutorial information is explicitly referenced in the book. So, if you follow along in the book, you'll be led through each tutorial in the proper order.

### Software

Contains installers for the demo versions of the software mentioned in the book. Because a copy of Photoshop is necessary for the book's tutorials, a fully functional, time-bombed version of Adobe Photoshop CS is included here.

### Images

Contains color versions of most of the images in the book. Because some of the color and image quality issues discussed in the book can be difficult to see using the color printing method used to produce the book, these electronic versions are included for you to examine on-screen, or to print out using your own printing equipment. Please do not reproduce any of these images in electronic or printed form without the consent of the author.

# GLOSSARY

**1-bit image** An image composed of pixels that are either black or white. Called 1-bit (or single-bit) because only one bit of information is required for each pixel.

**8-bit image** An image that uses 8 bits of data for each pixel. Because you can count from 0 to 255, a pixel can be any one of 256 different colors.

**24-bit image** An image that uses 24 bits of data for each pixel. Because you can count from 0 to roughly 16-and-a-half million, a pixel can be any one of 16.5 million colors.

**32-bit image** An image that uses 24 bits of data to store the color of each pixel and an additional 8 bits of data to store how opaque each pixel is. This transparency information is called an *alpha channel*.

**35mm equivalency** What a lens would be equivalent to in terms of a standard 35mm SLR camera. Used as a standard for discussing the field of view and magnification power of a lens. In 35mm equivalency, lenses over 50mm are telephoto, while lenses below 50mm are wide-angle or fisheye.

**aberrations** Irregularities in a piece of glass that cause light to be focused incorrectly. Aberrations produce artifacts and anomalies in images.

**Acquire plug-in** A special type of *plug-in* that allows for communication between your image editing application and your digital camera.

**action-safe area** The area of a video image that will most likely be visible on any video monitor. Essential action should be kept within the action-safe area, as action that falls outside might be cropped by the viewer's screen. See *title safe*.

**active autofocus** An autofocus mechanism that achieves focus by transmitting something into the scene, usually infrared light or sonar.

**additive** Light mixes together in an *additive* process whereby, as colors are mixed, they get brighter; that is, light is added as the colors are mixed. Additive colors eventually produce white. Red, green, and blue are the primary additive colors that can be used to create all other colors.

**Adjustment layers** Let you apply Levels, Curves, and many other image correction functions as a layer, allowing you to remove or adjust the effect at any time.

**aliasing** The stair-stepping patterns that can appear along the edges of diagonal lines in an image.

**alpha channel** Extra information stored about the pixels in an image. Alpha channels are used to store transparency information. This information can serve as a mask for compositing or applying effects.

**analog** As regards photography, light in the real world travels in a continuous wave. To record those continuous analog waves, your digital camera must first convert them into a series of numbers, or digits.

**aperture** An opening that is used to control the amount of light passing through the lens of a camera. Typically constructed as an expanding and contracting *iris*.

**Aperture priority** A shooting mode on a camera. Aperture priority lets you define the camera's aperture. The camera will then calculate a corresponding shutter speed based on its light metering.

**APS** Advanced Photography System. A fairly new format of film and cameras.

**artifacts** Image degradations caused by image processing operations. Compressing an image, for example, often results in the creation of many image compression artifacts. Different image processing tasks create different types of artifacts.

**ASA** A measure of film speed. See also *ISO*.

**aspect ratio** The ratio of an image's length to its width. Most computer screens and digital cameras shoot images that have an aspect ratio of 4:3. 35mm film and some digital cameras shoot in a 3:2 aspect ratio.

**aspherical** A lens that contains some elements that are not perfect hemispheres. These non-spherical elements are used to correct certain types of aberrations.

**auto-bracketing** Some cameras include special functions that cause them to automatically shoot a series of bracketed images when you press the shutter release.

**autofocus assist lamp** See *focus assist lamp*.

**automatic exposure** A feature that will automatically calculate the appropriate shutter speed, aperture, and sometimes ISO at the time you take a picture.

**backs** In a medium, or large-format camera, the film is held in the back of the camera. The back can be removed and replaced with other backs, including digital backs.

**barrel distortion** A type of distortion caused by a lens. Causes the edges of an image to bow outward. Most prevalent in wide-angle and fisheye lenses. See also *pincushion distortion*.

**Bayer pattern** The most common color filter array. A pattern of red, green, and blue filters that can be laid over the photosites of an image sensor and used to calculate the true color of every pixel in the sensor.

**bicubic interpolation** A method of interpolation used in a resampling process. Usually the best interpolation choice when you scale an image.

**bilinear interpolation** A method of interpolation used in a resampling process.

**bit depth** A measure of the number of bits stored for each pixel in an image. Images with higher bit depths contain greater numbers of colors. Also known as *color depth*.

**black and white** In the film world, "black and white" is used to refer to images that lack color; that is, images that are composed of only shades of gray. In the digital world, it's usually better to refer to such images as "grayscale" as your computer is also capable of creating images composed only of black and white pixels.

**blending mode** A setting that determines how the pixels in composited layers blend together. Also known as *transfer mode*.

**blooming** A flaring, smearing artifact in a digital photo caused by a photosite on the camera's CCD getting overcharged. The extra charge spills into the neighboring photosites and creates the artifact.

**boot time** How quickly (or slowly, depending on the camera) the camera will be ready to shoot after powering up.

**bracketing** The process of shooting additional frames of an image, each over or underexposed. By intelligently bracketing your shots, you stand a better chance of getting the image you want.

**bulb mode** A special shutter mode that opens the shutter for as long as you hold down the shutter release button.

**burst** See *drive*.

**catchlight** The white highlight that appears in people's eyes.

**CCD** Charge-coupled device, the image sensor used in most digital cameras.

**center-weight metering** A light metering system similar to *matrix metering*, but that lends more analytical weight to the center of the image.

**channel** One component of a color image. Different channels of color are combined to produce a full color image. For example, red, green, and blue channels are combined by your monitor or digital camera to create a full-color picture. Also known as *color channel*.

**chromatic aberrations** Color artifacts caused by the inability of a lens to evenly focus all frequencies of light. Usually appears as colored fringes around high-contrast areas in a scene. See also *purple fringing*.

**chrominance** Color information.

**clipping** When highlights or shadows suddenly cut off to completely white or black in an image, rather than fading smoothly.

**clone** See *Rubber Stamp*.

**CMOS** Complimentary Metal Oxide Semiconductor. A type of image sensor. Not yet widely used, but offers the promise of better image quality, lower cost, and lower power-consumption than a CCD.

**CMS** See *color management system*.

**CMYK** Cyan, magenta, yellow, and black, the primary subtractive colors that are used by a printing process to create all other colors. Although cyan, magenta, and yellow are subtractive primaries, it is impossible to create perfectly pure pigments. Therefore, black ink must be added to create true blacks and darker colors.

**coating** Special chemicals applied to a lens that serve to reduce flares and reflection.

**color calibration** The process of calibrating your input and output devices, as well as your monitor, so that color is accurately displayed on each.

**color channel** See *channel*.

**color depth** See *bit depth*.

**color filter array** The colored filters that are placed over the photosites on an image sensor. Because image sensors can only "see" in grayscale, a color filter array is required for them to capture color information.

**color gamut** The range of colors that can be described by a particular color model. Also known as *gamut* or *color space*.

**color management system (CMS)** A set of software components that work together to compensate for the differences in your monitor, printer, and scanner so that your images appear as accurately as possible on your display.

**color matching engine** The software component of a color matching system that performs the translations from one color space to another.

**color model** A method of representing color. RGB, CMYK, and Lab are all color models and each takes a different approach to representing color. Also see *color gamut*.

**color space** See *color gamut.*

**color temperature** Different lights shine at different temperatures, measured in degrees Kelvin (°K). Each temperature has a different color quality.

**CompactFlash** A type of reusable, removable storage. The most common form of storage used in digital cameras.

**compositing** The process of layering images on top of each other to create composite images. Compositing is used for everything from creating simple collages to performing complex image correction and adjustment.

**continuous autofocus** An autofocus mechanism that constantly refocuses as new objects move into its focusing zone.

**continuous mode** See *drive.*

**continuous tone** A printed image that is made up of continuous areas of printed color. Photographic film prints are continuous tone. Inkjet printers, laser printers, and offset presses use printing methods that don't print continuous tone. If you look closely at a print from one of these devices, you can see that it is made up of small patterns of dots.

**contrast detection** An autofocus mechanism that determines focus by measuring contrast in a scene. The mechanism assumes that maximum contrast means sharpest focus. Contrast detection is a method of *passive autofocus.*

**contrast filters** Filters that you can add to the end of a lens to increase contrast in an image.

**contrast ratios** The ratio of the darkest to lightest tones in an image. The higher the ratio, the more contrast there is in the image.

**CRT** Cathode ray tube.

**dark frame subtraction** A method of reducing noise in long-exposure digital photos.

**demosaicing** The interpolation process that a CCD uses to calculate color. The color of any individual pixel is determined by analyzing the color of the surrounding pixels.

**depth of field** A measure of the area of an image that is in focus. Measured as depth from the focal point of the image.

**destructive effects** Filters that actually modify the pixels in your image. Unlike non-destructive effects, there's no easy way to go back and change a destructive effect's settings, or undo its effects if you change your mind about it later.

**device-dependent color space** A color space that represents colors as combinations of other colors. RGB and CMYK are device-dependent color spaces because accurate color representation in these spaces is dependent on the quality of your primary colors.

**device-independent color space** A color space (such as Lab color) that records what a color actually looks like, rather than how it is made.

**device profile** A description of the color qualities of a particular device, such as a printer, scanner, digital camera, or monitor. Also known as *profile* or *ICC profile.*

**digital photography** In this book, the term *digital photography* is used to refer to images shot with a digital camera.

**digital zoom** A feature on many digital cameras that creates a fake zoom by capturing the center of an image and blowing it up to full image size.

**digitizing** The process of converting something into numbers (digits). In a digital camera, an image sensor captures an image that is then converted into numbers, or digitized.

**diopter** An optical control that lets you adjust the viewfinder on a camera to compensate for nearsightedness.

**downsample** The process of reducing the size of an image by throwing out data.

**DPI** Dots per inch, a measure of resolution.

**drive** A special shooting mode for shooting a sequence of images in rapid succession. Also known as *burst* or *continuous*.

**drybag** A sealable, waterproof bag that will keep your camera dry even if it gets submerged.

**dual-axis focusing zone** An autofocus mechanism that measures contrast along both horizontal and vertical axes.

**dynamic range** The range of colors that a device can represent. A digital camera with larger dynamic range can capture and store more colors, resulting in truer, smoother images.

**effective pixel count** The actual number of pixels that are used on an image sensor. In many digital cameras, some of the pixels on the camera's sensor are masked away or ignored.

**electron gun** The image on a CRT screen or television screen is created by three electron guns that paint the screen with three different streams of electrons. Separate guns are provided for the red, green, and blue components of a color image.

**electronic TTL viewfinder** An eyepiece viewfinder that uses a tiny LCD screen instead of normal optics, and looks through the lens. (This is the same mechanism you'll find on most video camcorders.)

**element** One individual lens. Most camera lens are composed of many different elements.

**emulsion** The light-sensitive chemical coating on the surface of a piece of film.

**EXIF** Exchangeable Image File. A digital image file format used by most digital cameras. Notable because it includes special header information where all of an image's parameters (shutter speed, aperture, etc.) are stored.

**exposure** The combination of aperture, shutter speed, and ISO settings that determine how much light will be recorded at the focal plane.

**exposure compensation** A mechanism for adjusting the exposure on your camera that is independent of any particular exposure parameter. In other words, rather than specifically changing the aperture or shutter speed, you can simply use exposure compensation to over- or underexpose an image. The camera will calculate the best way to achieve the compensation.

**exposure lock** A mechanism that lets you lock the exposure on your camera independently of focus.

**external flash sync connection** Allows you to connect an external flash (usually a specific model) to the camera using a small cable.

**falloff** How quickly an effect changes. For example, a depth of field blur might have a quick falloff, meaning that the blur goes from sharp to blurry very quickly.

**fast shutter mode** Forces a large aperture to facilitate a fast shutter speed. Sometimes called *sports mode*.

**feather** The process of blurring the edge of a selection to create a smoother blend between an edit and the rest of an image.

**fill flash** Allows you to force the flash to fire to provide a slight fill light. Also known as *force flash*.

**film** A quaint nineteenth-century analog technology for recording images. Requires lots of hazardous chemicals, a lot of patience, and doesn't offer cool features such as Levels dialog boxes or Rubber Stamp tools. Not for the impatient. Does have the advantage that the recording and storage mediums are included in the same package.

**filter factor** Most lens filters are documented with a filter factor, which will inform you of the exposure compensation (in stops) required when you use that filter.

**filters** Either colored plastics or glass that you can attach to the end of your camera's lens to achieve certain effects, or special effects that you can apply to your image in your image editing program (see *plug-ins*).

**FireWire** A type of serial connection provided by many computers and digital cameras. Can be used for transferring images between camera and computer. Much faster than USB. Also called *IEEE-1394* or *i.Link*.

**fisheye** An extremely wide-angle lens that creates spherical views.

**flash compensation** A control that allows you to increase or decrease the intensity of your camera's flash. Usually measured in stops.

**flash memory** A form of nonvolatile, erasable memory. Used in digital cameras in the form of special memory cards.

**focal length** The distance, usually measured in millimeters, between the lens and the focal plane in a camera.

**focal length multiplier** Many digital SLRs use an image sensor that is smaller than a piece of 35mm film. If you attach a lens to one of these cameras, its 35mm equivalency will be multiplied by the focal length multiplier. For example, if your digital SLR has a focal length multiplier of 1.6x, a 50mm lens mounted on your camera will have an effective focal length of 80mm.

**focal plane** The point onto which a camera focuses an image. In a film camera, there is a piece of film sitting on the focal plane. In a digital camera, a CCD sits on the focal plane.

**focus assist lamp** A small lamp on the front of the camera that the camera can use to assist autofocusing. Also known as *autofocus assist lamp*.

**focus ring** The ring on a lens that allows you to manually focus the lens. Most smaller digital cameras lack focus rings, which can make them difficult to manually focus.

**focus tracking** An autofocus mode provided by some cameras that can track a moving object within the frame and keep it in focus. Sometimes called *servo focus*.

**focusing spot** See *focusing zone*.

**focusing zone** An area in the camera's field of view in which the camera can measure focus. Most cameras only have one focusing zone. The camera will focus on the object in this zone. Some cameras have multiple zones.

**force flash** See *fill flash*.

**f-stop** Sometimes synonymous with *stop*, more specifically a measure of the size of the aperture on a camera. F-stop values are the ratio of the focal length of the lens to diameter of the aperture.

**gamma** The midpoint (between black and white) in a tonal range.

**gamut** See *color gamut*.

**gels** Thin pieces of plastic that are usually placed in front of lights to create colored lighting effects.

**gigapixel** Dream on.

**grayscale** An image composed entirely of shades of gray, rather than color. (Basically, a fancy name for "black and white.")

**group** Multiple elements cemented together in a lens.

**halftoning** A process used for printing photos that begins by shooting a photo of an image through a special halftone screen. The resulting photo gets broken down by the screen into a pattern of dots that can be easily printed using a single ink. Your computer can generate halftone output from a laser printer, allowing you to skip the photographic halftoning step.

**hardware calibration** Special devices that measure the color of an output device. The data gathered by the device is then used to create a color profile of the device. This profile is, in turn, used by color management software to ensure accurate color output.

**histogram** A graph of the distribution of tones within an image.

**hot shoe** A mount for attaching an external flash to a camera.

**ICC profiles** See *device profile.*

**i.Link** Sony's name for *FireWire.*

**IEEE-1394** The official name for *FireWire.*

**image buffering** The capability of a camera to temporarily store images in an internal memory buffer before writing them out to a memory card. A large image buffer facilitates the rapid shooting of multiple frames, as the camera doesn't have to stop shooting to offload images to storage.

**image stabilization** Some telephoto camera lenses offer special optics that can stabilize the tiny shakes and jitters that can be caused by your hand.

**interpolation** The process of calculating missing data in an image based on data that is already there.

**iris** A mechanism that can expand and contract to create circular apertures to control the amount of light passing through a lens.

**ISO** A measure of a film's "speed" or light sensitivity. The higher the ISO, the more sensitive the film. The sensitivity of digital camera sensors is also rated using the ISO scale.

**JPEG** Joint Photographic Experts Group. More commonly, the name of a popular lossy image compression scheme.

**L*A*B color** See *Lab color.*

**Lab color** A color model created by the Commission Internationale de l'Éclairage. Lab color describes colors as they actually appear, rather than by how they are made. As such, Lab color makes a great reference space for performing color management and calibration.

**latitude** How far colors in an image can be pushed or pulled.

**LCD** Liquid crystal display.

**lens flares** Bright color artifacts produced in a lens by reflections within the lens itself.

**line screen frequency** The density of the screen that is used in a halftoning process. A screen with more density yields an image with smoother tones and more detail.

**L-Ion** Lithium Ion. A type of rechargeable battery.

**linear array** A digital camera mechanism that uses a single row of sensors that makes three separate filtered passes over the imaging sensors to create a full-color image.

**lossless** Indicates that a particular process does not result in any loss of quality.

**lossy** Indicates that a particular process results in loss of quality.

**luminance** Brightness information.

**macro** A special type of lens used for photographing objects at extremely close distances.

**manual mode** A shooting mode on a camera that allows you to set both the aperture and shutter speed, giving you full control over the camera's exposure.

**matrix meter** A light meter that analyzes many different areas of your scene to determine proper exposure.

**megapixel** A million pixels. Usually used as a measure of the resolution of a digital camera's sensor.

**Memory Stick** A type of reusable, removable storage developed by Sony, not yet adopted by any other camera vendors.

**metering** The process of measuring light with a light meter (or by eye) so as to determine proper exposure for a shot.

**MicroDrive** A tiny hard drive that fits in a Type II CompactFlash slot on a camera. Note that a camera usually has to be approved for use with a MicroDrive.

**mirror lock-up** The ability to lock a camera's mirror into the "up" position to reduce vibration when shooting long exposure images. Some higher-end cameras also provide a lock-up feature to aid in cleaning the camera's sensor.

**multiple array** A digital camera mechanism that uses three separate CCDs for capturing a color image, one each for red, green, and blue.

**multi-segment meter** See *matrix meter.*

**multi-spot focus** An autofocus mechanism on a camera that can focus on one of several different places within an image.

**nearest neighbor** A method of interpolation used in a resampling process.

**neutral density filter** A filter that cuts down on the light entering your camera's lens, without altering the color of the light. Enables you to use wider apertures or faster shutter speeds in bright light.

**NiCad** Nickel Cadmium. A type of rechargeable battery. Not recommended for use in a digital camera.

**NiMH** Nickel Metal Hydride. A type of rechargeable battery.

**nodal point** The optical center of a camera's lens.

**noise** The bane of all digital photographers. Noise appears in an image as very fine-grained patterns of multicolored pixels in an area. Shadow areas are particularly susceptible to noise as are images shot in low light. Noise is very different looking than the grain found in film photos. Unfortunately, it's also far less attractive.

**normal lens** A lens that has a field of view that is equivalent to the field of view of the human eye. Roughly 50 mm.

**overexposed** An image that was exposed for too long. As an image becomes more overexposed, it gets brighter and brighter. Highlights and light-colored areas wash out to completely white.

**parallax** The easiest way to understand parallax is simply to hold your index finger in front of your face and close one eye. Now close the other eye and you'll perceive that your finger has jumped sideways. As you can see, at close distances, even a change of view as small as the distance between your eyes can create a very different perspective on your subject. A camera that uses one lens for framing and another for shooting faces the same problems. Parallax is not a problem at longer ranges, as the parallax shift is imperceptible.

**passive autofocus** An autofocus mechanism that achieves focus by analyzing the camera's view of the scene.

**PC Card adapter** A special adapter that lets you insert a storage card from your camera into the PC card slot of your computer.

**PC Cards** Small, credit-card-sized peripheral cards that can be inserted into a PC Card slot on a laptop computer, or into a special PC Card drive on a desktop computer. PC Card adapters are available for most types of digital camera media, allowing you to insert media directly into your PC Card slot.

**PCMCIA** See *PC cards*.

**phase detection** See *phase difference*.

**phase difference** An autofocus mechanism that uses measurements taken through different parts of the camera's lens to determine focus. Also known as *phase detection*.

**photosite** A tiny electrode that sits on the surface of an image sensor. There is one photosite for each pixel on a sensor.

**picture elements** The smallest area of color information that can be displayed on a computer monitor. Also, the smallest area of color information that can be detected by a digital imaging sensor. Also known as *pixels*.

**pincushion distortion** A type of distortion caused by a lens. Causes the edges of an image to bow inward. Most prevalent in telephoto lenses. See also *barrel distortion*.

**pixel** See *picture elements*.

**pixel mapping** A feature included on some digital cameras. When activated, the camera examines all of the pixels on the camera's image sensor and creates a map of which ones are bad. It then excludes these pixels from all color calculations. The pixel map is stored and used for all shots until you execute the pixel mapping again. Some cameras lose their pixel maps when you change the camera's batteries.

**pixellate** Sometimes, the individual pixels in an image can become visible, a process called pixellation.

**plug-ins** Special bits of code, usually effects or image processing filters that can be added to your image editing application. Most plug-ins conform to the Photoshop plug-in standard.

**polarizers** Special filters that can be fitted onto the end of a lens. Polarizers only allow light that is polarized in a particular direction to enter your lens. Polarizers can completely remove distracting reflections from water, glass, or other shiny surfaces. Polarizers can also be used to increase the contrast in skies and clouds.

**posterization** Reduction of the number of tones in an image. As a particular tonal range gets posterized, it will appear more "flat."

**PPI** Pixels per inch, a measure of resolution.

**prefocus** The process of autofocusing, metering, and white balancing that occurs when you press your camera's shutter release button halfway.

**prefocus time** How long it takes a camera to perform its prefocus steps (autofocus, metering, and white balance).

**prime lens** A lens with a fixed focal length.

**profile** See *device profile*.

**proportional zoom control** A zoom control whose rate of zoom changes depending on how far you push or pull the control.

**prosumer** A marketing term for a camera that sits somewhere between the professional and consumer market.

**purple fringing** A color artifact specific to digital cameras with resolutions greater than two megapixels. Appears in an image around the edges of high-contrast objects, usually shot with wide-angle lenses. Usually confined to the edges of the screen. See also *chromatic aberrations*.

**quantization** In JPEG compression, the process of averaging the colors in one 64-pixel square area.

**quantizing** The process of assigning a numeric value to a sample. Part of the digitizing process.

**rangefinder** A viewfinder mechanism on a camera. A fixed-focus or zoom lens is used for imaging, while a separate optical viewfinder is used for framing your shot.

**Raw data** Pixel data that comes directly from the CCD with no further processing. Processing is usually performed later using special software. Raw files offer quality equivalent to an uncompressed image, but require much less space.

**read-out register** The mechanism that reads the signals from each row of photosites on an image sensor. The read-out register amplifies the signals from the photosites and sends them to the camera's analog-to-digital converter.

**reciprocity** Exposure parameters have a reciprocal relationship so that different combinations of parameters produce the same exposure. For example, setting your camera to a shutter speed of 1/250th of a second at f8 is the same as setting it to 1/125th at f16.

**rectilinear** A type of wide-angle lens that includes corrective elements that prevent barrel distortion.

**recycling** The time it takes a camera to reset itself and prepare to shoot another shot.

**red-eye** When the flash from a camera bounces off a subject's eyes and back into the camera's lens, the subject will appear to have bright red eyes. Most prevalent in cameras where the flash is very close to the lens.

**red-eye reduction** A special flash mode that attempts to prevent red-eye by firing a short initial flash to close down the irises in your subject's eyes.

**refraction** The process of slowing and bending light using a transparent substance such as air, water, glass, or plastic.

**refresh rate** How often the image on a camera's LCD viewfinder is redrawn. An LCD with a higher refresh rate will produce an image with smoother motion.

**registration** When primary color channels are positioned over each other so that a full-color image is produced, the images are said to be "in registration."

**resampling** The process of computing new pixel information when resizing a document in your image editing application. If you are resizing upward, the resampling process will generate new pixels. If you are resizing downward, the resampling process will discard pixels.

**resolution** In a monitor or digital camera, the number of pixels that fit into a given space. Usually measured in pixels per inch (ppi) or dots per inch (dpi). In a printer, the number of printer dots that fit into a given space, usually measured in dots per inch (dpi).

**RGB** Red, green, and blue, the additive primary colors that are used by your computer monitor and digital camera to produce all other colors.

**Rubber Stamp** An image editing tool that works like a paint brush but that copies image data from one part of your image to another. A staple retouching tool.

**sampling** The process of analyzing something to determine its content. A digital camera samples light to determine how much, and what color the light is, at any given point in a scene.

**saturation** A characteristic of color. Colors that are more saturated are typically "deeper" in hue and often darker. As saturation increases, hue shifts slightly.

**SCSI** Small Computer System Interface. An older, high-speed computer interface for attaching hard drives, scanners and other peripherals.

**servo focus** See *focus tracking.*

**sharpening** The process of using software to increase sharpness in a digital image. Sharpening can happen inside a digital camera or through post-processing on your computer.

**shutter** A mechanism that sits in front of the focal plane in a camera and can open and close to expose the image sensor or film to light. Many digital cameras do not have physical shutters, but instead mimic shutter functionality by simply activating and deactivating their image sensors to record an image. Cameras that do have shutters typically use a two-curtain mechanism. The first curtain begins to slide across the focal plane to create a gap. It is followed usually very quickly by a second shutter that closes the gap. As the gap passes across, the entire CCD is exposed.

**shutter lag** A delay between the time you press the shutter release button on a camera and the time it actually shoots a picture.

**shutter priority** A shooting mode on a camera. Shutter priority lets you define the camera's shutter speed. The camera will then calculate a corresponding aperture based on its light metering.

**shutter speed** The length of time it takes for the shutter in a camera to completely expose the focal plane.

**single array system** A digital camera mechanism that uses a single image sensor for imaging. Sometimes called a "striped array."

**single-axis focusing zone** An autofocus mechanism that measures contrast along a single axis only, usually horizontal.

**single lens reflex** A camera whose viewfinder looks through the same lens that your camera uses to make its exposure. Also known as *SLR.*

**slow sync mode** A special flash mode that combines a flash with a slow shutter speed to create images that contain both still and motion-blurred objects.

**SLR** See *single lens reflex.*

**SmartMedia** A type of reusable, removable storage.

**soft proof** An on-screen proof of a color document.

**specular highlights** The bright white glints and reflections that occur on very shiny surfaces and on the edges of objects.

**spot meter** A light meter that measures a very narrow circle of the scene.

**sRGB** An RGB color space defined by Microsoft and Hewlett-Packard. It is intended to represent the colors available on a typical color monitor. A little too small for digital photography work.

**step-up ring** An adapter that attaches to the end of a lens and allows for the addition of filters or other lens-attachments. Serves to change the thread size of the lens.

**stitching** The process of joining and blending individual images to create a panoramic image.

**stop** A measure of the light that is passing through a camera's lens to the focal plane. Every doubling of light either through changes in aperture, shutter speed, or ISO is one stop. See also *f-stop.*

**striped array** See *single array system*.

**subtractive** Ink mixes together in a *subtractive* process whereby as colors are mixed together they get darker; that is, light is subtracted as the colors are mixed. Subtractive colors eventually produce black. Cyan, magenta, and yellow are the primary subtractive colors that can be used to create all other colors.

**telephoto** A lens with a focal length that is longer than *normal*. As a lens gets more telephoto, its field of view decreases.

**TFT** See *Thin Film Transistor*.

**Thin Film Transistor** A technology used to create LCD screens. Typically used for the LCD viewfinder/monitors included on the backs of many digital cameras.

**three-shot array** A digital camera mechanism that uses three *single arrays*, one each for red, green, and blue.

**through the lens** See *TTL*.

**title safe** A guide similar to the *action-safe* area. The title-safe area is slightly smaller.

**transfer mode** See *blending mode*.

**trilinear array** A digital camera mechanism that uses three *linear arrays* stacked on top of each other to create a full-color image in a single pass over the image sensor.

**TTL** A viewfinder mechanism that looks through the same lens that is used to focus the image onto the focal plane. Short for *through the lens*.

**underexposed** An image that was not exposed enough. In an underexposed image, dark, shadow areas turn to completely black.

**upsample** The process of enlarging an image by calculating (interpolating) new data.

**USB** Universal Serial Bus. A type of serial connection provided by many computers and digital cameras. Can be used for transferring images between camera and computer.

**VGA resolution** 640 × 480 pixels.

**Video LUT Animation** A feature available in some versions of Photoshop that allows for real-time, on-screen viewing of color corrections and changes.

**video RAM** The memory in a computer that is used for displaying images on-screen. The more video RAM, the larger your images can be, and the greater the bit depth they can have. Also known as *VRAM*.

**vignetting** A darkening of the image around the edges.

**virtual reality movie** See *VR movie*.

**VR movie** A digital movie that lets you pan and tilt in real time to explore and navigate a virtual space.

**wavelet compression** A new fractal-based compression scheme. Converts your image from a series of raster dots into a collection of tiny fractal curves.

**white balance** A color calibration used by a camera. Once a camera knows how to accurately represent white, it can represent all other colors. Because white can look different under different types of light, a camera needs to be told what white is, a process called white balancing.

**wide-angle** A lens with a focal length that is shorter than normal. As a lens gets more wide angle, its field of view increases.

**XGA resolution** 800 × 600 pixels.

**zone system** A method of calculating exposure.

**zoom lens** A lens with a variable focal length.

# INDEX